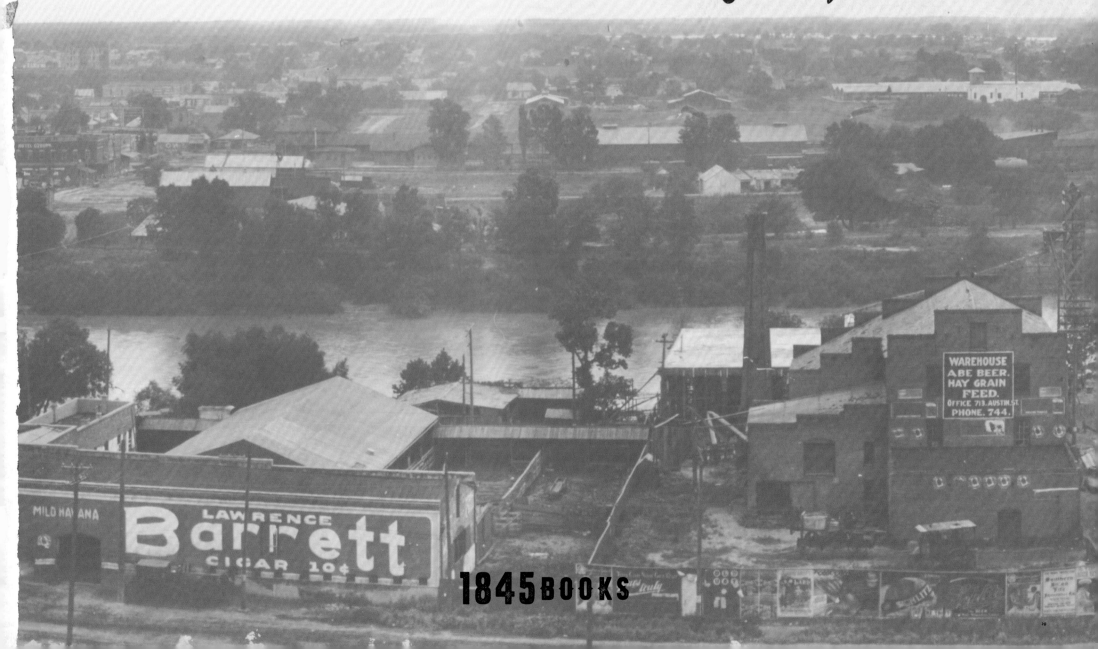

Gildersleeve
Waco's Photographer

1845 BOOKS

This book is dedicated to

KENT KEETH

Former Director of The Texas Collection

1938–2017

Introduction by

JOHN S. WILSON

Image selection and preparation by

GEOFF HUNT

CONTENTS

The authors wish to thank the faculty and staff of The Texas Collection for their assistance in preparing this book. A special thank you to Brian Simmons and Tiff Sowell for their patience and help along the journey.

This volume was assembled from Fred Gildersleeve's professional work and private family albums, in a number of mediums: glass plate photo negatives, cellulose negatives, and photo prints. Those interested in photography and Texas history may find enjoyment in these images of people, places, and things that have been lost to time but not to the photographic archive.

Gildersleeve's early photography of Waco was created during a period when the cotton industry was booming, skyscrapers were being constructed, and extravagant exhibitions and events were celebrated. Industry was strong. Several railroads transported goods and people to and from Waco, building its thriving economy. Gildersleeve's photography focused primarily on downtown—the central business district. From his pictures taken atop the twenty-two-story Amicable (Alico) Building, the once-thriving Waco Square and its surroundings come into focus. Gildersleeve's photographs of Waco easily demonstrate his slogan: "Photographs Tell the Story."

Fred Gildersleeve's personal collection of photo negatives and prints were donated to The Texas Collection in the 1970s by Roger N. Conger. Conger was a close friend of Gildersleeve during the latter part of his life. He also knew the importance of his work and expressed an interest in one day owning Gildersleeve's collection. Conger, a former Waco mayor and well-known local historian, acquired what was left of the photographer's collection after it was willed to him.

In the time since Roger Conger donated Fred Gildersleeve's work to The Texas Collection, advancements in photo reproduction have made it possible to reproduce digitally some of his original 8x10 inch glass plate and cellulose negatives. Whenever possible, minimal post editing was done to preserve what the photographer may have intended. In some instances, cropping was done to bring a closer focus on the subject matter.

INTRODUCTION

FRED A. GILDERSLEEVE

Fred Allen Gildersleeve, also known as "Gildy," was a brilliant and prolific photographer as well as a gifted artist. During his lifetime and even after his death, Gildersleeve never truly received the professional respect and accolades he deserved. Later in his life, Roger Conger stated that he thought Gildersleeve's work was as good as the famed Civil War era photographer Mathew Brady's.

Gildersleeve's creativity behind the lens was extraordinary; he could visualize a photograph before it was taken. He was wonderfully skilled at framing a person or place to perfection, and his ingenious talent for capturing movement such as a play or down in a football game on Baylor's Carroll Field was uncanny for his day. The majority of Gildersleeve's photographs are clear and crisp, and as vibrant today as they were when he developed them in his studio. Gildersleeve recorded taking over 5,800 images in his studio register, but during his lifetime he undoubtedly took many more photographs. Several personal photo albums of his early years in Illinois, Missouri, and Texas depict examples of his prolific work. These include photographs of his wife, Florence, and their Jack Russell Terrier "Jack"; his sister, Jessie Ellen; their mother, Sarah; and several unidentified friends.

THE EARLY YEARS

Fred A. Gildersleeve was born near Boulder, Colorado, on June 30, 1880, to Captain Allen Jesse and Sarah Ellen Pew Gildersleeve. Allen Jesse was a Civil War veteran. He had enlisted in the Union Army as a private and earned the rank of Captain in the Missouri Cavalry, 14, Regiment, Company D.

Gildersleeve was the younger of two children. His sister Jessie Ellen, was born April 17, 1877, in Truxton, Missouri. She remained close to Fred over the years and they would live either in the same residence or near each other throughout their lives. Little is known about Gildersleeve's time in Boulder, as he was only an infant when his father, Allen, died at the age of forty-six in 1881. His mother, Sarah, was thirty at the time. She and Allen had been married just nine short years. After his father's death, the family moved to Kirksville, Missouri.

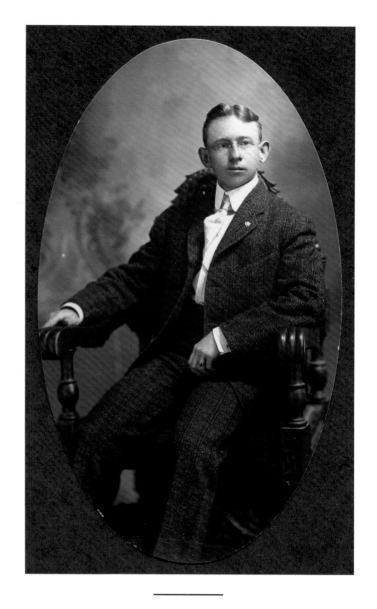

PORTRAIT OF A YOUNG FRED GILDERSLEEVE
A rather youthful Fred Gildersleeve takes time to pose for his own photograph.

c. 1900. 5"x8" silver gelatin print
Photographer: Unknown
Gildersleeve-Conger Collection #0430

Information about Fred Gildersleeve's life before moving to Waco is scarce. However, in 1943, Gildersleeve jotted down numerous life stories and reminiscences on bits of stationery, from the Roosevelt Hotel in Waco. The pages are difficult to read and interpret but provide some small insights into Gildersleeve's life at different periods of time. One example is a short story by him from October 18, 1943, providing a memory of his father most likely told to him by his sister or mother:

> Daddy had sky blue eyes, light hair, ruddy complexion, hair and whiskers auburn. It has always been said by those who knew him he was handsome with a very graceful carriage (I wonder where I got my ugliness and slouchy carriage) . . .
> As a dancer—some of the old ladies remarked that had danced with him (in) Montgomery (Co.), Missouri "he was as light as a feather on his feet and as graceful as an antelope."

Also recorded in Gildersleeve's journal is a remembrance regarding his unattractive appearance made by his mother, Sarah. It stayed with him throughout his life. There was no indication from Gildersleeve of his exact age at the time when this harsh life-lesson was spoken:

> Mother told me when quite young, "son you are not handsome, sorry to say [I] can't understand it, your sister is and your father was a handsome man . . . dress neatly, comb your hair in a becoming way, be polite, and manly and act a gentleman at all times, use good language, read good books no trashy literature, be able to carry on a conversation, don't try and do all the talking yourself and listen attentively to others and people will forget that freckled face and your ugliness. I don't say you are as homely as Abraham Lincoln but remember you are homely and you will succeed in life, but by your actions and proper carriage in any society." Now to me that is real philosophy, she never had anything but a rural education but had a good will to read the Bible diligently and good books and was always popular and had such a happy pleasant smile and laughing blue eyes.

This stark revelation about Gildersleeve's looks seems severe for a mother to make to a young son. Gildersleeve was often described as a little man who was strong and wiry. He was slightly built and his features were exaggerated, having larger than normal ears, a pointed nose, and weak chin. In photographs he appeared more homely than handsome, but certainly not ugly. Gildersleeve did seem to listen to his mother's advice—he developed good manners, was outgoing, and personable. He had no difficulty meeting people, developed numerous lasting friendships, such as those with Waco photographers C. W. Burdsal and Jimmie Willis, as well as Samuel Palmer Brooks, president

of Baylor University from 1902–1931. He met and photographed several U.S. presidents such as Theodore Roosevelt, Woodrow Wilson, William Howard Taft, and Calvin Coolidge.

Gildersleeve wrote in his journal at least twice about his mother disciplining him when he went astray:

> When I was sixteen, I remember it as if it was yesterday, it was in Kirksville, a hot day I was trying to put down carpet, and I swore, she said, "son if you swear again I am going to whip you," well of course I didn't think as old as I was she meant it, and a few minutes later I hit my thumb and I said a cuss word, she very quietly left the room, I hadn't missed her and all of [a] sudden, wham across my back and she had a real stick—not a small limb[—] and pelting me over the back. I jumped up and as she was whipping me she was also crying[,] tears streaming down her cheeks, after she was through sobbing she said, "son that hurt me more than you" and I know it did, she laughingly told that many times after I was grown.

At another time, Gildersleeve recalls his mother saying:

> "Sony [sic] boy don't do that," if I did I got a whipping that was a real reminder, I remember she went to an old apple tree and I started to run to grandmother's house about 300 yards away, when she caught me and grandmother came out and I tried to stop her, saying "I'll learn this boy not to run from me"—yes it taught me I had better in the future take a whipping, like a man, don't understand me to say she was brutal or hot tempered but she believes in obedience, the old saying "spare the rod and you ruin a man."

Taken from the Friday, June 5, 1898, *Weekly Graphic*, page 5 (Kirksville, Missouri) Gildersleeve attended the Model School (part of the Normal School) in Kirksville and graduated at the age of 16. There were seventeen in his class who graduated in the Normal Chapel on Friday, May 29, 1896. It is interesting to note that Gildersleeve did not think of himself as a good student. Later in his life he also added a short entry in his journal: "I am going to reminscence (reminisce), may not be spelled correctly because I am exceeding bad at spelling and mathematics. . . ."

Waco newspapers credited Gildersleeve with being a jockey in Kirksville and riding mules at county fairs. He seemed to tell the story more than once during his lifetime, but no local Kirksville article could be found to verify his often-quoted claim.

The first time Gildersleeve takes any type of photograph appears to have been in 1898. An article in the Sunday, October 30, 1949, *Waco Tribune-Herald*, page 15, reported that Gildersleeve at the age of eighteen was given an 1898 Kodak camera by his mother, Sarah Gildersleeve. He photographed students at the school and sold them for twenty-five cents each (even though he

had graduated two years earlier). According to the article, "There was only one hitch. He could only work on sunshiny days because the printing was done by sunlight on solio paper."[1]

According to the *1900 U.S. Population Census*, Gildersleeve moved to Belvidere, Illinois, to 710 North State Street. The family appears to have relocated to Belvidere sometime after Gildersleeve graduated from high school in Kirksville. His sister, Jessie, was listed as the head of household; we assume due to her income and profession as an osteopath. In a Wednesday, August 28, 1901, page 9 news blurb in the *Belvidere Daily Republican*, a secondary heading reads, "Fred Gildersleeve Overcome While at Work Friday." Gildersleeve then twenty-one, was working at the Sabin Brothers store. The *Republican* reports, "He is still quite sick. His illness is the result of a reoccurrence of heat prostration which he suffered some time ago." In Gildersleeve's memoir he mentions several times that he suffered poor health while he was young and stayed home from school, nursed by his mother, Sarah. She seemed to enjoy spending time with him while he was convalescing.

In his early working years, along with Sabin Brothers, Gildersleeve was employed at a door paint factory and a sewing machine manufacturing plant before finding his calling as a professional photographer. In 1903, Gildersleeve graduated from the Illinois College of Photography in Effingham. During these formative years, he was instructed in the theory and practice of the camera and lens, composition, use of light, and negative and printmaking. These skills would enable him to become a successful photographer wherever he went.

In 1905 or 1906, Fred Gildersleeve travelled from Texarkana, Arkansas, to Waco to work in the photography business. Gildersleeve's first recorded photograph in his studio register is of the Metropole Hotel and

ILLINOIS COLLEGE OF PHOTOGRAPHY CLASS

In this Illinois College of Photography class portrait, Fred Gildersleeve stands out as he poses with another classmate (lower left). At ICP, he learned the skills that would help him to become an expert in his field.

1903. 6"x8" silver gelatin print
Photographer: Unknown
Place: Effingham, Illinois
Gildersleeve-Conger Collection #0430

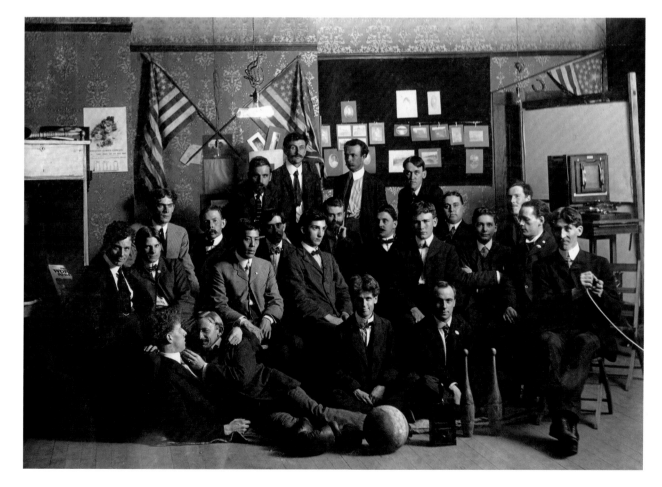

[1] *Solio paper was a proprietary paper made by Eastman Kodak that used the sun to develop the image.*

dates to circa 1910. Another register might have existed but may not have survived or it has not surfaced. His sister, Jessie Ellen, arrived in Waco around the same time. Their mother, Sarah, later joined them and lived with her daughter. Jessie and Fred lived next door to each other in Waco on Ethel Avenue for most of their lives. Jessie accepted a position as assistant to Dr. J. F. Bailey, osteopath, in 1906. Prior to this time, she had been practicing in Texarkana. Evidence of Gildersleeve's time in Texarkana is provided in the January 7, 1938, *Dallas Daily Times-Herald*, section 2, page 14.

> Death Claims Early Waco Photographer:
>
> C. W. Burdsall Succumbs in Dallas, Waco Friends are Informed
>
> Word of the death in Dallas of C. W. Burdsall, former Waco photographer, was a shock to Fred Gildersleeve, Waco photographer. Burdsall was Gildersleeve's first employer in Waco, and helped make the Waco man the first commercial photographer in the southwest.
>
> Gildersleeve came to Waco to help Burdsall after the latter had pneumonia and was unable to keep up with a rush of work during convalescence. . . . In 1906, Gildersleeve sold his Texarkana home, and moved with his sister, Dr. J. Ellen Gildersleeve . . . to Waco, where he ran the Jackson studio for a while and then went into business for himself, with Burdsall's aid.
>
> Burdsall[2] was a generous employer, the Wacoan recalls, "When I worked for him I was the second highest paid photographer in Texas, and he always paid me a bonus for overtime, which was unusual in those days."

Gildersleeve's permanent move to Waco is recorded in newspaper articles as early as 1905 and as late as 1907. He is first listed in the *Waco City Directory* of 1906–1907 working for Burdsal as a photo finisher. His sister, Jessie Ellen, and his mother, Sarah, first appear in the 1907–1908 *Waco City Directory*. They are all originally listed as living at the same residence at 610 North 4th St. This close knit Gildersleeve clan seemed to enjoy each other's companionship, living and working near one another. After living in Waco for just five years, Sarah Ellen Gildersleeve died on July 10, 1912. She had been ill for a year prior to her death. Her remains were shipped back to the Pew Family Cemetery in Montgomery County, Missouri, for burial.

Fred Gildersleeve married Florence Boyd on December 24, 1908, in Texarkana, Arkansas. The couple then resided at 1311 Franklin Avenue in Waco. She helped Fred in the photography business and assisted in his studio work. In one of Gildersleeve's photographs she can be seen sitting with other employees trimming the edges of photo prints for customers. Florence is also

[2] *Waco City Directory 1906–1907 lists Burdsall with one L not two, as in Burdsal.*

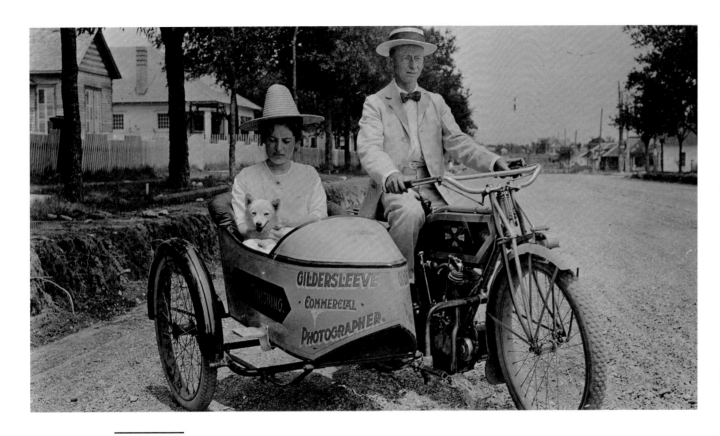

MOTORCYCLE AND SIDECAR

Fred and Florence Gildersleeve (with dog) pose on their Excelsior motorcycle with sidecar.

c. 1910. 3"x5" silver gelatin print
Photographer: unknown
Gildersleeve-Conger Collection #0430

photographed sitting in a biplane with Fred and suited up for a photographic outing and ready for takeoff. Florence's mother, Teresa Boyd, came to live with the couple and is listed in the *1940 U.S. Population Census* at their later address at 2219 Ethel Avenue in Waco.

The Gildersleeve couple remained married and living together until a split occurred sometime around 1943. In an August 16, 1946, *Waco News-Tribune* article, page 10, Florence Gildersleeve and her mother, Teresa, are mentioned as living at 1501 Maple Avenue. Fred Gildersleeve remained at the address on Ethel until his death. Florence continued to live in Waco after their separation and died March 31, 1965, at the age of 79. She is buried in Oakwood Cemetery, Waco. There was no recorded divorce located at the McLennan County Court House.

Gildersleeve was an active and prominent member in the Waco community. The *Standard Blue Book of Texas, 1920*, lists him as being a member of the Masons, York Rite, Shriners, Rotary Club, Ad Club, Young Men's Business League (Y.M.B.L.), Chamber of Commerce, and as serving on the committees of Liberty Loan, the Salvation Army, and the Red Cross. Fred Gildersleeve's involvement with these groups and organizations allowed him to prosper in his photography business as well as give back to his community. When the Y.M.B.L. went on their "Trade Excursions" to promote the city of Waco, Gildersleeve joined them as both a photographer and member. The promotional pamphlets they gave out contained publicity photographs of the city mostly taken by him. His commitment to these organizations lasted for decades. The Sunday, April 9, 1950, *Waco News-Tribune* article, page 32, upon Gildersleeve's retirement from the Waco Rotary Club, mentions that he designated his status as commercial photographer to fellow Rotarian and prominent local

photographer Jimmie Willis. "For 37 years I wore this Rotary emblem. Please accept it with my best wishes. I was not a charter member but joined a few months after the Waco Rotary Club was organized."

A lifelong passion of Gildersleeve's was his love of fishing, hunting, and the great outdoors. In a July 25, 1939, letter to Mr. W. L. Thompson of the *Southern Sportsman* (Austin, Texas), Gildersleeve recalls:

> Began my fishing when I lived in Belvidere, Ill., this was a number of years ago, would spend the week ends fishing in the lakes in Wis., caught plenty of bass, some large mouth, some small mouth, never caught a Musky that went over 18 pounds, or Pike of any size, so you see I can't brag.
>
> Came south, Waco, Texas, lived here ever since, and began to go to Fort Aransas, fished with Mr. W. W. Woodson, pres. First Natl Bank, now deceased, he was an ardent Tarpon Fisherman . . .
>
> In the mean time I had joined the [*Club Deportivo* "Don Martin"] Club, Old [Coahuila] Mexico, I had been fishing in that part of Mexico for a number of years

Gildersleeve recalled other memorable fishing trips to Lake County, Florida, and Eagles Nest, New Mexico.

A *Waco Tribune-Herald* news article dated Wednesday, September 5, 1928, page 2, reports an incident from when Gildersleeve was dove hunting in Leroy, Texas. He places his loaded gun against a fence so he can open a gate; when he picks the gun up, the trigger gets caught on a wire and he accidentally shoots himself in the thumb. The thumb is shattered and must be amputated. He later tells those who ask about his missing thumb that it was eaten away by photographic processing solution. Gildersleeve is known to have hunted for deer near San Antonio, elk in British Columbia, and leopard in Mexico. Throughout most of his early life, Fred Gildersleeve would travel, fish, hunt, and enjoy his time outdoors. Early in their marriage, in

FRED AND FLORENCE GILDERSLEEVE
Mr. and Mrs. Fred Gildersleeve pose in their Overland automobile for the camera.

1910. 8"x10" silver gelatin print
Photographer: Unknown
Gildersleeve-Conger Collection #0430

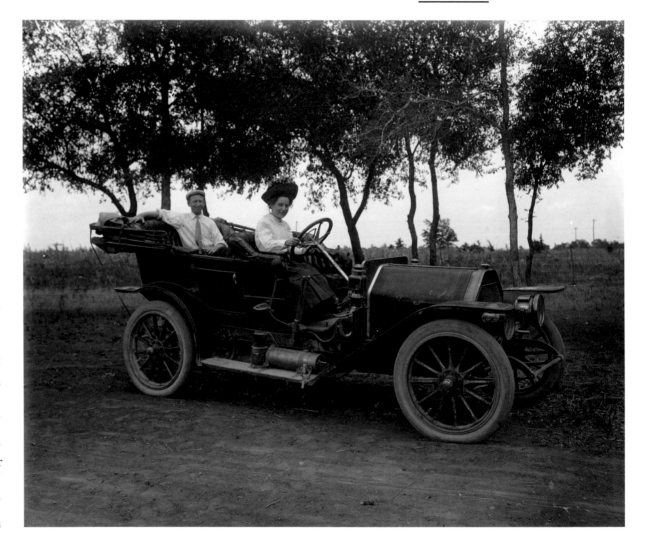

1915, Gildersleeve, Florence, and his sister Jessie traveled to Colorado and camped for several weeks. The purpose of the trip was recreational, to see and enjoy the Rocky Mountains and also to locate his father's gravesite.

GILDERSLEEVE'S PHOTOGRAPHIC BRILLIANCE

From the time Fred Gildersleeve began working in Waco, his photographs were in demand and his impact on Waco and its people was positive and lasting. During his early years working in Waco, Gildersleeve was frequently seen riding his Excelsior motorcycle with a sidecar, on his way to and from his numerous photographic engagements. His large box camera, tripod, glass plate negatives, flash powder, and other equipment were stuffed into the seat of the sidecar. The tripod was always hanging out on one side or the other. In his later years, he drove a Ford automobile. It was not nearly so distinctive, but likely more comfortable and convenient during rainy or cold weather.

There were several Gildersleeve firsts and major events often repeated in articles in the *Waco Tribune-Herald* over the course of Gildersleeve's lifetime and even after his death. This regular referencing of Gildersleeve and his groundbreaking work elevated him from local personality and photographer to iconic photographer and local legend. Gildersleeve was the photographer of choice by local businesses and Waco's society. Near the end of his life, Waco newspaper articles would write short blurbs about him on his seventy-third and seventy-fourth birthdays. His birthday was also chronicled by the *Lubbock Morning Avalanche* on July 1, 1953, page 12.

It can certainly be disputed, but Gildersleeve is given credit for being the first commercial photographer in Texas. He was employed by business owners and associations in Waco and Texas to photograph their establishments; a few of those were Sanger Brothers, Goldstein-Migel, Crow Brothers Laundry, Hall Cycle Car, the Huaco Club, Southwestern Bell Telephone Company, the Cotton Palace Association, the Associated Ad Clubs of Texas, and the Amicable Life Insurance Company.

Gildersleeve worked for at times and/or provided photographs to the *Waco Times-Herald* and the *Waco Tribune-Herald*. Gildersleeve's Studio Register lists others too numerous to mention. He left his mark on just about every image he developed by writing in white (actually black on the photo negative) his last name "-Gildersleeve-" and "-Waco-" and "copyright" on a few developed prints.

He was ahead of his time in identifying his work and claiming copyright. An example of this was his well-engineered nighttime photographs of the Prosperity Banquet, where his expert use of the flash helped illuminate a part of the downtown Waco area where about 1,200 people were seated for a dinner celebration. Other clients that employed Gildersleeve were Baylor University, the Waco School system, Paul Quinn College, Texas Christian University, and civic groups such as the Y.M.B.L., Y.W.C.A., and Y.M.C.A.

Many, but certainly not all, of his glass plate negatives have survived. However, there are many Gildersleeve photo prints still surviving that were produced by his studio and later by others. Additionally, Gildersleeve's studio was a commercial facility and would process film brought in by customers. In these instances, the Gildersleeve name would be stamped on the back of the print, too, as the source of photographic development. Other sources that published photographs taken by Fred Gildersleeve were early annuals, and trade and commercial literature. In a Friday, June 17, 1955, *Waco News-Tribune*, page 7 article "Gildersleeve to Observe 75th Birthday," Gildersleeve mentions the passing of Jim Pattillo just a week earlier on Saturday. Apparently, Jim Pattillo and A. R. McCollum

> paid him $1.50 each for two photographs of the June 1907 flood, his first news photographs.
> "I took these pictures of the flood and I carried a couple of them to the newspaper office and pitched them on the desk and started to walk out.
> They called me back and gave me a check for $3. I told them I was selling the pictures for 25 cents, and they told me to boost the price to 50 cents. I did."

Another example of some of his fascinating and pioneering work is his Thanksgiving Day, November 25, 1909, photography of Baylor University's first homecoming parade and football game. Baylor played then crosstown rival Texas Christian University and won the game 6–3. This is the first known homecoming college football game. Gildersleeve's work is especially remarkable because he captured on the field action as the game was in progress. His shutter speed would have been painfully slow compared to modern cameras; he must have managed this feat with great skill and a steady hand. There are several of these action shots that survived and were printed in the *1910 Round Up*, Baylor University's student yearbook.

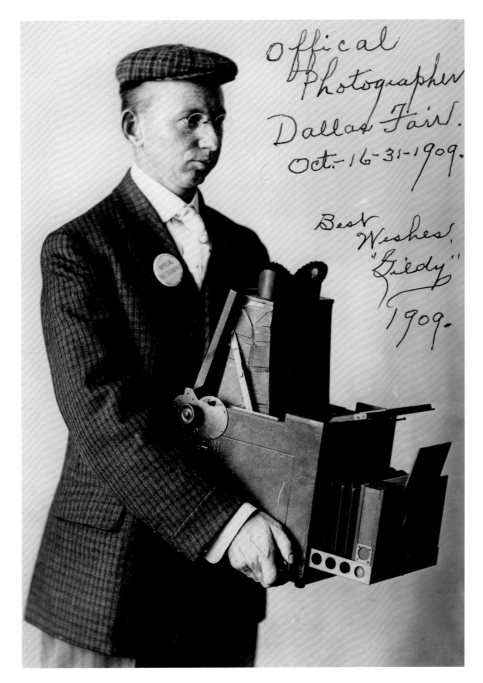

FRED GILDERSLEEVE—THE OFFICIAL PHOTOGRAPHER

Fred Gildersleeve was the official photographer of the Dallas Fair for 1909 as noted on this signed photograph.

1909. 4"x6" silver gelatin print
Photographer: Unknown
Gildersleeve-Conger Collection #0430

Right about the same time, in 1909, Gildersleeve was appointed the official photographer of the Dallas Fair. Not too long after this job he began working on special assignments for the *Dallas Morning News*. In 1910, an assignment took him to Campeche, Mexico, to photograph an extensive plantation holding. These images of the local people and places are some of the most artistic and interesting cultural studies in his portfolio.

One incident recorded by Fred Gildersleeve that may have clouded the public's perspective of him was his documentation of the Jesse Washington lynching near Waco City Hall on May 15, 1916. Gildersleeve published photographs made into postcards of the event. His intention in photographing the Washington incident is not known, but as a result, the sale and distribution of the graphic and gruesome act may have helped galvanize the NAACP (National Association for the Advancement of Colored People) into national action against lynching.

The Crisis, published by the NAACP, printed a piece called *Supplement to the Crisis*, in July 1916, and titled it "The Waco Horror." This publication includes several of Gildersleeve's graphic photographs of the event as well as an article giving an in-depth look into the events leading to the trial of Jesse Washington, who was an African American accused of killing a white woman named Lucy Fryer. The article describes how Washington was tried by a court of law in her slaying, convicted of murder, and then received a death sentence.

Subsequent to this sentencing, a mob stormed the courtroom, grabbed the defendant, Jesse Washington, and lynched him in a gruesome manner near the old city hall building in Waco's downtown square. *The Crisis* supplement on page 6, then goes on to state:

> ". . . Photographer Gildersleeve made several pictures of the body as well as the large crowd which surrounded the scene as spectators. The photographer knew where the lynching was to take place, and had his camera and paraphernalia in the City Hall. He was called by telephone at the proper moment. He writes us:
>> " 'We have quit selling the mob photos, this step was taken because our 'City dads' objected on the grounds of 'bad publicity,' as we wanted to be boosters and not knockers, we agreed to stop all sale.' "

> "F.A. Gildersleeve."

Documenting the construction of the twenty-two story Amicable Building starting in 1910 was one of Gildersleeve's major photographic achievements, stretching and then improving his photographic talent. The Amicable Building was significant as it became the tallest building in the southwestern United States when it was finished in 1911. The successful completion of this task by Gildersleeve led to new, and often unexpected, photographic opportunities. He was not the first photographer to take nighttime photographs, but he was certainly adroit at using the camera flash. On April 15, 1911, the Young Men's Business League hosted the first Waco Prosperity Banquet on the streets of downtown Waco. Its purpose was to toast grandly the successful completion of the Amicable Building. Over 1,200 guests were seated for dinner when Gildersleeve took their photograph. He used a considerable charge of flash powder to take this beloved and often used image of a jubilant Waco. Taken in about 1917, one of his other great nighttime images was of the Texas Cotton Palace's main building. This unique photograph is one of his most stunning and memorable taken at night.

Later in the 1930s, Gildersleeve was employed to document photographically 2,500 Shriners having dinner in the old Cotton Place. He set up his usual flash powder (possibly more than was needed) in the rafters of the aging and little used building and took the shot. He got his picture but made a mess with pigeon droppings, feathers, dust, and shattered glass as well as considerable smoke and fumes all gracing the Shriner diners. Apparently, Gildersleeve was nowhere to be found for a few days following the memorable event. This telling of the tale is from Thomas E. Turner's article "When Gildy Put Waco on Film," in the *Dallas Morning News,* July 4, 1964.

Aerial photography was in its infancy when Gildersleeve began his flyovers of Waco with pilot Marion Sterling. When Waco's Rich Field was built in 1917, Gildersleeve would make friends with the pilots and take regular flights over Waco and the surrounding countryside. He continued his flying and aerial photography with a trip to Mexia and then a much later 1923 excursion over Des Moines, Iowa, when he accompanied the Karem Shriners from Waco to a meeting of the Imperial Council. Indeed, Gildersleeve left several amazing aerial images for the public to enjoy over one hundred years after taking them.

Gildersleeve extensively documented Camp MacArthur, one of the best-known landmarks in Waco. This 10,500-acre U.S. Army installation was built in July 1917 and opened in September of 1917 in northwest Waco. It was used as a training facility and later as a demobilization center. The camp closed in the spring of 1919, with the war ending on November 11, 1918. While Camp MacArthur was still active, Gildersleeve documented numerous parts using panoramic photographs that measured as large as 47.5 inches wide. The Library of Congress has digitized several of these Gildersleeve photographs and they are available for viewing on their website.

Another of Gildersleeve's celebrated moments was told by Roger Conger in a two-page leaflet "Photographs Tell the Story: Gildersleeve, Waco."

It was in 1913 that he dazzled the photographic fraternity, including the Eastman factory, by envisioning an enlargement of one of his favorite shots—the Texas Cotton Palace—to the unheard-of size of ten feet. The Eastman people readily supplied him with a suitable "bolt" of photographic paper, brought down personally by a factory technician; and in the special shallow tray which Gildy had constructed for developing it, the great print was brought to vivid life—all 120 inches of it. It was the world's largest at the time, and with Gildersleeve's prideful permission was featured in exhibits in many major cities of America.

The photographs highlighted in this volume are mostly from Gildersleeve's early years during the first quarter of the twentieth century. He was an active and highly productive photographer in Waco working for over fifty years and claiming he was still active almost until his death. As evidence, the Baylor football team always requested that Gildersleeve take the team's annual photograph. The last team photograph documented with "Gildersleeve" written on the print was 1955.

Much of Gildersleeve's later work on acetate film has been lost. Some was lost due to poor storage conditions. To make matters worse, some is said to have disappeared when his wife, Florence, separated from him in about 1943, but there is no definitive evidence put forth by this claim made by Roger Conger. However, Conger did accurately document the sad tale of finally being granted access to Gildersleeve's backyard storage shed late in the photographer's life. This is where his remaining glass plate negatives were stored. He wrote:

> The aged padlock didn't want to give up either, but it finally did. When the musty door was drawn open, the sight which greeted us was sickening. The accumulated weight of the dozens of flat cartons of heavy glass, stored in a section of too-light wood shelving had literally pulled the shelves loose, perhaps years before, and allowed the entire treasure to crash forward across the floor. There lay in a shattered pile, with half or more effectually lost and destroyed.

Considering how groundbreaking and innovative Gildersleeve's previous work was, it is tempting to speculate on what might have been if most of his later work had survived.

His friend Roger Conger, began to care for Gildersleeve in the 1950s when Gildersleeve's health started to decline. Conger and Gildersleeve were both members of First Presbyterian Church of Waco. Conger said in his oral history (pages 236–237) in regards to Gildersleeve:

> I visited him almost daily and cut his hair and even shaved him and brought him cigarettes and beer and with the help of some of the other church members arranged for his funeral and burial and arranged the purchase of a bronze marker for his grave.

The following quote helps sum up how a lot of people regard Fred Gildersleeve and his work. Kent Keeth, former director of The Texas Collection, Baylor University, states in a 1990 Waco City Cable Channel documentary, "Photos Tell the Story—Fred Gildersleeve":

> "I don't believe many cities or towns have had the quality of photography done that Gildersleeve was able to bring to Waco—he was an artisan, a craftsman, a professional, almost a world-class photographer, and he liked what he did. . . . He would take pictures when nothing in particular was going on and so Waco has a record of what its daily life was like. . . . I think it was very fortunate for Waco to have a photographer of Gildersleeve's quality in town. Many of the things that he did are not just snapshots but they are actually works of art. And not many towns have had their existence, and as it now their past existence, recorded quite so well and so carefully as Gildersleeve was able to do for Waco."

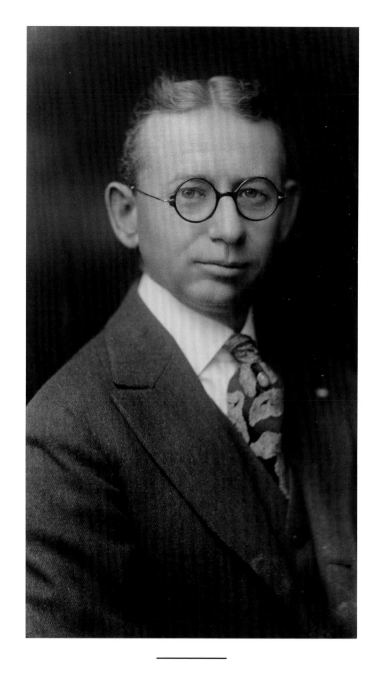

PORTRAIT OF FRED GILDERSLEEVE
A fine portrait of Fred Gildersleeve.

c. 1915. 3"x6" silver gelatin print
Photographer: Unknown
Gildersleeve-Conger Collection #0430

FINAL DAY

On Wednesday, February 26, 1958, Gildersleeve, famed Waco and Texas pioneer photographer passed away at 5:30 a.m., before the sun rose on his Waco residence. The cause of death was listed on his death certificate as pneumonia with complications from arterioscoliosis. He was seventy-seven at the time of his death. His funeral service was presided over by Dr. C. T. Caldwell and Dr. Roy Sherrod. It seemed only natural for Gildersleeve to be laid to rest next to his beloved sister, Dr. Jessie Ellen Gildersleeve in Waco Memorial Park. Jessie Ellen had died February 1, 1955 from a tumor that had been found only one week prior to her death.

A modest sample of Gildersleeve's brilliant photographic record lives on today in this volume. When people look back at early Waco and beyond, the name Fred A. Gildersleeve should be richly remembered. •

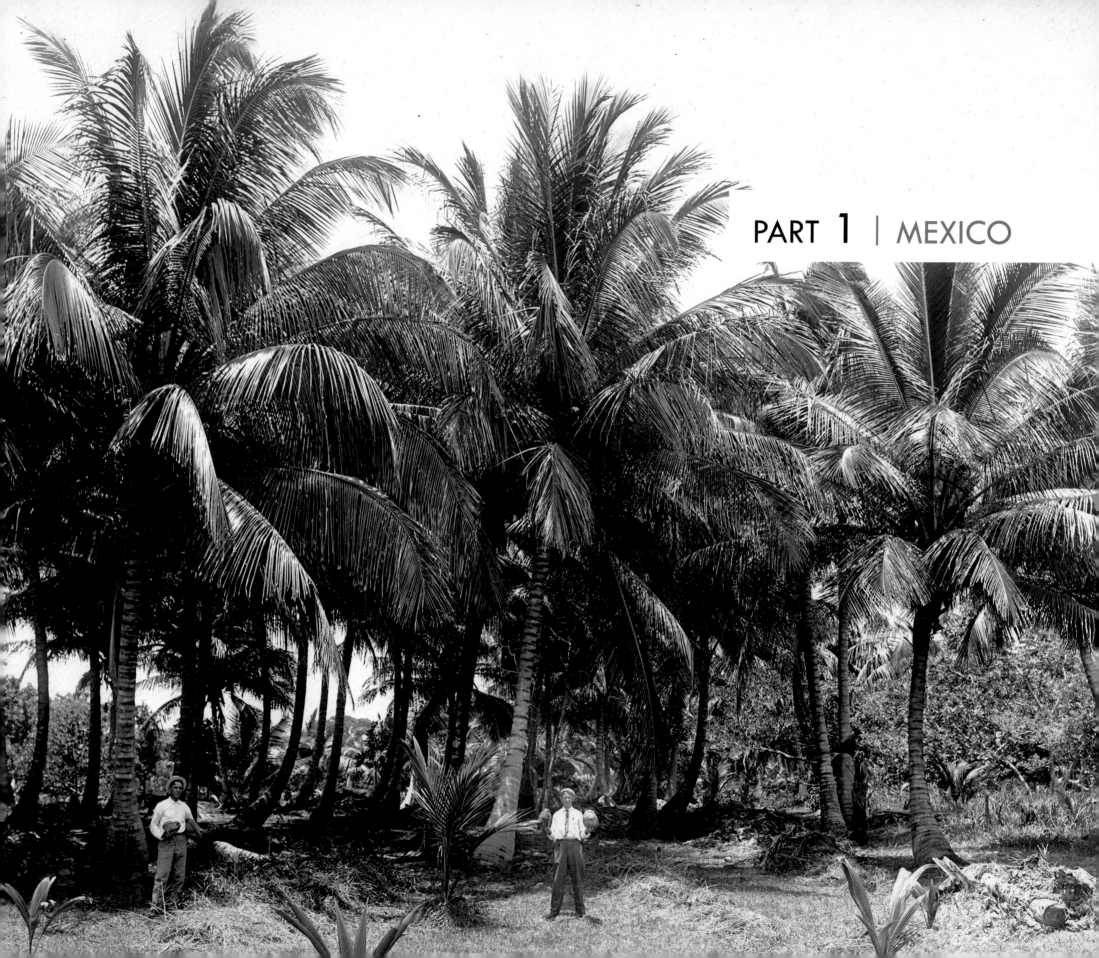

PART **1** | MEXICO

◀◀◀ AMONG THE COCONUT TREES

Fred Gildersleeve (center) holds coconuts while standing in a coconut grove.

1910. 8"x10" silver gelatin print
Photographer: Unknown
Place: near Carmen, Campeche, Mexico
Gildersleeve-Conger Collection #0430

WEIGHING DYEWOOD FOR EXPORT

These workers are using a makeshift scale to weigh dyewood, most likely for export.

1910. 8"x10" silver gelatin print
Photographer: F. A. Gildersleeve
Place: near Carmen, Campeche, Mexico
Gildersleeve-Conger Collection #0430

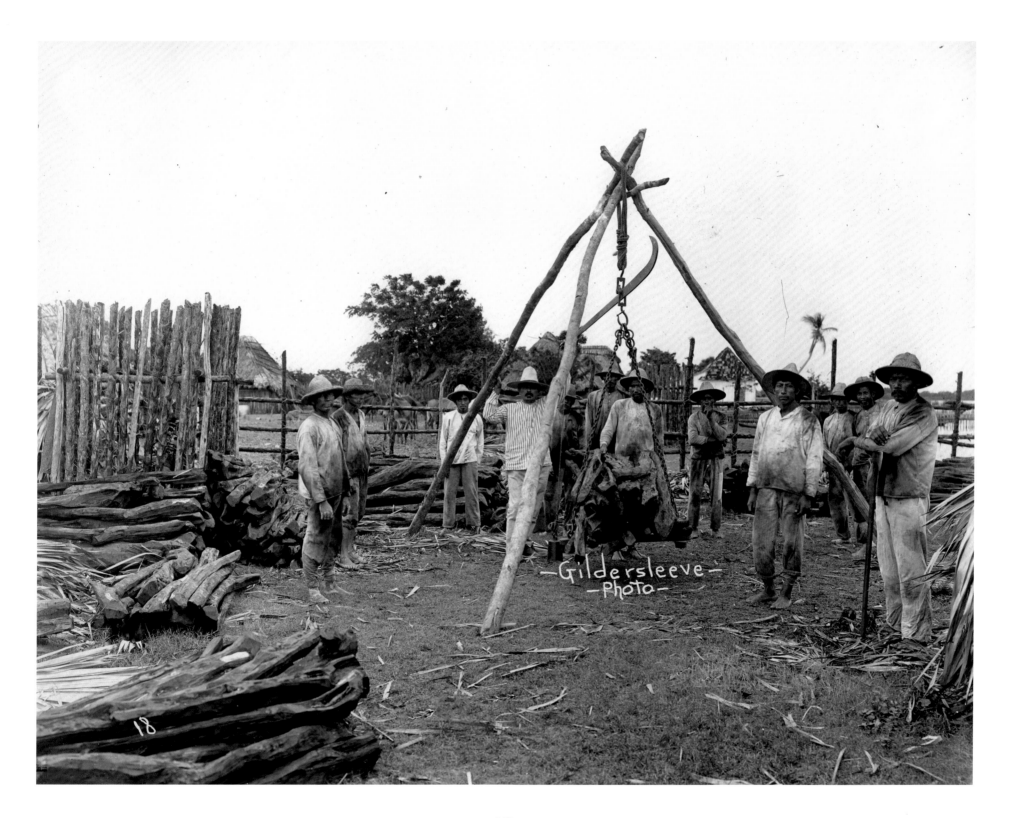

Gildersleeve
Photo

18

HITCHING A RIDE

**Fred Gildersleeve uses local transportation
for his photographic needs during this trip.**

1910. 8"x10" silver gelatin print
Photographer: Unknown
Place: near Carmen, Campeche, Mexico
Gildersleeve-Conger Collection #0430

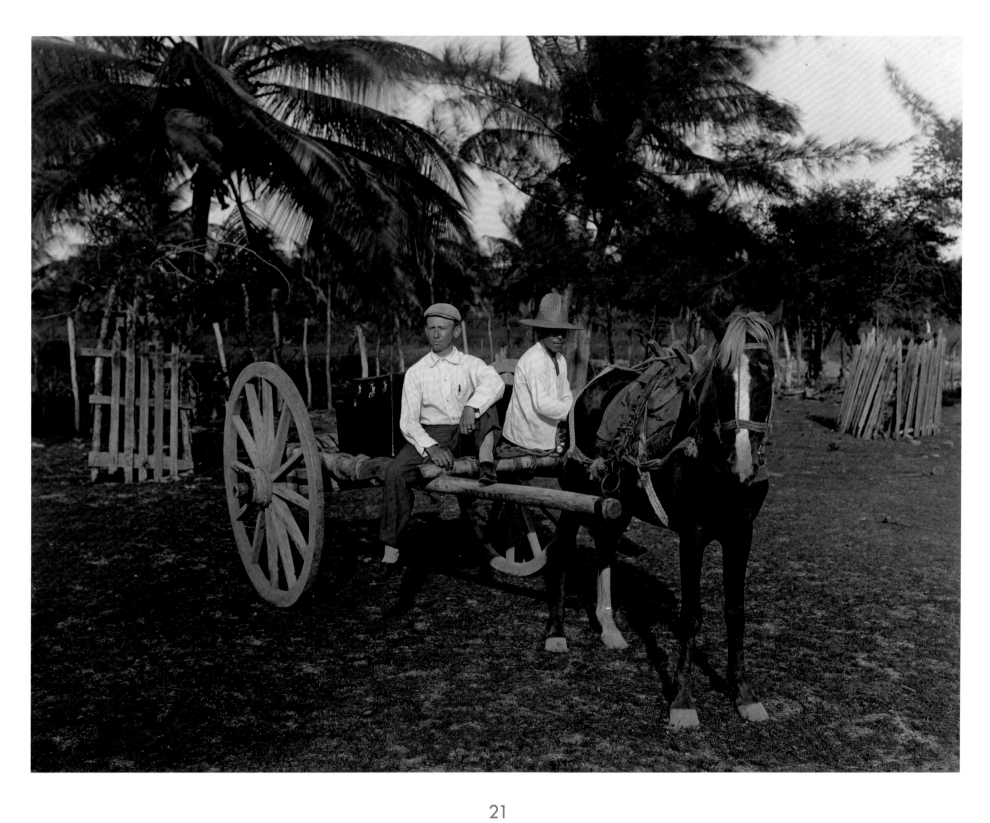

BOY AND CART

**A little boy hitches a small wagon
to a goat to carry goods.**

1910. 8"x10" silver gelatin print
Photographer: F. A. Gildersleeve
Place: near Carmen, Campeche, Mexico
Gildersleeve-Conger Collection #0430

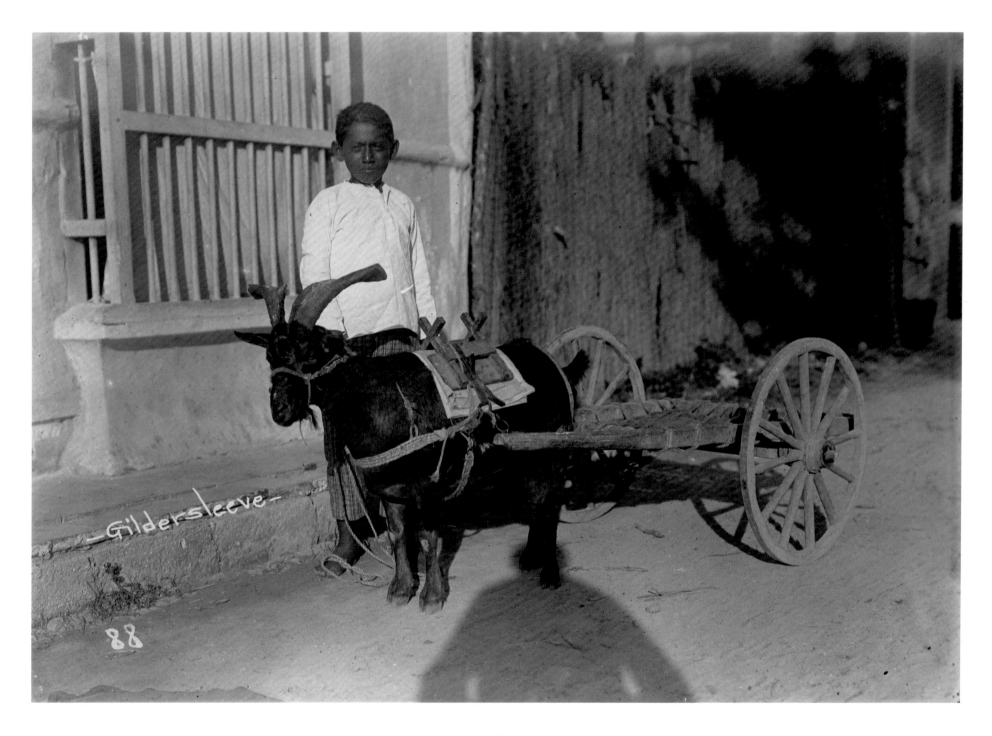

—Gildersleeve—

88

23

BANANA BOAT

Freshly picked bananas from a local
plantation await processing for export.

1910. 8"x10" silver gelatin print
Photographer: F. A. Gildersleeve
Place: near Carmen, Campeche, Mexico
Gildersleeve-Conger Collection #0430

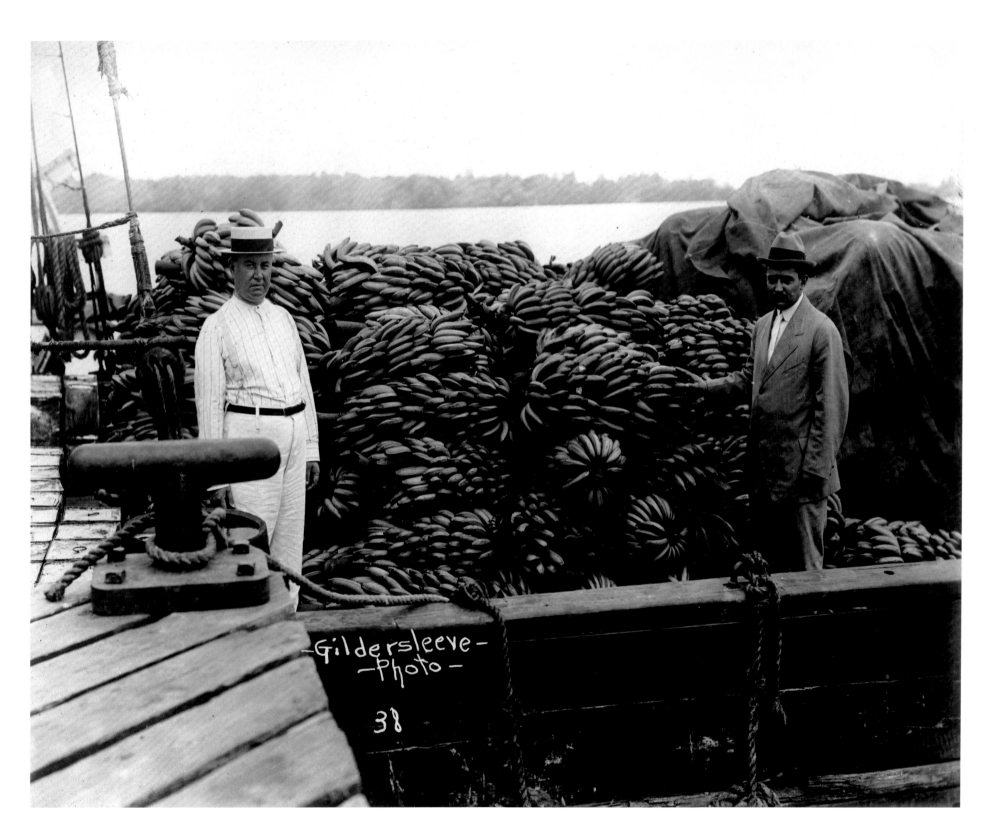

-Gildersleeve-
-Photo-

38

GRINDING CORN

A young lady grinds corn by hand
in a way passed down by many generations.

1910. 8"x10" silver gelatin print
Photographer: F. A. Gildersleeve
Place: near Carmen, Campeche, Mexico
Gildersleeve-Conger Collection #0430

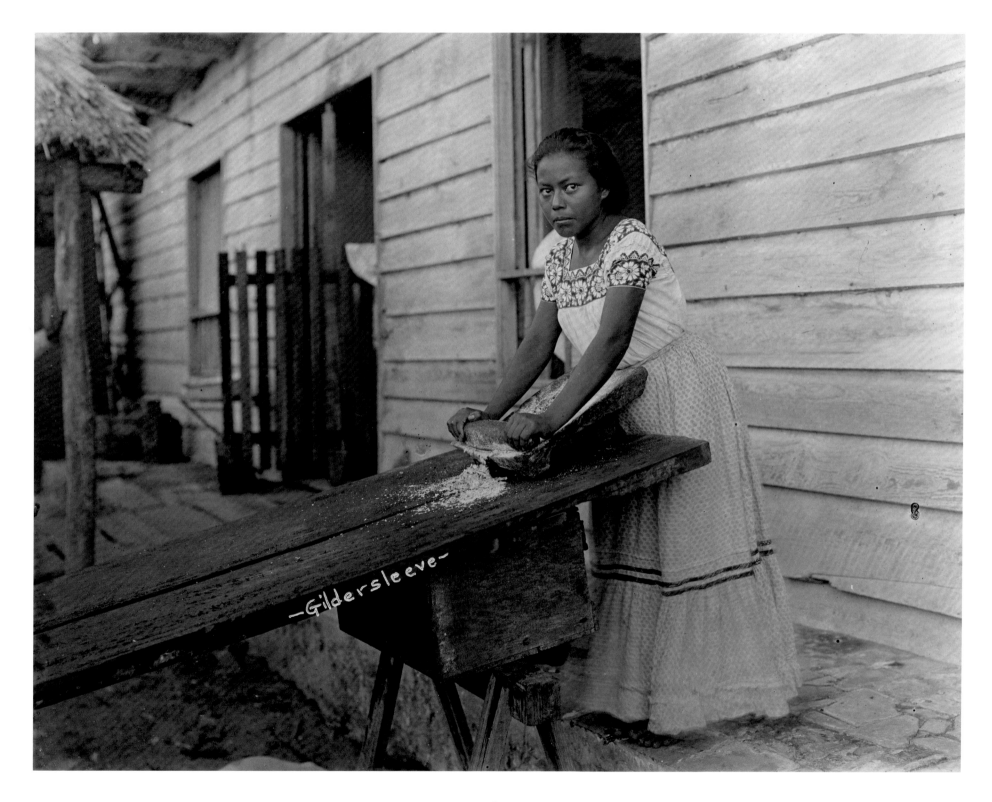

A GIFT OF FOOD

A family is given a package of biscuits
made by the National Biscuit Company.

1910. 8"x10" silver gelatin print
Photographer: F. A. Gildersleeve
Place: near Carmen, Campeche, Mexico
Gildersleeve-Conger Collection #0430

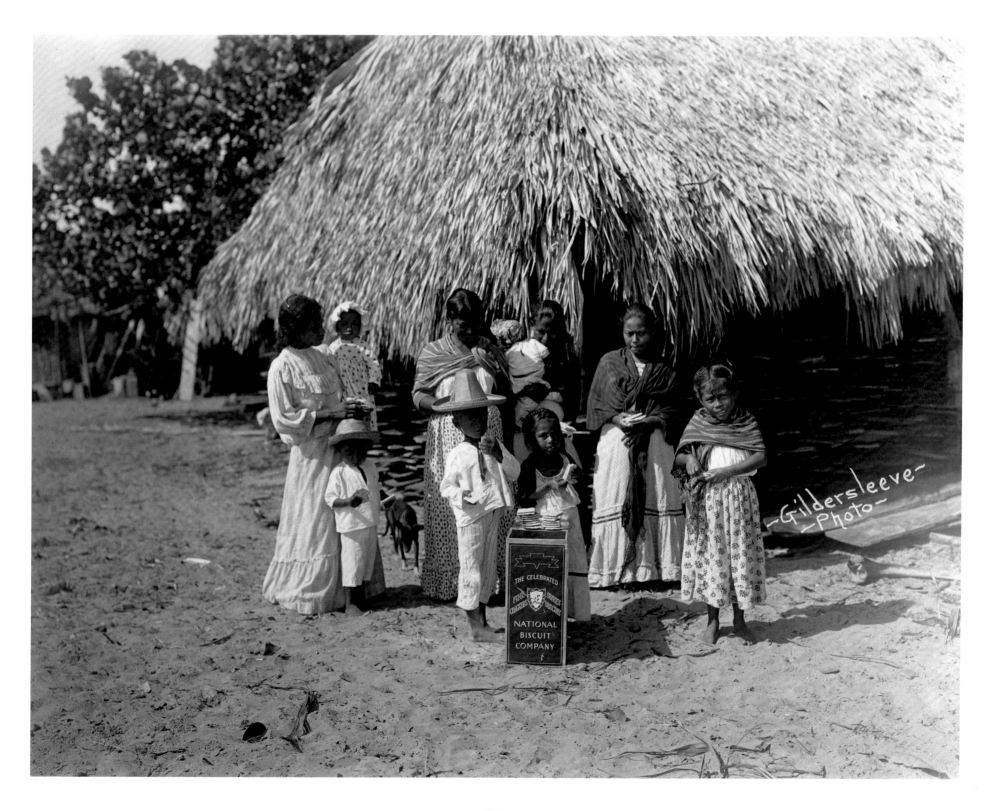

BUILDING A BOAT

A group of young men skillfully craft
a boat out of wood.

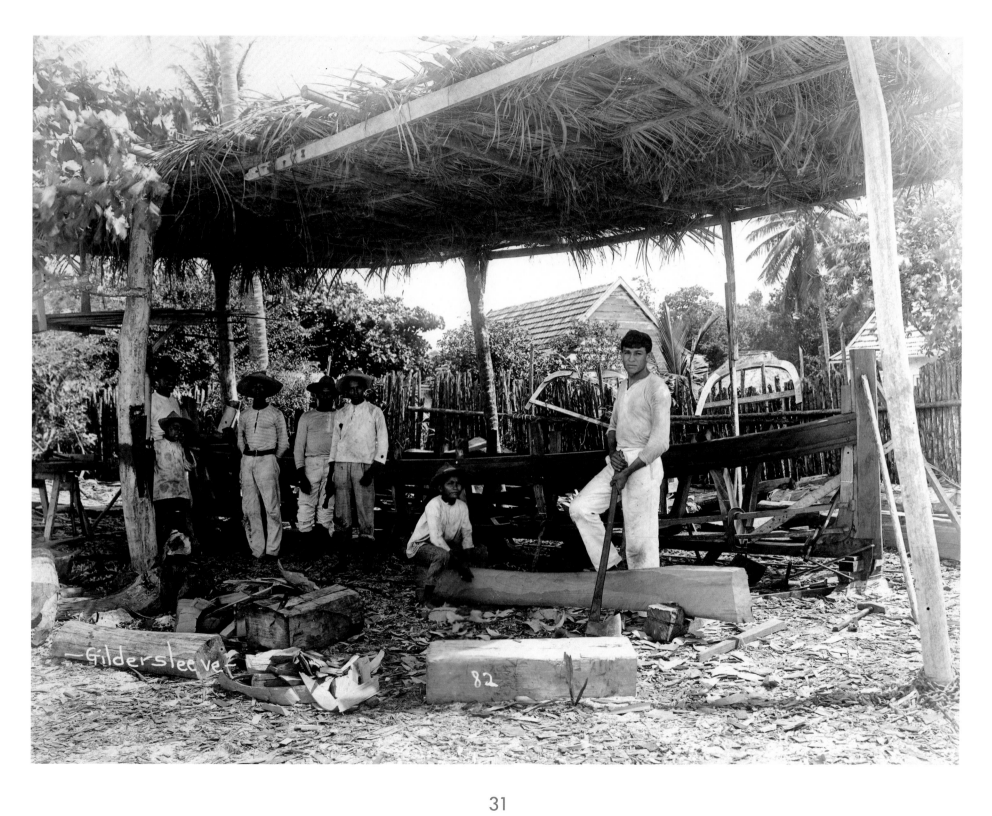

Gildersleeve

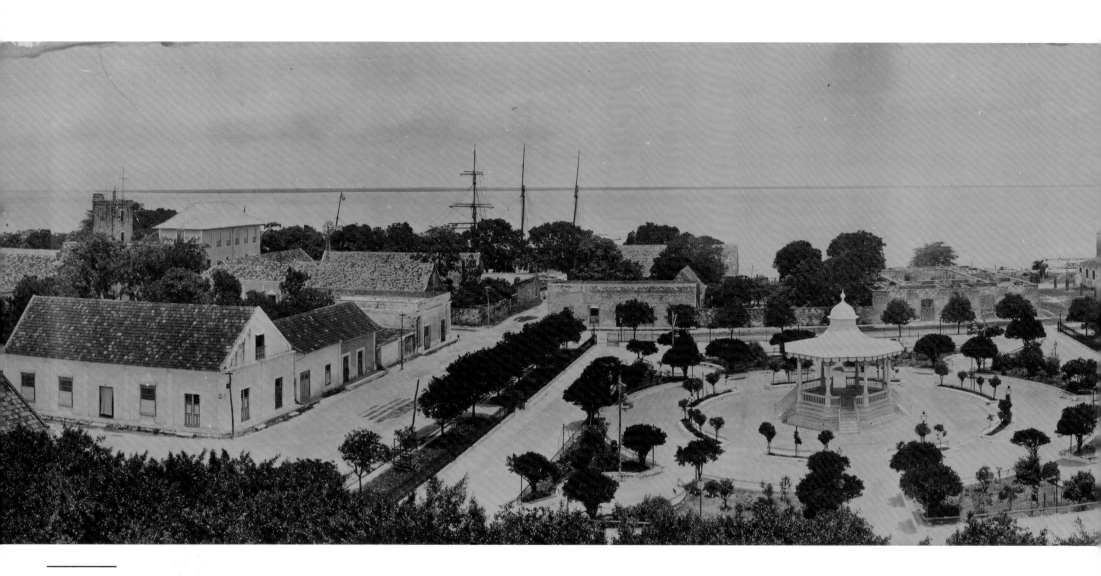

A BIRD'S EYE VIEW OF A MEXICAN CITY

A bird's eye view looking west of Carmen, Campeche, Mexico.
Fred Gildersleeve spent time here in 1910 doing commercial
photography. His work at Carmen includes a rare glimpse
into the lives of the local people.

1910. 10"x21" silver gelatin print (hand-colored)
Photographer: F. A. Gildersleeve
Place: Carmen, Campeche, Mexico
The Texas Collection General Photo Files #3976

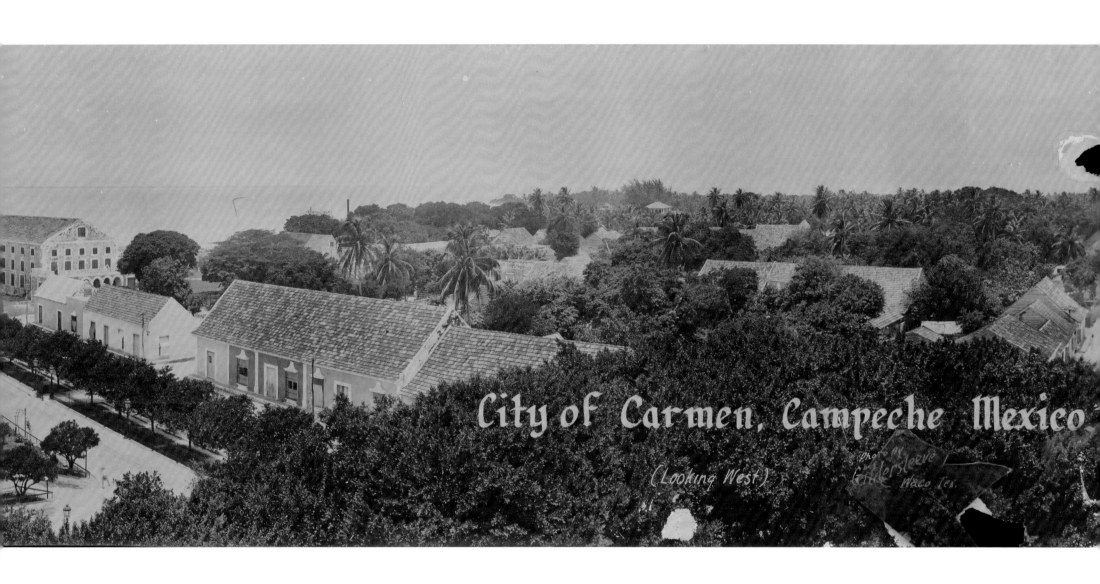

City of Carmen, Campeche Mexico

(Looking West)

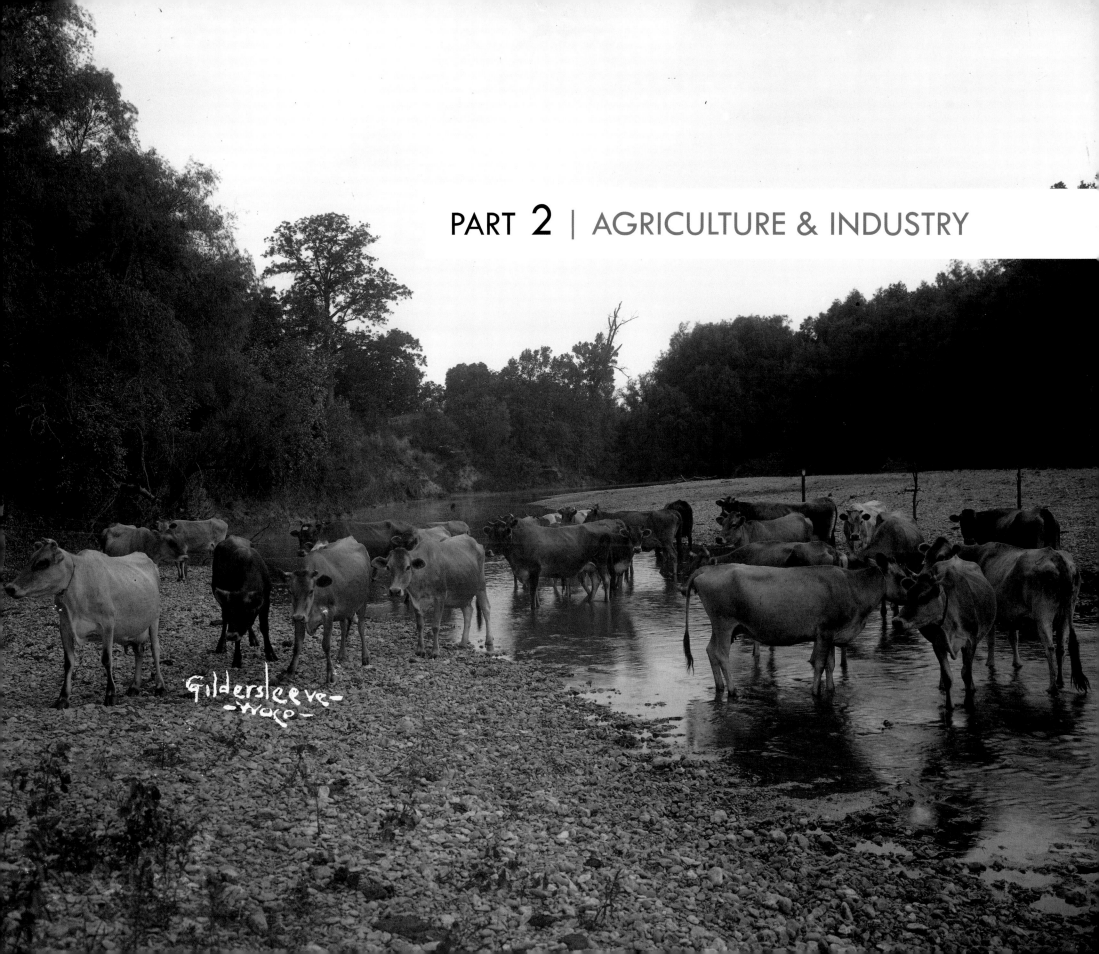

Gildersleeve
-waco-

≪ COWS AT RIVER

A herd of cows seek refreshment as they look in the direction of the photographer.

c. 1910. 8"x10" glass plate negative
Photographer: F. A. Gildersleeve
Place: near Waco, Texas
Gildersleeve-Conger Collection #0430

THRESHING MACHINE

A large group of people stand beside a threshing machine during harvest time.

1904. 5"x7" silver gelatin print
Photographer: F. A. Gildersleeve
Place: near Kirksville, Missouri
Gildersleeve-Conger Collection #0430

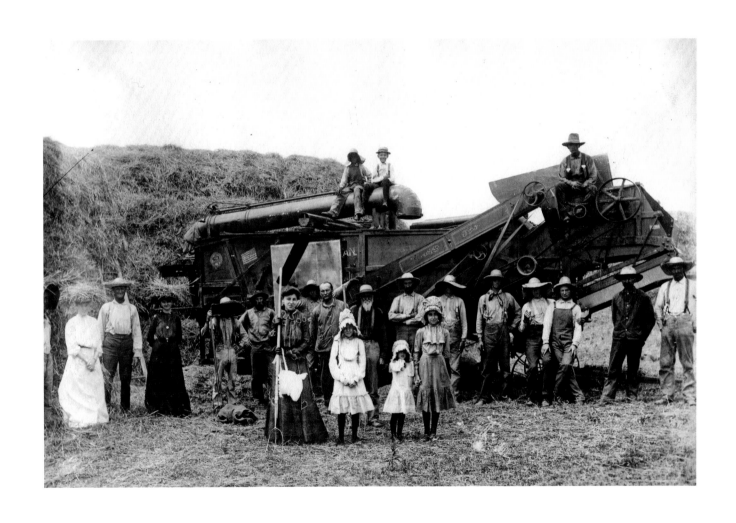

JACKSON'S LIVERY AND BOARDING STABLE

**Employees stand with horses and
carts outside of this livery once located at
813 Franklin Avenue.**

c. 1910. 8"x10" glass plate negative
Photographer: F. A. Gildersleeve
Place: Waco, Texas
Gildersleeve-Conger Collection #0430

—Gildersleeve—
—Waco—

Cat. 80

39

ROBINSON PACKING COMPANY

**Employees and delivery wagons stand
outside for a photograph at their
203 South 8th Street location.**

c. 1910. 8"x10" glass plate negative
Photographer: F. A. Gildersleeve
Place: Waco, Texas
Gildersleeve-Conger Collection #0430

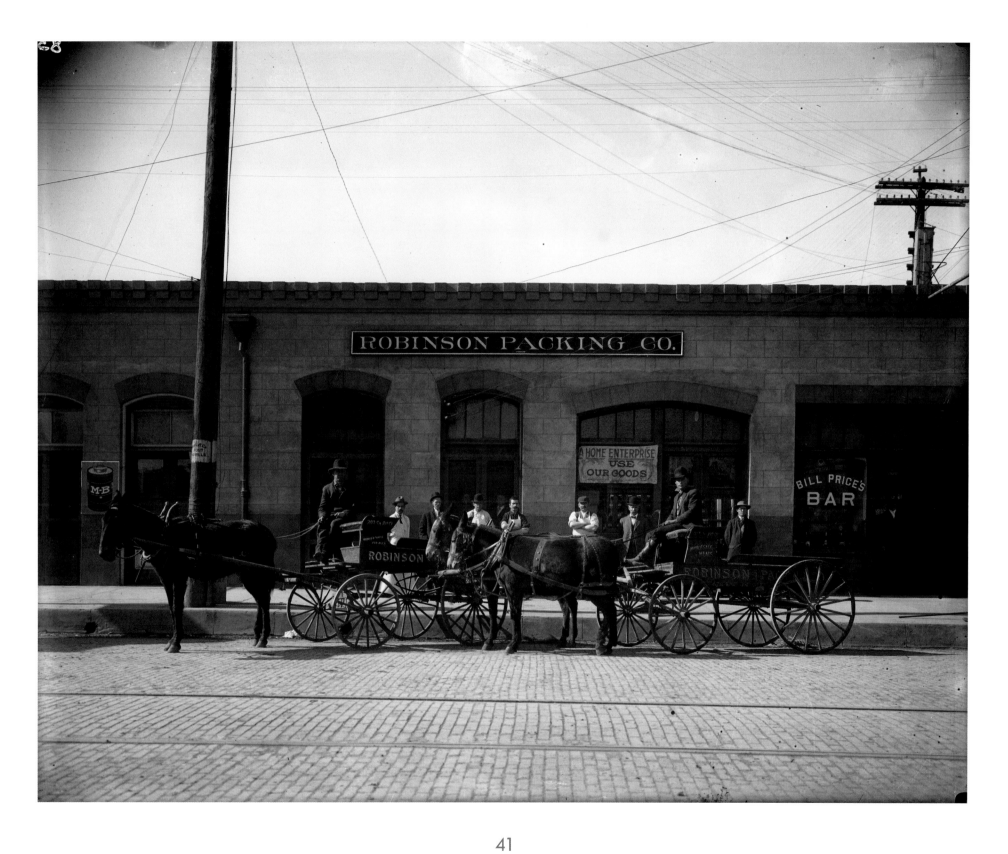

WACO MACHINERY AND SUPPLY COMPANY

Workers are busy on their lathes and other
equipment in this machine shop once located
at 611–617 Franklin Avenue.

c. 1910. 8"x10" glass plate negative
Photographer: F. A. Gildersleeve
Place: Waco, Texas
Gildersleeve-Conger Collection #0430

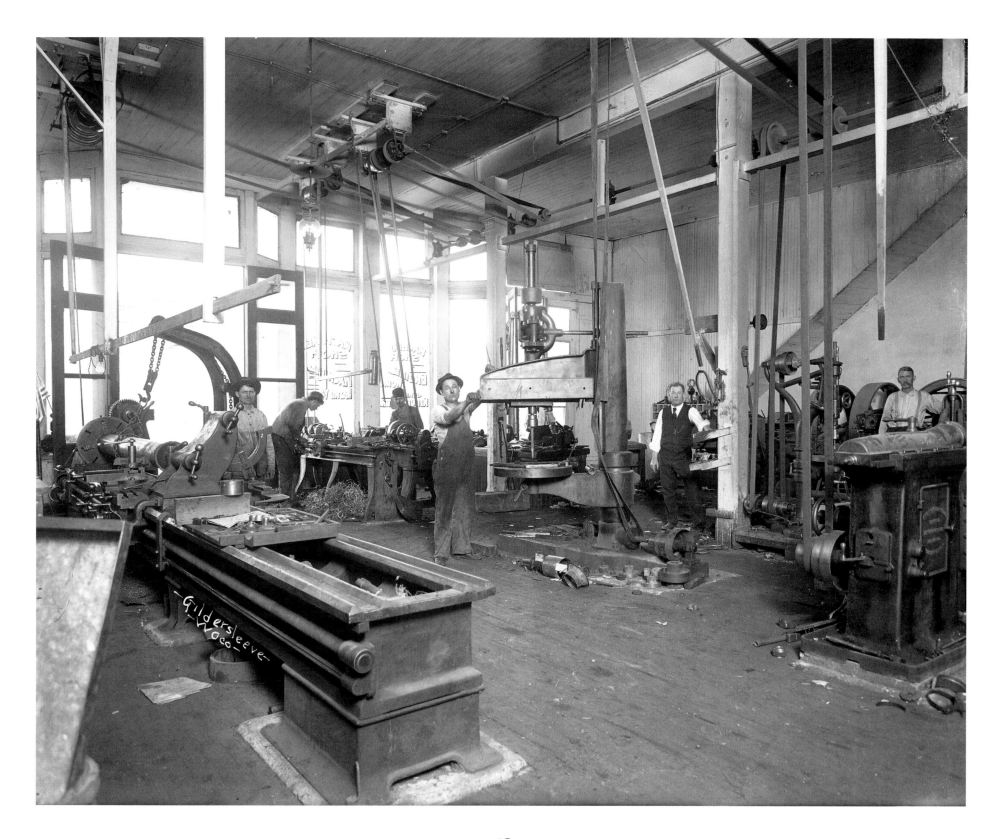

43

WACO MACHINERY AND SUPPLY COMPANY

Workers are busy on their heavy-duty
equipment in this machine shop.

c. 1910. 8"x10" glass plate negative
Photographer: F. A. Gildersleeve
Place: Waco, Texas
Gildersleeve-Conger Collection #0430

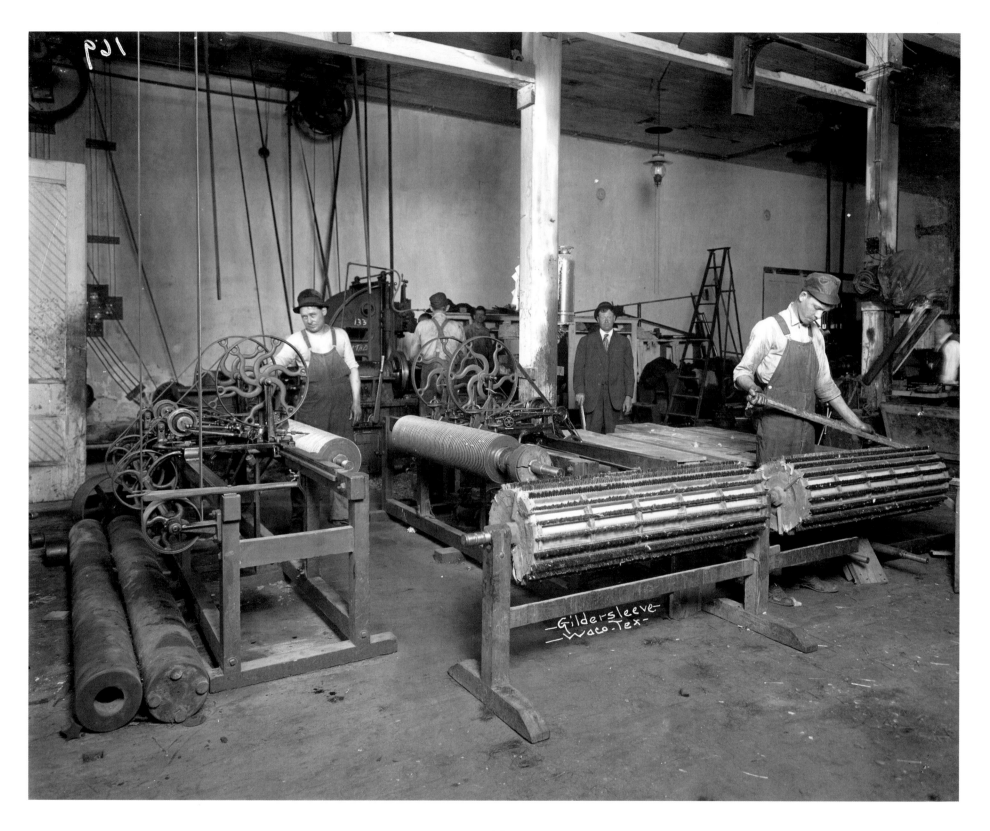

Gildersleeve
Waco. Tex.

45

D.M.WILSON
In the Middle of the Job

47

THE WORSWICK-HAARDT COTTON HARVESTER

This pneumatic harvester demonstrates an interesting example of early mechanical cotton picking. For its day, it seemed quite advanced but still needed extensive labor and animals to be drawn. It was not until the mid-twentieth century that significant advances in equipment made automated harvesting more efficient.

c. 1910. 8"x10" glass plate negative
Photographer: F. A. Gildersleeve
Place: Waco, Texas
Gildersleeve-Conger Collection #0430

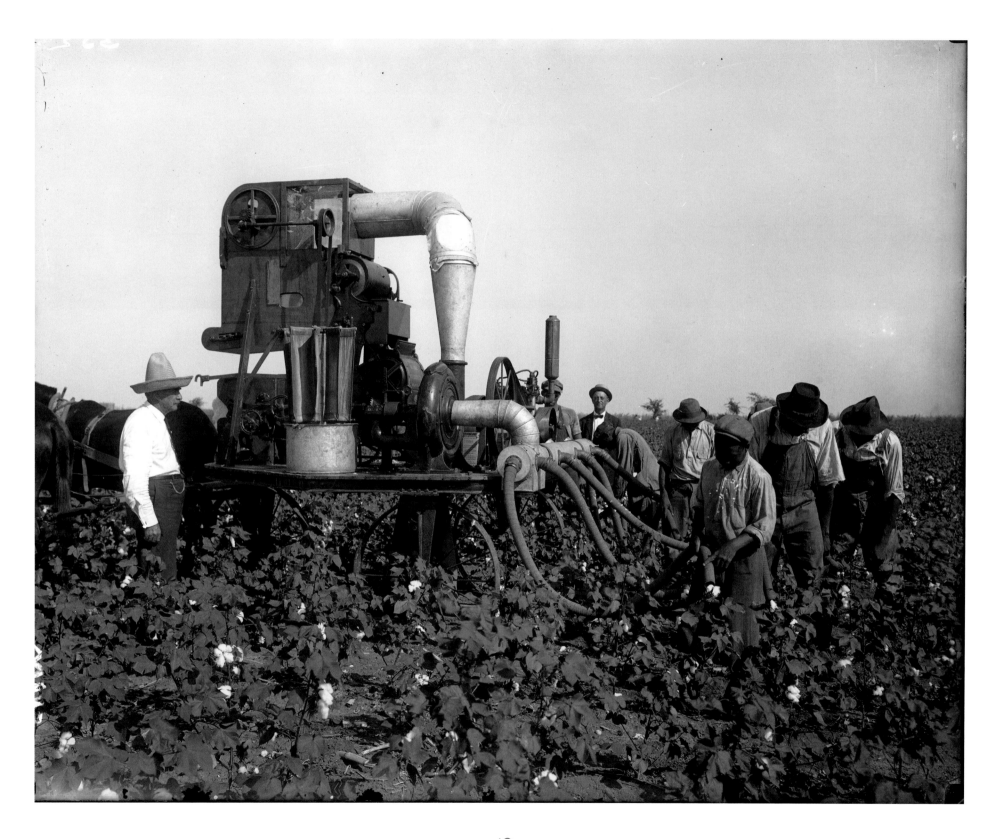

A large stock of baled cotton awaits pickup
at this yard on South 3rd Street.

1916. 8"x10"glass plate negative
Photographer: F. A. Gildersleeve
Place: Waco, Texas
Gildersleeve-Conger Collection #0430

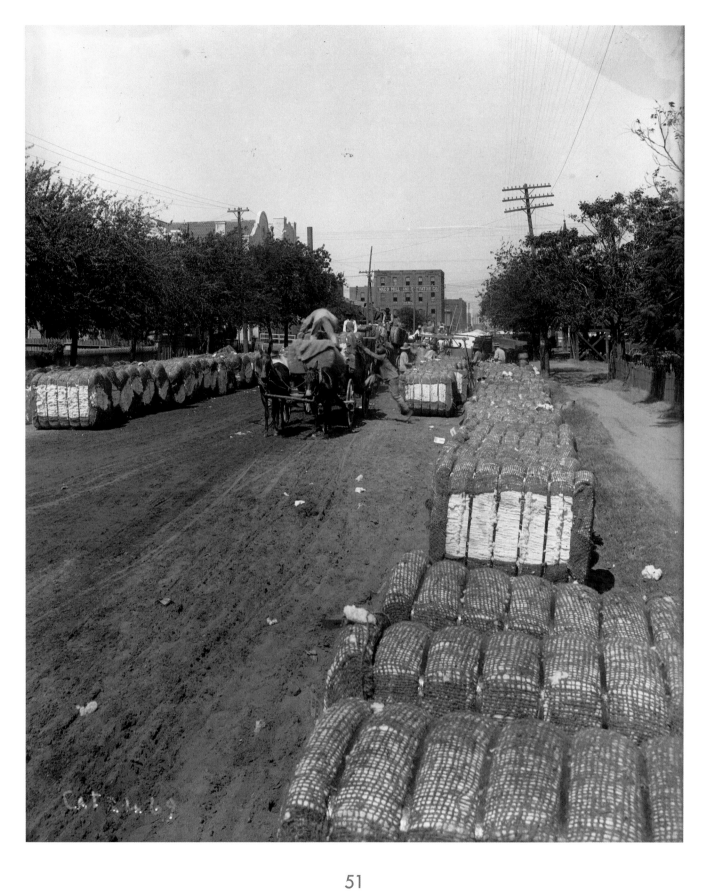

BUYING COTTON AT WOULFE'S BOOK STORE
The "Woulfe girls buy a bale" is Gildersleeve's
caption for this photograph. Local merchants such
as these booksellers used to buy bales to show
their support when "Cotton was King" in this part
of the state. The business was located at
618 Austin Avenue.

1914. 8"x10" glass plate negative
Photographer: F. A. Gildersleeve
Place: Waco, Texas
Gildersleeve-Conger Collection #0430

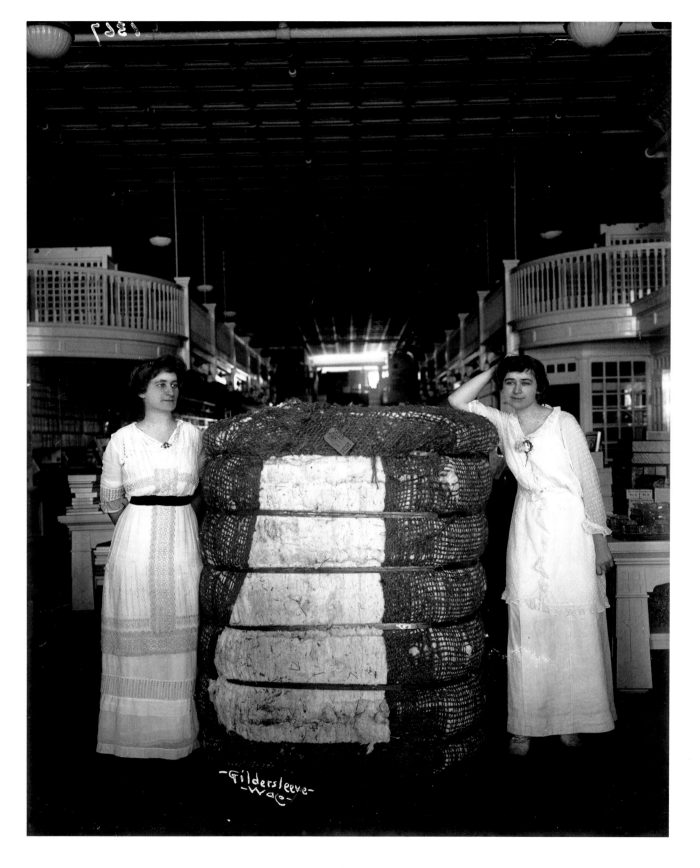

WAGON LOADS OF ICE CREAM

**Three wagon loads of ice cream are ready
for delivery. The M-B (McLendon and Braun)
Ise Kream Company was located at 8th
and Franklin Avenue.**

c. 1910. 8"x10" glass plate negative
Photographer: F. A. Gildersleeve
Place: Waco, Texas
Gildersleeve-Conger Collection #0430

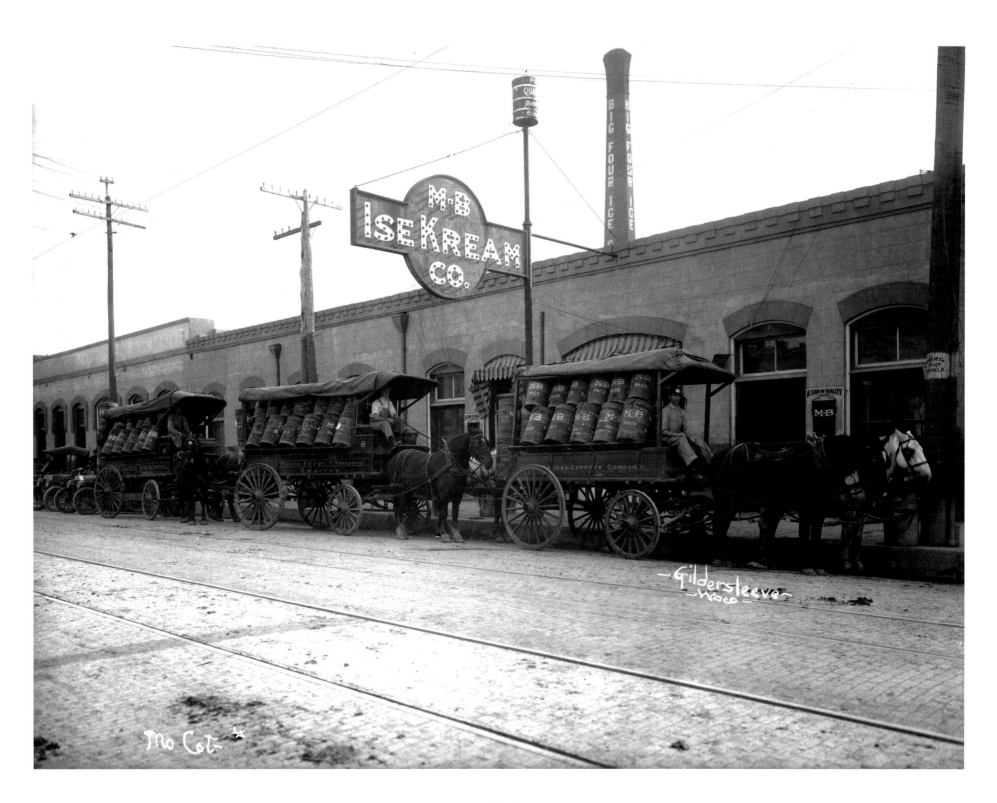

FRED A. GILDERSLEEVE PHOTOGRAPHY STUDIO

This image provides an inside view of some of F. A. Gildersleeve's employees, including his wife, Florence, in black, all at work trimming and mounting finished photographs. His studio location was 400$^1/_2$ Austin Avenue.

February 1911. 8"x10" glass plate negative
Photographer: F. A. Gildersleeve
Place: Waco, Texas
Gildersleeve-Conger Collection #0430

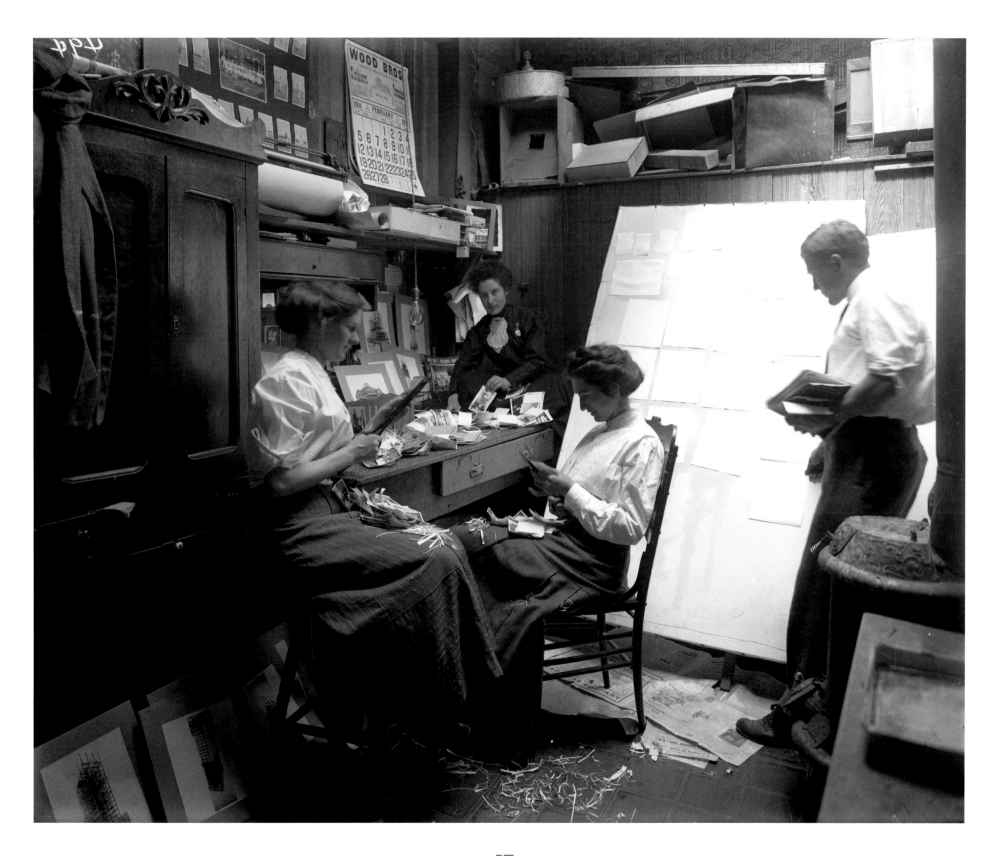

OLD CORNER DRUG STORE GRAND OPENING

People gather at the opening of the Old Corner
Drug Store when it relocated next door to the
Amicable Building.

1912. 8"x10" glass plate negative
Photographer: F. A. Gildersleeve
Place: Waco, Texas
Gildersleeve-Conger Collection #0430

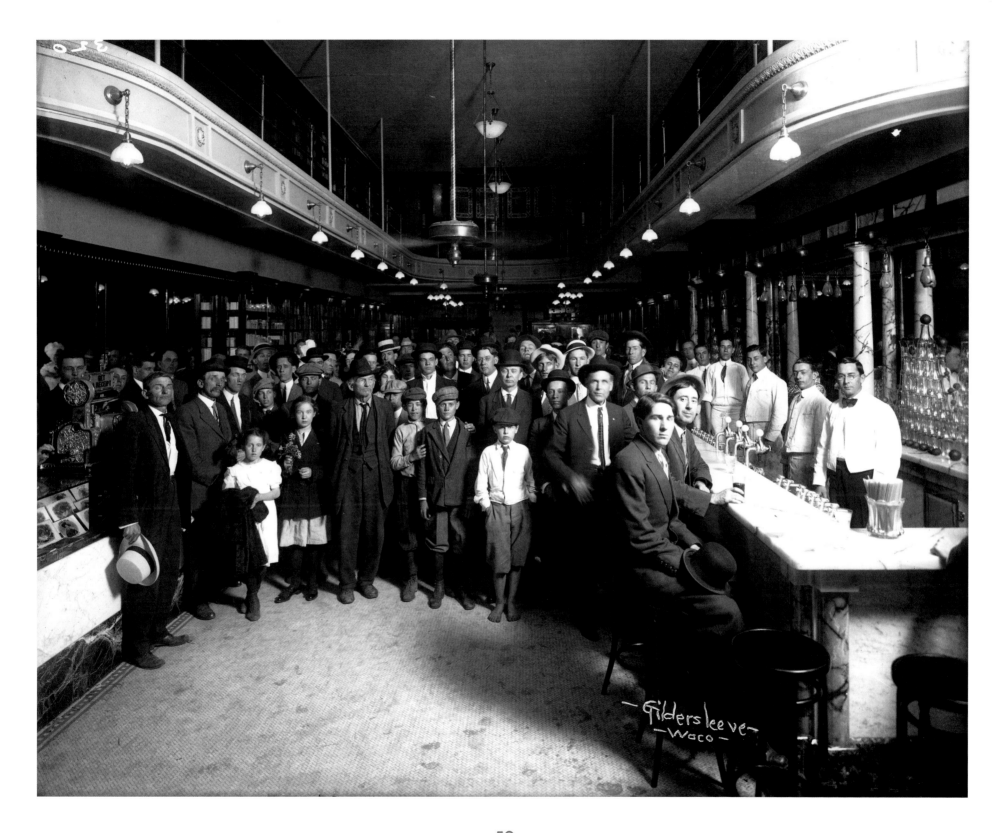

COOPER GROCERY COMPANY

A look inside the offices of Cooper Grocery
Company shows a multitude of workers. The
business was located at the corner of
South 4th and Mary Streets. One of the young
men in the foreground is most likely Madison
Cooper Jr., who later became a famous author
and philanthropist and was the son of the
grocery's owner, Madison Cooper.

c. 1913. 8"x10" silver gelatin print
Photographer: F. A. Gildersleeve
Place: Waco, Texas
The Texas Collection General Photo Files #3976

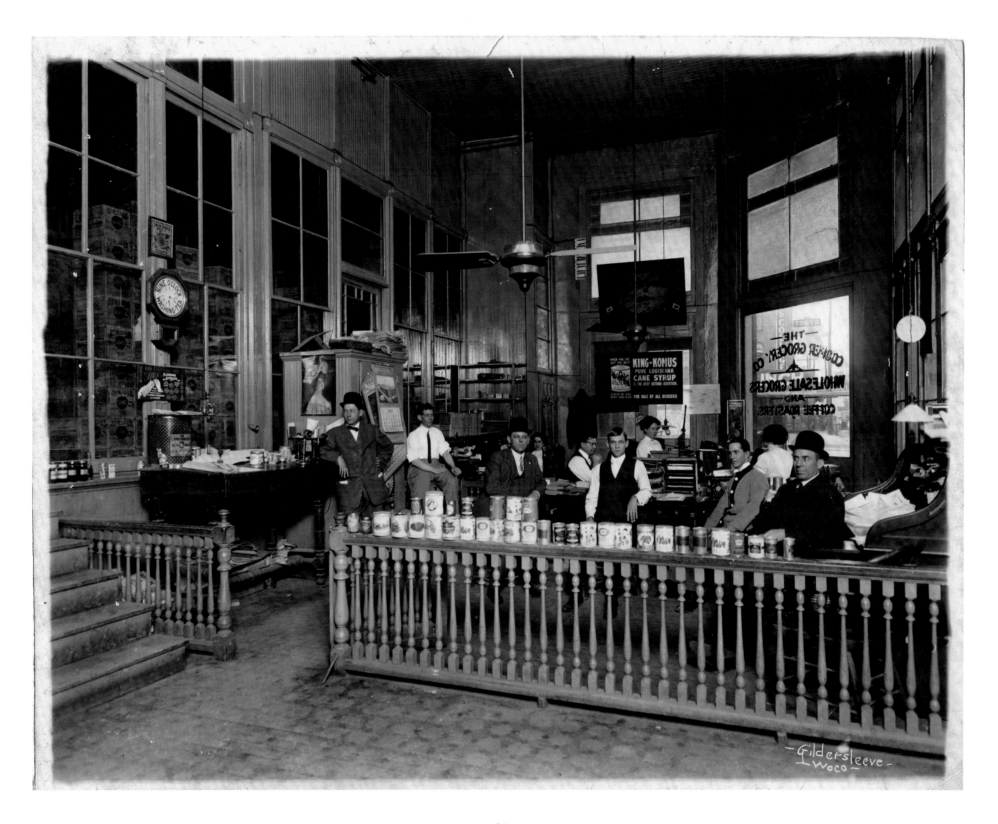

BALING ALFALFA

**Farm workers bale alfalfa at the
plantation of J. E. Horne near Waco.**

c. 1913. 8"x10" glass plate negative
Photographer: F. A. Gildersleeve
Place: near Waco, Texas
Gildersleeve-Conger Collection #0430

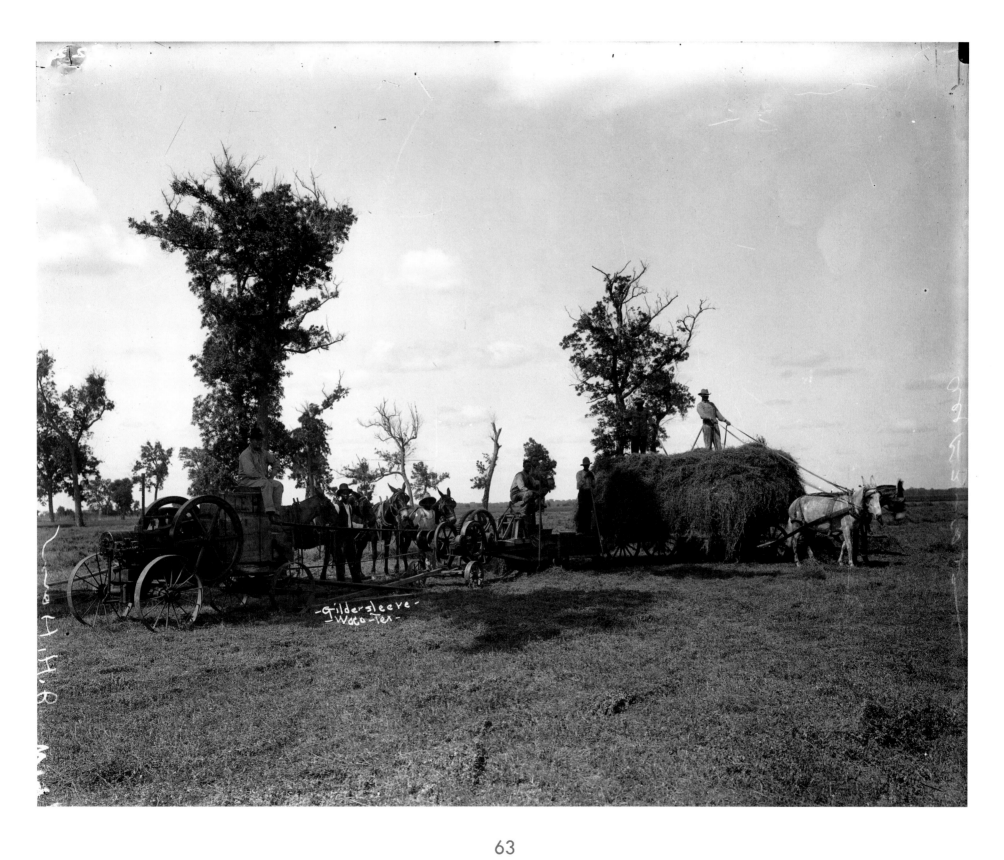

-Gildersleeve-
-Waco-Tex-

63

THE CORN FIELD

Field workers tend the corn crop at the plantation of J. E. Horne.

c. 1913. 8"x10" glass plate negative
Photographer: F. A. Gildersleeve
Place: near Waco, Texas
Gildersleeve-Conger Collection #0430

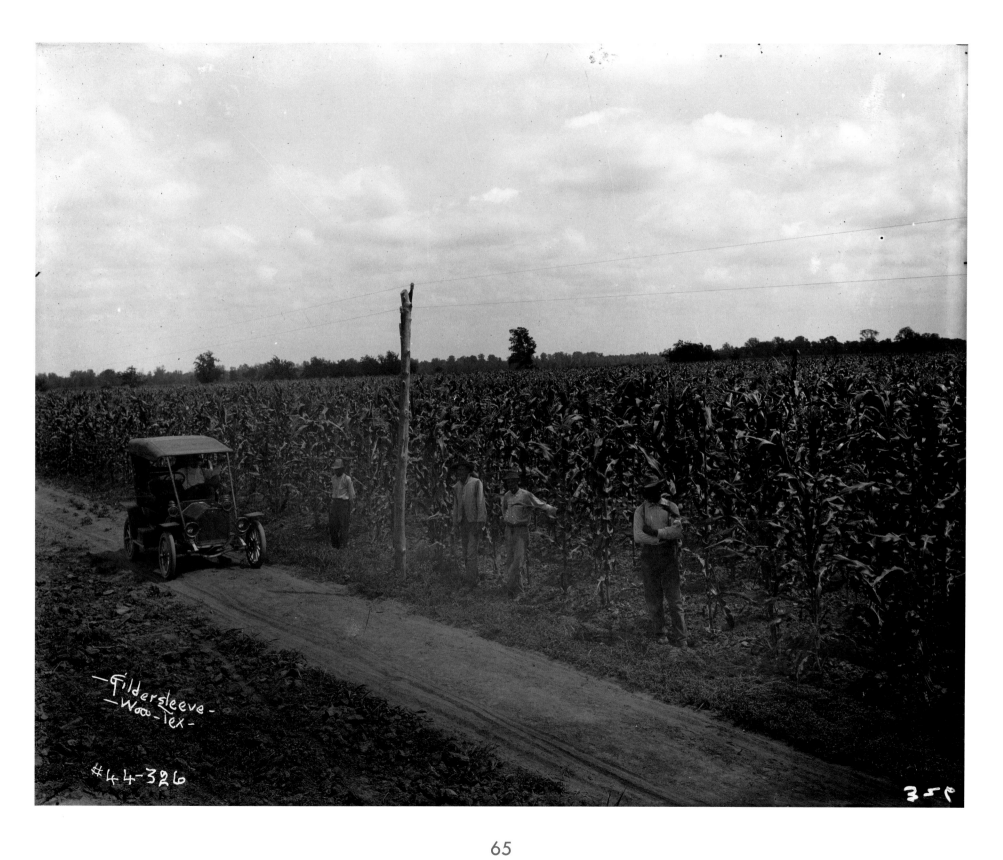

-Gildersleeve-
-Woco-Tex-

#44-326

350

65

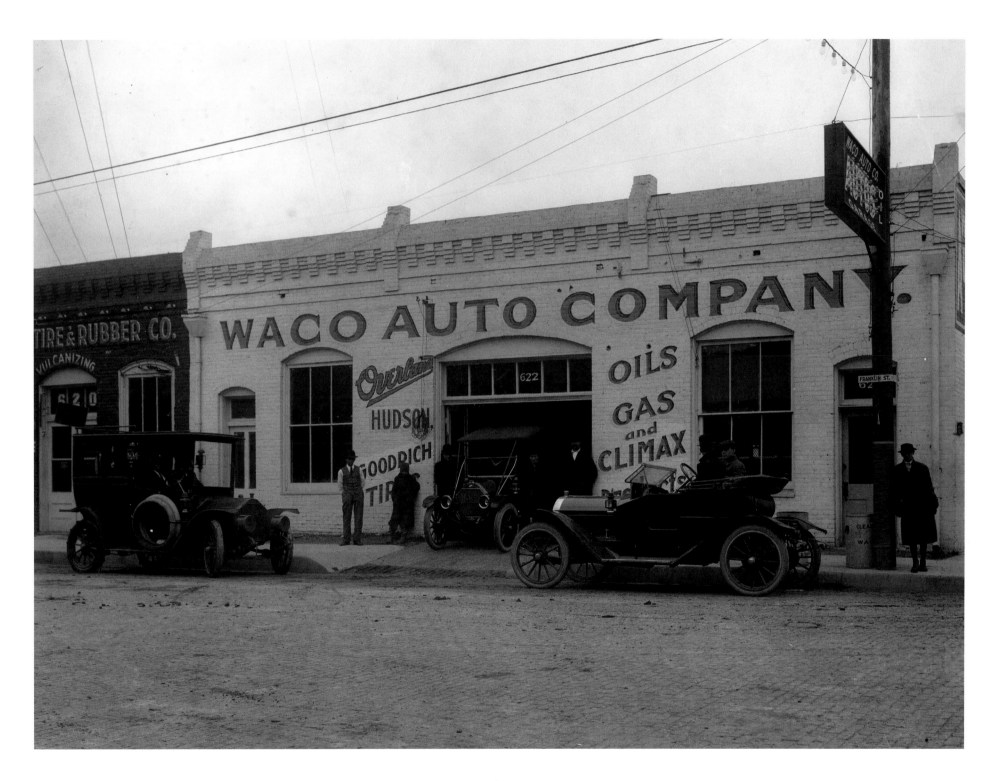

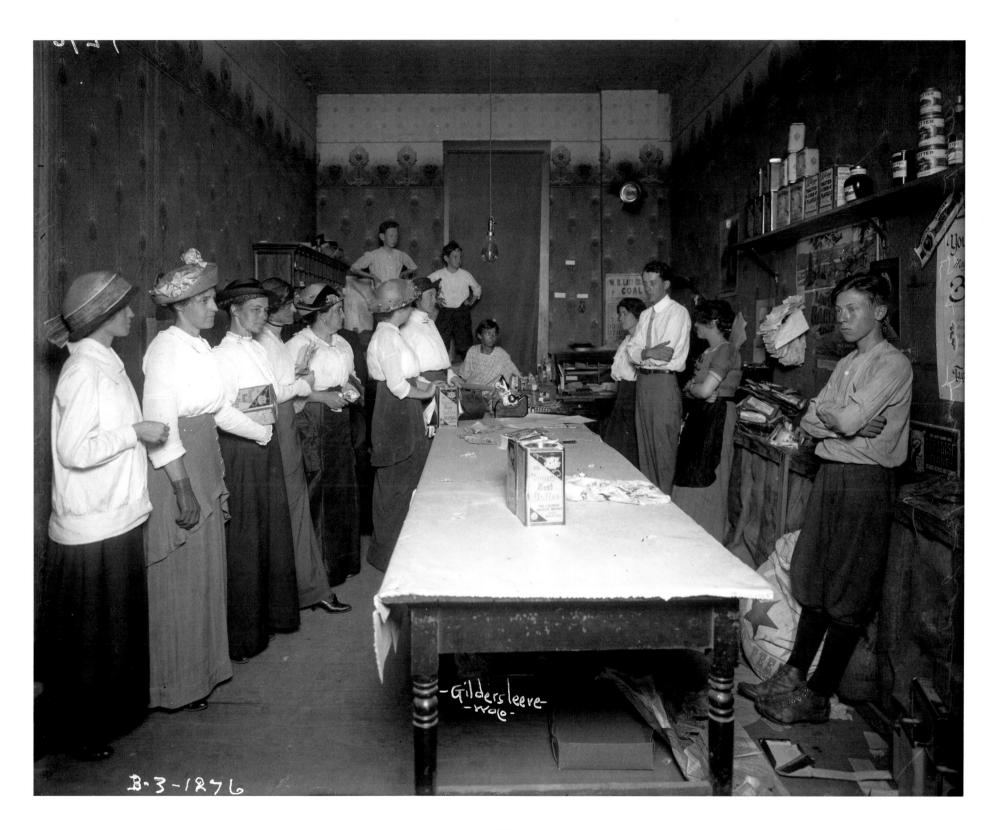

-Gildersleeve
-wolo-

B-3-1876

ROCKDALE COAL MINERS ON THE JOB

Miners take a break to pose at
the entrance of a mine shaft. Here they
mined lignite, also known as brown coal.

c. 1914. 8"x10" glass plate negative
Photographer: F. A. Gildersleeve
Place: Rockdale, Texas
Gildersleeve-Conger Collection #0430

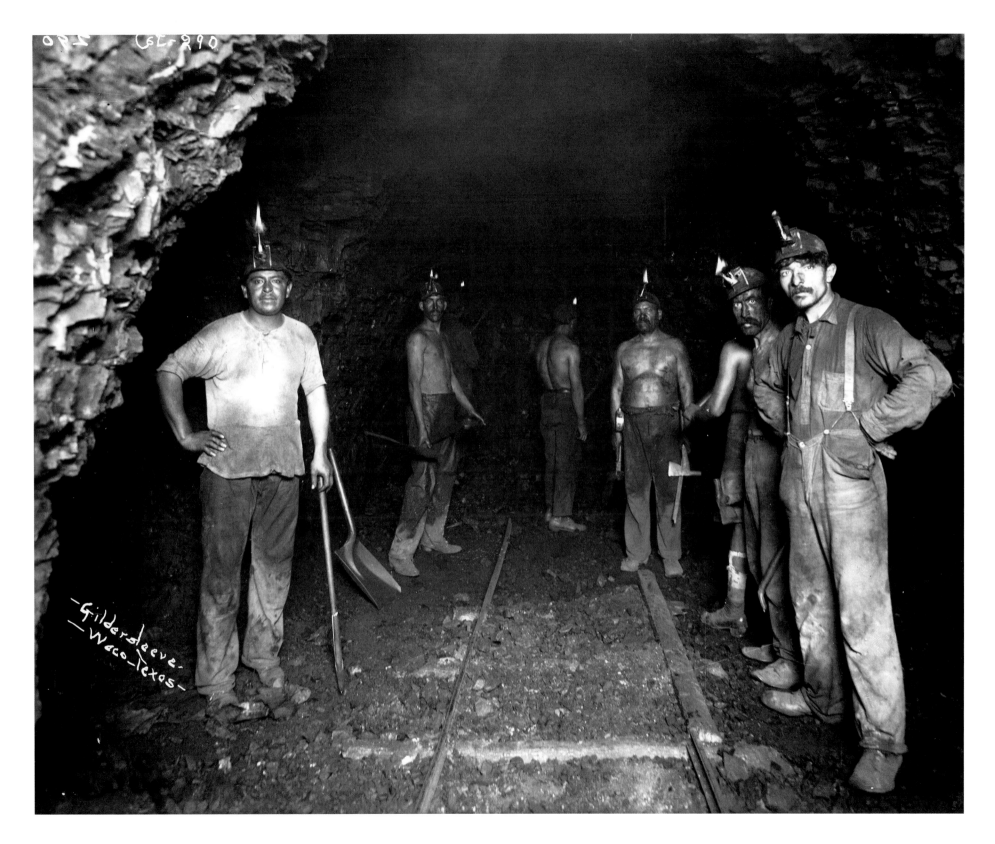

Gildersleeve-
Waco Texas-

71

ROCKDALE COAL MINERS TAKE A BREAK

A mine shaft elevator gives this group of miners
a good location to pose for a photograph.

c. 1914. 8"x10" glass plate negative
Photographer: F. A. Gildersleeve
Place: Rockdale, Texas
Gildersleeve-Conger Collection #0430

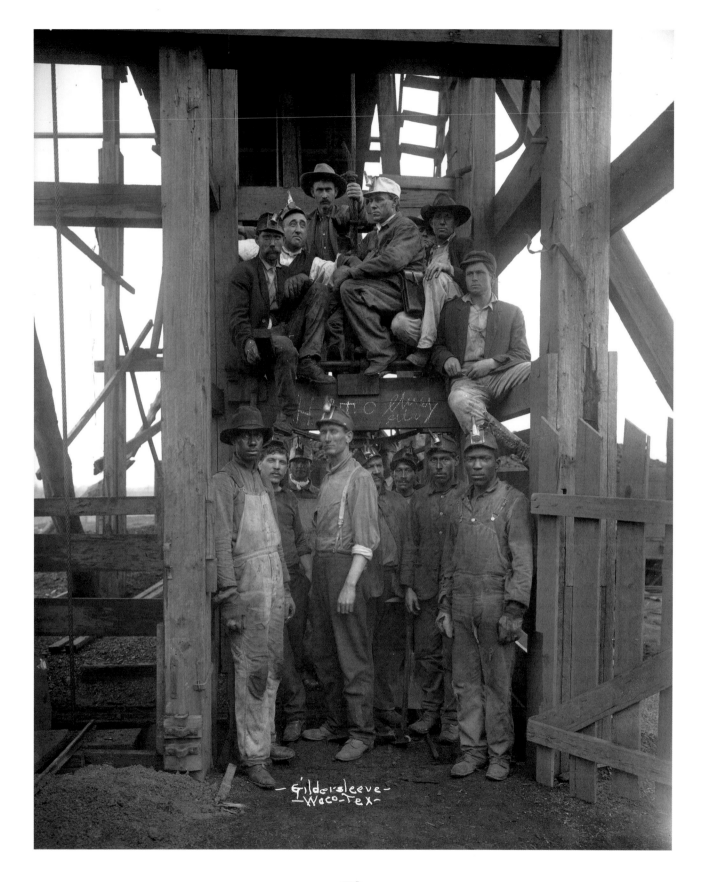

F. W. WOOLWORTH COMPANY INTERIOR

Many items are on display as seen in this Christmas exhibit at Woolworth's. One of the store's advertising slogans was "Nothing in this store is over 15 cents." The business was located at 605–607 Austin Avenue.

1914. 8"x10" glass plate negative
Photographer: F. A. Gildersleeve
Place: Waco, Texas
Gildersleeve-Conger Collection #0430

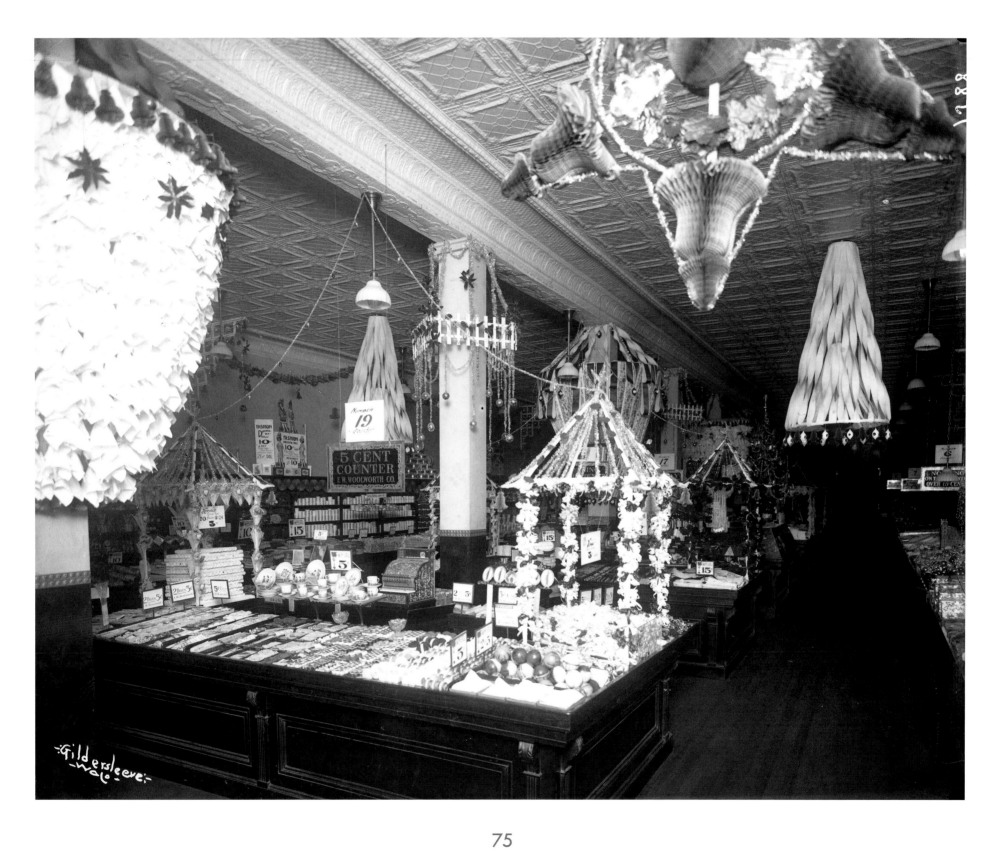

GOLDSTEIN-MIGEL COMPANY OFFICES

This picture shows the business operations staff of this former Waco company. The large department store building took up 521–527 Austin Avenue.

February 1914. 8"x10" glass plate negative
Photographer: F. A. Gildersleeve
Place: Waco, Texas
Gildersleeve-Conger Collection #0430

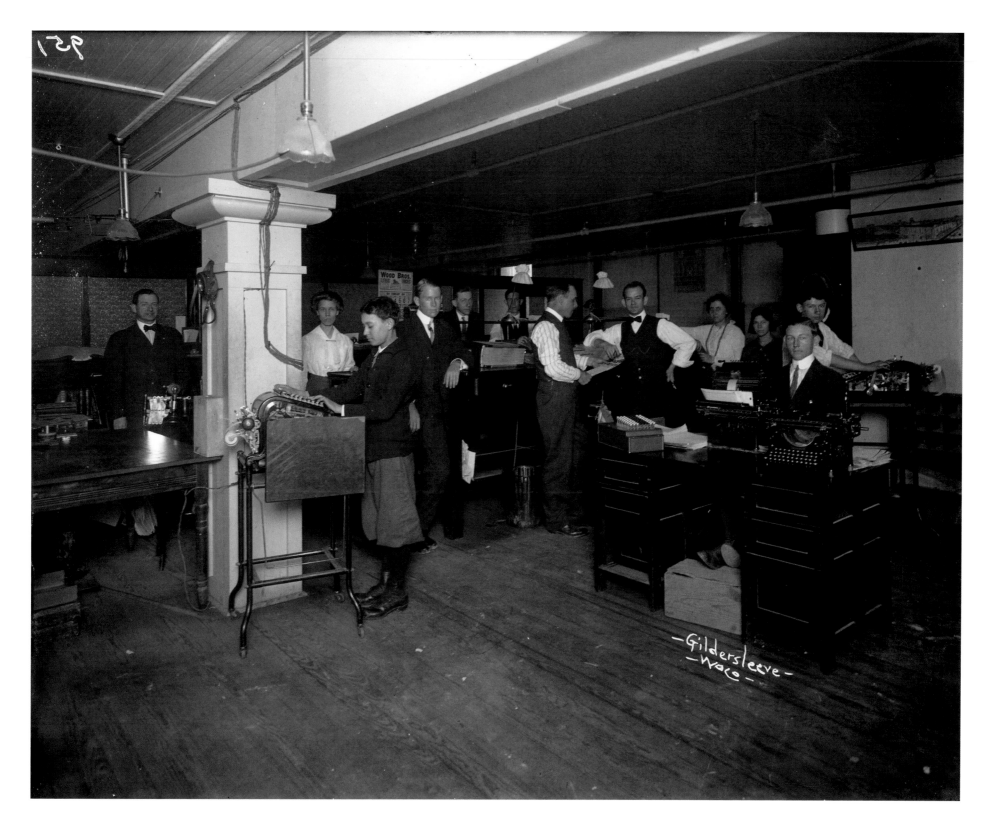

Gildersleeve
-Waco-

GOLDSTEIN-MIGEL COMPANY

The Goldstein-Migel Building received some
significant remodeling as seen
in this "Rebuilding Sale" photograph.

c. 1914. 8"x10" glass plate negative
Photographer: F. A. Gildersleeve
Place: Waco, Texas
Gildersleeve-Conger Collection #0430

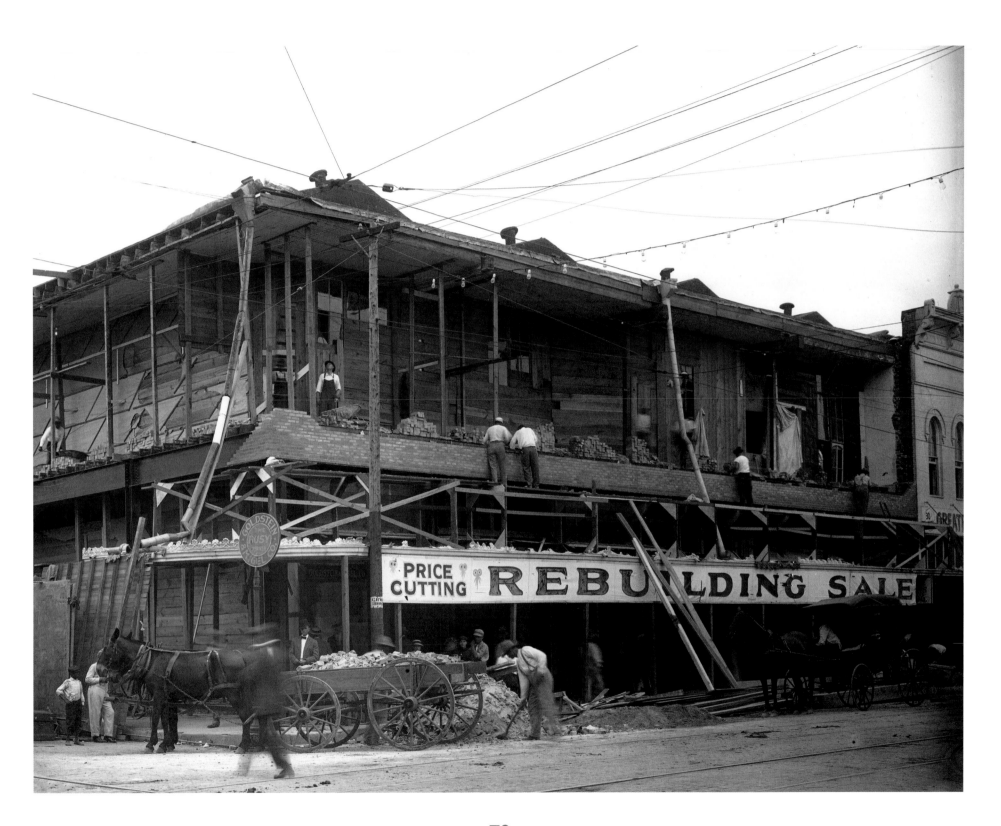

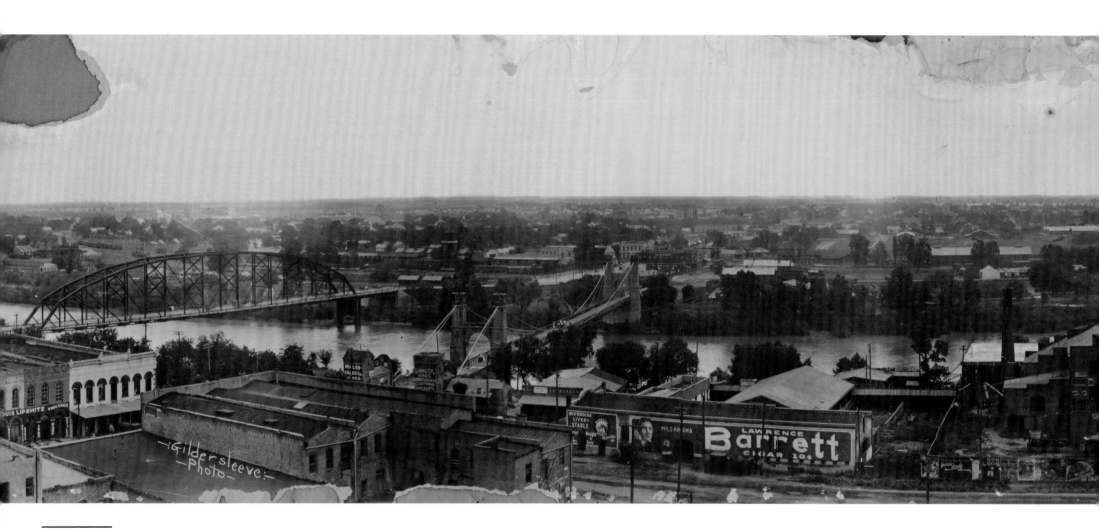

A VIEW FROM WEST OF THE BRAZOS

This image shows downtown Waco with a view toward the "east"
part of the city. From left to right, the Washington Avenue Bridge,
Suspension Bridge, and the Cotton Belt Bridge span the
Brazos River. In the foreground, what was known as 1st Street
is shown in this once industrialized part of the city.

c. 1909. 11"x49" silver gelatin print
Photographer: F. A. Gildersleeve
Place: Waco, Texas
The Texas Collection General Photo Files #3976

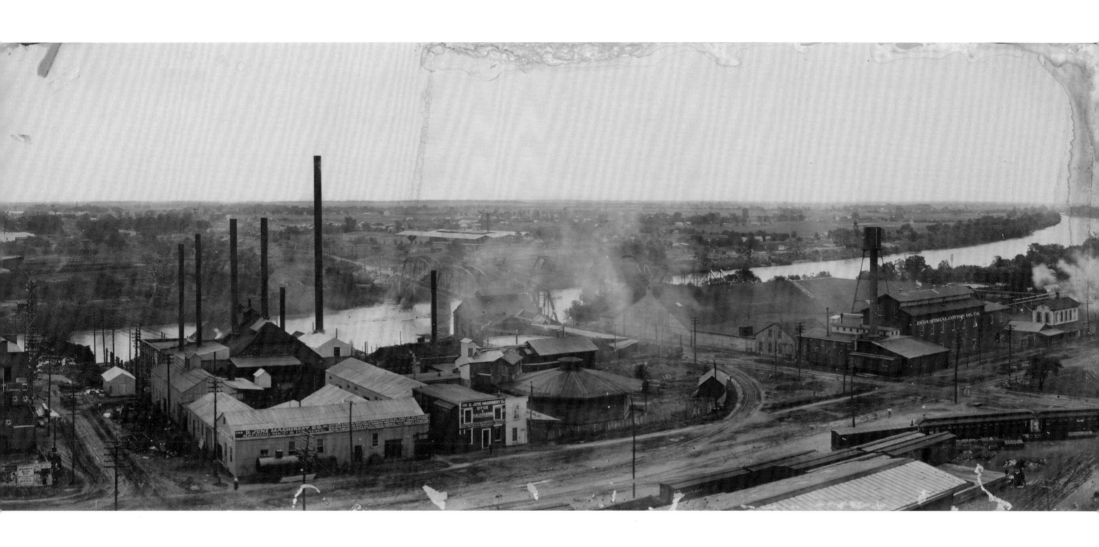

WOLFE THE FLORIST

Many generations of the Wolfe family have served
the central Texas community. Pictured are some of their
greenhouses, delivery vehicle, and a representative
of the business.

c. 1915. 8"x10" glass plate negative
Photographer: F. A. Gildersleeve
Place: Waco, Texas
Gildersleeve-Conger Collection #0430

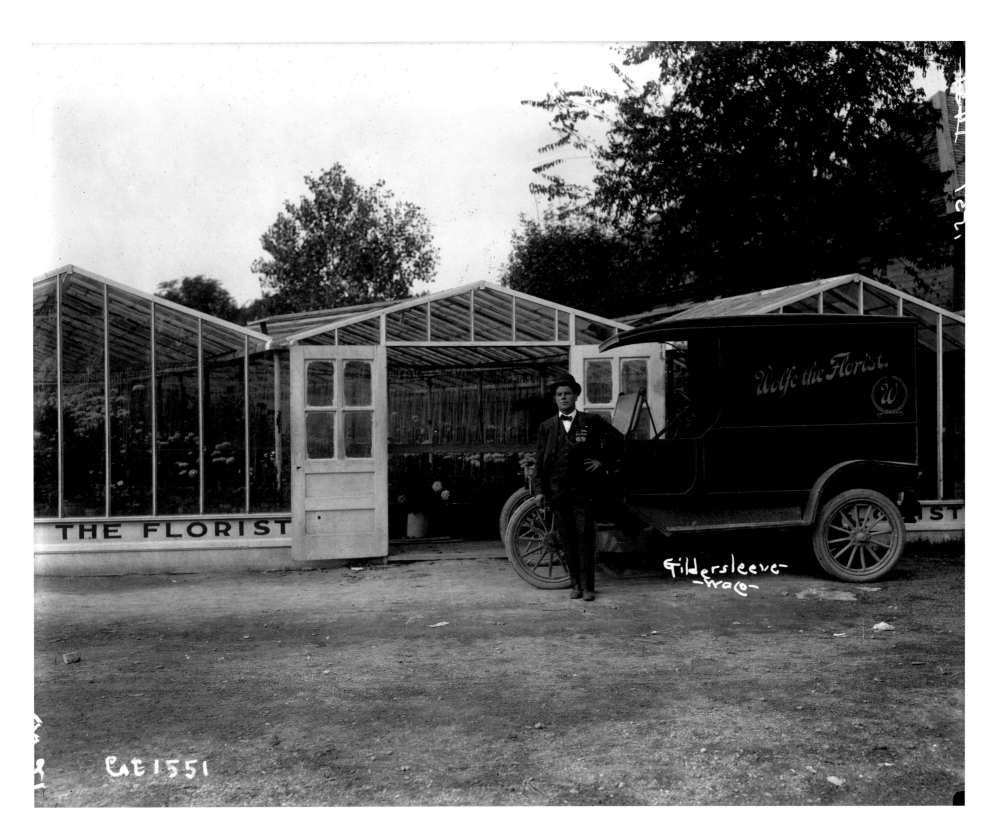

THE FLORIST

Wolfe the Florist.

Gildersleeve
-Waco-

GE1551

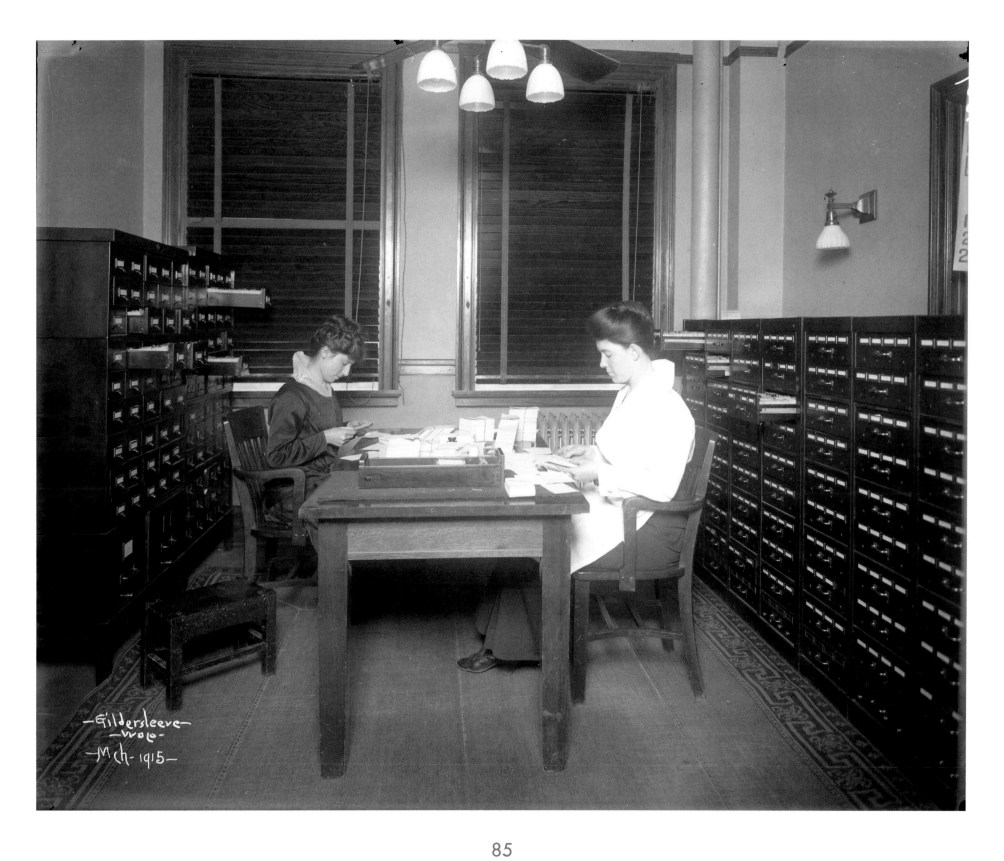

Gildersleeve
—Wolo—
Mch-1915-

THE CRYSTAL THEATRE LOBBY

The Crystal Theatre's lobby shows an elaborate arrangement of movie posters on display in this photograph.

c. 1915. 8"x10" glass plate negative
Photographer: F. A. Gildersleeve
Place: Waco, Texas
Gildersleeve-Conger Collection #0430

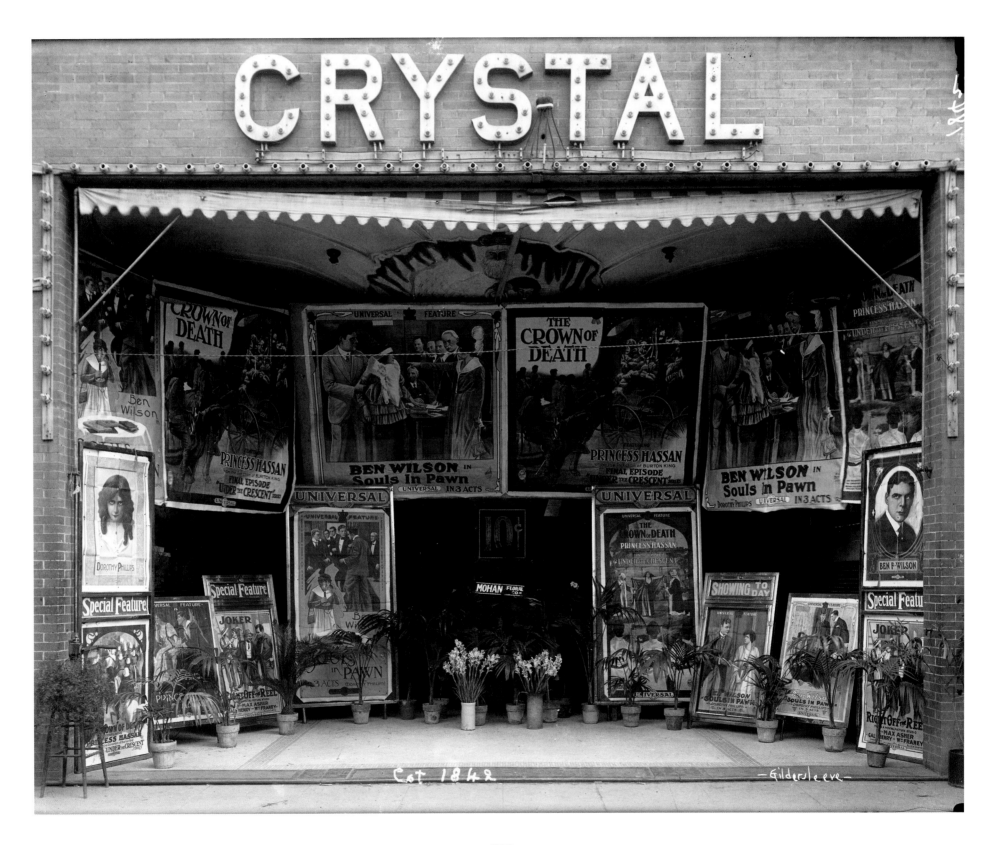

METHODIST CHILDREN'S HOME FARM
In addition to various agricultural duties, children
at this facility took care of dairy cows.

c. 1915. 8"x10" glass plate negative
Photographer: F. A. Gildersleeve
Place: Waco, Texas
Gildersleeve-Conger Collection #0430

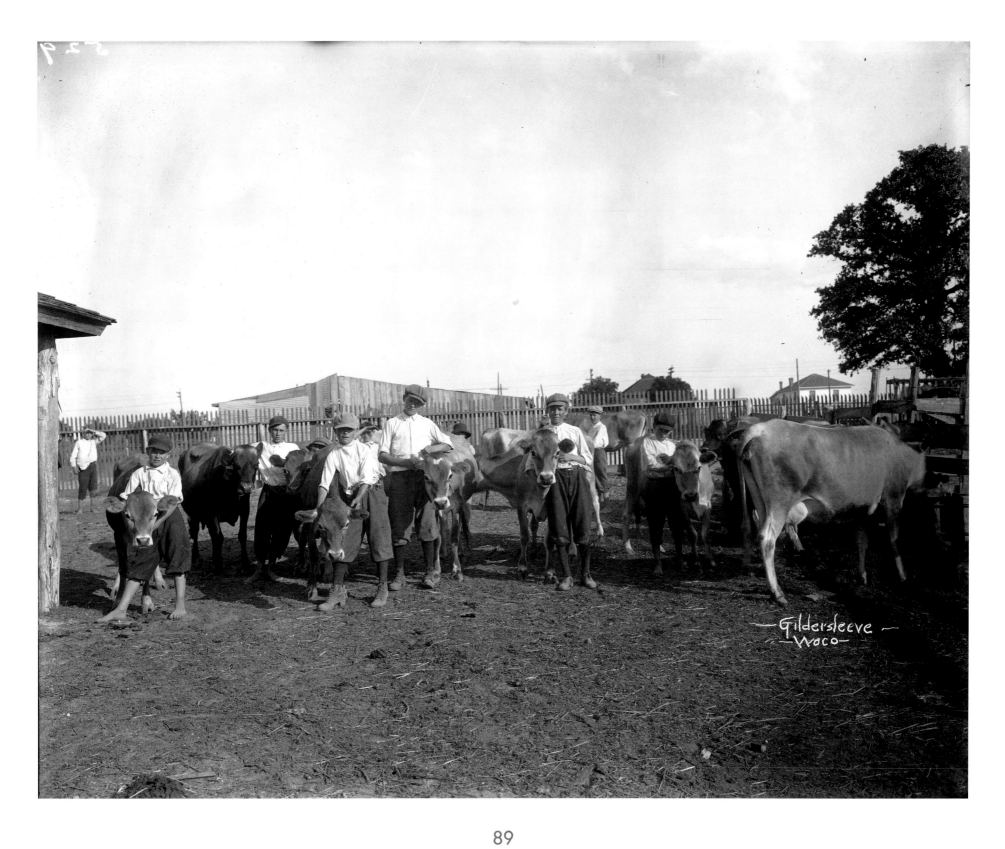

GREEN ART STUDIO

Artists, and those aspiring to be, finely paint
decorative designs on white china in this art studio.
The location was at 1001 North 5th Street.

1915. 8"x10" glass plate negative
Photographer: F. A. Gildersleeve
Place: Waco, Texas
Gildersleeve-Conger Collection #0430

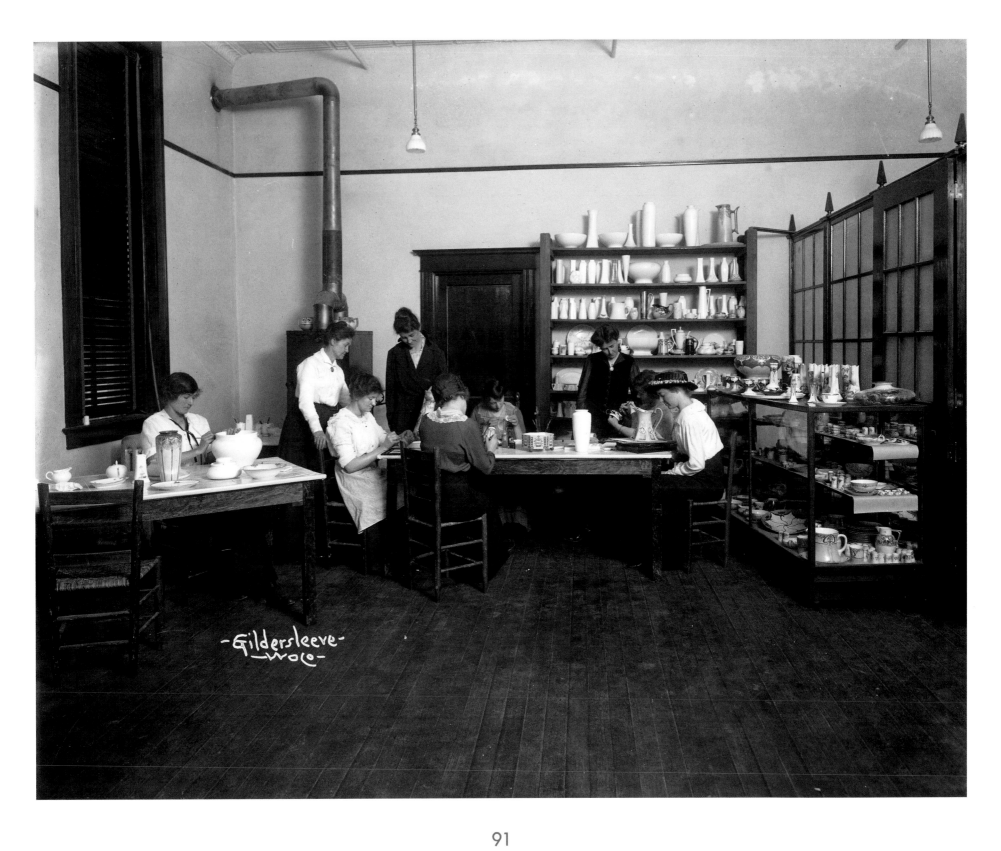

Gildersleeve
WOLO

TOM PADGITT COMPANY WHOLESALE SADDLERY

This Waco business helped supply the British Royal Horse and
Royal Field Artillery units during World War I as seen in part of this
large order. It consisted of 2,500 saddles and 300 sets of
six-horse harnesses. The business later filled similar orders for
U.S. forces in the same conflict. Padgitt's was located on the
corner of 5th Street and Franklin Avenue and was
one of the largest manufacturers of its kind in the South.

1915. 8"x10" glass plate negative
Photographer: F. A. Gildersleeve
Place: Waco, Texas
Gildersleeve-Conger Collection #0430

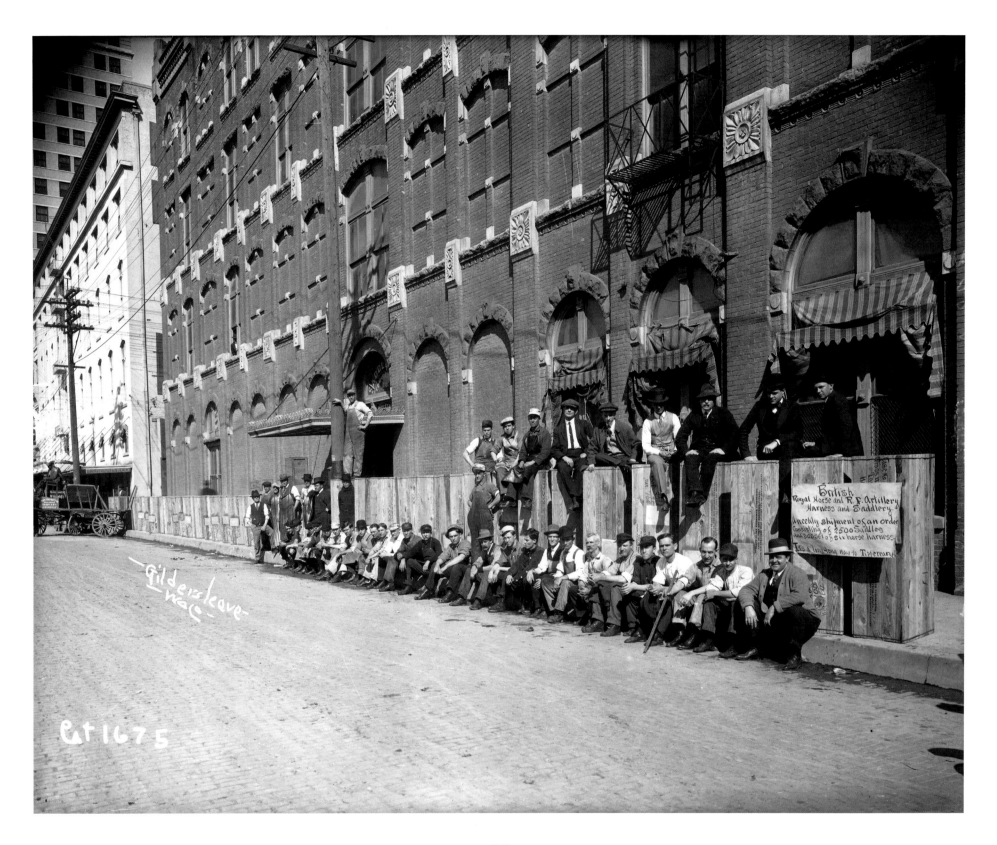

British
Royal Horse and R. F. Artillery
Harness and Saddlery

Weekly shipment of an order
Consisting of 2500 Saddles
and 2000 sets of six horse harness

It's a long long way to Tipperary.

Gildersleeve
Waco

Gt 1675

ARTESIAN MANUFACTURING AND BOTTLING COMPANY

Several horse-drawn wagons and an early
motor-driven delivery vehicle line up on the side
of, what is at present, the Dr Pepper Museum
and Free Enterprise Institute.

c. 1913. 8"x10" glass plate negative
Photographer: F. A. Gildersleeve
Place: Waco, Texas
Gildersleeve-Conger Collection #0430

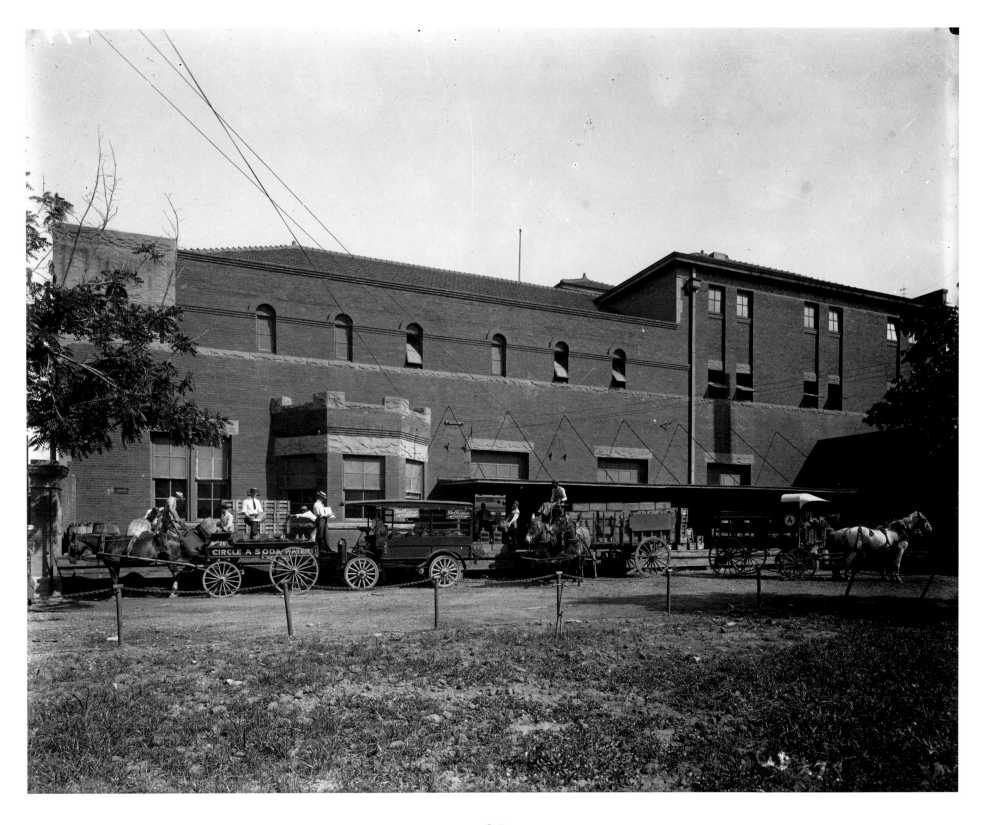

Delivery trucks line up in front of what is presently
the Dr Pepper Museum and Free Enterprise Institute.
The trucks each have a "Dr. Pepper" sign and appear
dressed up for a parade.

c. 1913. 8"x10" glass plate negative
Photographer: F. A. Gildersleeve
Place: Waco, Texas
Gildersleeve-Conger Collection #0430

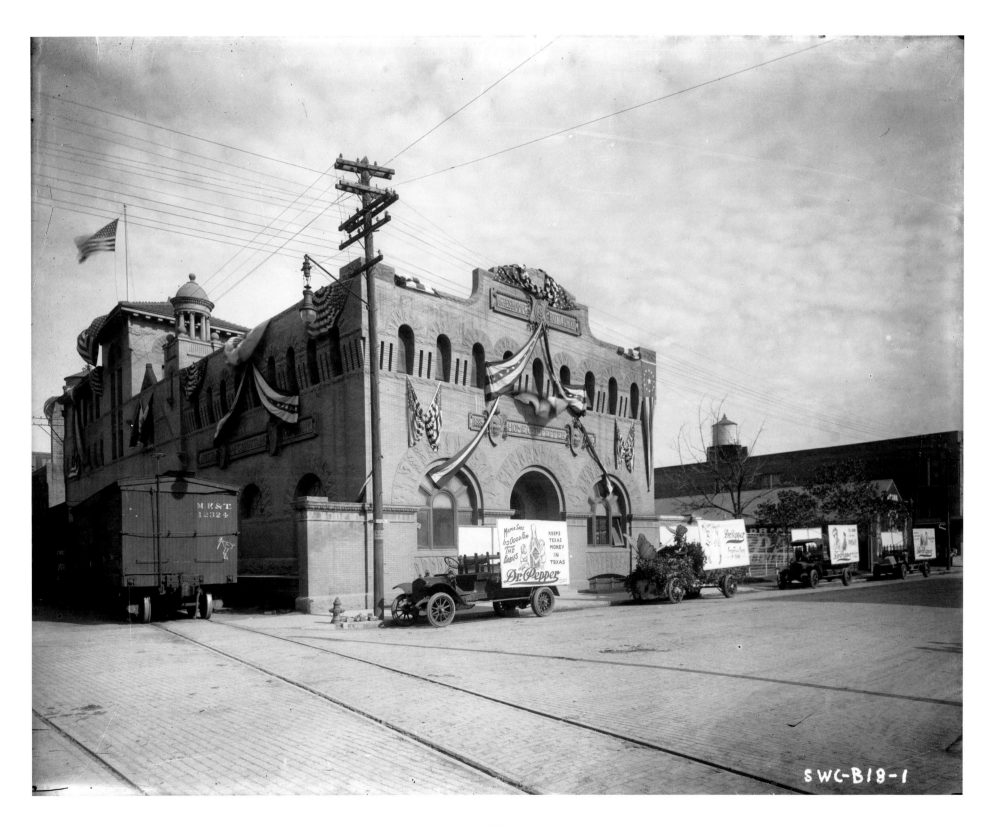

SWC-B18-1

THE TURNER-COFFIELD COMPANY
A variety of fruits and vegetables are displayed
in the image to show customers what is offered.

1915. 8"x10" glass plate negative
Photographer: F. A. Gildersleeve
Place: Waco, Texas
Gildersleeve-Conger Collection #0430

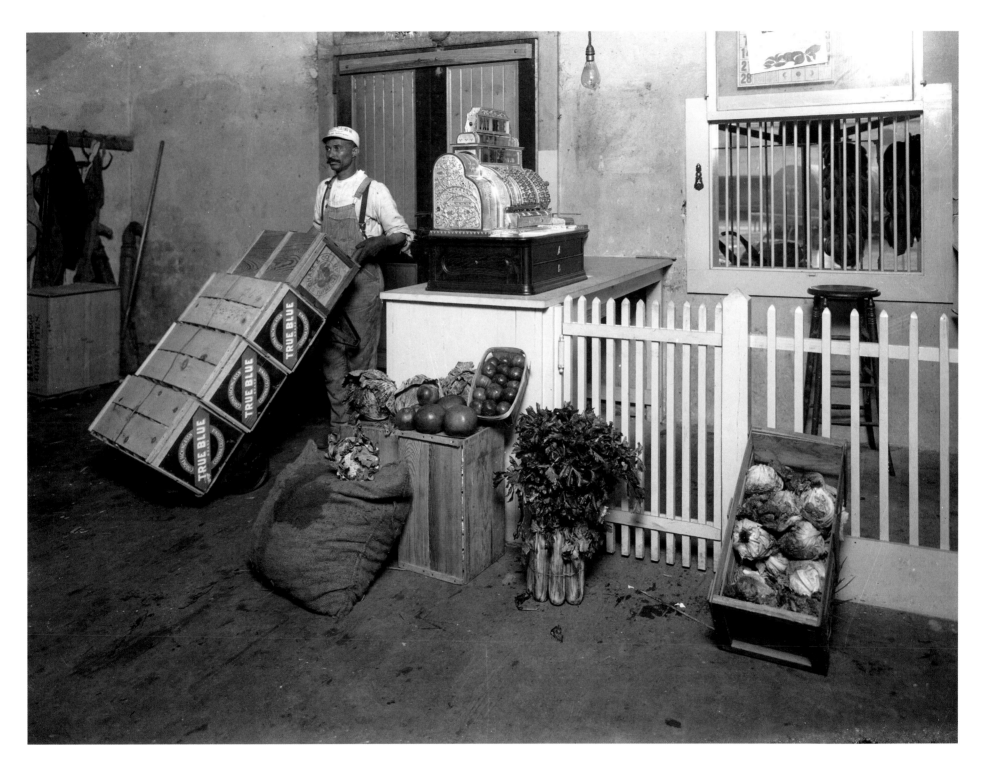

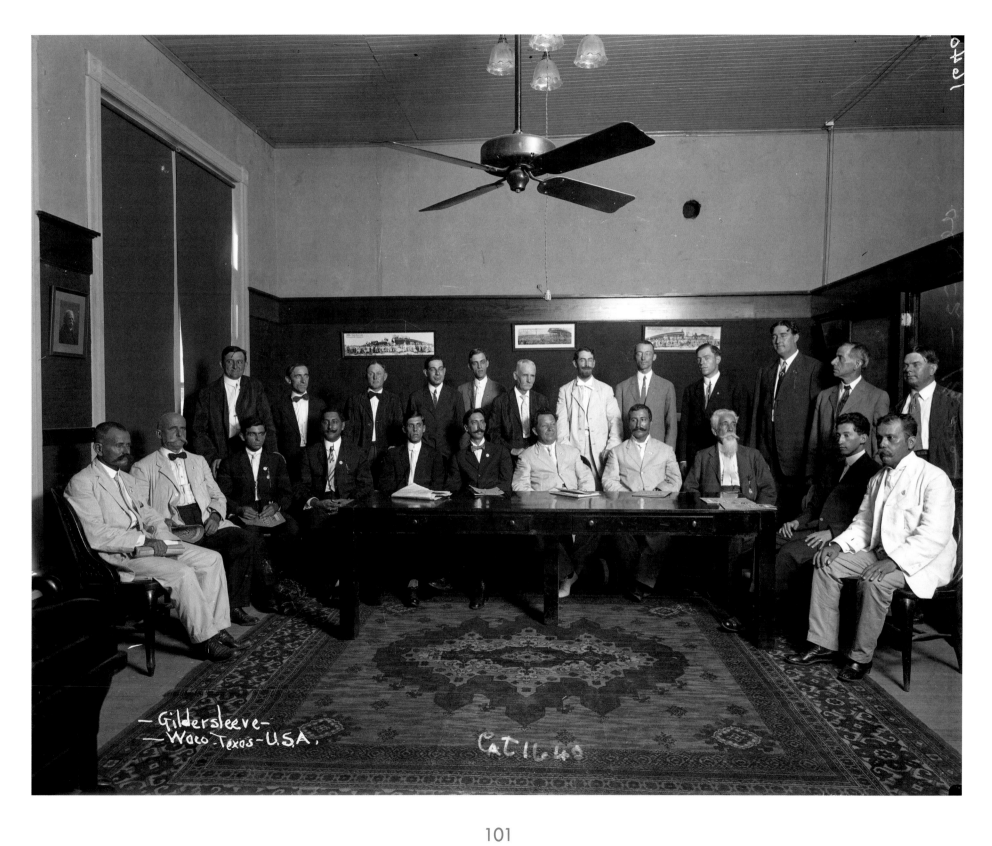

—Gildersleeve—
—Waco-Texas-U.S.A.

Cat 1640

POLL TAX

Members from the Young Men's Business League
try to encourage citizens to pay their poll tax
in order to vote.

c. 1915. 8"x10" glass plate negative
Photographer: F. A. Gildersleeve
Place: Waco, Texas
Gildersleeve-Conger Collection #0430

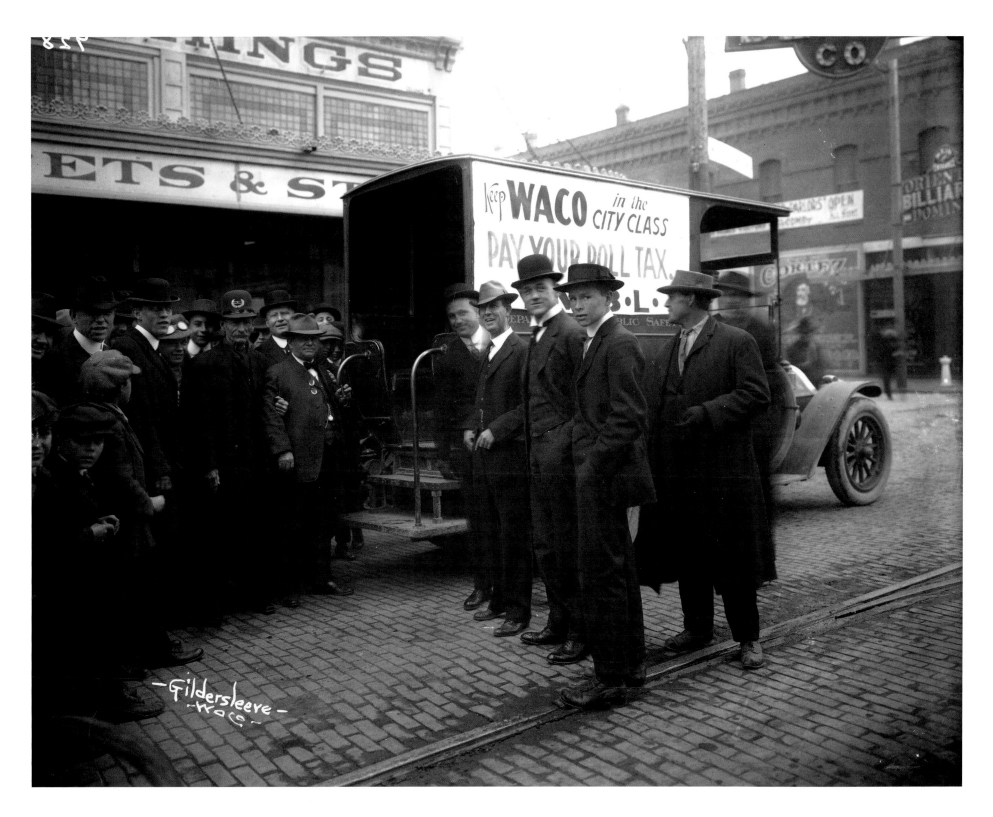

HALL MOTOR CAR AND MAJESTIC THEATRE

**Members representing the Hall Motor Car Company
and Majestic Theatre promote the arrival of
Adelaide Irving and her theatre company to Waco.
Note the silhouette of Gildersleeve that the
shadow provides.**

1915. 8"x10" glass plate negative
Photographer: F. A. Gildersleeve
Place: Waco, Texas
Gildersleeve-Conger Collection #0430

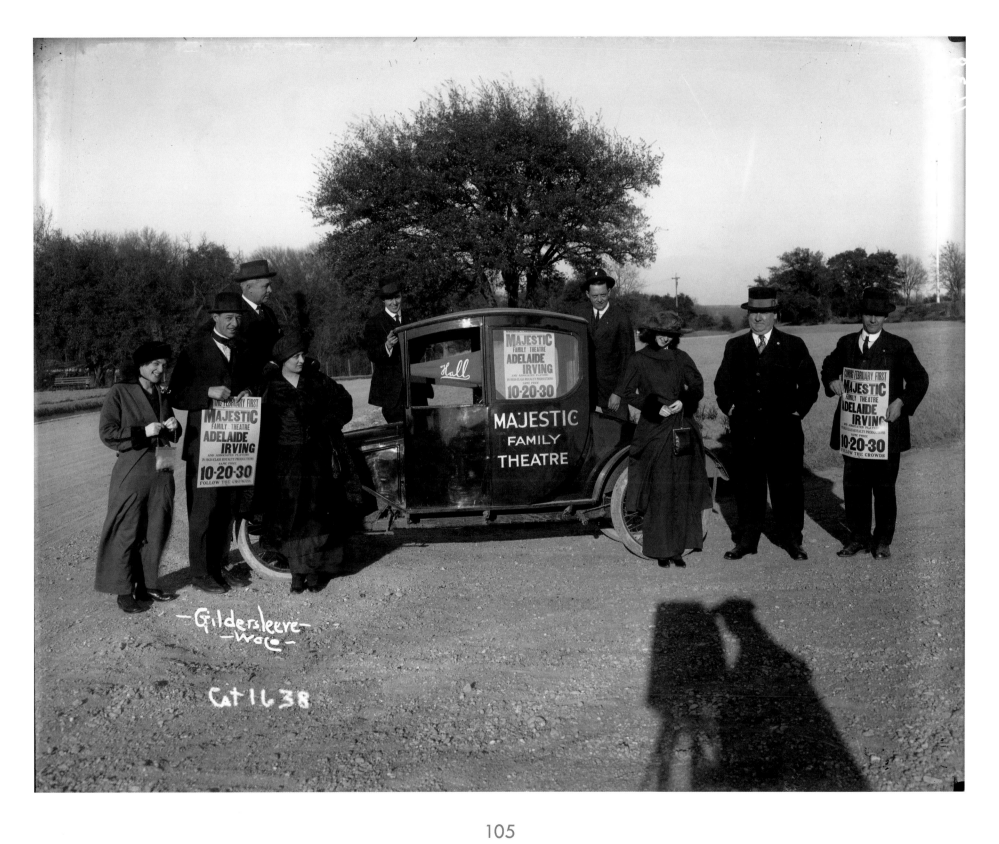

THE LARGEST PHOTO PRINT OF ITS TIME

This image shows a giant print of the Texas Cotton Palace
main building being processed. At the time, this photograph
set a world record among photo prints being 120″ wide. A
representative from Eastman Kodak personally delivered the
large roll of photo paper it required and supervised the
enlargement process. The photo was exhibited for some time
until it was sold for $50.00. Gildersleeve later recalled that
was "a good price in those days."

1913. 8"x10" glass plate negative
Photographer: F. A. Gildersleeve
Place: Waco, Texas
Gildersleeve-Conger Collection #0430

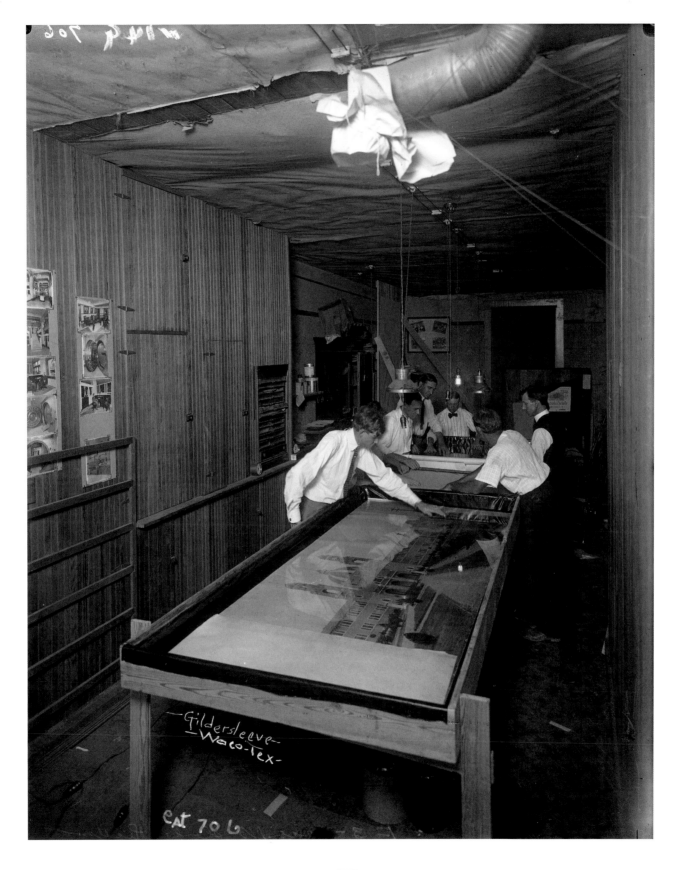

**A Mitchell auto parks in front of the Waco
Mitchell Auto Company at 721 Washington Avenue.**

1916. 8"x10" glass plate negative
Photographer: F. A. Gildersleeve
Place: Waco, Texas
Gildersleeve-Conger Collection #0430.

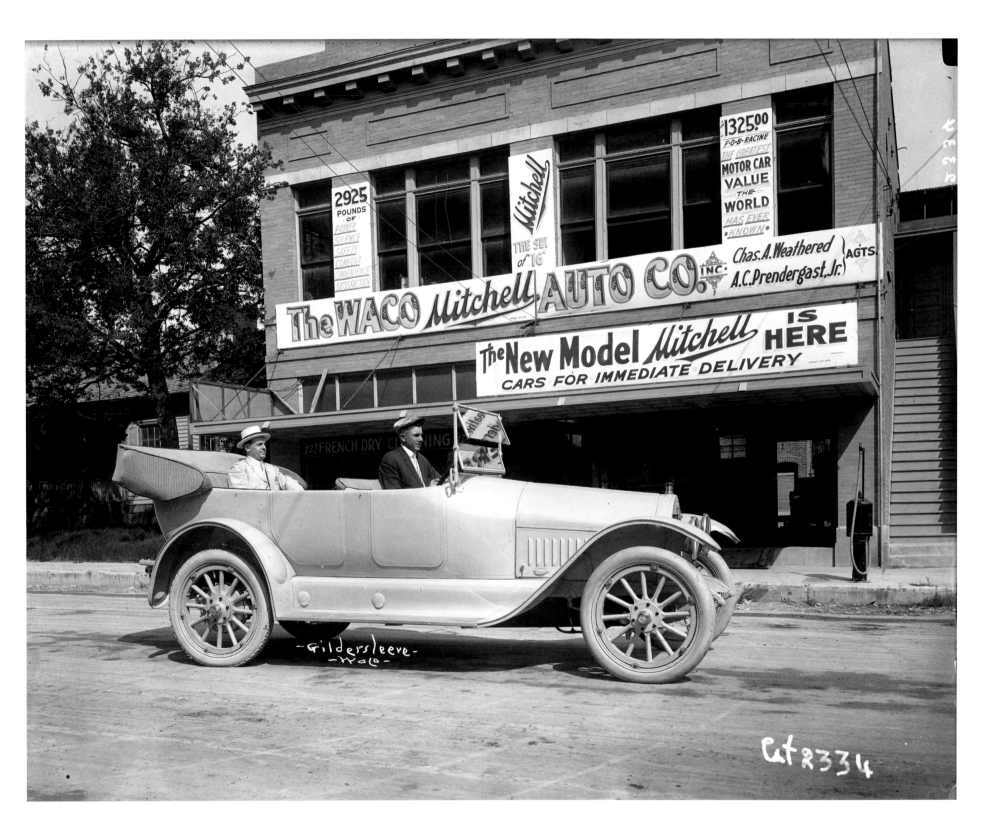

COWS IN PASTURE

A herd of cows occupy a wooded portion
of a pasture in this scene.

1916. 8"x10"glass plate negative
Photographer: F. A. Gildersleeve
Place: near Waco, Texas
Gildersleeve-Conger Collection #0430

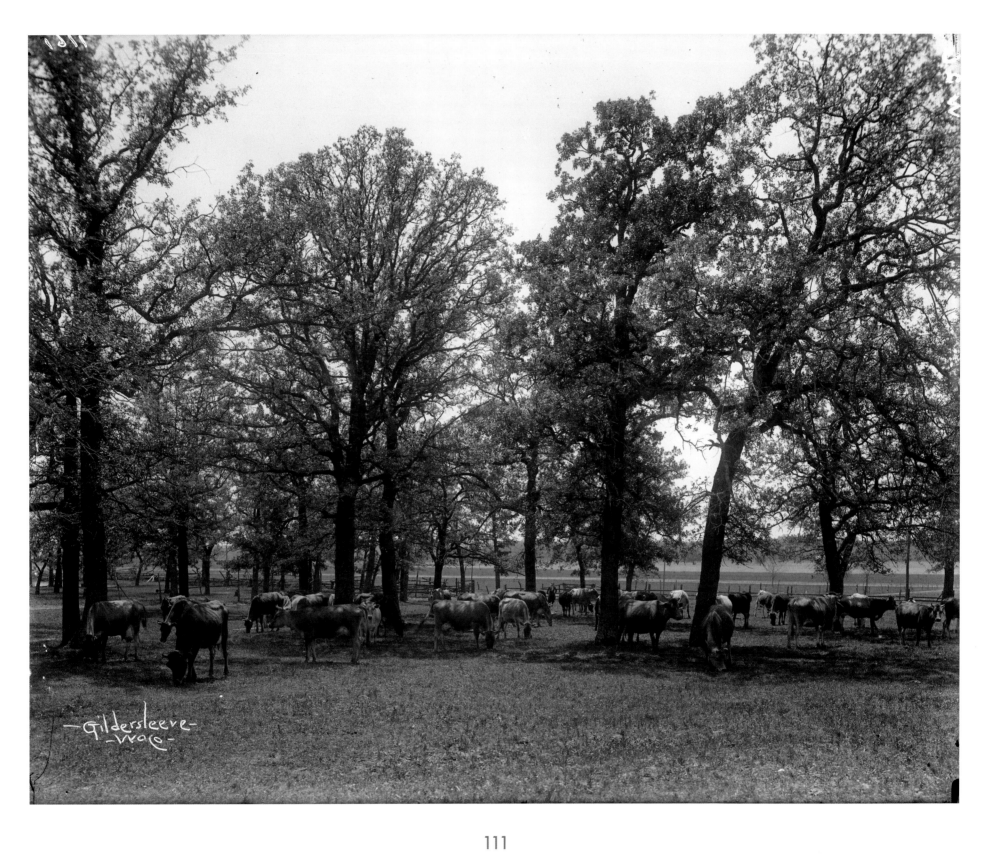

-Gildersleeve-
-Waco-

PATRONS AT SALOON

Occupants of this saloon take time to pose
for Fred Gildersleeve's camera.

1916. 8"x10" glass plate negative
Photographer: F. A. Gildersleeve
Place: Waco, Texas
Gildersleeve-Conger Collection #0430

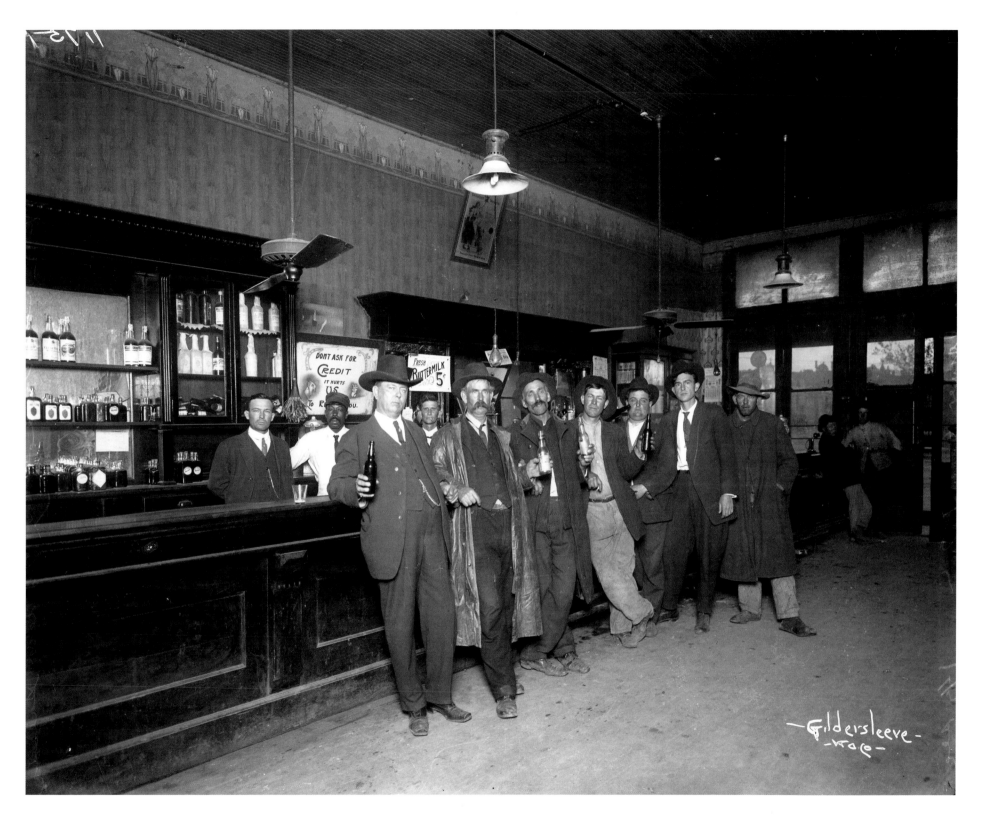

SOUTHLAND BARBER SHOP
Located at 602 Austin Avenue, this barber shop
had twelve stations. Vincent Nicosia was the owner.

c. 1916. 8"x10"glass plate negative
Photographer: F. A. Gildersleeve
Place: Waco, Texas
Gildersleeve-Conger Collection #0430

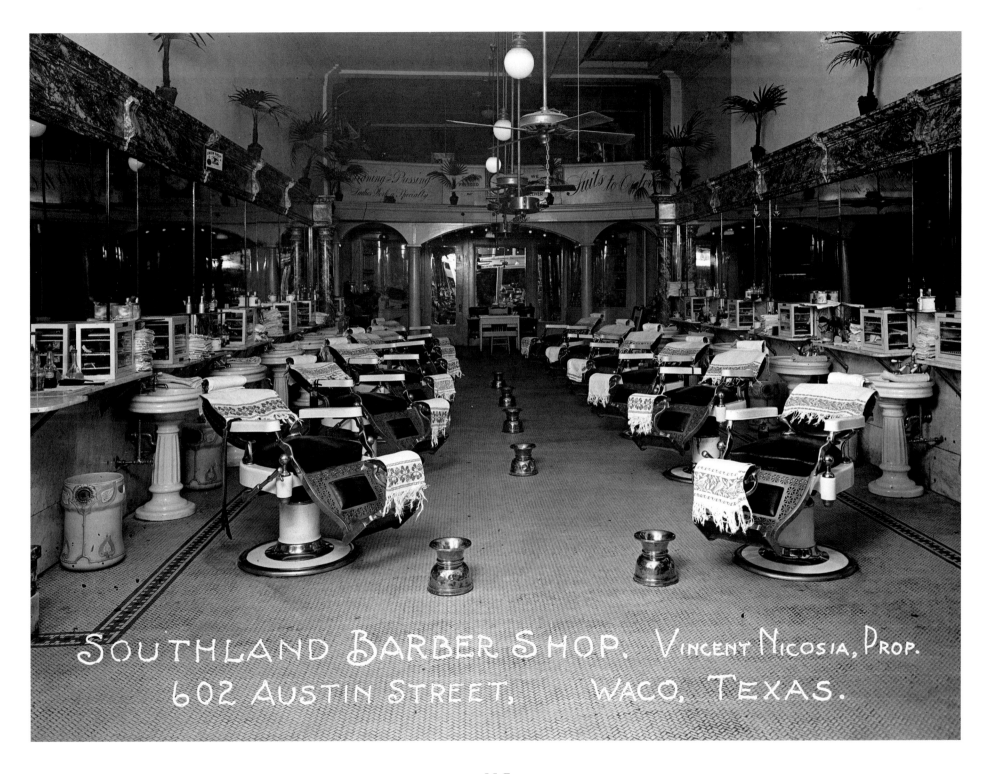

SOUTHLAND BARBER SHOP. Vincent Nicosia, Prop.
602 Austin Street, Waco, Texas.

A farm worker displays his freshly picked bell peppers.

c. 1915. 8"x10"glass plate negative
Photographer: F. A. Gildersleeve
Place: near Waco, Texas
Gildersleeve-Conger Collection #0430

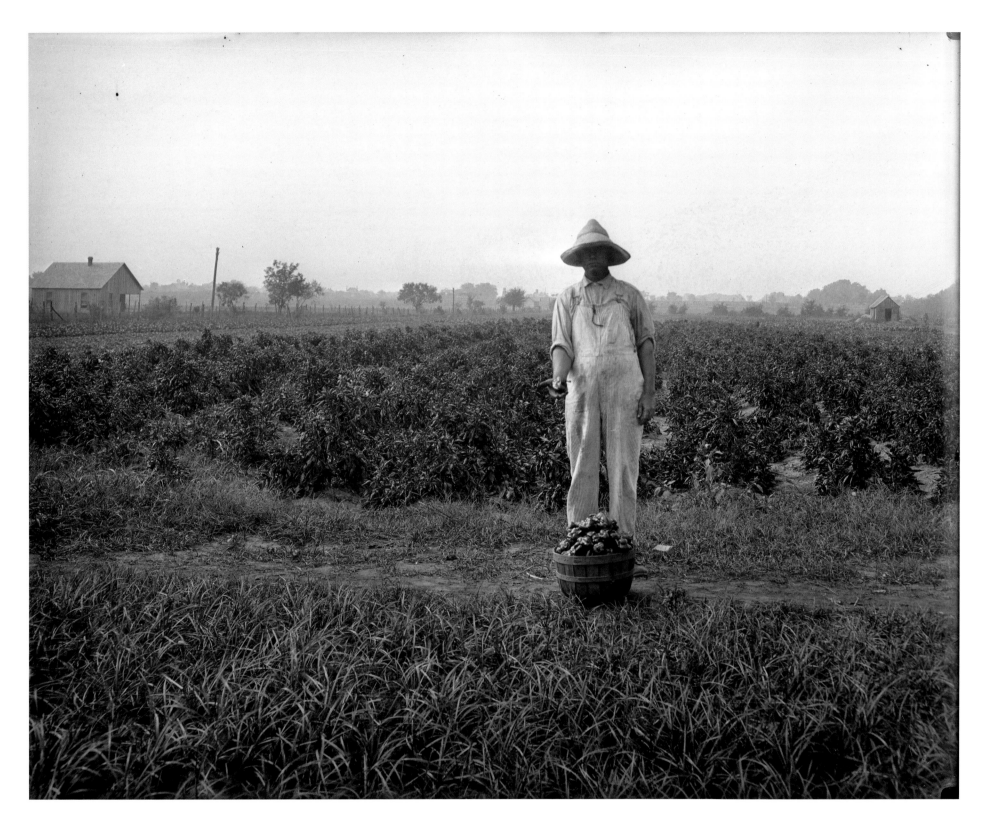

THE SODA GRILL

**A look inside The Soda Grill shows plenty of staff
on hand ready to serve.**

1918. 8"x10"glass plate negative
Photographer: F. A. Gildersleeve
Place: Waco, Texas
Gildersleeve-Conger Collection #0430

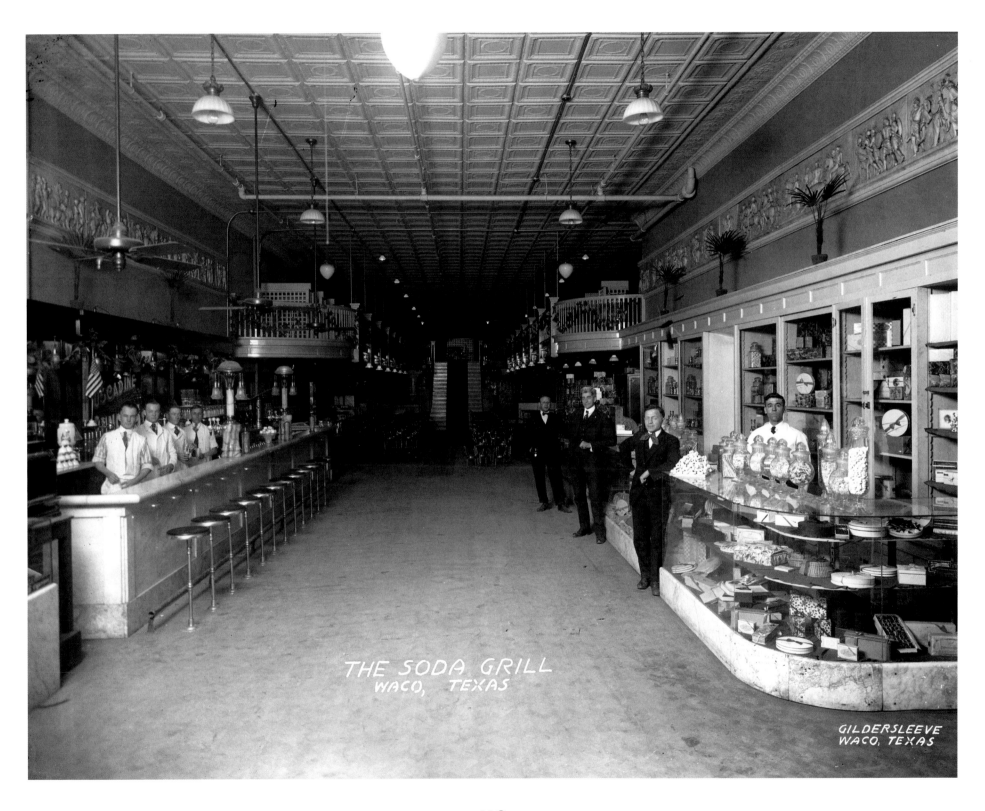

THE SODA GRILL
WACO, TEXAS

GILDERSLEEVE
WACO, TEXAS

WASHINGTON THEATRE

An elaborate marquee in front of Washington Theatre,
located at 708 Austin Avenue, advertises William Farnum's
silent film "For Freedom."

1918. 8"x10"glass plate negative
Photographer: F. A. Gildersleeve
Place: Waco, Texas
Gildersleeve-Conger Collection #0430

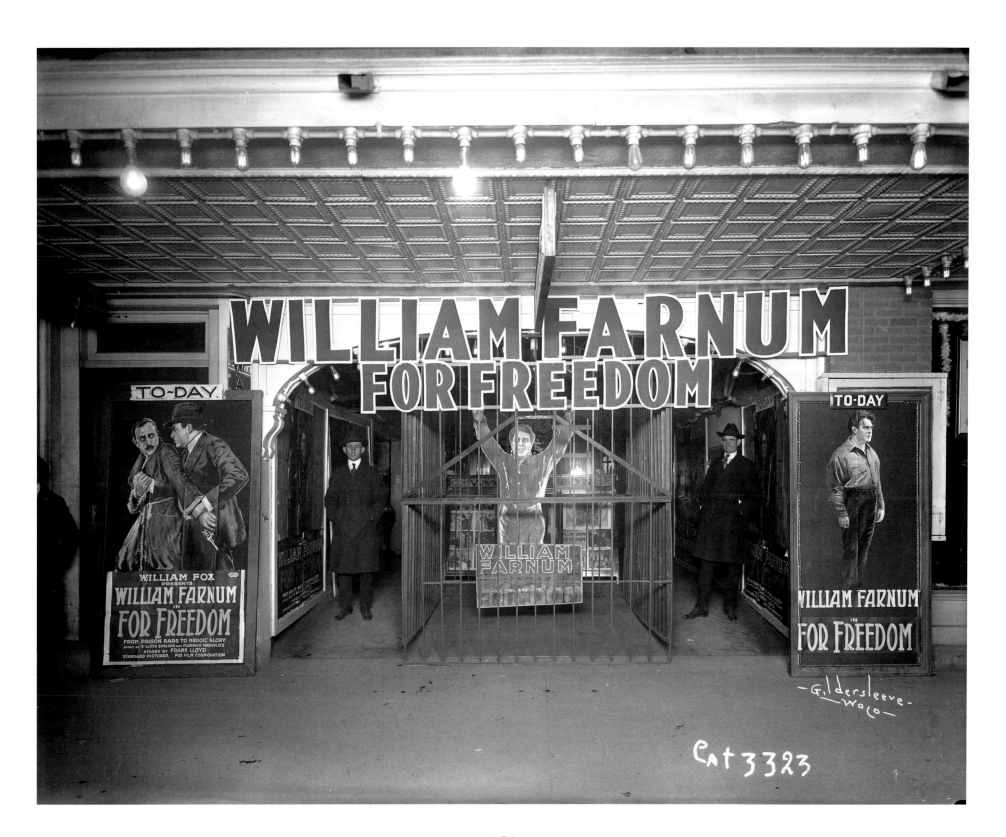

121

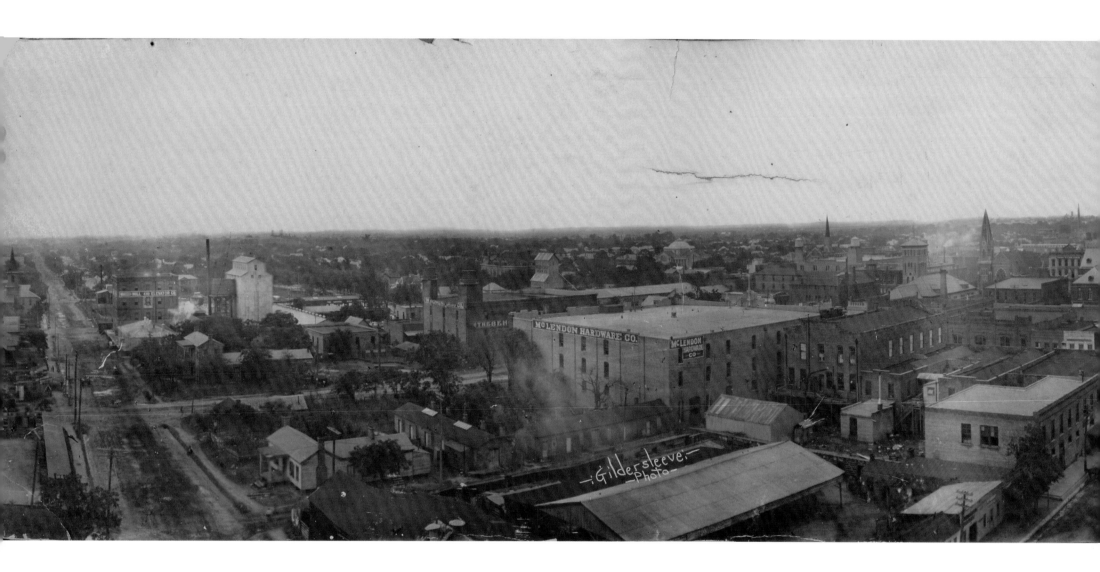

DOWNTOWN BIRD'S EYE VIEW

At the far right, the Waco City Hall building stands surrounded
by the town square. Adjacent is Austin Avenue, then Franklin Avenue,
and Second Street to the far left.

c. 1909. 10"x46" silver gelatin print
Photographer: F. A. Gildersleeve
Place: Waco, Texas
The Texas Collection General Photo Files #3976

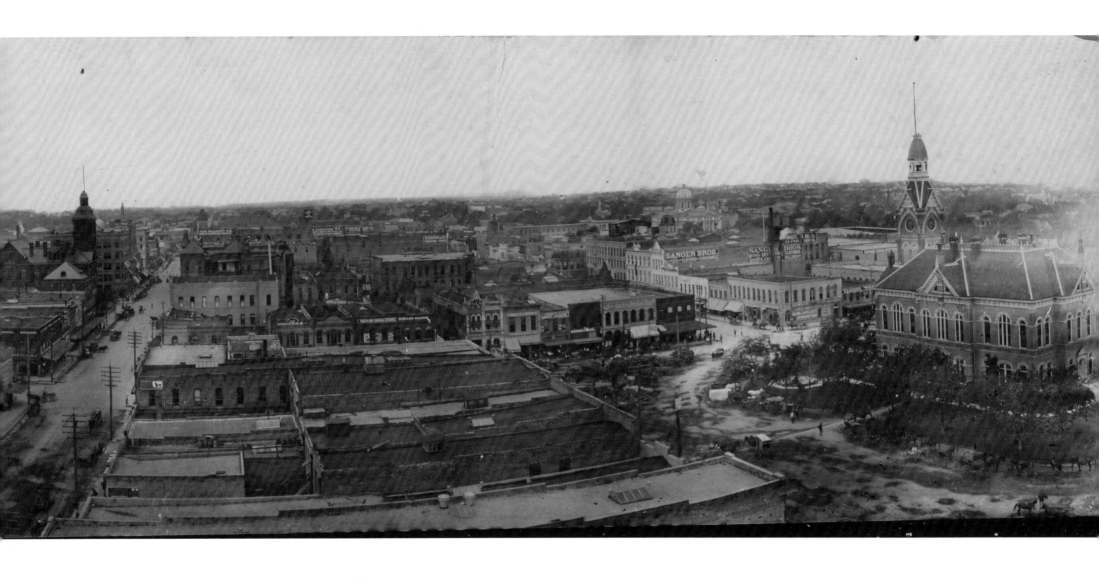

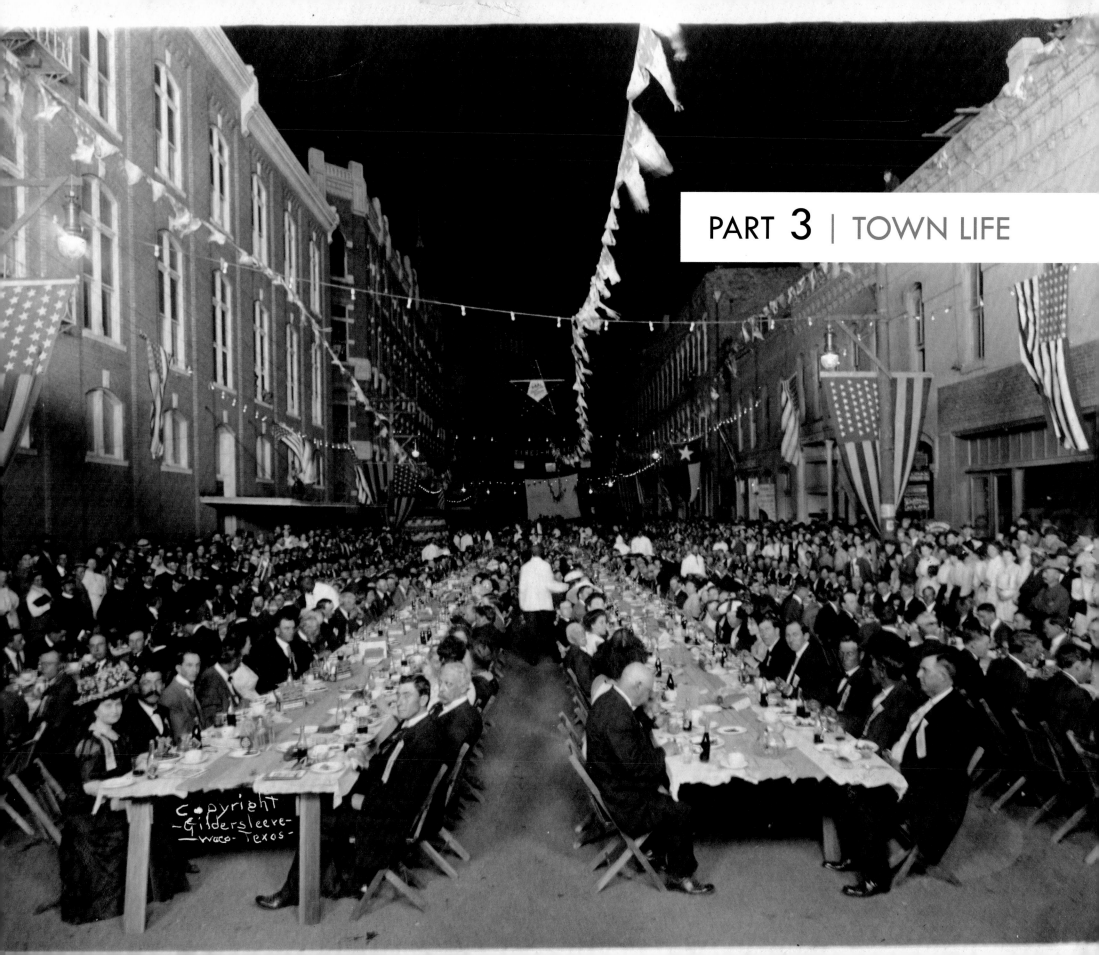

Copyright
-Gildersleeve-
-Waco-Texas-

April 11, 1911. 8"x10" silver gelatin print
Photographer: F. A. Gildersleeve
Place: Waco, Texas
[Waco] Amicable Life Insurance Company Records #3196

PROSPERITY BANQUET (LOOKING SOUTH)

Gildersleeve's Prosperity Banquet photograph was taken on South 5th Street. Tables were joined together to total 370 feet and seated 1,200 people. The length of the tables stretched across Austin and Franklin Avenues. The event was given under the direction of the Young Men's Business League to celebrate achievements made by Waco industry. For Gildersleeve, it was one of his most famous and well-engineered photographs of its day making national headlines for being the biggest flash-photograph ever made at the time.

April 11, 1911. 8"x10" silver gelatin print
Photographer: F. A. Gildersleeve
Place: Waco, Texas
[Waco] Amicable Life Insurance Company Records #3196

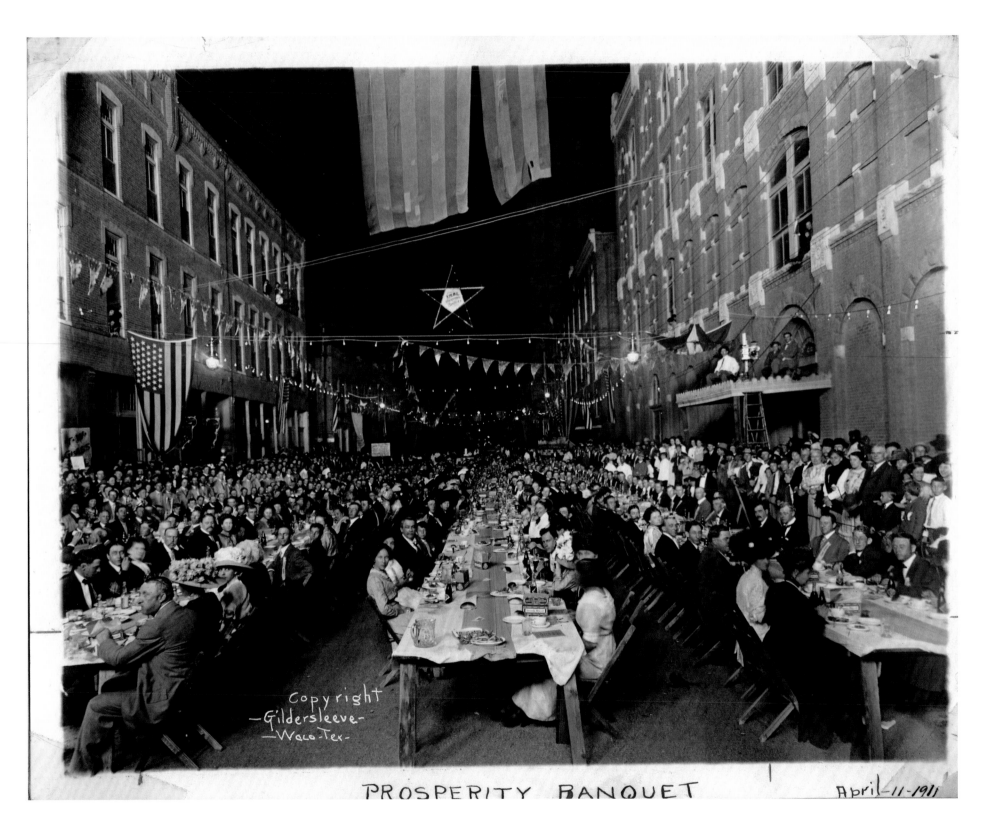

Copyright
—Gildersleeve—
—Waco-Tex-

PROSPERITY BANQUET

April-11-1911

127

NEW HOPE BAPTIST CHURCH CHOIR

Waco's New Hope Baptist Church is one of the
city's oldest African American institutions.
The church's choir and orchestra was comprised
of church members and those of Paul Quinn College.

1909. 8"x10" silver gelatin print
Photographer: F. A. Gildersleeve
Place: Waco, Texas
The Texas Collection General Photo Files #3976

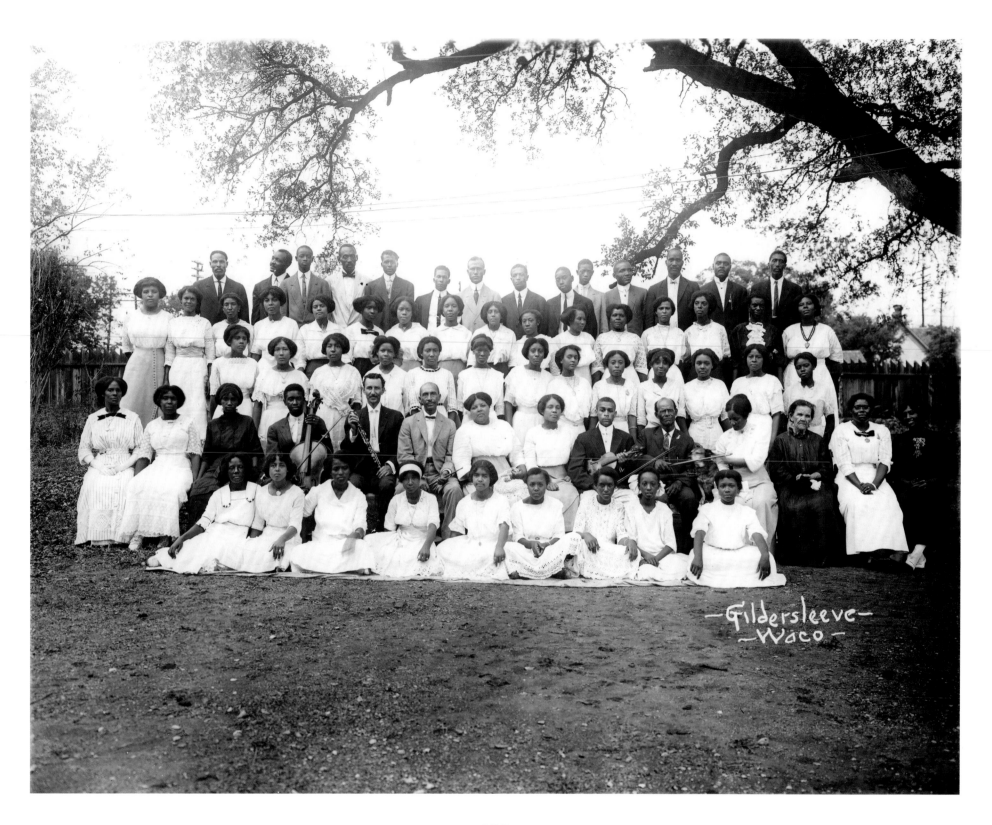

FEEDING THE DOG

**Florence Gildersleeve feeds her dog Dr. Pepper
straight out of the bottle.**

c. 1910. 3"x6" silver gelatin print
Photographer: F. A. Gildersleeve
Place: Waco, Texas
Gildersleeve-Conger Collection #0430

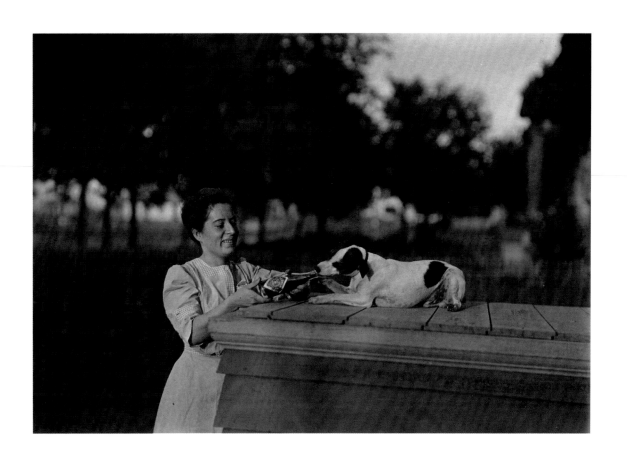

THE NATIVE AMERICANS OF WACO

A group of Waco Native Americans at the Texas
Cotton Palace visit the city from Oklahoma and
take part in the exposition. They were
invited by businessman Clint Padgitt.

1912. 8"x10" glass plate negative
Photographer: F. A. Gildersleeve
Place: Waco, Texas
Gildersleeve-Conger Collection #0430

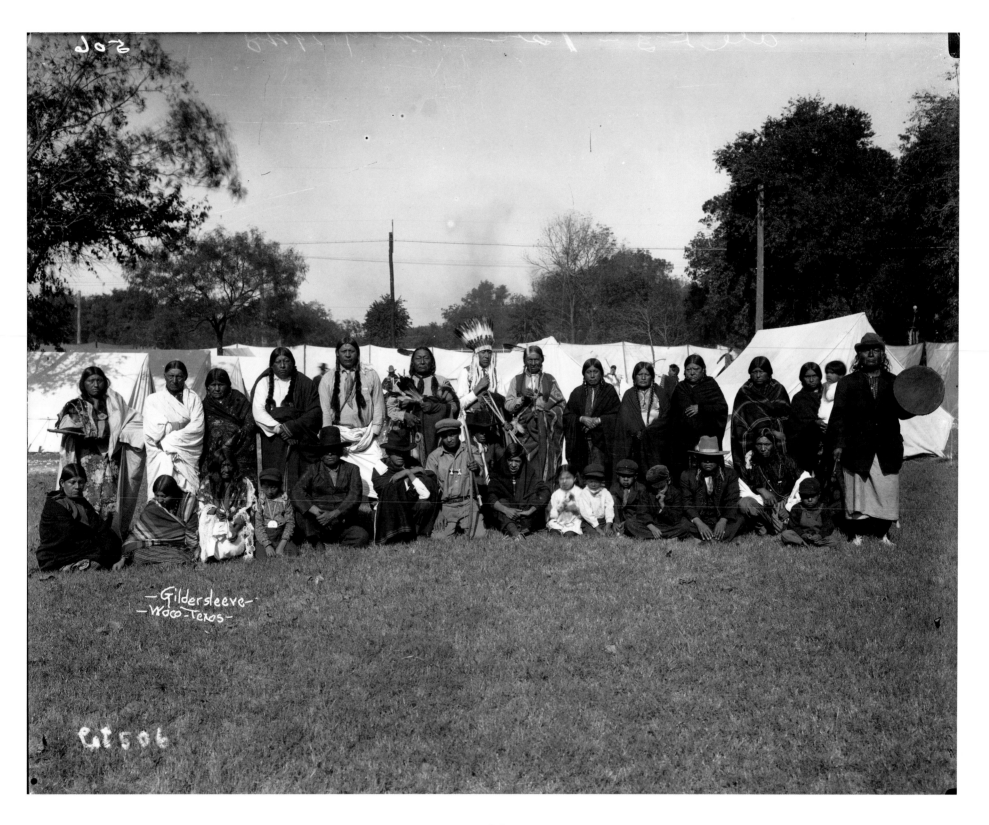

-Gildersleeve-
-Waco-Texas-

133

WACO AD CLUB BANQUET
The Waco Ad Club holds a banquet at the Texas Cotton Palace. The Baylor University band is seen to the right.

1910. 8"x10" glass plate negative
Photographer: F. A. Gildersleeve
Place: Waco, Texas
Gildersleeve-Conger Collection #0430

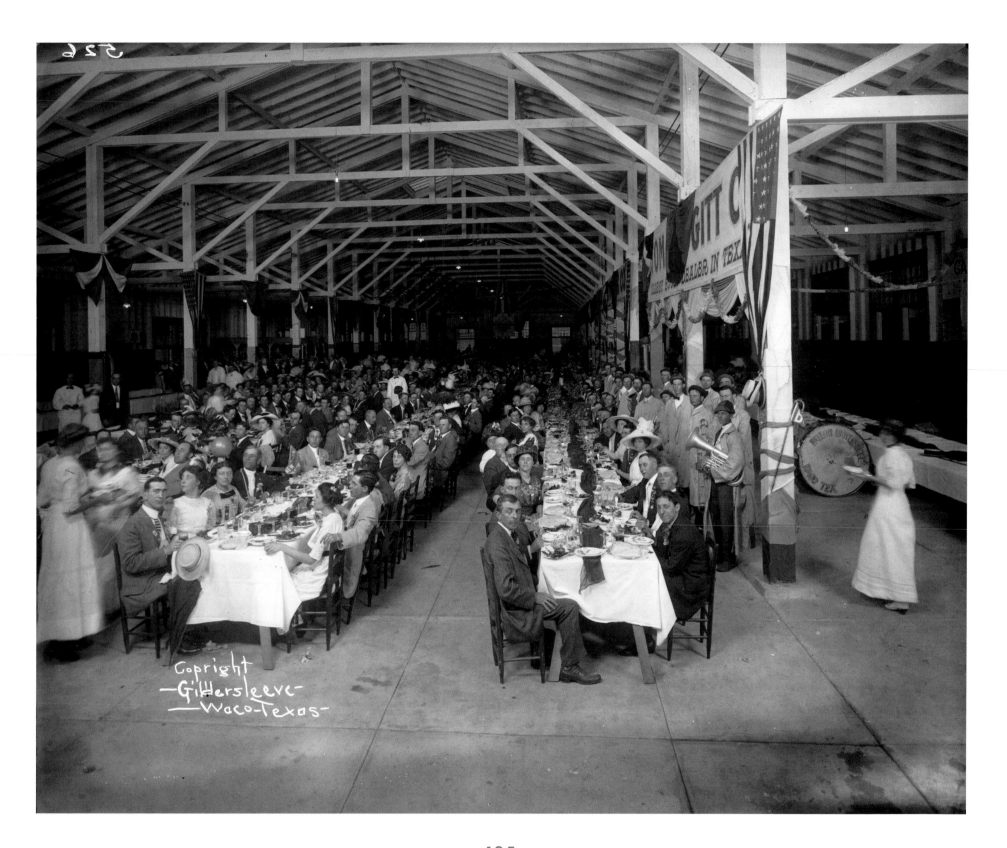

135

STREET CARS TRAVEL FOR THE FIRST TIME TO EAST WACO

Street cars make it to East Waco across the Brazos River and a crowd of citizens turn out to greet them on Elm Street.

1911. 8"x10" glass plate negative
Photographer: F. A. Gildersleeve
Place: Waco, Texas
Gildersleeve-Conger Collection #0430

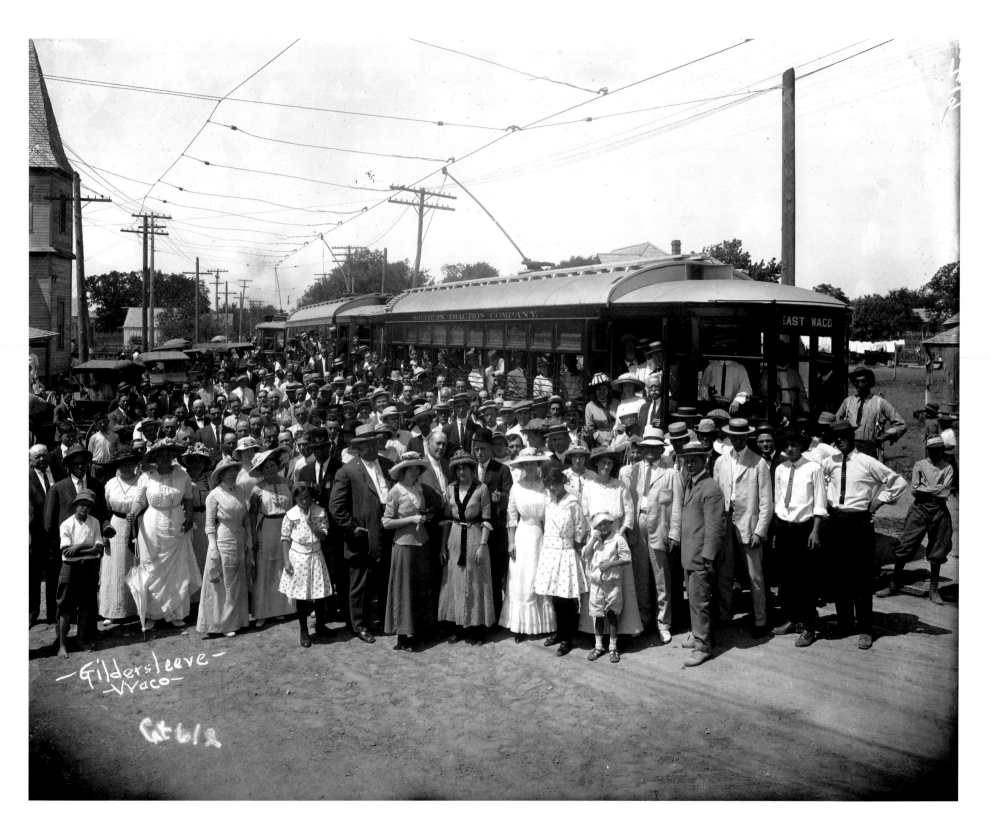

Gildersleeve
Waco

Cat 612

**Former President Theodore Roosevelt comes to
town with his entourage seen here as they make
their way down Clay Avenue.**

March 13, 1911. 8"x10" glass plate negative
Photographer: F. A. Gildersleeve
Place: Waco, Texas
Gildersleeve-Conger Collection #0430

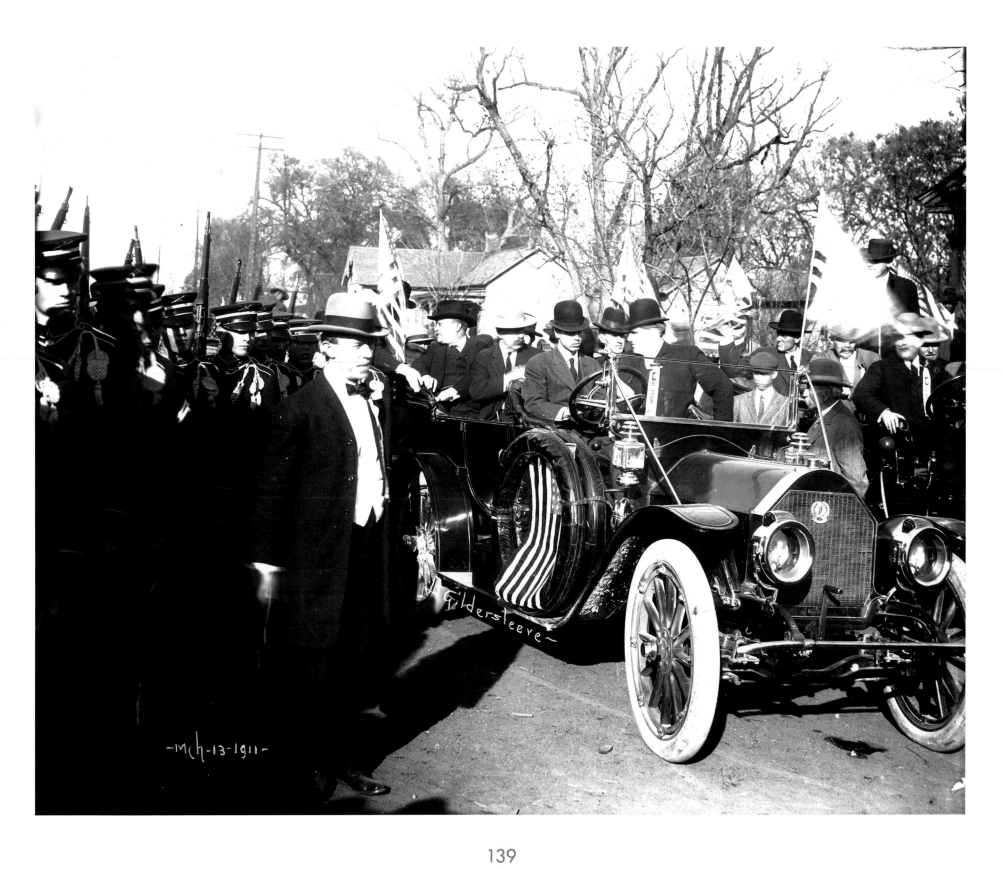

-Mch-13-1911-

Gildersleeve-

ST. BASIL'S COLLEGE BASEBALL TEAM

St. Basil's College, located in College Heights,
was established in 1899 and remained in Waco
until 1915. During their time here, the school
even formed their own baseball team.

c. 1912. 8"x10" silver gelatin print
Photographer: F. A. Gildersleeve
Place: Waco, Texas
The Texas Collection General Photo Files #3976

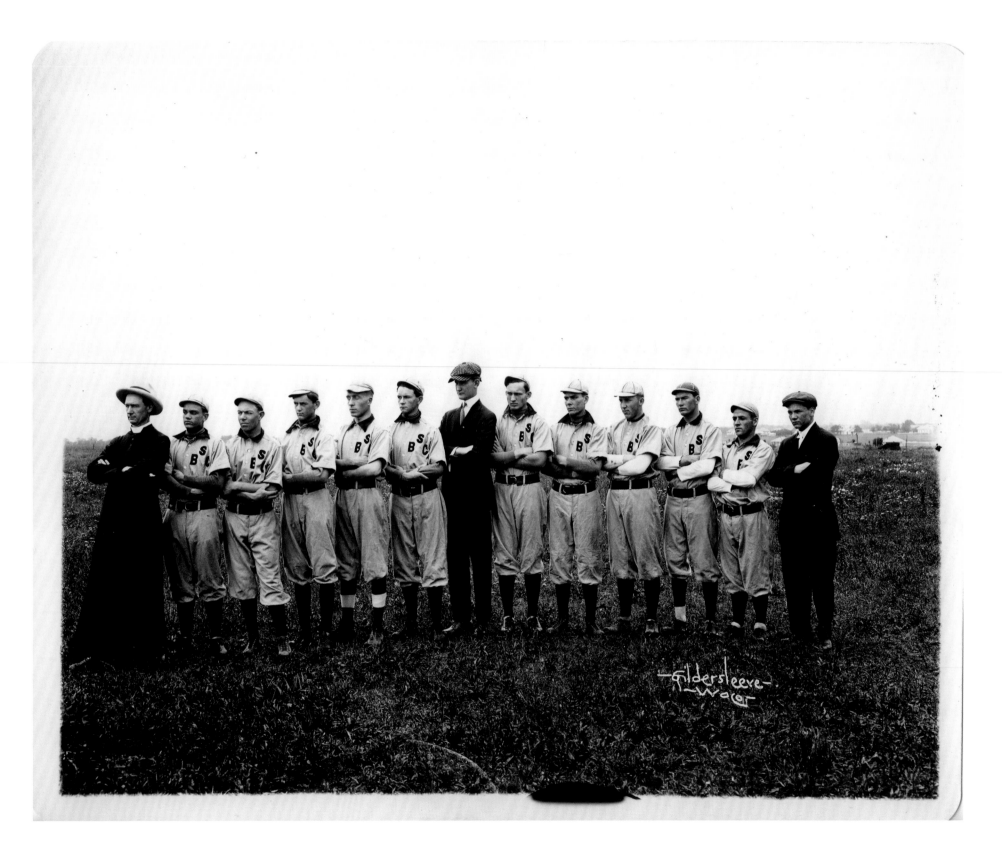

141

SUL ROSS ELEMENTARY SCHOOL

Teachers and their assistants sit around a classroom where pupils take instruction on dancing.

c. 1930. 8"x10" silver gelatin print
Photographer: F. A. Gildersleeve
Place: Waco, Texas
The Texas Collection General Photo Files #3976

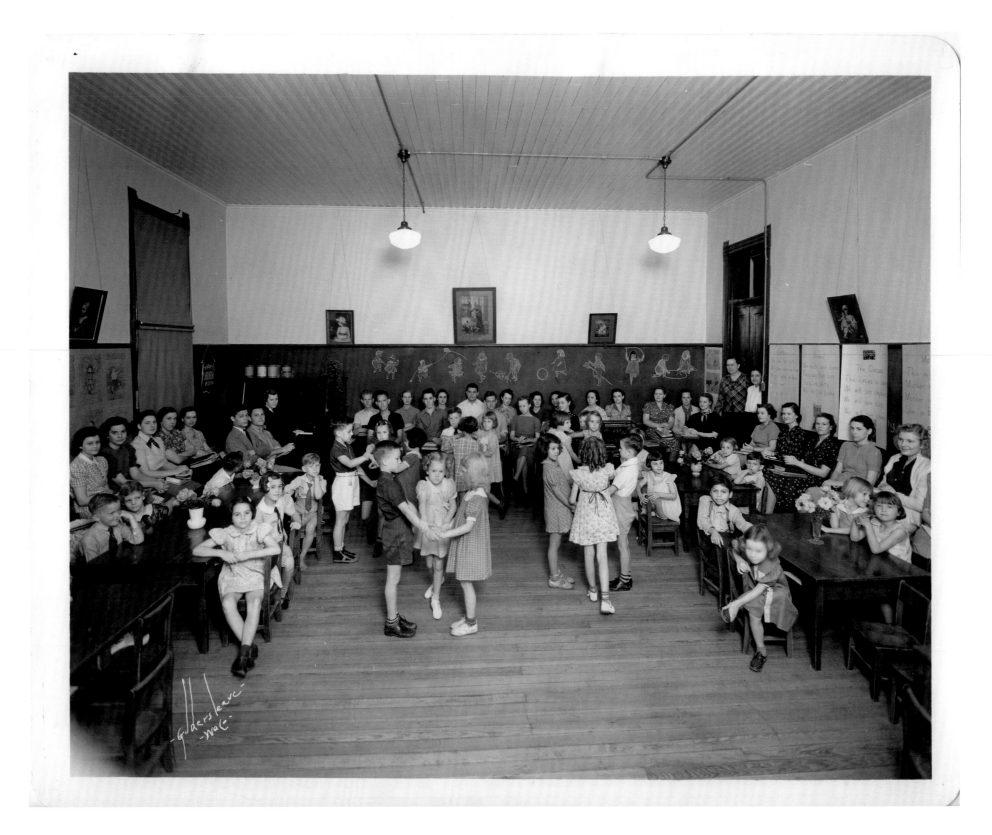

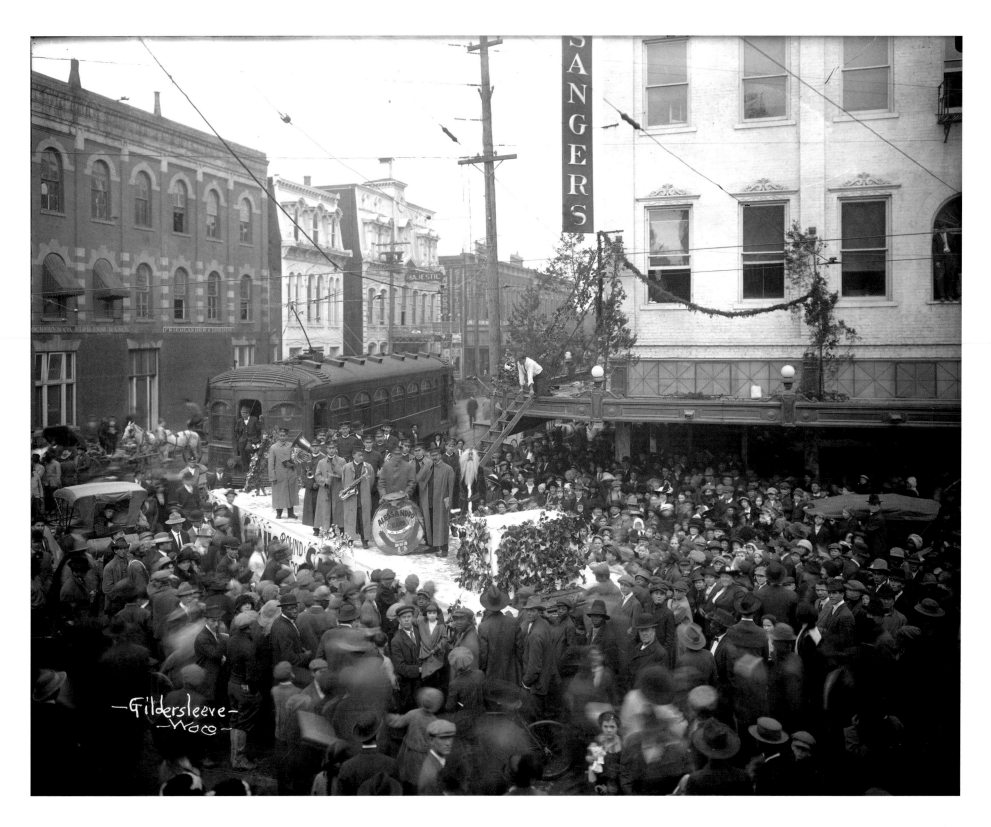

SANGER BROTHERS CHRISTMAS DISPLAY
This scene shows that hundreds of people
turned out for this Christmas event held at
Sanger Brothers Department Store.

1914. 8"x10" glass plate negative
Photographer: F. A. Gildersleeve
Place: Waco, Texas
Gildersleeve-Conger Collection #0430

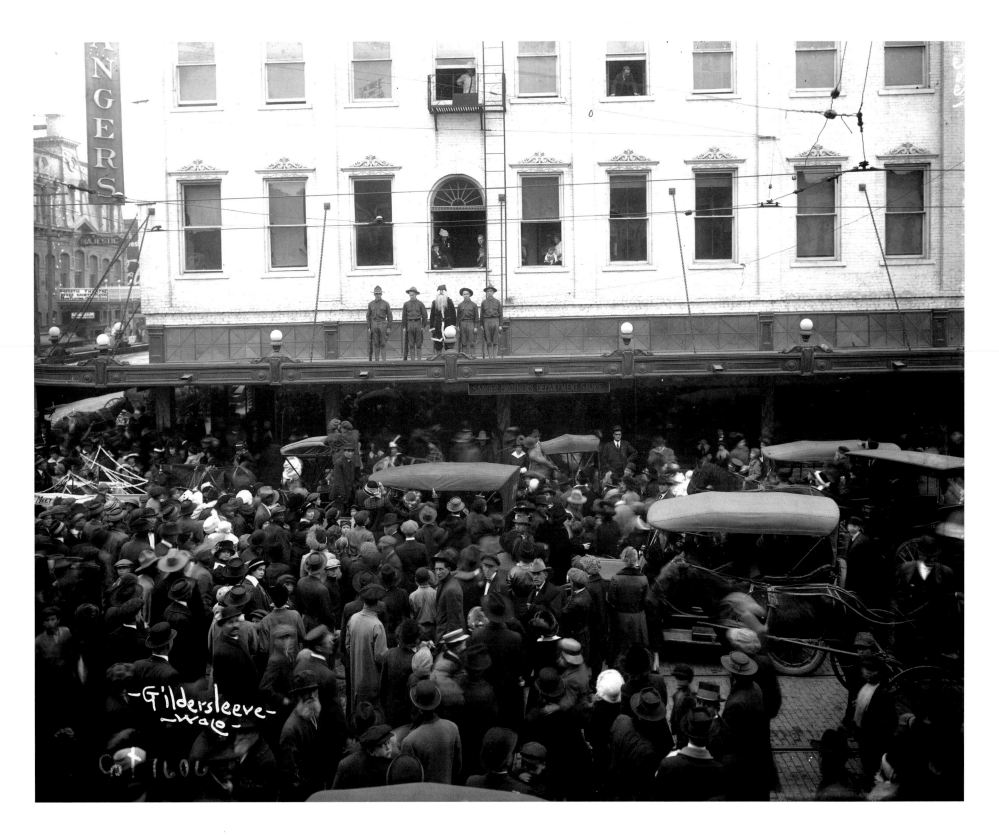

ST. PAUL'S EPISCOPAL CHURCH
Young parishioners are greeted as they enter
the church for a reception. The location was
North 5th Street and Columbus Avenue.

1913. 8"x10" glass plate negative
Photographer: F. A. Gildersleeve
Place: Waco, Texas
Gildersleeve-Conger Collection #0430

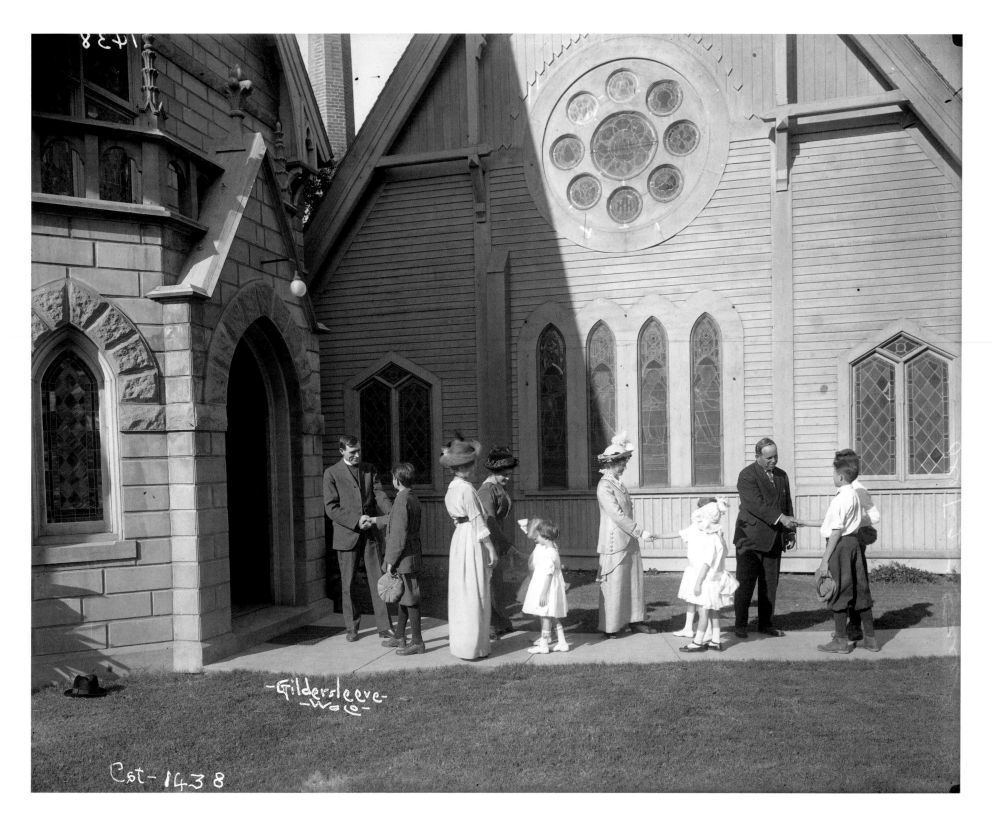

-Gildersleeve-
-Waco-

Cst-1438

CHRIS'S CAFÉ

This business advertised that they were
"The most popular place in Waco." Being at
420 Austin Avenue and across from the
Alico Building certainly helped. A large display
of "Stock Show Meats" is exhibited.

1913. 8"x10" glass plate negative
Photographer: F. A. Gildersleeve
Place: Waco, Texas
Gildersleeve-Conger Collection #0430

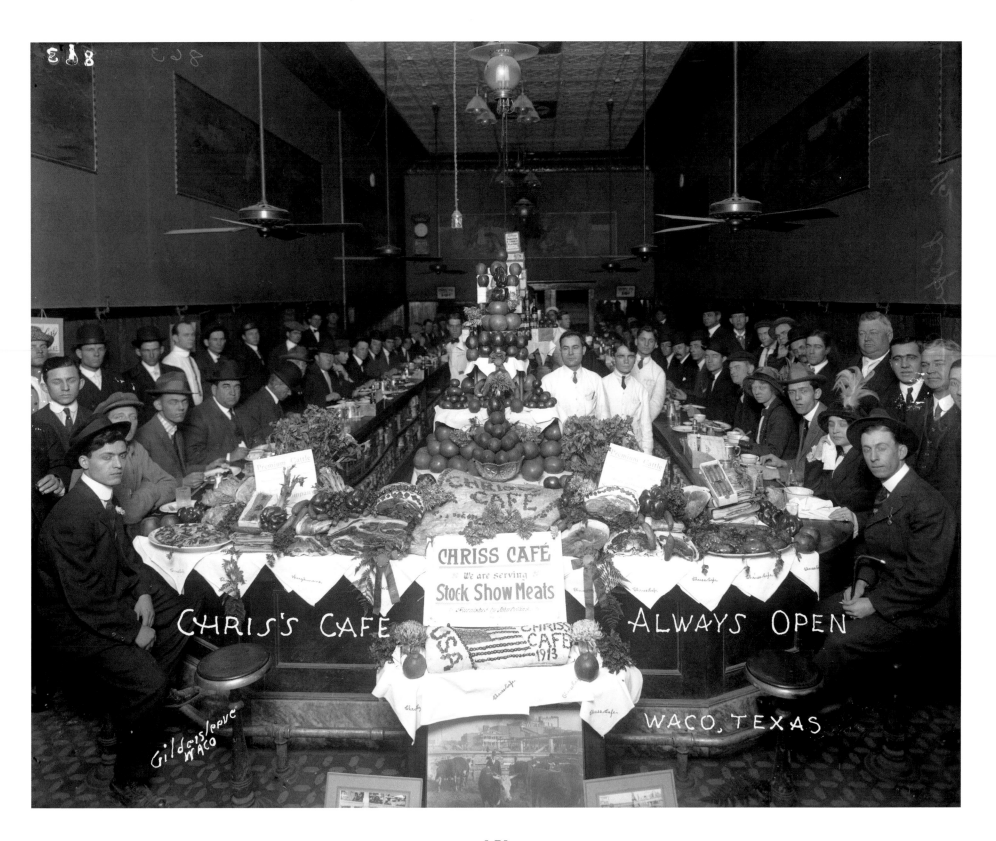

AUSTIN AVENUE CIRCUS PARADE

**The Barnum and Bailey Circus comes to Waco
and proceeds up Austin Avenue with countless
spectators. The circus coming to town was a
major event.**

1908. 8"x10" glass plate negative
Photographer: F. A. Gildersleeve
Place: Waco, Texas
Gildersleeve-Conger Collection #0430

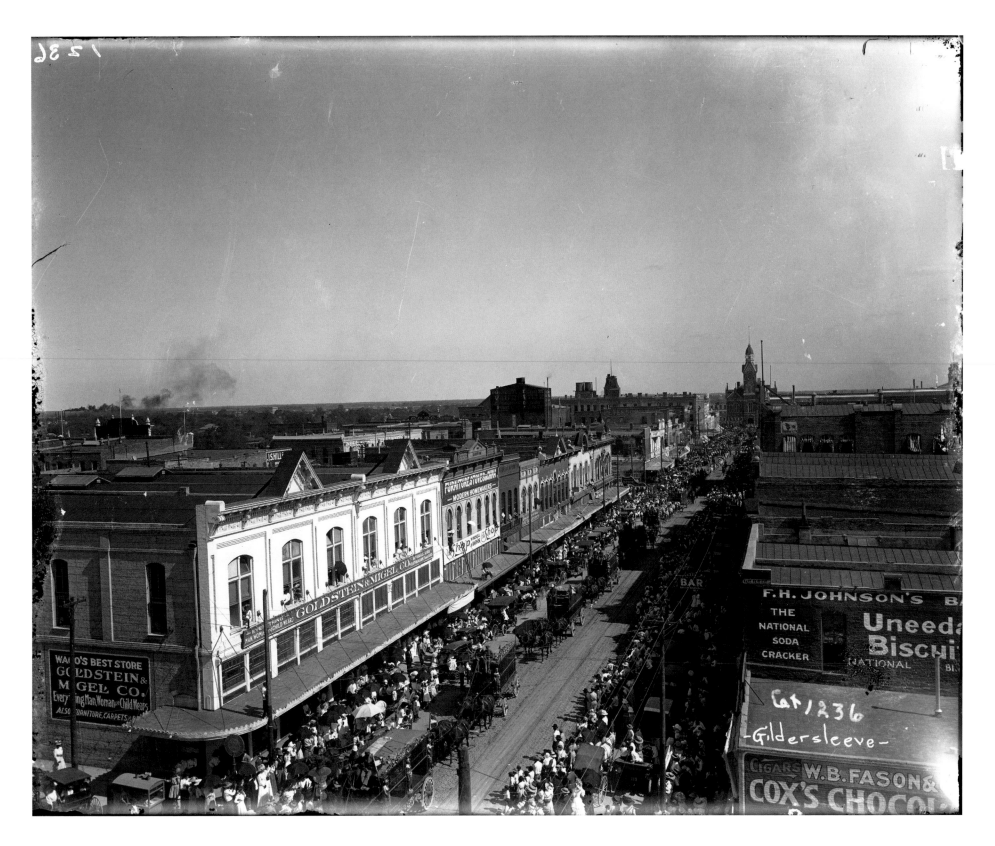

153

LABOR DAY PARADE

Many people, carriages, and automobiles turn up and line Austin Avenue for this Labor Day parade.

c. 1915. 8"x10" glass plate negative
Photographer: F. A. Gildersleeve
Place: Waco, Texas
Gildersleeve-Conger Collection #0430

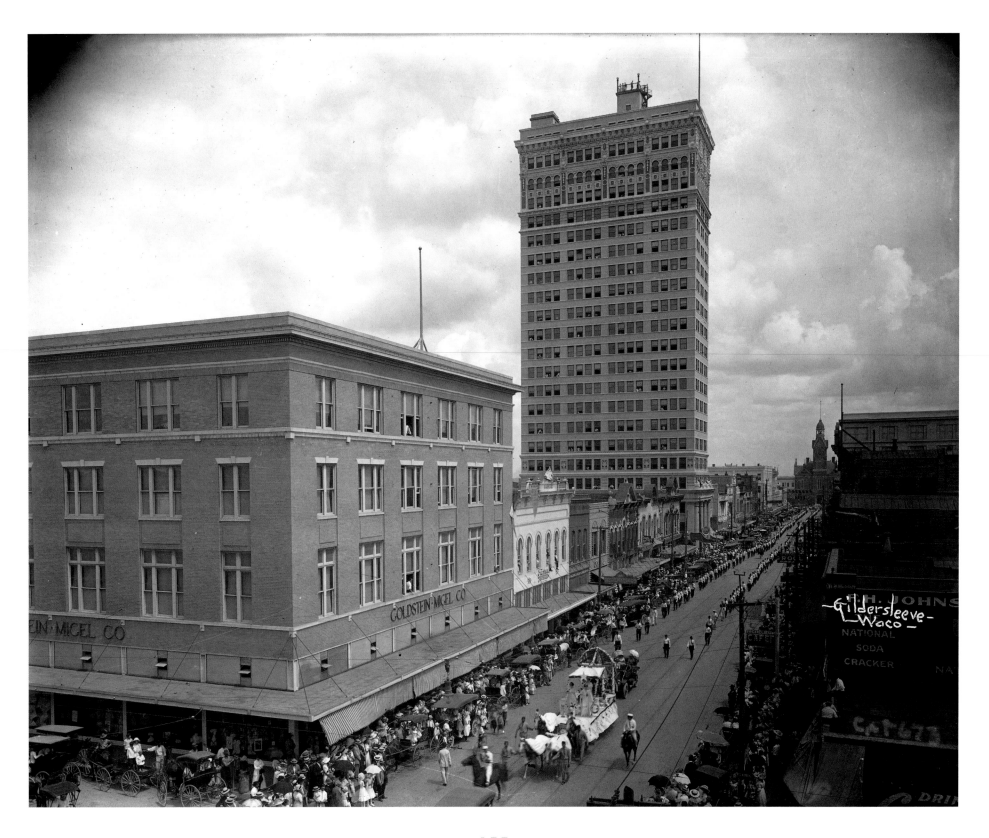

TOBY'S BUSINESS COLLEGE

These business students are hard at work
learning the latest practices to enter the world
of commerce successfully.

c. 1914. 8"x10" glass plate negative
Photographer: F. A. Gildersleeve
Place: Waco, Texas
Gildersleeve-Conger Collection #0430

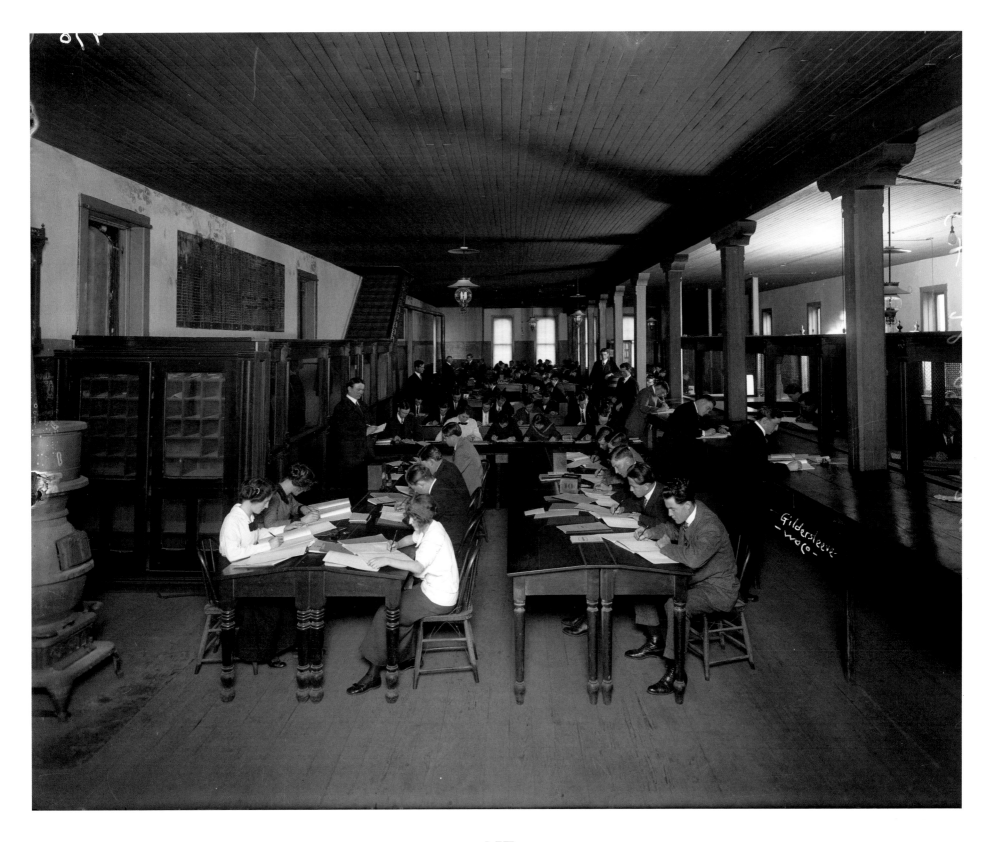

WACO FIRE ENGINE AT TEXAS COTTON PALACE

**Waco Fire Department's Engine Company
Number 1 parks outside one of the Texas Cotton
Palace's exhibit buildings.**

c. 1914. 8"x10" glass plate negative
Photographer: F. A. Gildersleeve
Place: Waco, Texas
Gildersleeve-Conger Collection #0430

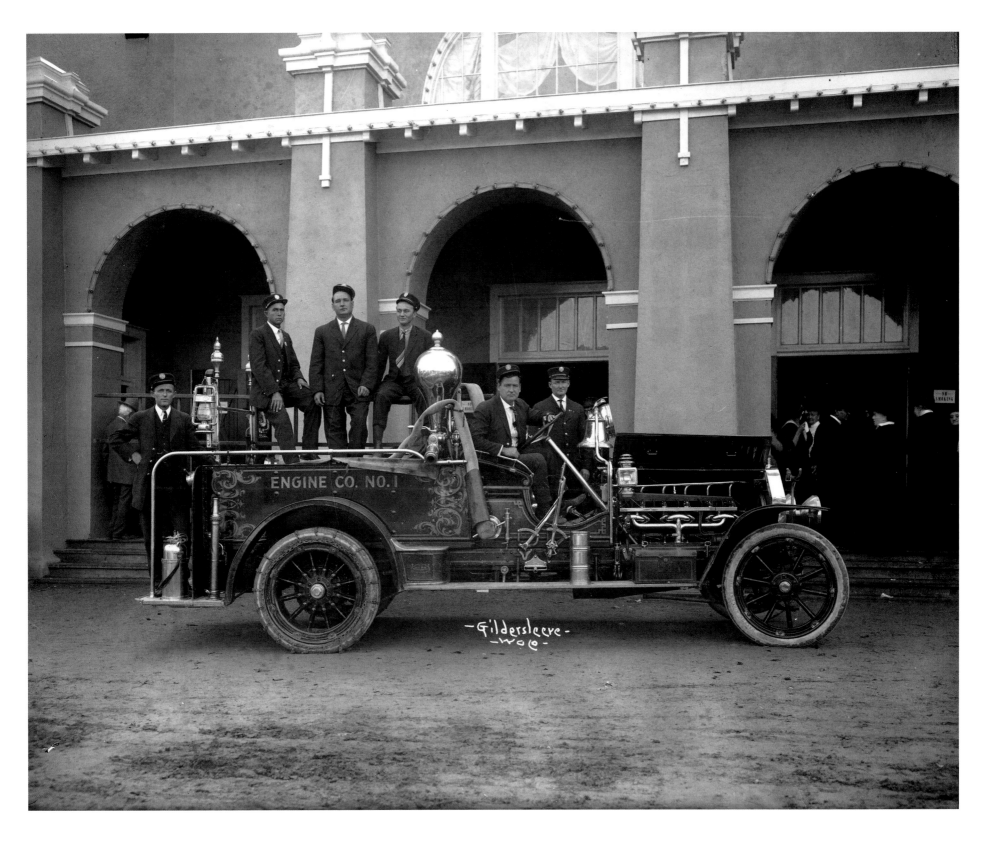

WACO AD CLUB

**The Waco Ad Club on their way to Toronto, Canada
to promote the City of Waco. The pennants read:
"The City with a Soul."**

c. 1914. 8"x10" glass plate negative
Photographer: F. A. Gildersleeve
Place: Waco, Texas
Gildersleeve-Conger Collection #0430

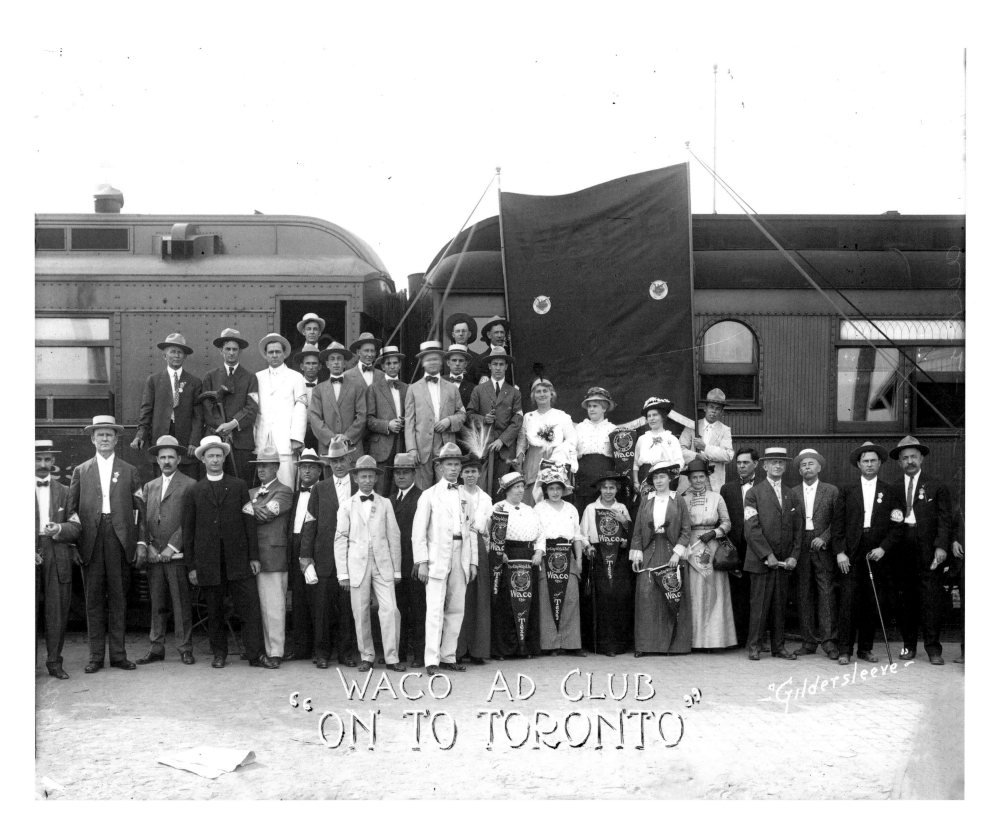

WACO AD CLUB
"ON TO TORONTO"

Gildersleeve

EDGEFIELD PARK

Children are shown having a good time at this
park but take a moment to pause for a picture.

c. 1914. 8"x10" glass plate negative
Photographer: F. A. Gildersleeve
Place: Waco, Texas
Gildersleeve-Conger Collection #0430

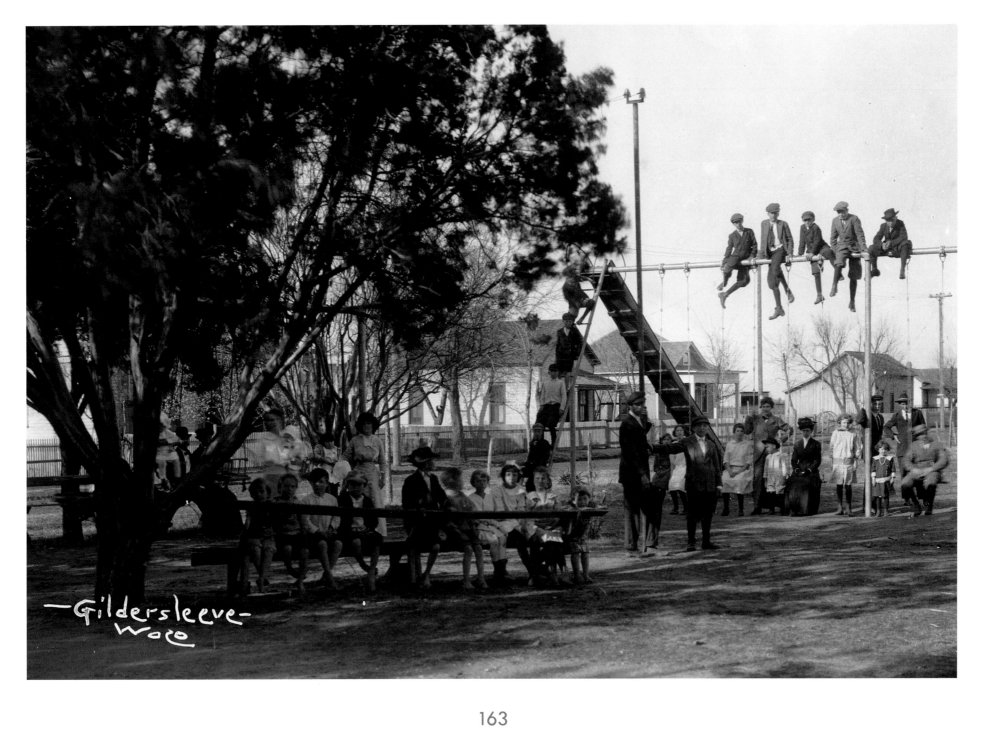

Gildersleeve
Waco

163

WORKING BOYS' CLUB ON THE
MCLENNAN COUNTY COURTHOUSE STEPS

This boys' club neatly poses with their Bibles
on the courthouse steps. Note the lack of shoes as
seen by those in the front row. Members of the club
received instruction through on-the-job training.

1914. 8"x10" glass plate negative
Photographer: F. A. Gildersleeve
Place: Waco, Texas
Gildersleeve-Conger Collection #0430

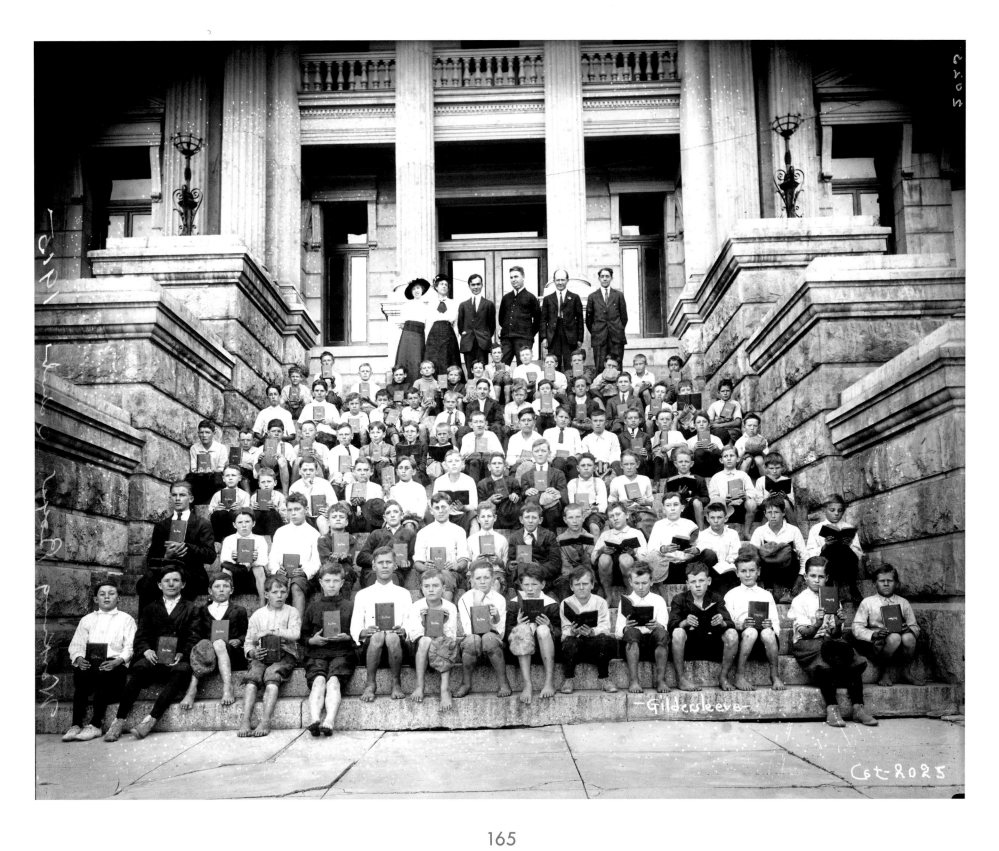

-Gildersleeve-

Cst-2025

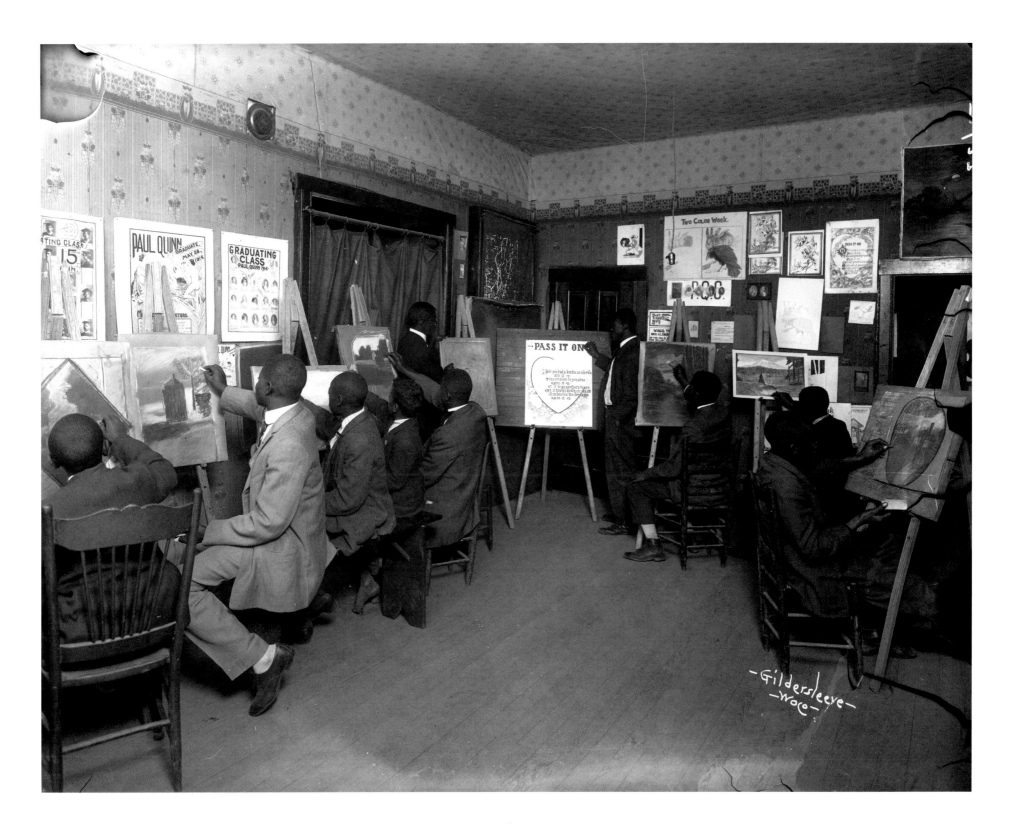

PAUL QUINN COLLEGE PRINTING CLASS

Part of Paul Quinn College's Industrial Department, the
Printing Department advertised that the school
"embraces all kinds of commercial and book work."
These students are demonstrating some hands-on
training at this trade.

c. 1914. 8"x10" glass plate negative
Photographer: F. A. Gildersleeve
Place: Waco, Texas
Gildersleeve-DuCongé Collection #1149

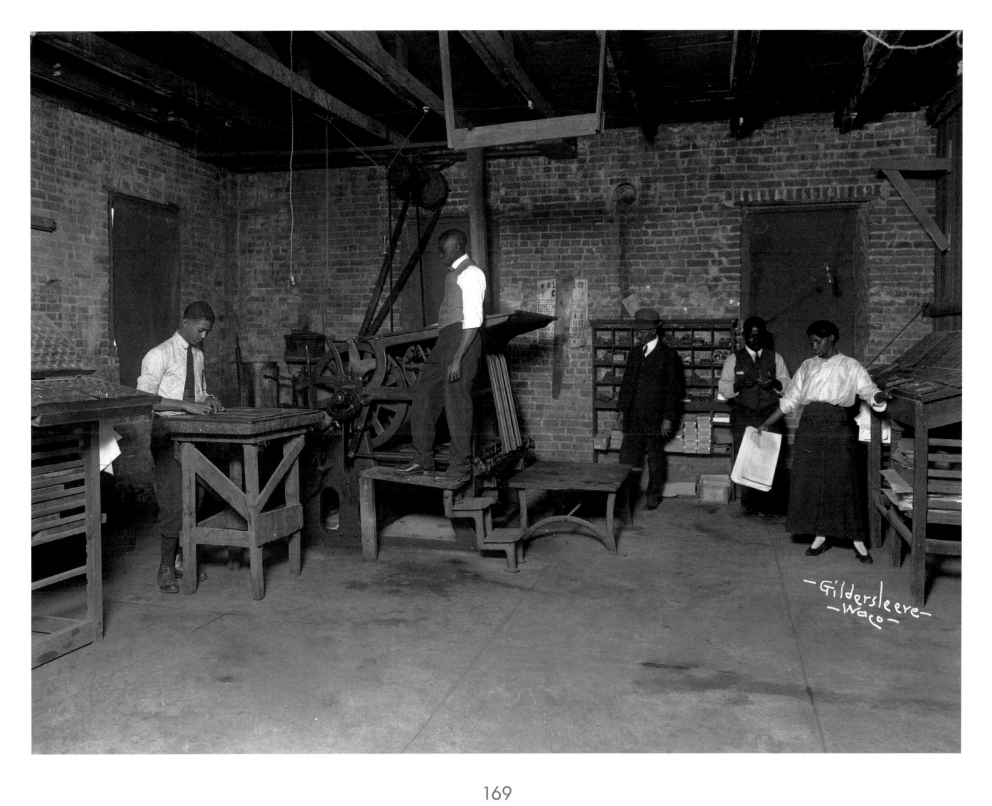

PAUL QUINN COLLEGE FACULTY GROUP

A group picture of the faculty at Paul Quinn College located at 1020 Elm Avenue. The Rapoport Academy now occupies some of the buildings and land of the former campus of Paul Quinn College, which is now located in Dallas, Texas.

c. 1914. 8"x10" glass plate negative
Photographer: F. A. Gildersleeve
Place: Waco, Texas
Gildersleeve-DuCongé Collection #1149

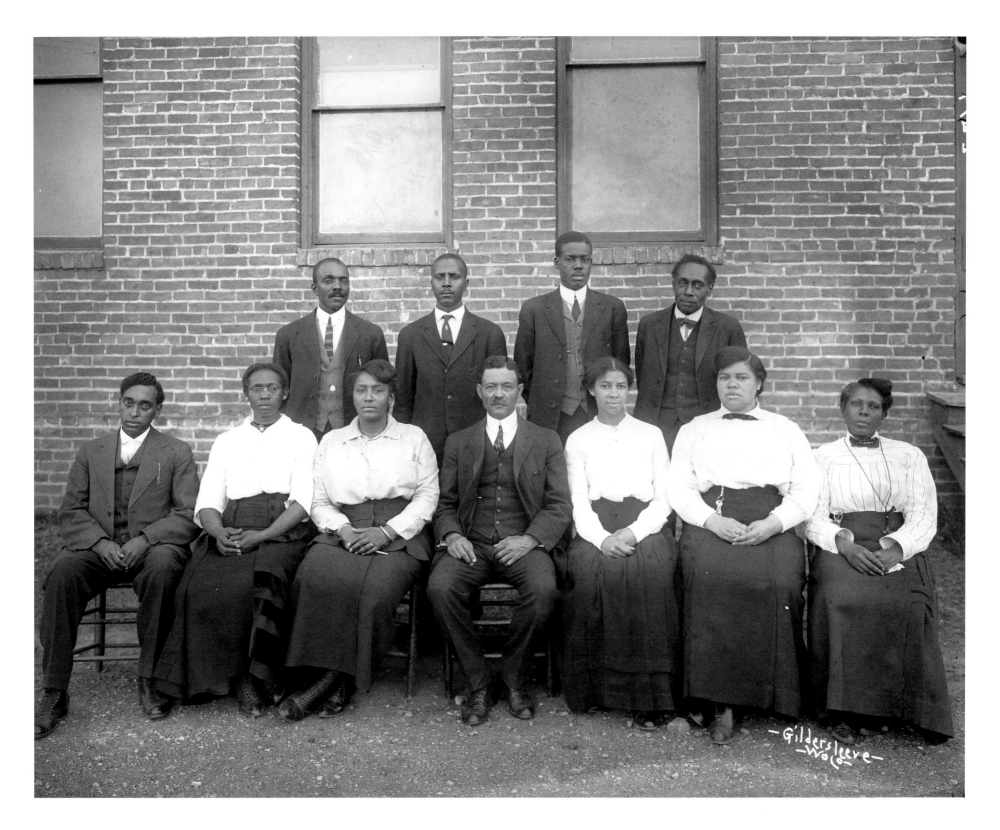

TEXAS COTTON PALACE PARADE

**The Cotton Palace parade makes its way around
the old city square with plenty of fanfare.**

1915. 8"x10" glass plate negative
Photographer: F. A. Gildersleeve
Place: Waco, Texas
Gildersleeve-Conger Collection #0430

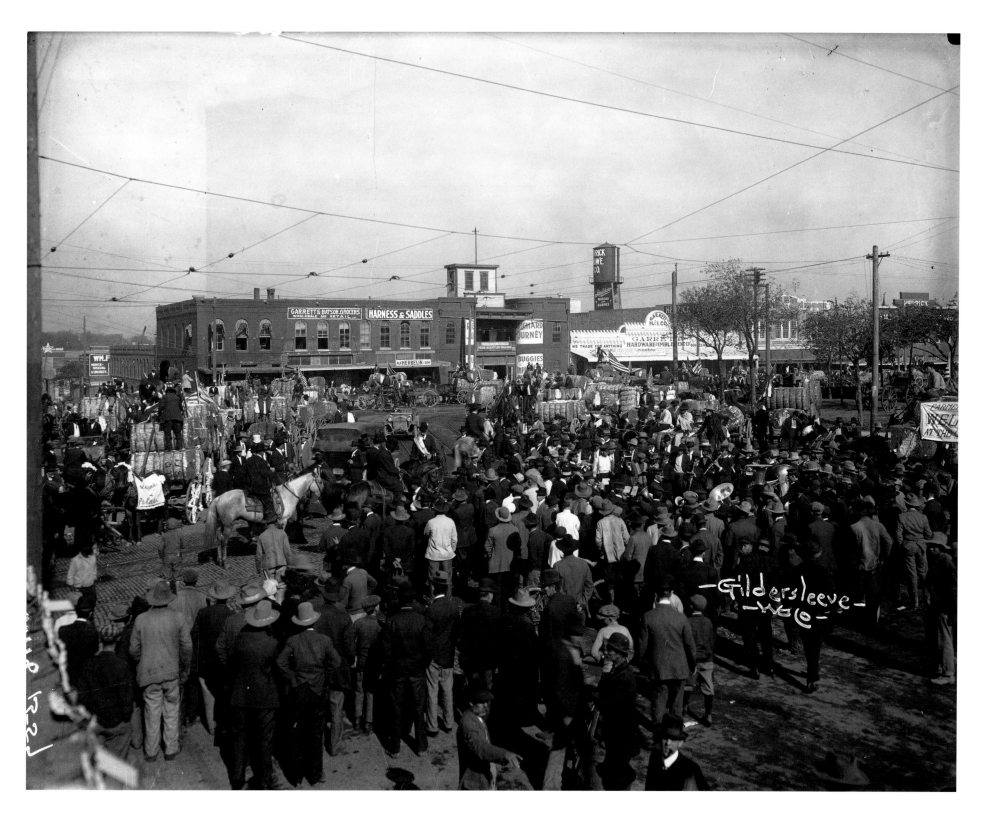

TEXAS COTTON PALACE PARADE

Some of the parade's well-known participants such as Texas Governor Jim Ferguson (seated next to man in white on wagon) are seen in the image.

1915. 8"x10" glass plate negative
Photographer: F. A. Gildersleeve
Place: Waco, Texas
Gildersleeve-Conger Collection #0430

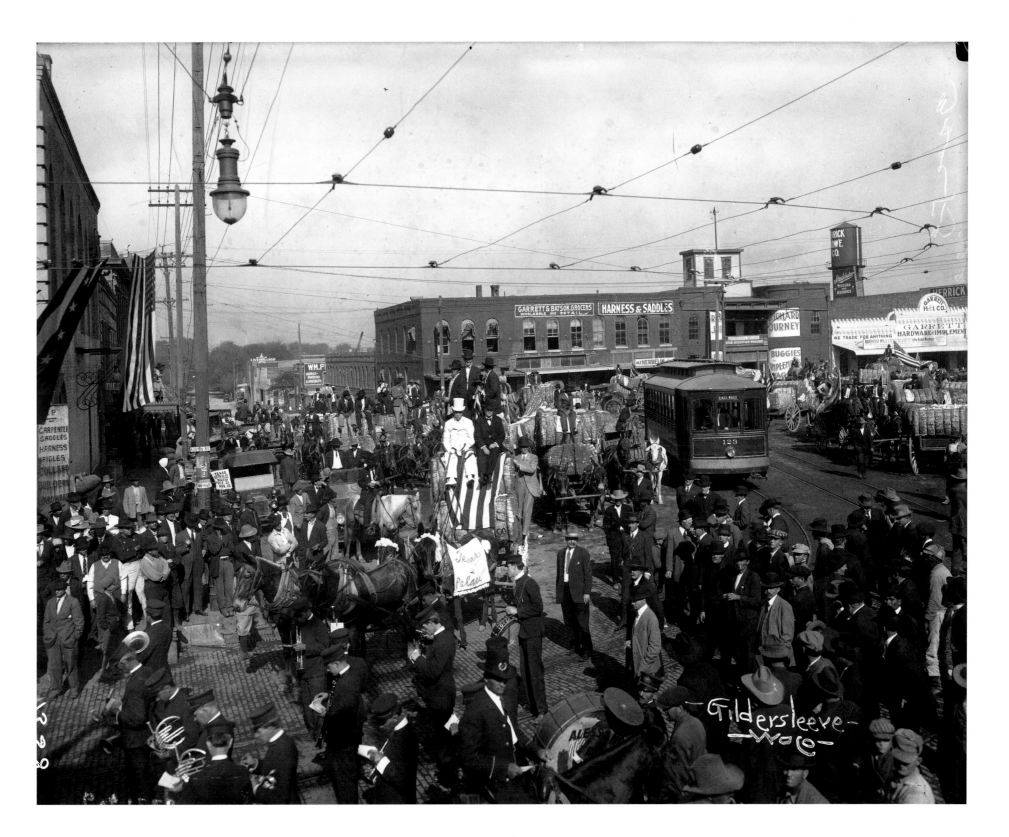

A boy demonstrates a Burroughs Adding Machine
with a little help from a makeshift step stool.

c. 1915. 8"x10" glass plate negative
Photographer: F. A. Gildersleeve
Place: Waco, Texas
Gildersleeve-Conger Collection #0430

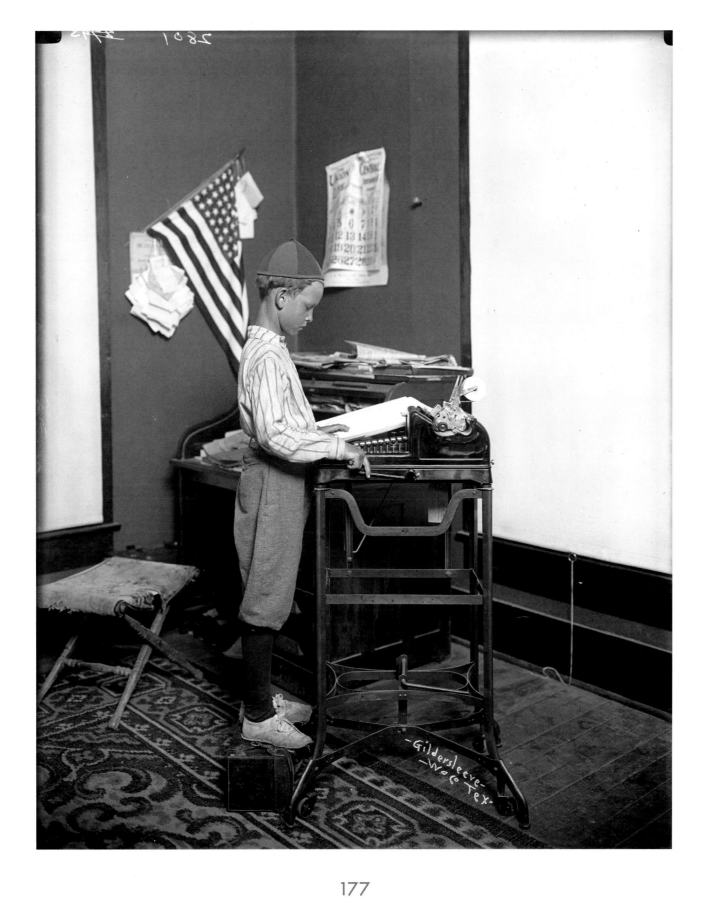

WACO POLICEMEN DRESSED IN WHITE
FOR THE ELKS PARADE

A group of the city's policemen are wearing their
white uniforms to lead the Elks parade.

May 1915. 8"x10" glass plate negative
Photographer: F. A. Gildersleeve
Place: Waco, Texas
Gildersleeve-Conger Collection #0430

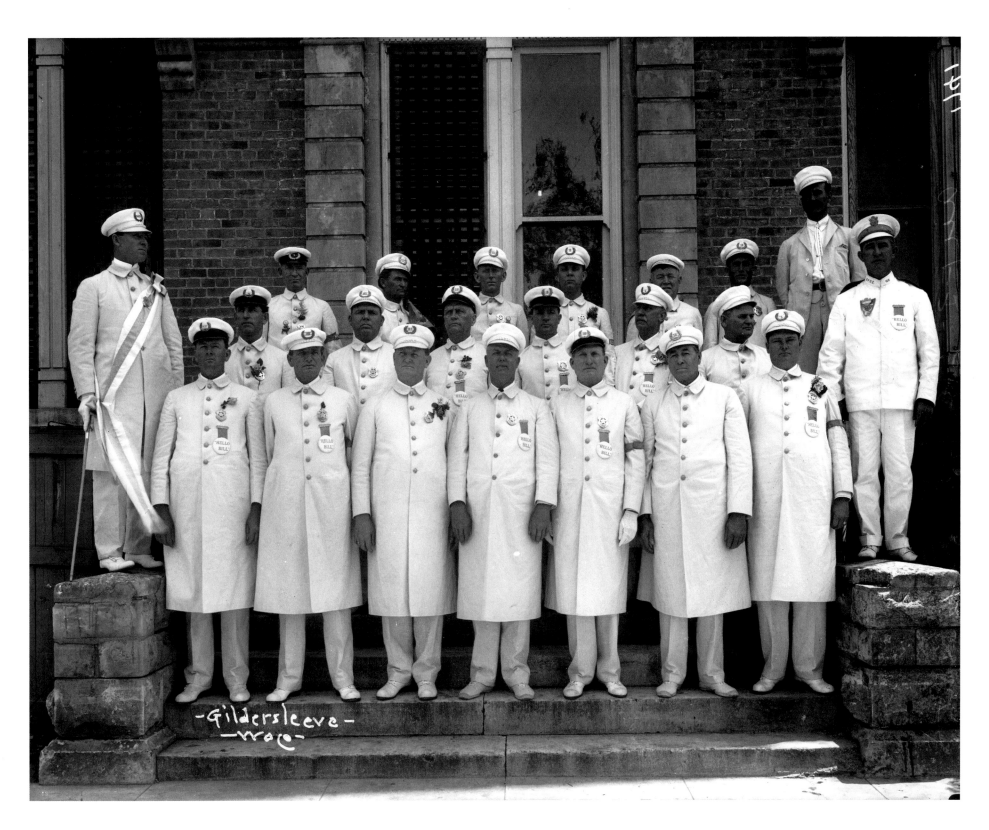

WACO POSTAL EMPLOYEES

Postal employees pose for a group photograph
on the steps of the old U.S. Post Office on
the corner of 4th Street and Franklin Avenue.

c. 1915. 8"x10" silver gelatin print
Photographer: F. A. Gildersleeve
Place: Waco, Texas
The Texas Collection General Photo Files #3976

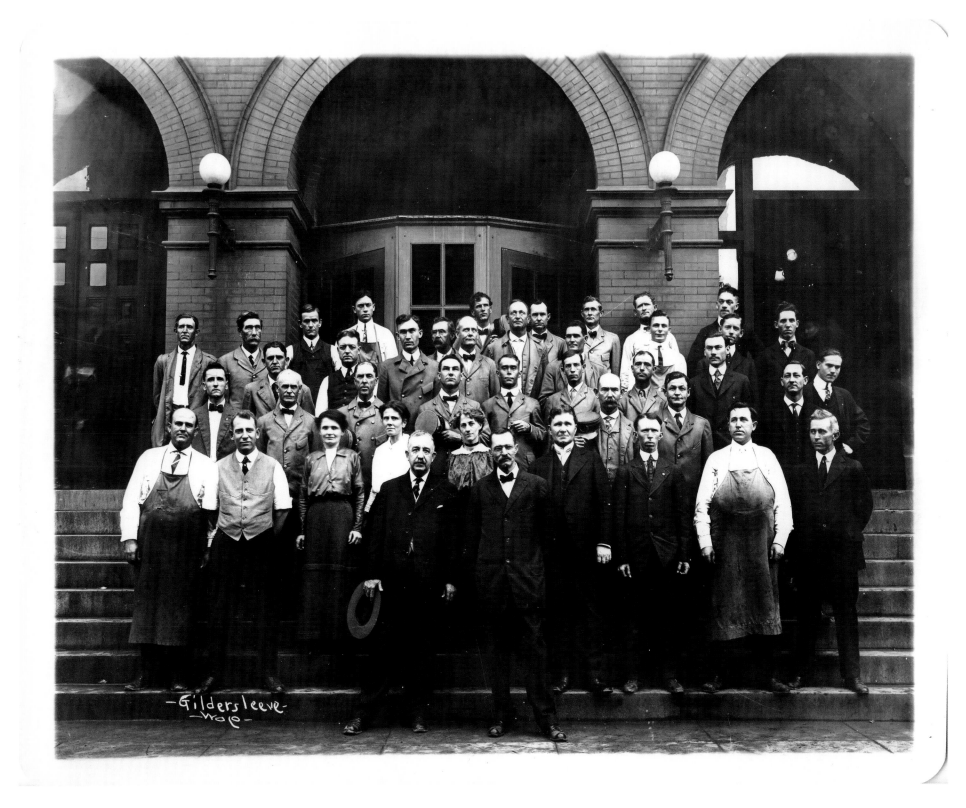

GOLDSTEIN-MIGEL STYLE SHOW

**Goldstein-Migel Company at 521–527 Austin Avenue
held style shows that drew hundreds of people.
Gildersleeve's expert use of the flash helps
record the event in amazing detail.**

1916. 8"x10" glass plate negative
Photographer: F. A. Gildersleeve
Place: Waco, Texas
Gildersleeve-Conger Collection #0430

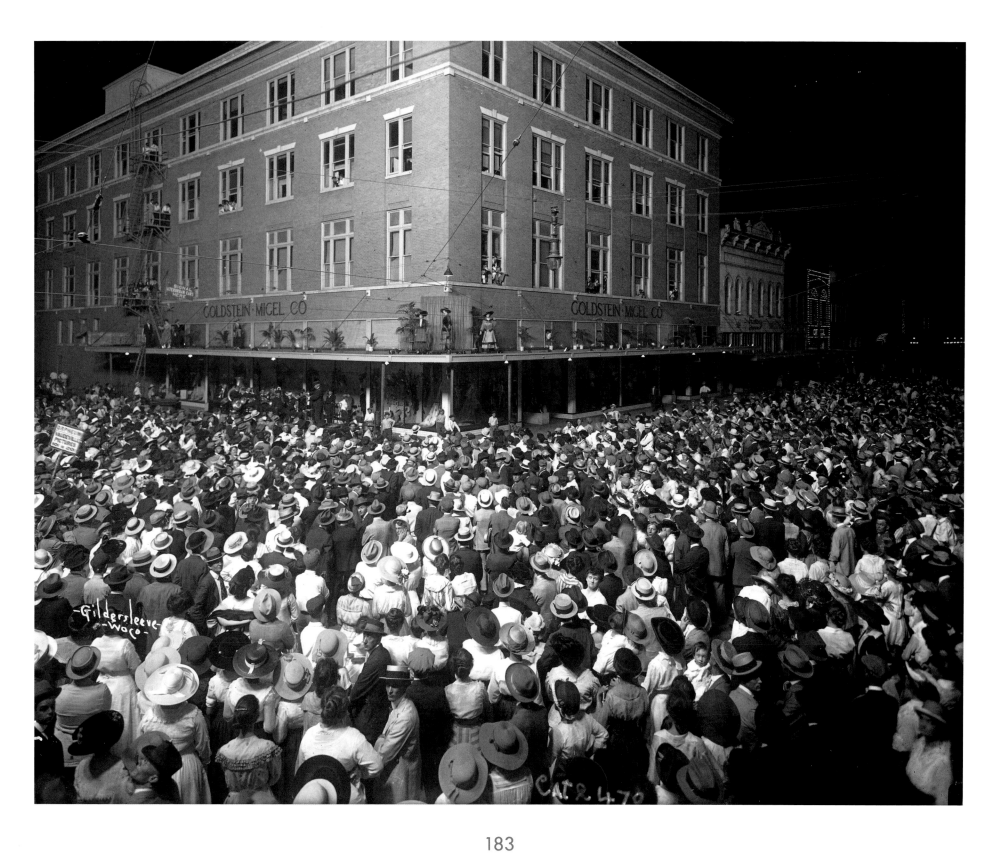

TYPING AT TOBY'S PRACTICAL BUSINESS COLLEGE

Toby's Practical Business College taught students
the skills needed to find employment in institutions
of finance and commerce. The school was
located at 215–217 South 4th Street.

1916. 8"x10" glass plate negative
Photographer: F. A. Gildersleeve
Place: Waco, Texas
Gildersleeve-Conger Collection #0430

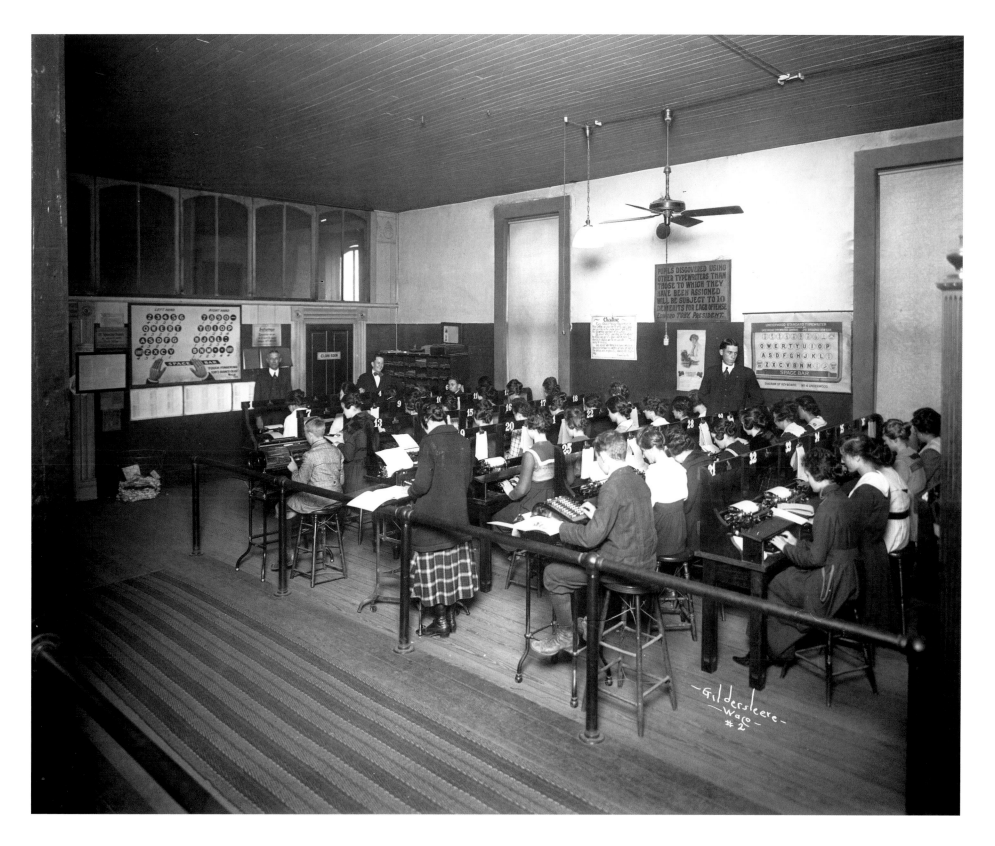

185

AFTER THE FLOOD

Workmen for the city prepare to clean up debris
from flooded areas around the Brazos River.
This image was taken in the Waco city square.

1916. 8"x10" glass plate negative
Photographer: F. A. Gildersleeve
Place: Waco, Texas
Gildersleeve-Conger Collection #0430

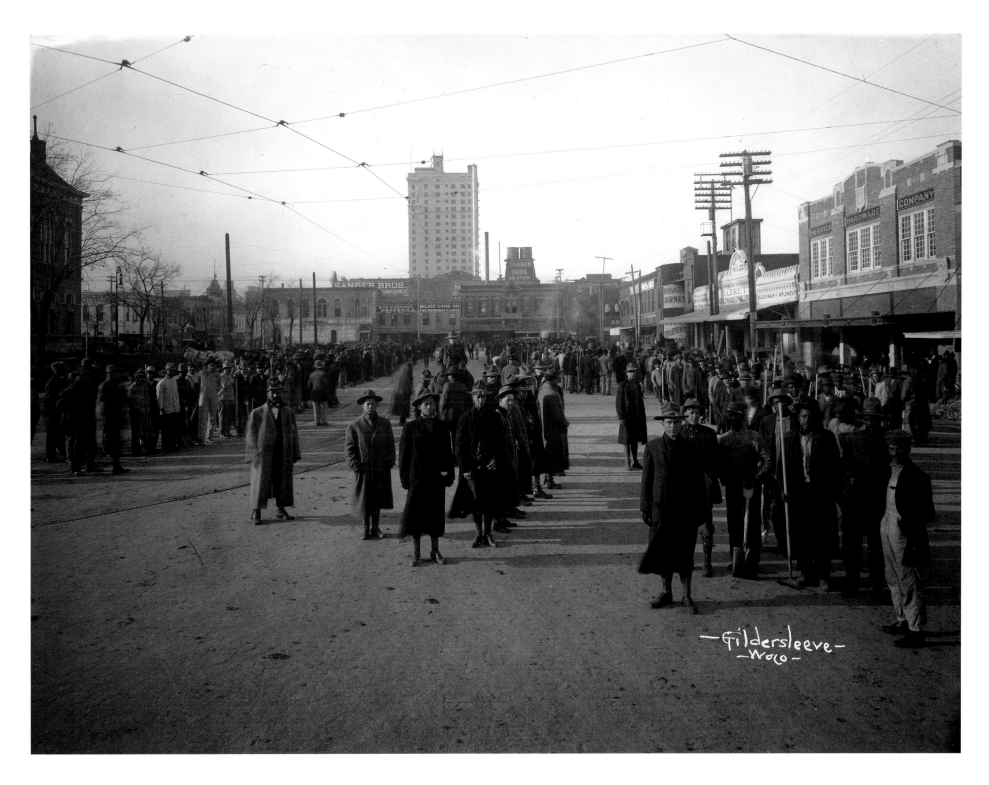

SANGER AVENUE ELEMENTARY SCHOOL

Students at this school celebrate May Day and are
seen posing with their May Queen. Plenty of flowers
and pretty dresses help adorn the scene.
The school was located at the corner of
Sanger Avenue and 18th Street.

c. 1916. 8"x10" glass plate negative
Photographer: F. A. Gildersleeve
Place: Waco, Texas
Gildersleeve-Conger Collection #0430

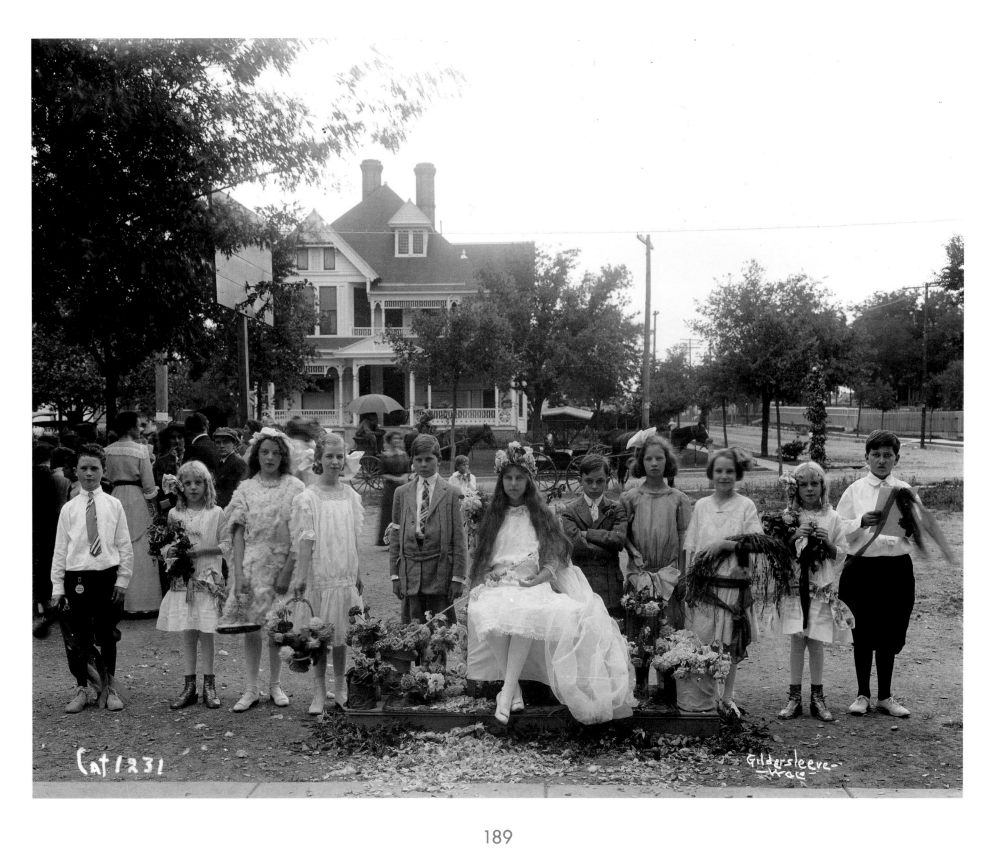

Cat 1231

Gildersleeve
—Waco—

SANGER AVENUE ELEMENTARY SCHOOL CLASSROOM

Students and teachers take a moment to pose
for a class picture.

1916. 8"x10" glass plate negative
Photographer: F. A. Gildersleeve
Place: Waco, Texas
Gildersleeve-Conger Collection #0430

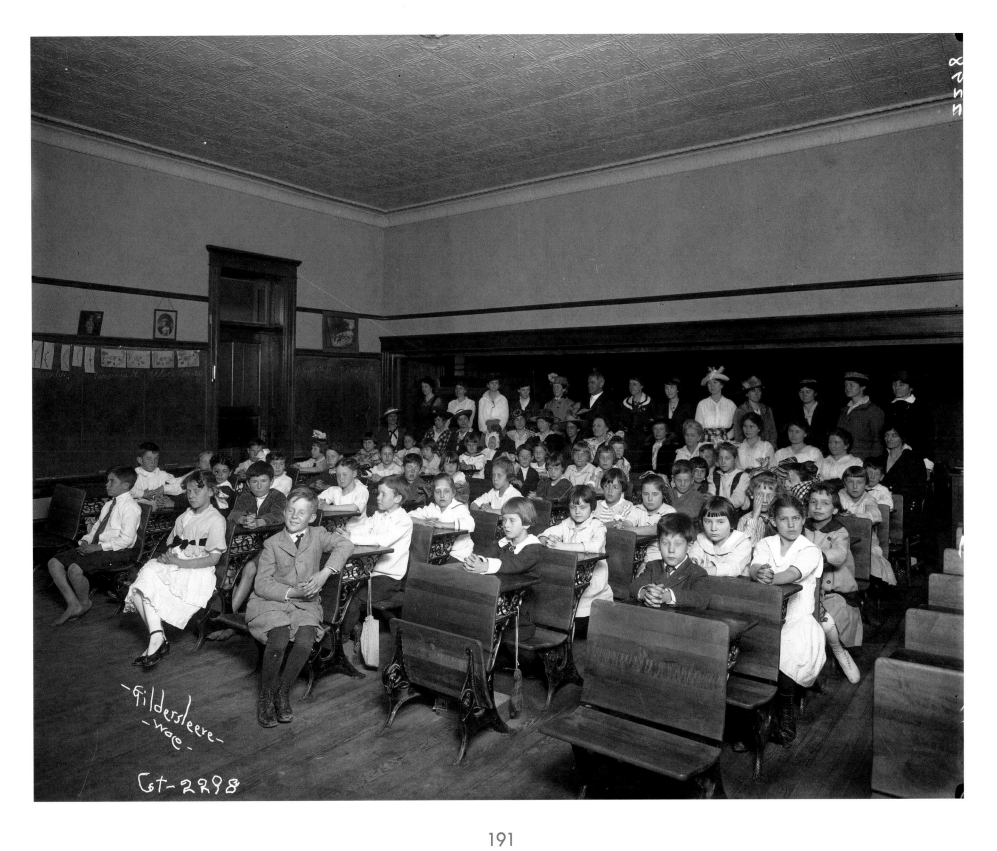

-Gildersleeve-
-Wac-

Gt-2298

SUL ROSS SCHOOL

Students from Sul Ross School take a break from playing to look briefly at the camera. The school was located at 920 South 8th Street.

c. 1916. 8"x10" glass plate negative
Photographer: F. A. Gildersleeve
Place: Waco, Texas
Gildersleeve-Conger Collection #0430

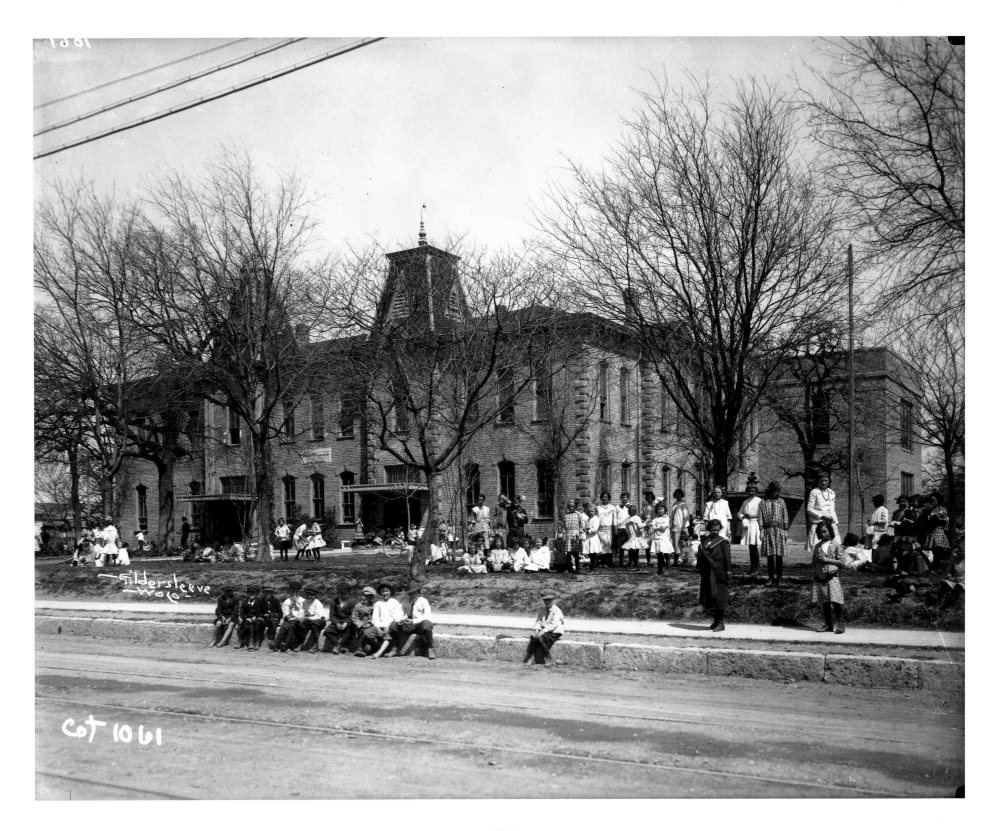

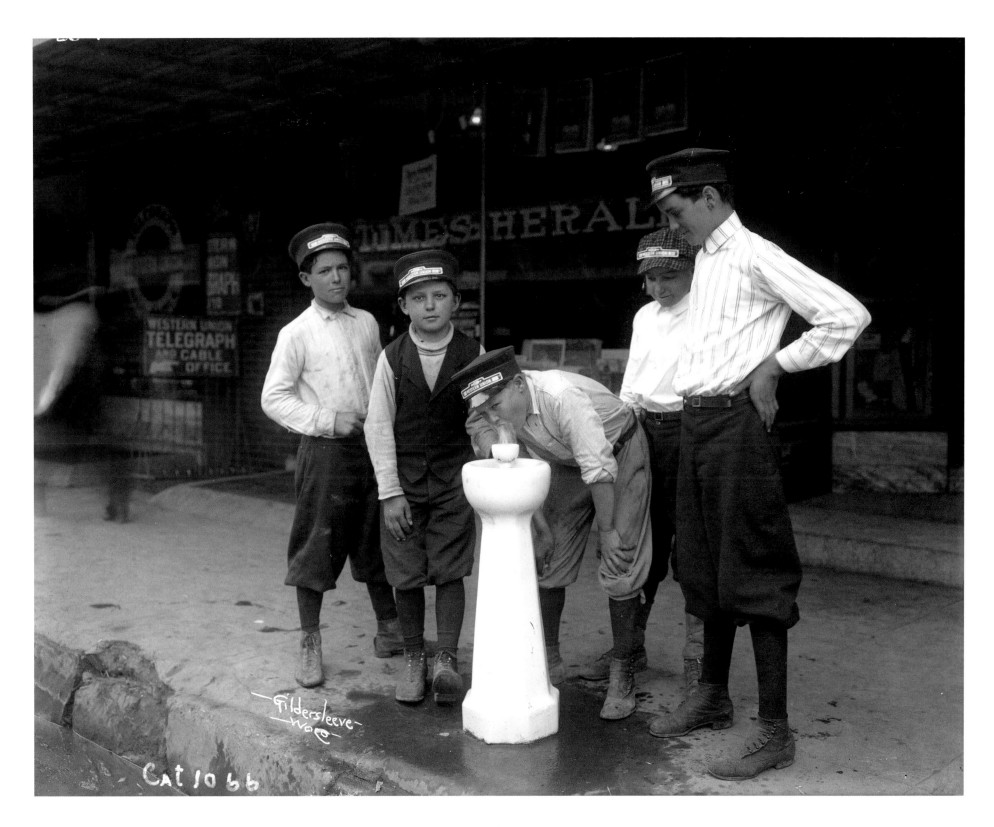

THE WACO NAVIGATORS BASEBALL TEAM

The Waco Navigators became part of the Texas League in 1889 and played on and off until 1919. They are shown here at Katy Ball Park located on 8th and Jackson Streets.

1916. 8"x10" glass plate negative
Photographer: F. A. Gildersleeve
Place: Waco, Texas
Gildersleeve-Conger Collection #0430

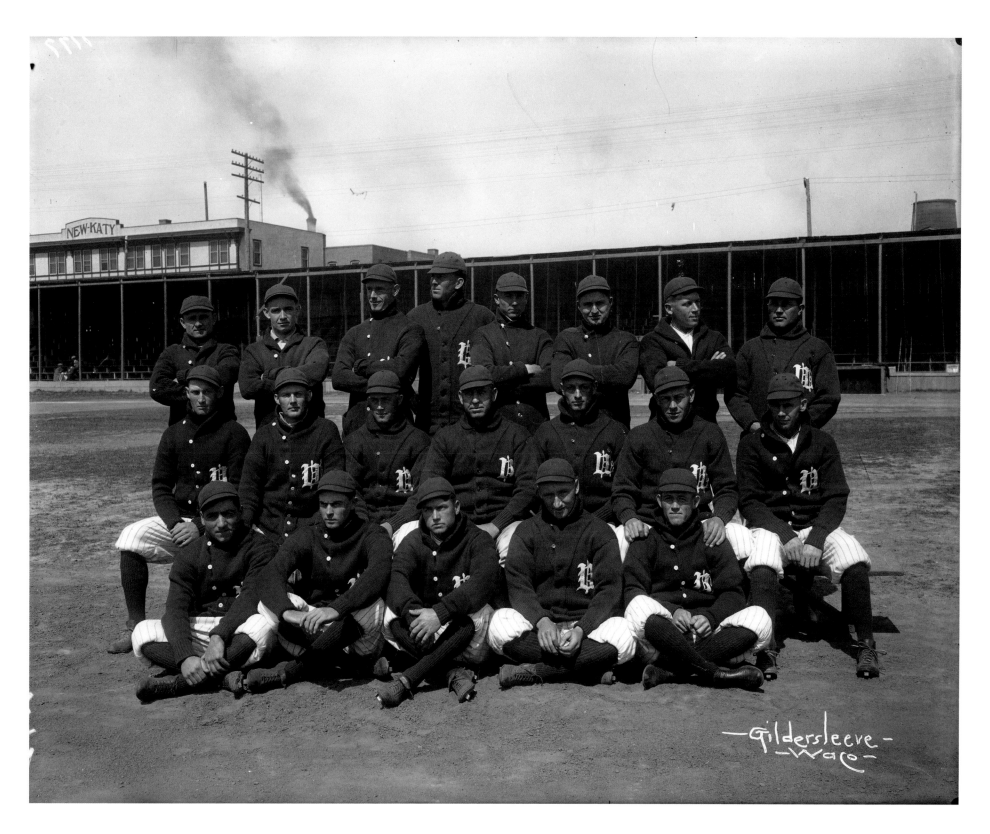

197

CAMP MACARTHUR SCENE

Camp MacArthur, on Waco's outskirts at the time, began
construction in July 1917. Soldiers from Michigan and Wisconsin
arrived that September. A total of 10,699 acres were allocated
for its use, but the camp grounds covered only 1,377 acres.
It held no more than 28,000 troops during any month
of its existence. The camp closed on March 7, 1919.

1917. 8"x10" glass plate negative
Photographer: F. A. Gildersleeve
Place: Waco, Texas
Gildersleeve-Conger Collection #0430

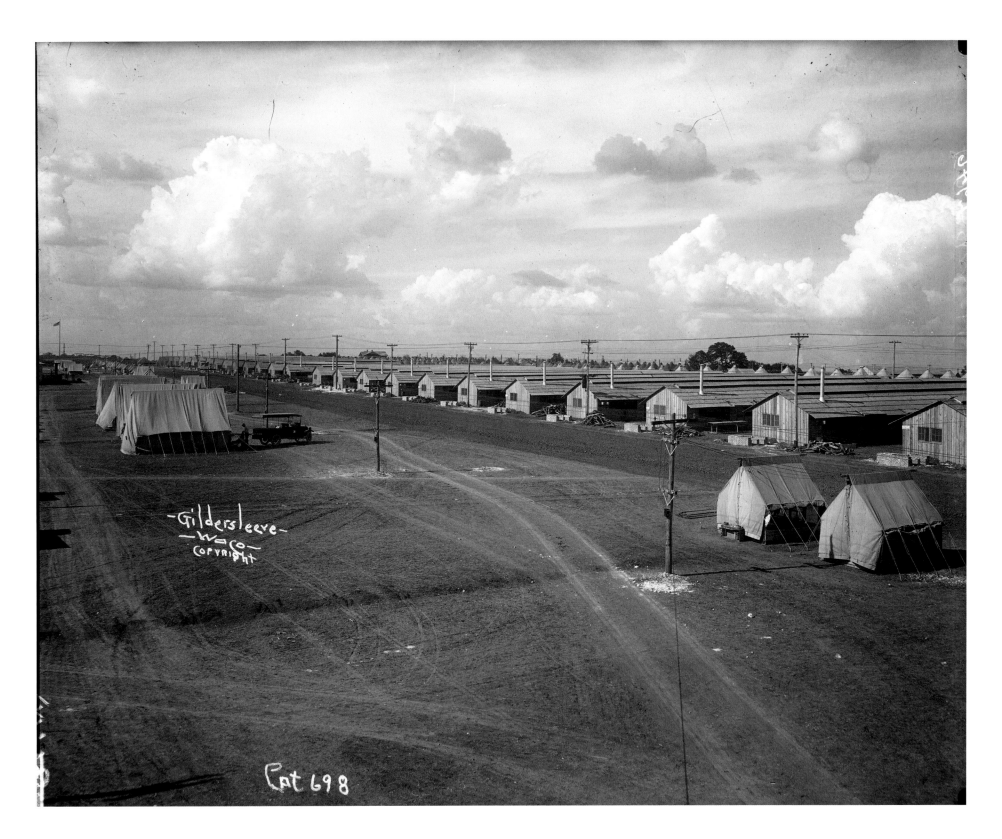

-Gildersleeve-
-Waco-
Copyright

Cat 698

CAMP MACARTHUR TROOPS AND TENTS
At Camp MacArthur, tents as far as the lens could
capture are seen in this "Section A" portion of the camp.

1917. 8"x10"glass plate negative
Photographer: F. A. Gildersleeve
Place: Waco, Texas
Gildersleeve-Conger Collection #0430

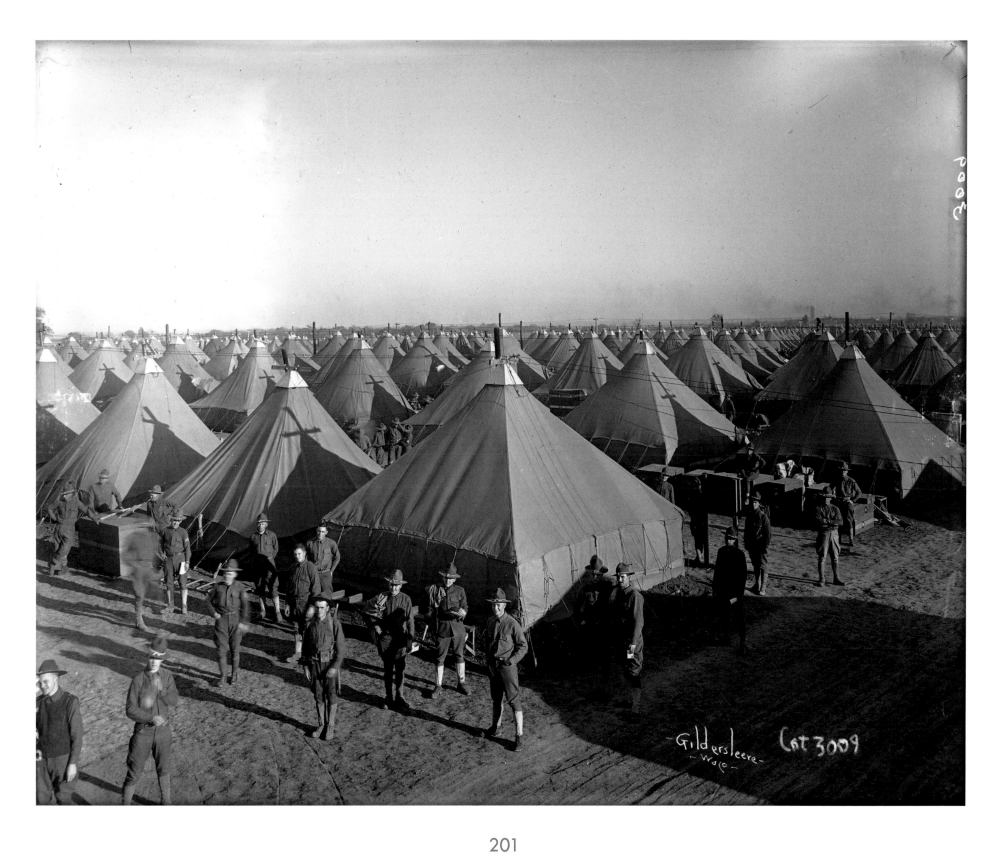

Gildersleeve
-Waco-

Cat 3009

SOLDIERS AT CAMP MACARTHUR

**Troops at Camp MacArthur line up at the
water fountain inside the base Y.M.C.A.**

October 1917. 8"x10" silver gelatin print
Photographer: F. A. Gildersleeve
Place: Waco, Texas
The Texas Collection General Photo Files #3976

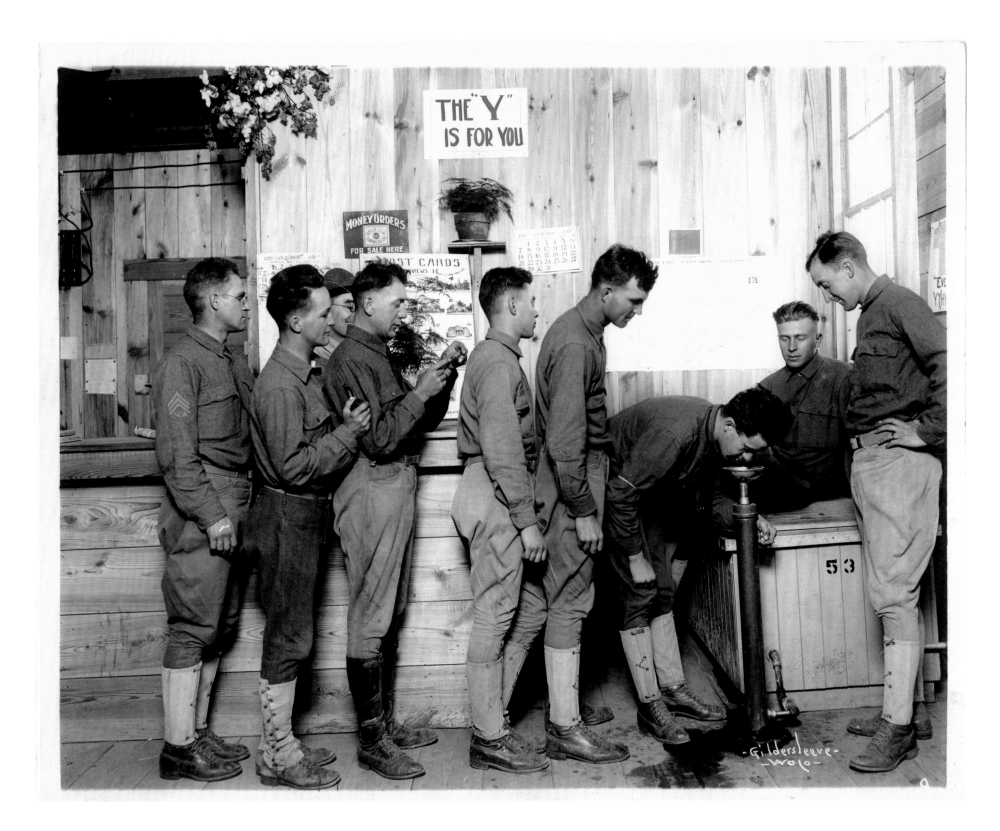

CAMP MACARTHUR TROOPS AT
CHURCH OF THE ASSUMPTION

Troops from nearby Camp MacArthur pose
in front of Church of the Assumption
at 9th Street and Washington Avenue.

1917. 8"x10" silver gelatin print
Photographer: F. A. Gildersleeve
Place: Waco, Texas
Camp MacArthur Collection #2176

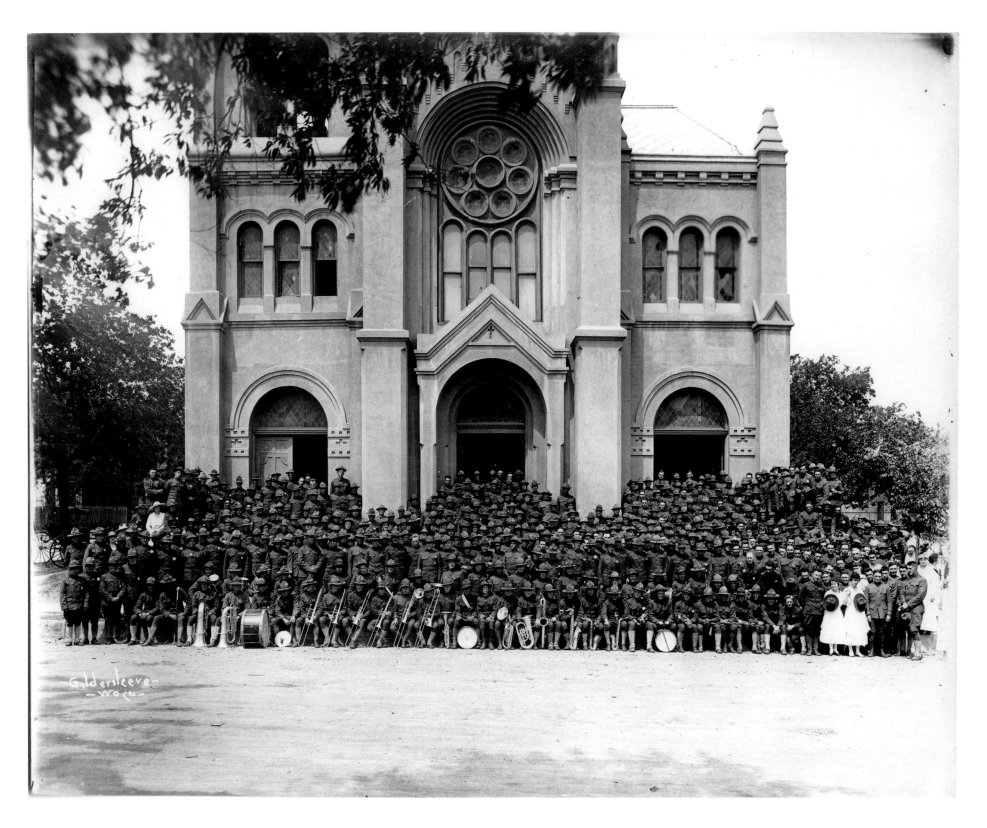

205

A Christmas Eve service for the U.S. Army
127th Infantry Regiment held by Chaplain Stearns.

1917. 8"x10" silver gelatin print
Photographer: F. A. Gildersleeve
Place: Waco, Texas
Camp MacArthur Collection #2176

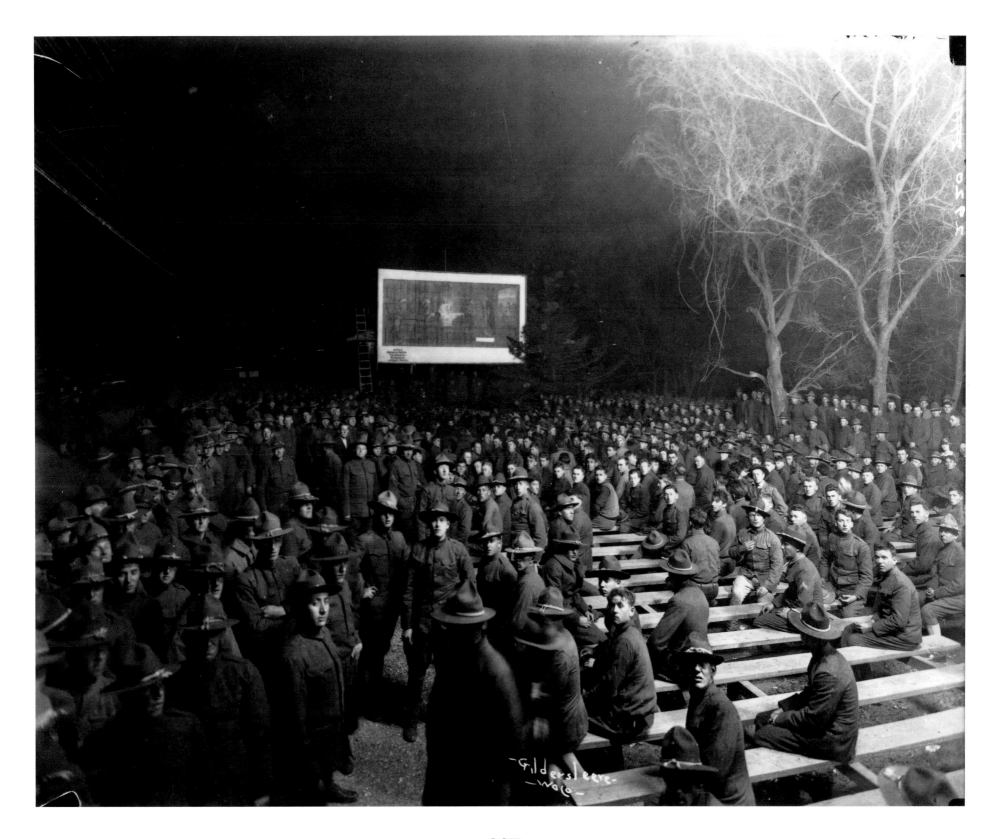

207

ROTARY CLUB DINNER

Taken at the former McLennan County Courthouse that
later become Crow Brothers Waco Steam Laundry,
this image of a Rotary Club dinner provides a rare
glimpse into the building's interior. It was located
at 2nd Street and Franklin Avenue.

March 19, 1917. 8"x10" glass plate negative
Photographer: F. A. Gildersleeve
Place: Waco, Texas
Gildersleeve-Conger Collection #0430

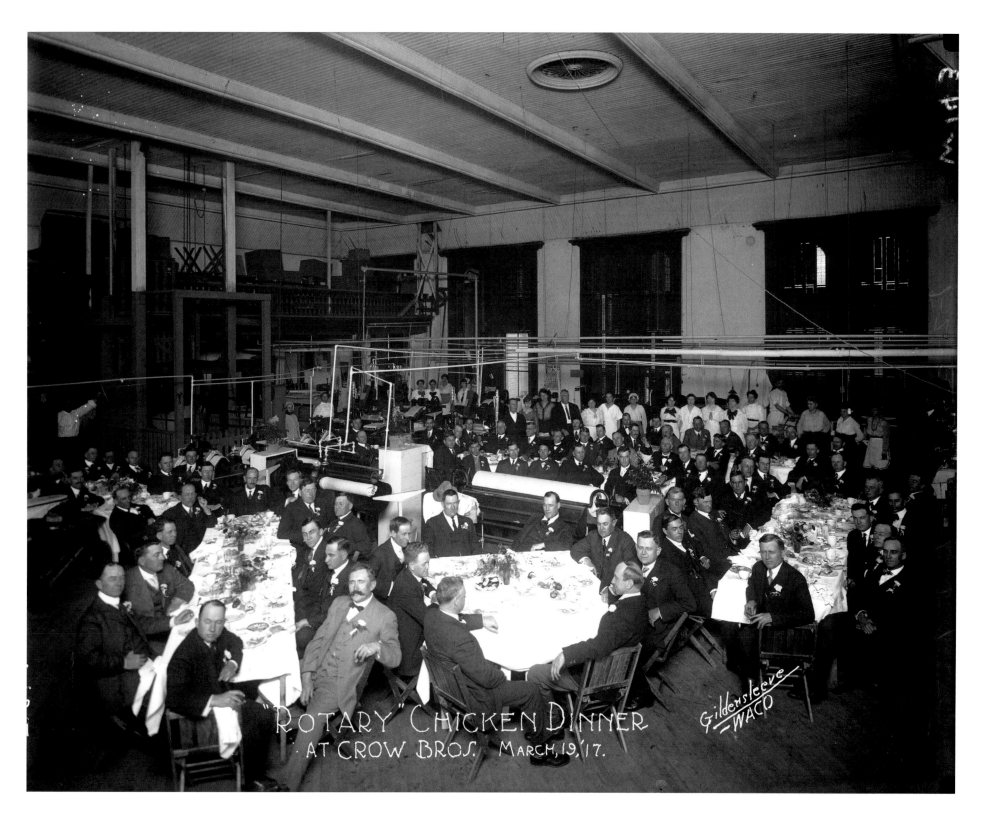

"ROTARY" CHICKEN DINNER AT CROW BROS. MARCH, 19, '17.

Gildersleeve —WACO

THE ACADEMY OF THE SACRED HEART

U.S. Army soldiers and friends pose in front of the
Academy of the Sacred Heart once located
on the corner of 8th Street and Washington Avenue.

c. 1917. 8"x10" glass plate negative
Photographer: F. A. Gildersleeve
Place: Waco, Texas
Gildersleeve-Conger Collection #0430

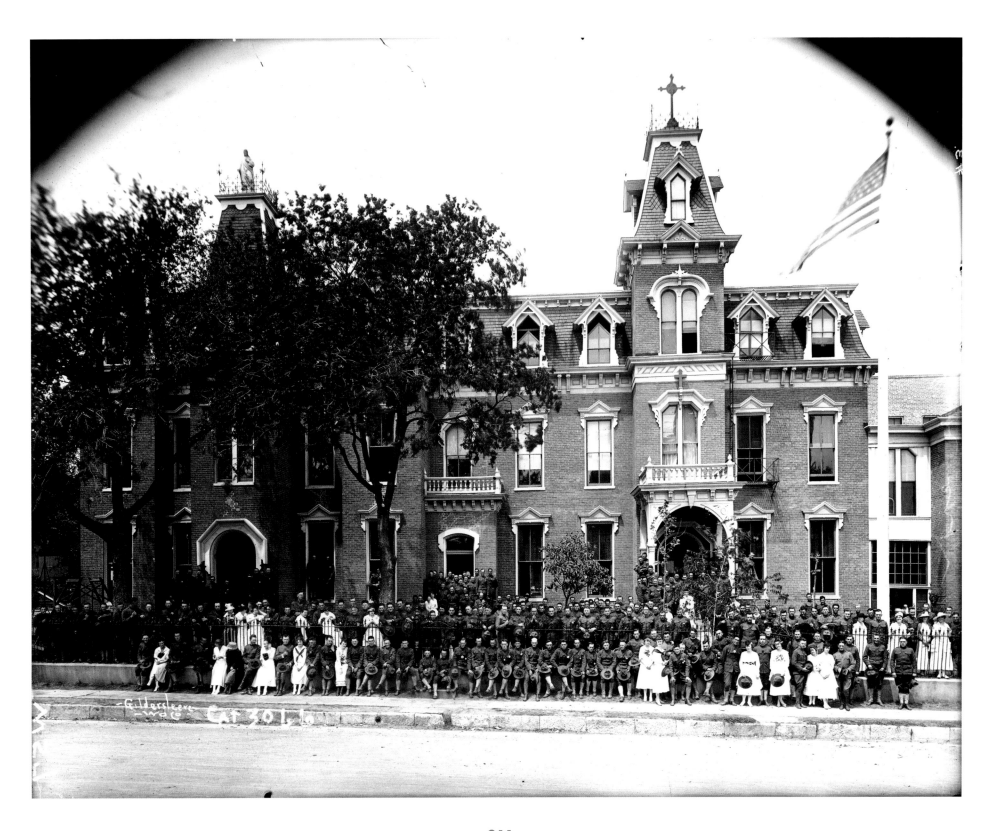

THE C.M. TRAUTSCHOLD COMPANY

An early look into the offices and employees
of the C.M. Trautschold Company. The business
has been operating for over 100 years and
offers millwork among its specialities.
This location was 621–625 Franklin Avenue.

1918. 8"x10" glass plate negative
Photographer: F. A. Gildersleeve
Place: Waco, Texas
Gildersleeve-Conger Collection #0430

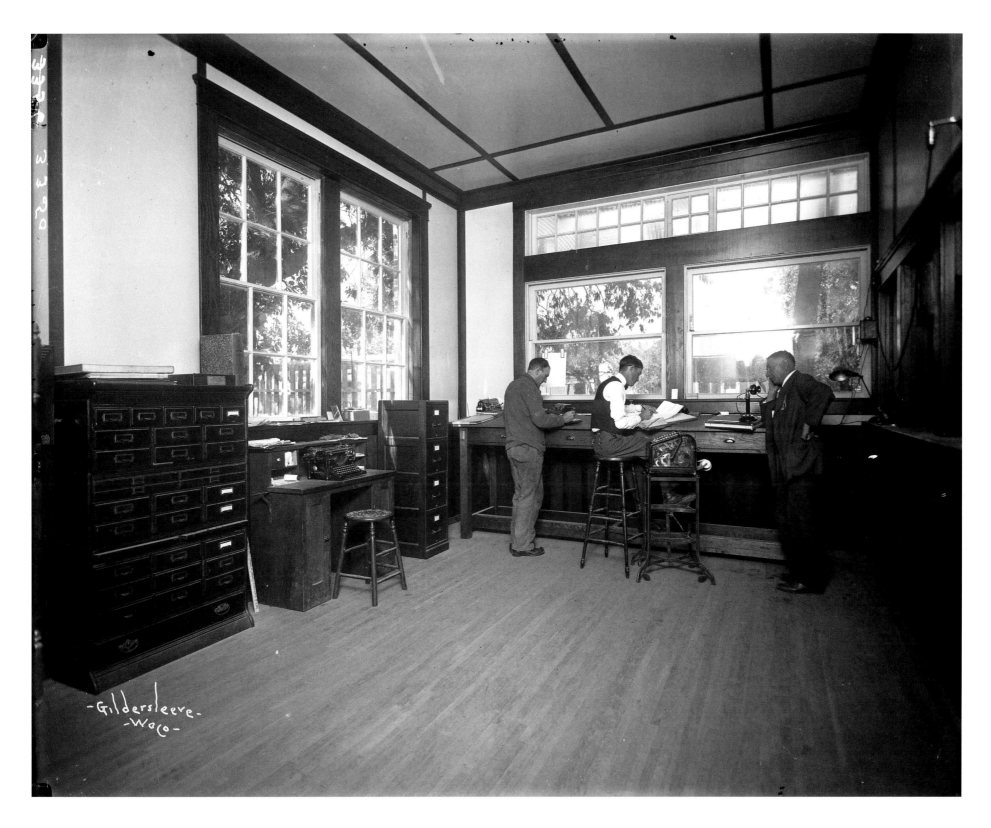

-Gildersleeve-
-Waco-

"PAPPY" O'DANIEL

A large group surrounds then Texas Governor-elect
Wilbert Lee "Pappy" O'Daniel. He's the gentleman
with Gildersleeve's signature below his overcoat.

August 14, 1938. 8"x10" cellulose acetate negative
Photographer: F. A. Gildersleeve
Place: Waco, Texas
Gildersleeve-Conger Collection #0430

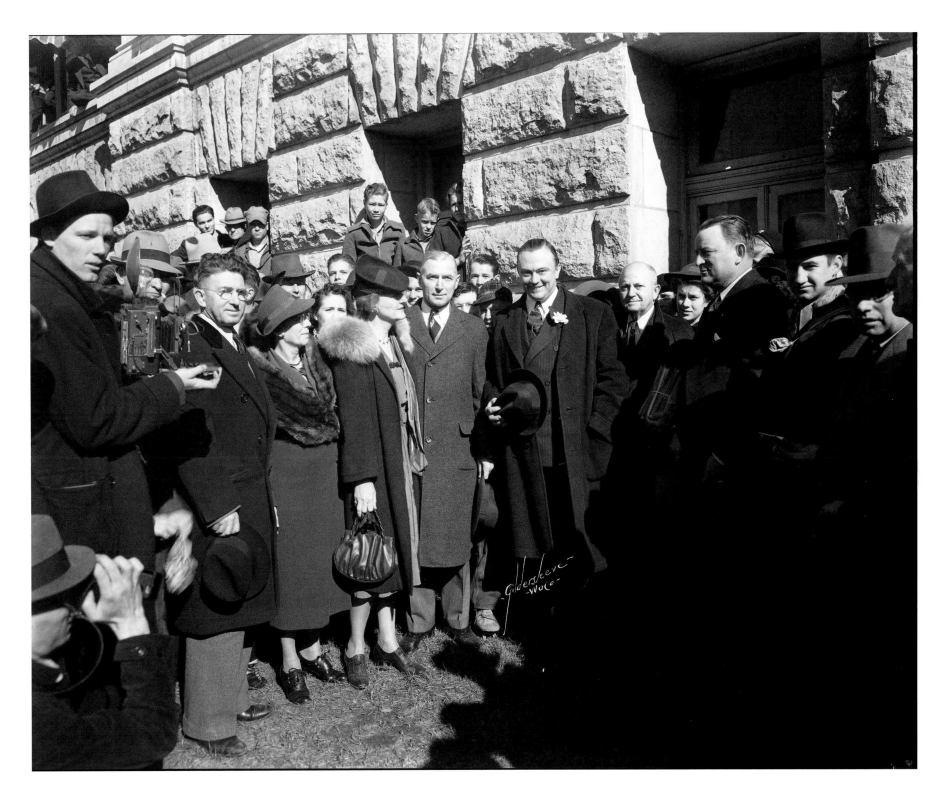

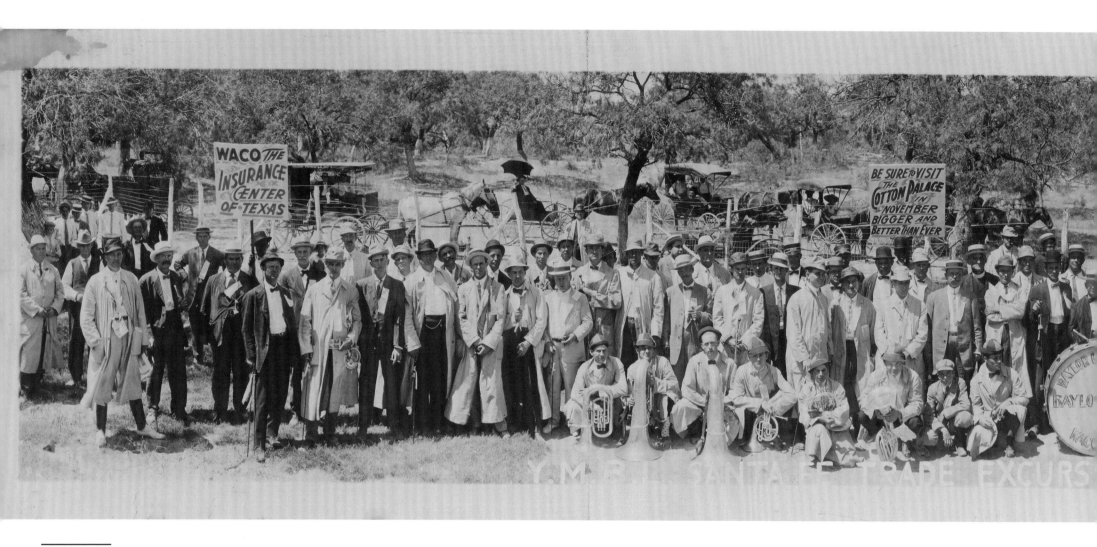

Y.M.B.L. SANTA FE TRADE EXCURSION

Shown is the Young Men's Business League of Waco setting out to promote trade and commerce for the city. The organization was the forerunner of the Waco Chamber of Commerce. One of the big Waco events they helped advance was the Texas Cotton Palace.

June 8, 1911. 10"x45" silver gelatin print
Photographer: F. A. Gildersleeve
Place: Waco, Texas
The Texas Collection General Photo Files #3976

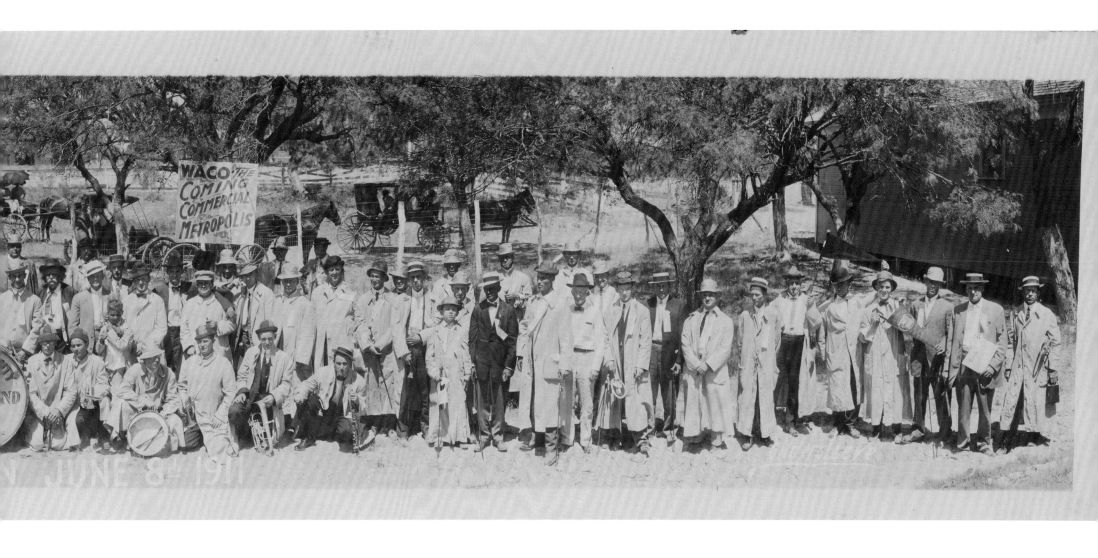

PART **4** | TRANSPORTATION

The construction of the Interurban Bridge allowed trolley cars to pass over the Brazos River into east Waco. It was situated next to the Waco Suspension Bridge as seen at the entranceway to the left covered in ivy. Bridge Street can be seen ahead.

c. 1911. 8"x10" glass plate negative
Photographer: F. A. Gildersleeve
Place: Waco, Texas
Gildersleeve-Conger Collection #0430

KATE FRIEND'S ANIMAL FOUNTAIN

This fountain once stood on the city square and was a popular spot for people to give their animals rest and refreshment.

c. 1910. 8"x10" glass plate negative
Photographer: F. A. Gildersleeve
Place: Waco, Texas
Gildersleeve-Conger Collection #0430

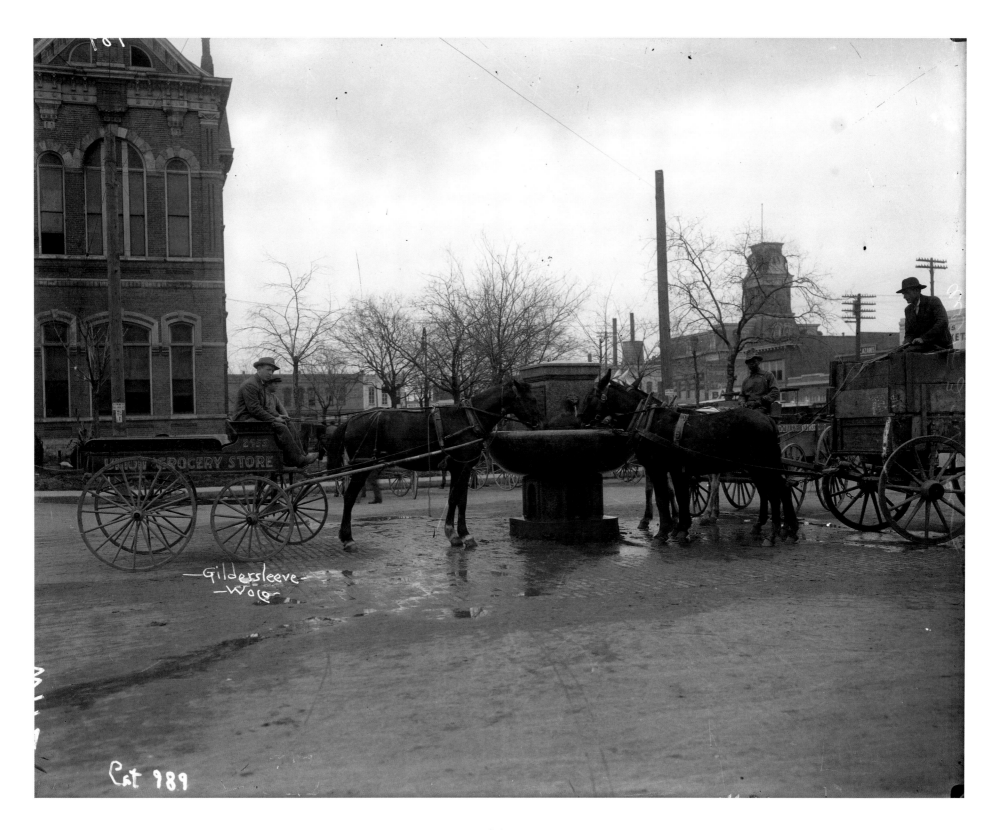

Gildersleeve
Waco

Cat 989

UNION GROCERY STORE

MOTORCYCLISTS READY TO RACE

A group of motorcyclists are set to
start a race at Gurley Park.

c. 1912. 5"x7" silver gelatin print
Photographer: F. A. Gildersleeve
Place: Waco, Texas
The Texas Collection General Photo Files #3976

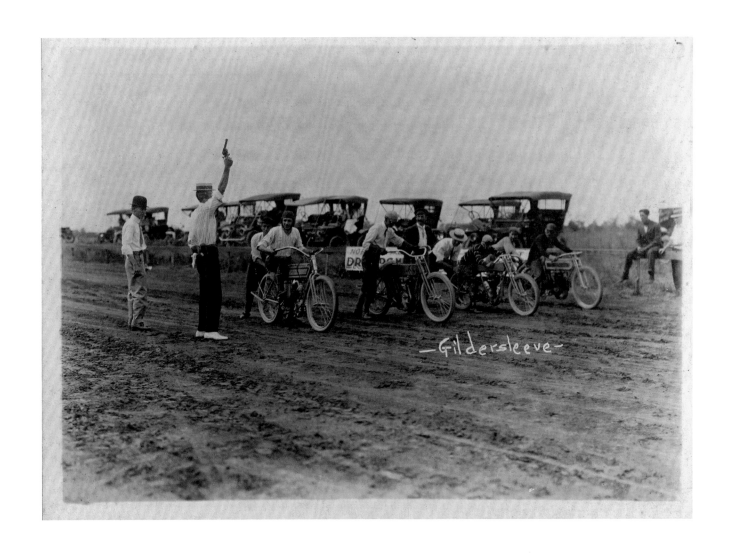

—Gildersleeve—

MOTORCYCLE ACTION

**A motorcyclist speeds along the track
at Gurley Park.**

c. 1912. 5"x7" silver gelatin print
Photographer: F. A. Gildersleeve
Place: Waco, Texas
The Texas Collection General Photo Files #3976

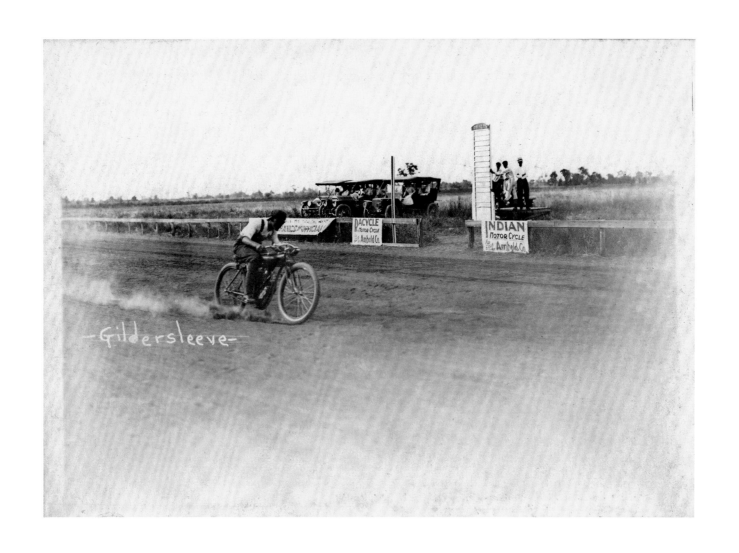

Gildersleeve

225

REEVES & ROTAN AUTOS

A line up of new models from the Inter-State and
De Tamble auto companies stand prominently
on display at this early Waco car dealership
once located at 107 South 5th Street.
Notice the steering wheels on the right-hand side.

c. 1913. 8"x10" glass plate negative
Photographer: F. A. Gildersleeve
Place: Waco, Texas
Gildersleeve-Conger Collection #0430

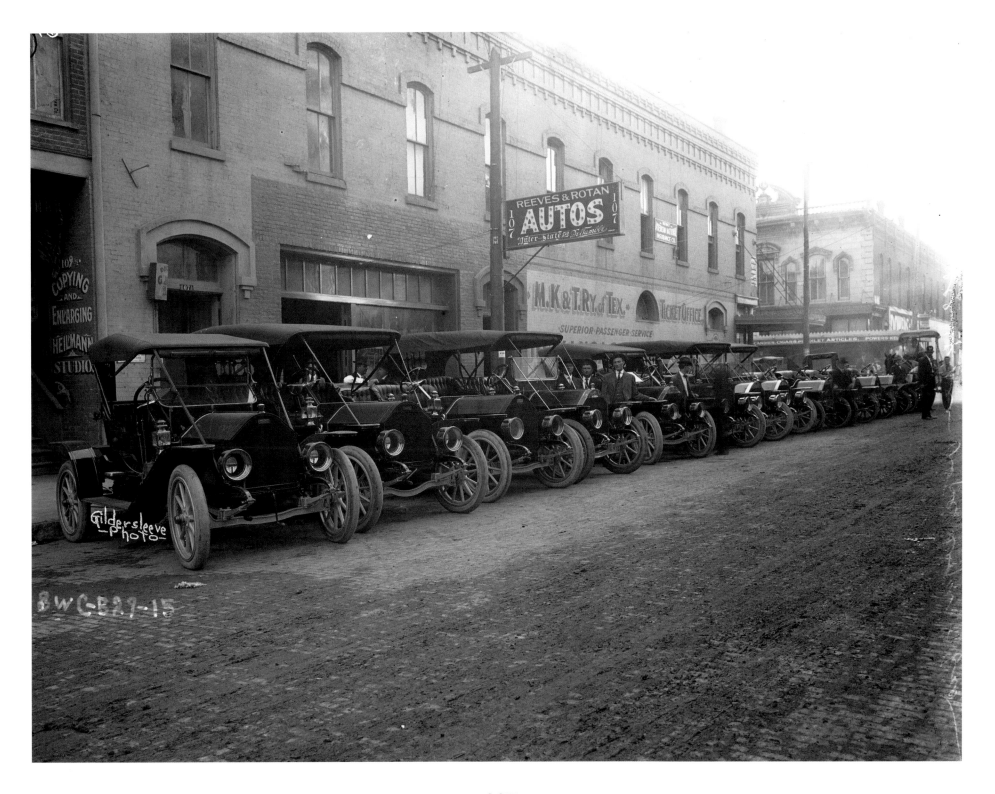

MAN WITH MOTORCYCLE

**An unidentified man proudly poses
with his Indian motorcycle.**

c. 1913. 8"x10" glass plate negative
Photographer: F. A. Gildersleeve
Place: Waco, Texas
Gildersleeve-Conger Collection #0430

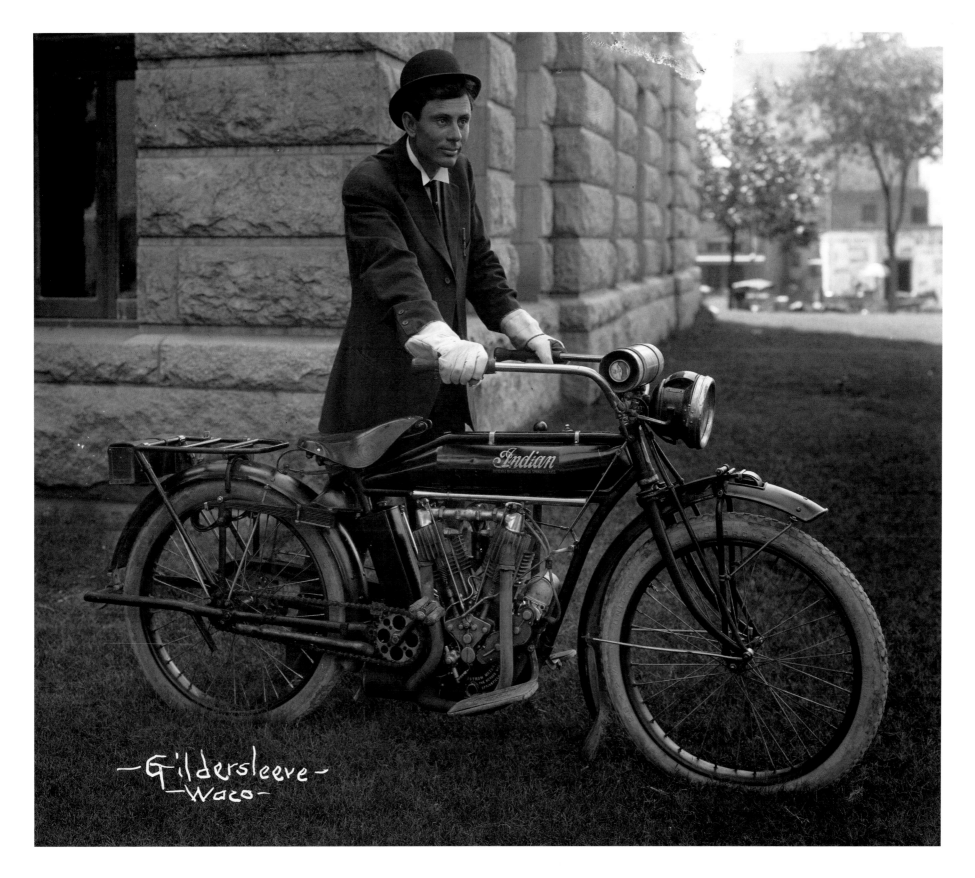

Gildersleeve
Waco

229

WACO AVIATION SCHOOL
Captain Charles
Theodore ran the Waco Aviation School and flew
this Curtiss powered biplane.

c. 1913. 8"x10" glass plate negative
Photographer: F. A. Gildersleeve
Place: Waco, Texas
Gildersleeve-Conger Collection #0430

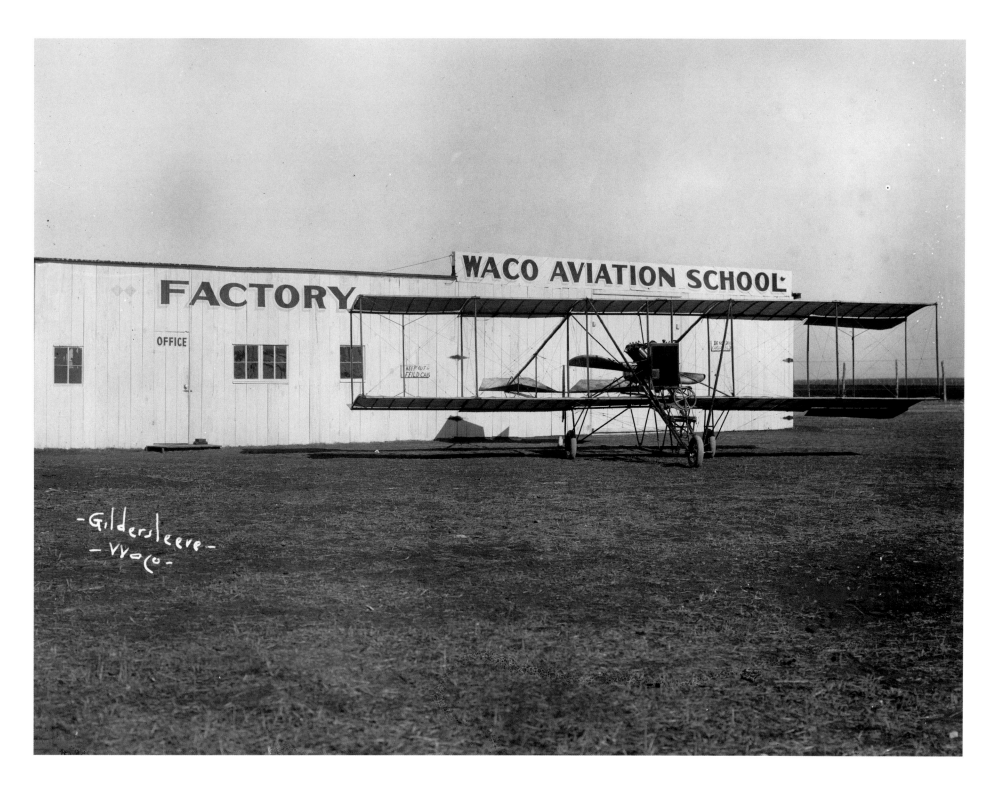

THE DETROITER AUTOMOBILE

A man poses in a Detroiter automobile.
The State of Texas with flags has been painted
on the radiator.

c. 1913. 8"x10" glass plate negative
Photographer: F. A. Gildersleeve
Place: Waco, Texas
Gildersleeve-Conger Collection #0430

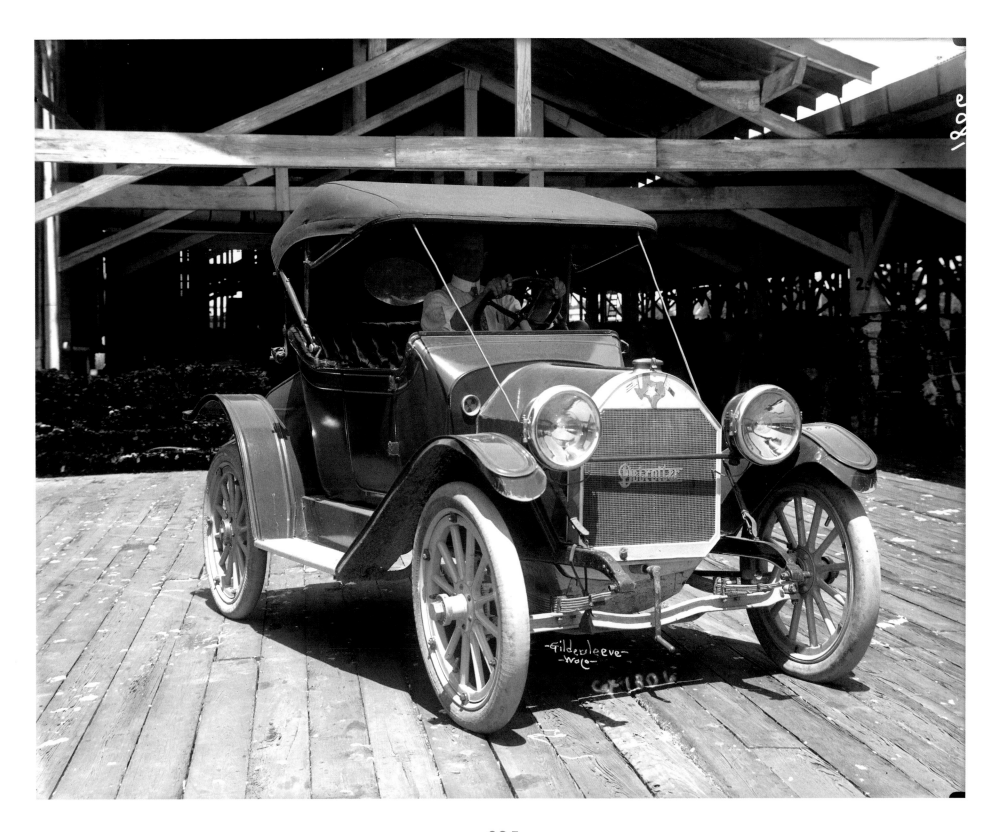

COAL TRAIN READY TO DEPART

**Men pose with a train loaded with lignite coal
ready to depart from the Rockdale area.**

c. 1914. 8"x10" glass plate negative
Photographer: F. A. Gildersleeve
Place: Rockdale, Texas
Gildersleeve-Conger Collection #0430

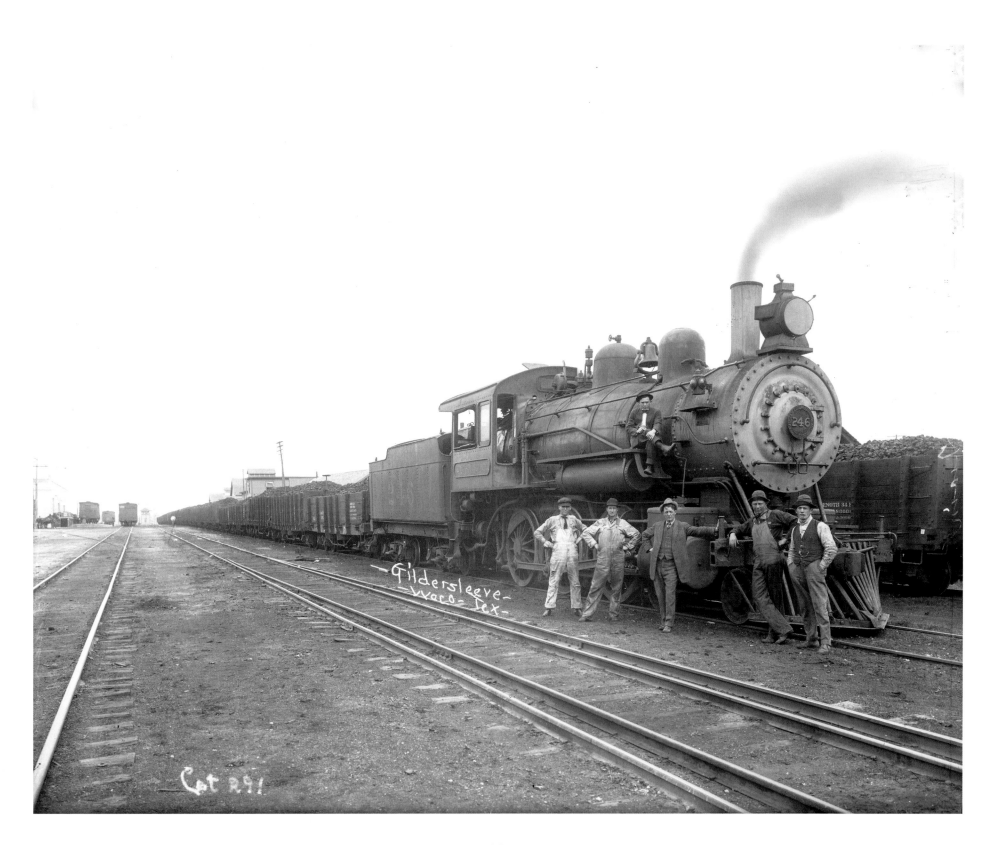

Gildersleeve
Waco Tex

Cat 291

237

HALL CYCLE CAR

**The Hall Cycle car had a two-cylinder motorcycle
engine and was designed by Lawrence Hall of Waco.**

c. 1914. 8"x10" glass plate negative
Photographer: F. A. Gildersleeve
Place: Waco, Texas
Gildersleeve-Conger Collection #0430

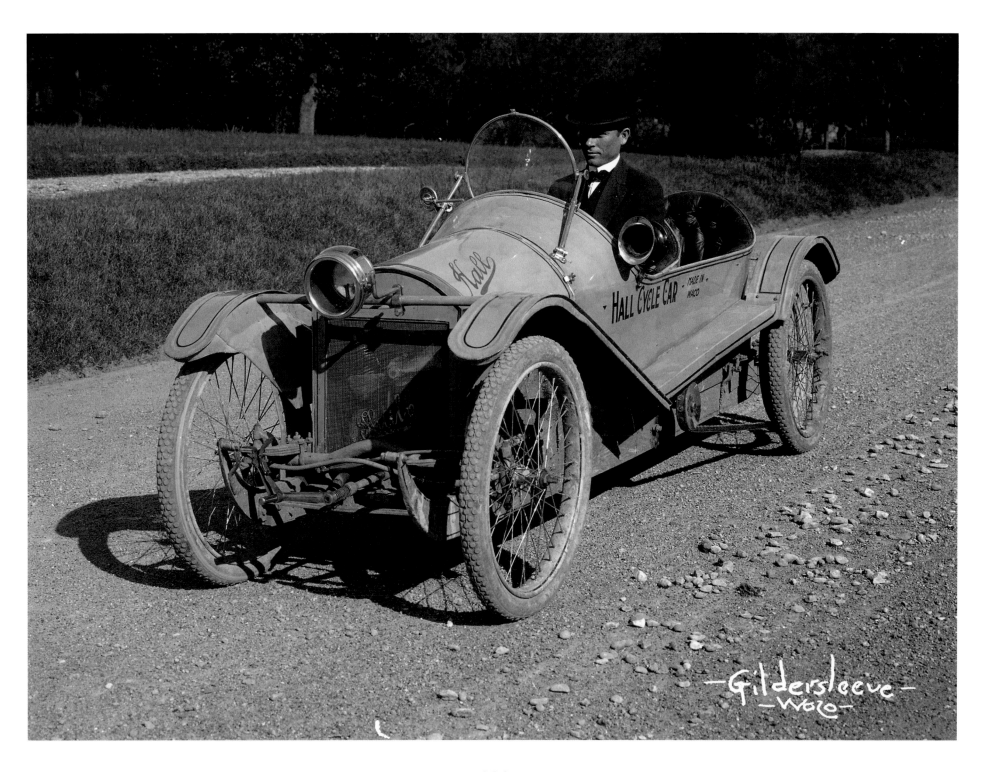

WACO BUILT HALL MOTOR COMPANY AUTOMOBILES

The Hall Cycle Car Manufacturing Company became
the Hall Motor Car Company in 1915 and was
located at 623 Jackson Street. They produced
in their Waco factory several models: Hall Coupe,
Roadster, Speedster, and a delivery vehicle. It was
also referred to as the "Hall Light Car."

1915. 8"x10" glass plate negative
Photographer: F. A. Gildersleeve
Place: Waco, Texas
Gildersleeve-Conger Collection #0430

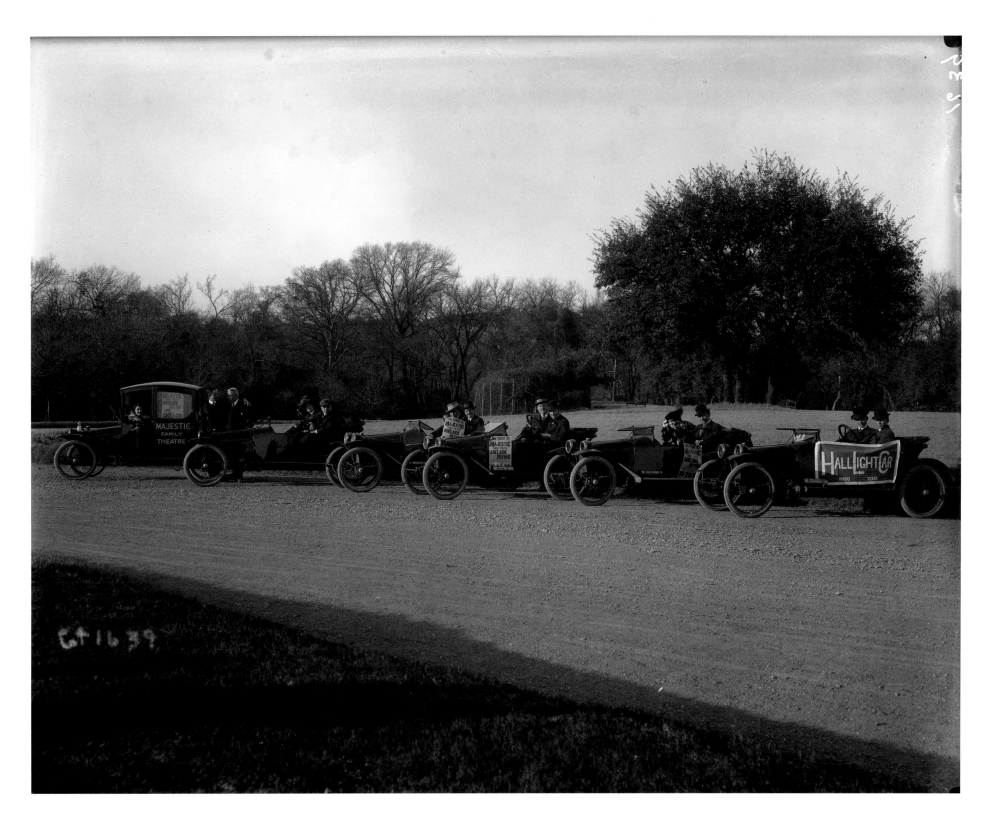

TIRE TESTING IN CAMERON PARK

W. M. Oden's Goodrich Tire Store shows a unique
way of testing its tire inner tubes. One car pulls
three others linked together by Goodrich
"Indian Tubes" to demonstrate their strength.

c. 1915. 8"x10" glass plate negative
Photographer: F. A. Gildersleeve
Place: Waco, Texas
Gildersleeve-Conger Collection #0430

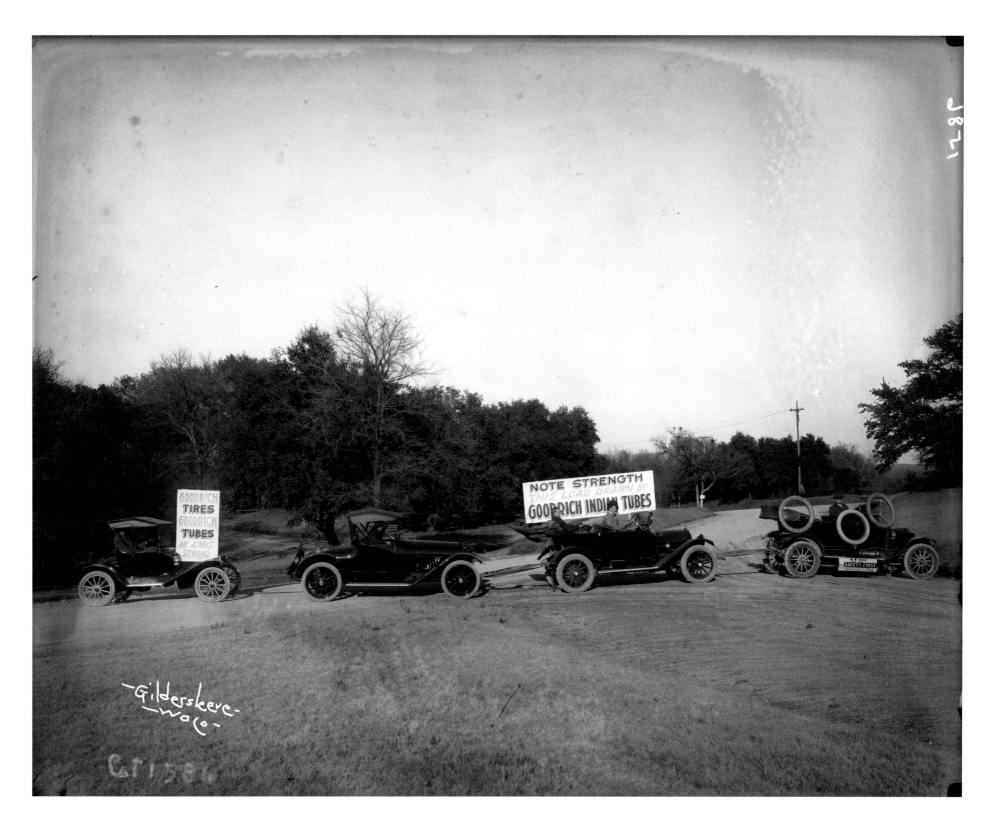

243

UNLOADING A RAILCAR

Patterson Light Company has power generators
loaded off of a St. Louis Southwestern Railway
boxcar. Randall M. Patterson ran an acetylene
lighting plant at 1211 Cleveland Street.

c. 1915. 8"x10" glass plate negative
Photographer: F. A. Gildersleeve
Place: Waco, Texas
Gildersleeve-Conger Collection #0430

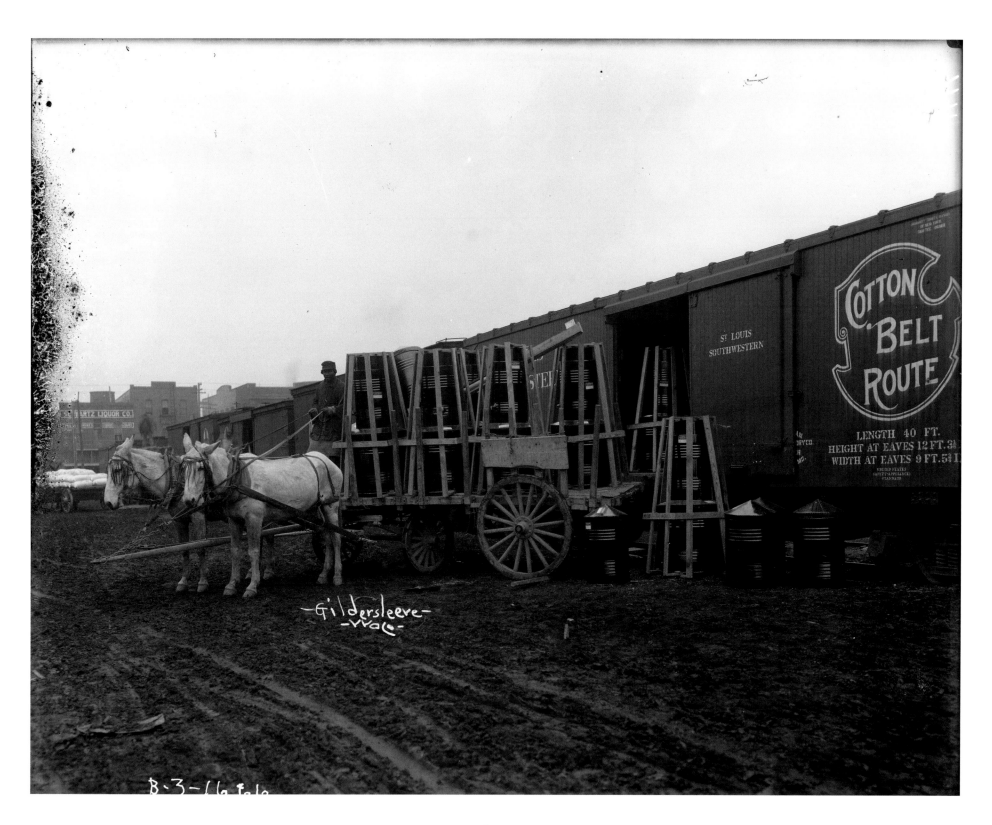

ST. LOUIS
SOUTHWESTERN

COTTON
BELT
ROUTE

LENGTH 40 FT.
HEIGHT AT EAVES 12 FT. 3½
WIDTH AT EAVES 9 FT. 5½ I.

-Gildersleeve-
-Woc-

B-3-16 Feb

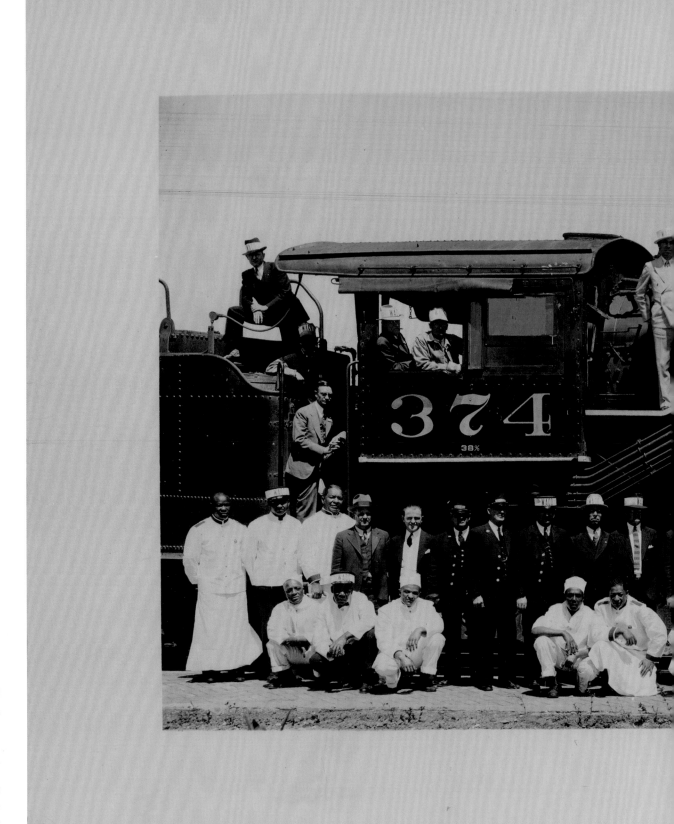

WACO CHAMBER OF COMMERCE TRADE TRIP

The Waco Chamber of Commerce departs for a
trade excursion to east Texas. Here they are seen
posing with the Texas Special and her crew of the
Katy and Frisco Railroad line. The W.C.C. succeeded
the Young Men's Business League.

1936. 10"x21" silver gelatin print
Photographer: F. A. Gildersleeve
Place: Waco, Texas
The Texas Collection General Photo Files #3976

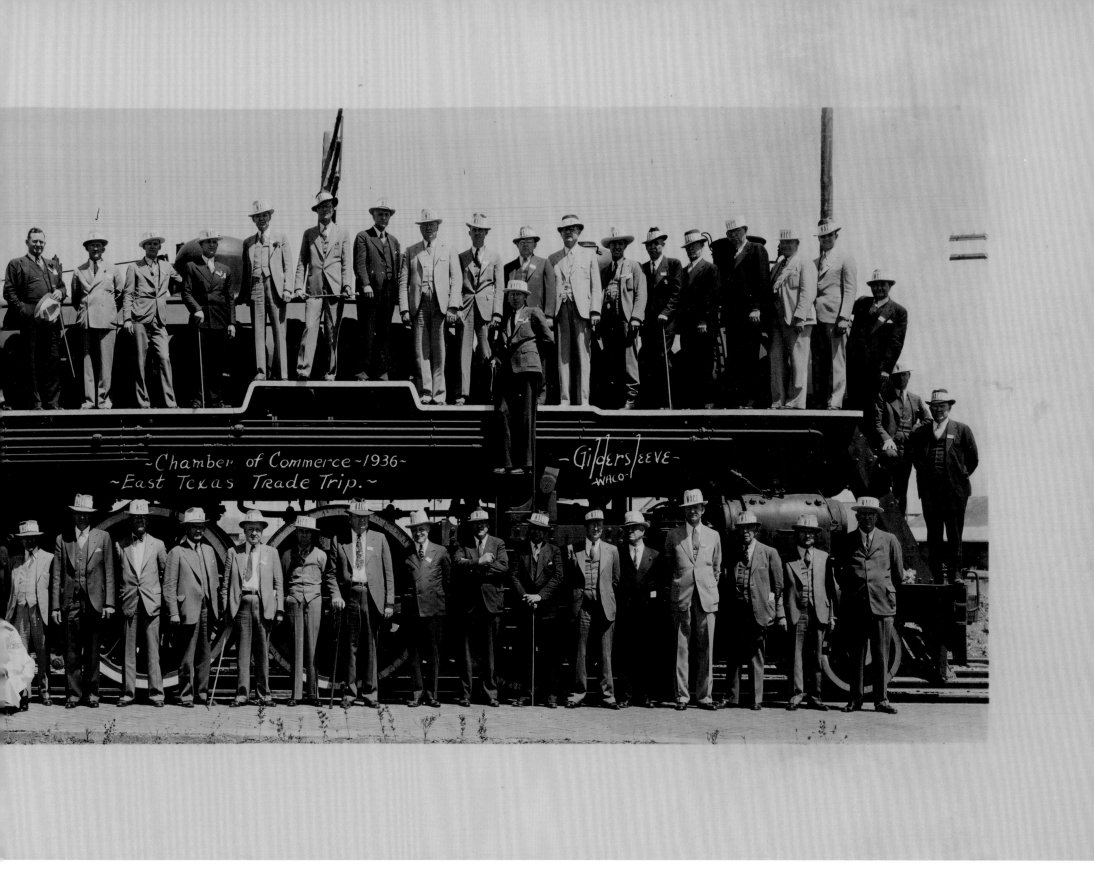

Chamber of Commerce ~1936~
East Texas Trade Trip.

Gildersleeve
WACO

THE SAXON AUTOMOBILE

The Saxon automobile dealer at 700 Austin Avenue
went to great lengths to demonstrate the power and
durability of its brand. The car here is holding
seven people, a cow, and two bales of cotton.

c. 1915. 8"x10" glass plate negative
Photographer: F. A. Gildersleeve
Place: Waco, Texas
Gildersleeve-Conger Collection #0430

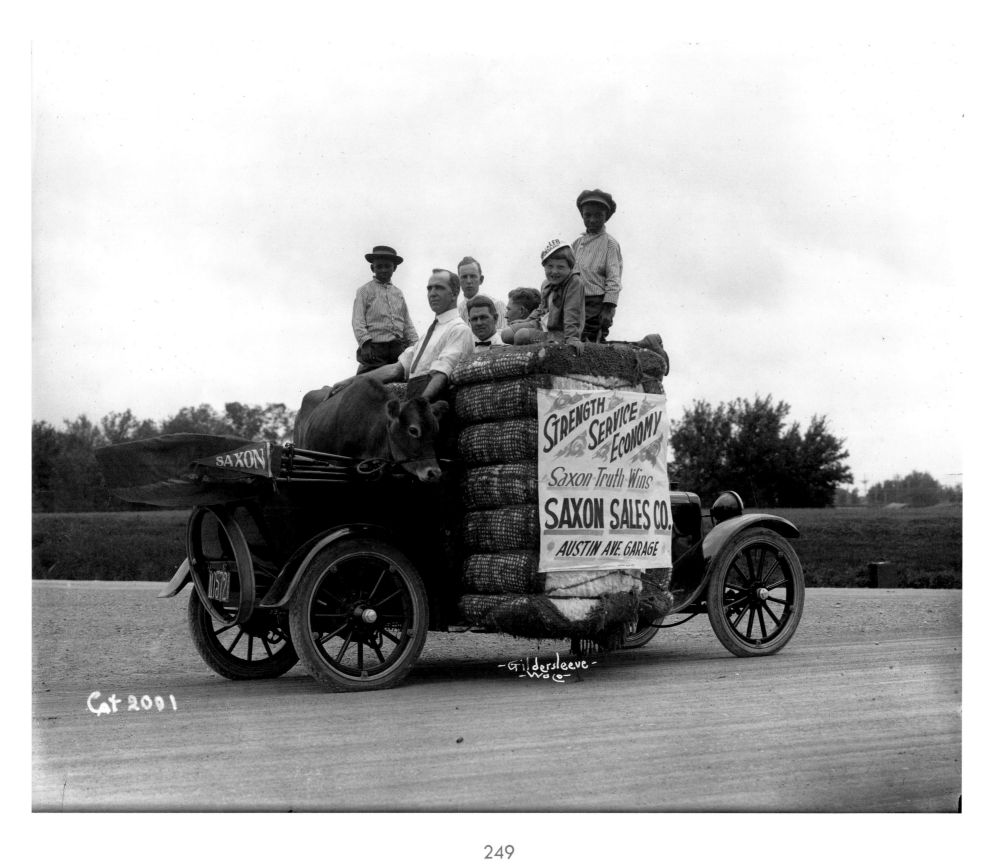

FORD HAULING COTTON BALE

This Ford appears to have taken on the task of
hauling this cotton bale fairly well. The location is
the H.T. Cruger Company/A. H. Bell Machinery,
a Ford automobile dealer and machinist once
located at 209 South 6th Street.

1915. 8"x10" glass plate negative
Photographer: F. A. Gildersleeve
Place: Waco, Texas
Gildersleeve-Conger Collection #0430

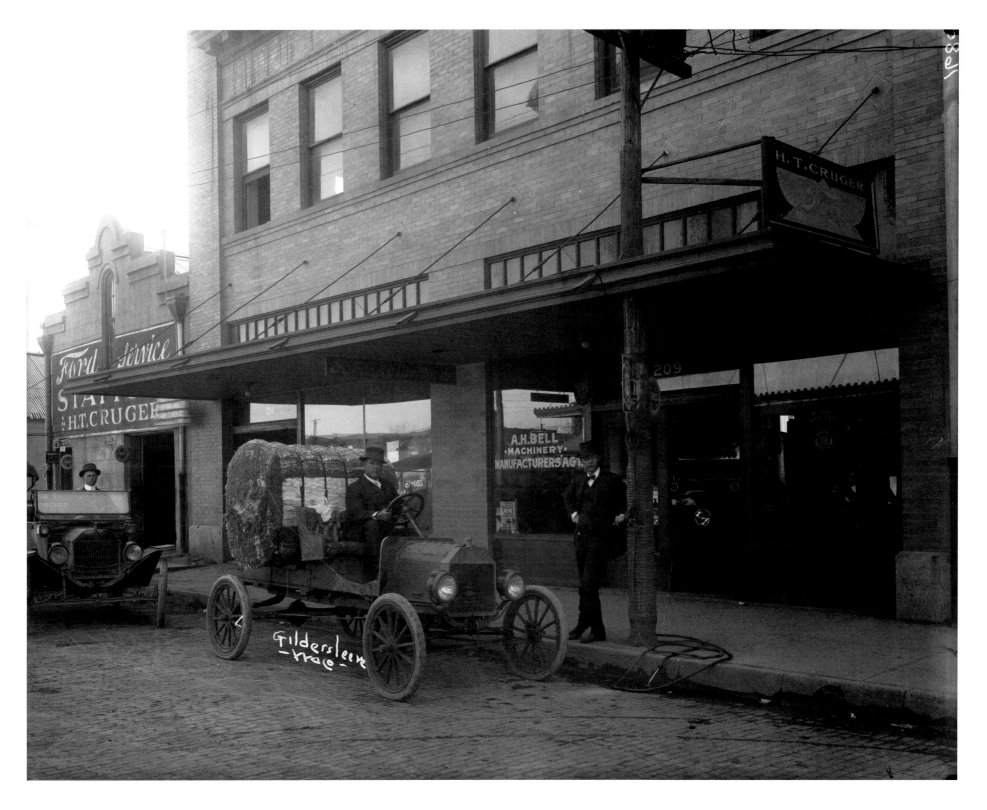

Gildersleeve race

WESTERN UNION DELIVERY SQUAD

A group of Western Union delivery personnel
pose with their bicycles in front of the
Western Union Telegraph and Cable office.

1915. 8"x10" glass plate negative
Photographer: F. A. Gildersleeve
Place: Waco, Texas
Gildersleeve-Conger Collection #0430

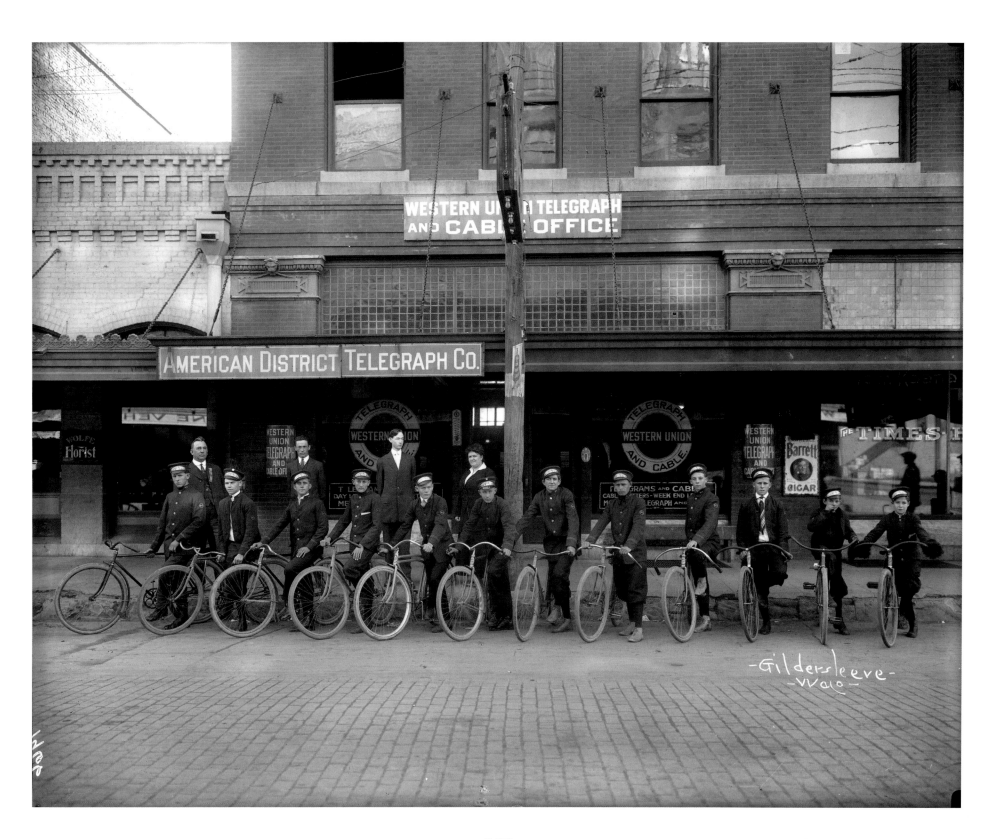

SPRING STYLE SHOW

This float helped to represent the opening of 1916's
Spring Style Show. The theme of the float is that
of a "huge Paris hat-box, lying with its cover open."

March 1916. 8"x10" glass plate negative
Photographer: F. A. Gildersleeve
Place: Waco, Texas
Gildersleeve-Conger Collection #0430

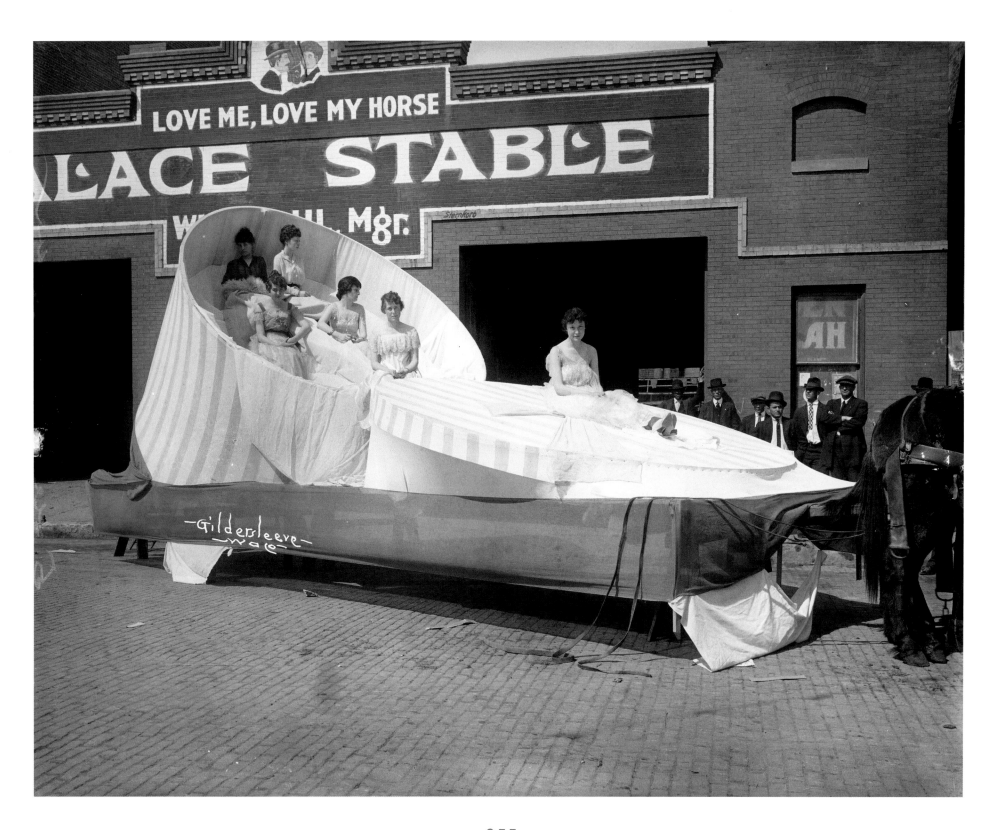

255

TEXAS COTTON PALACE AUTO RACE

Drivers await the start of this automobile race in the grueling early days of the sport. These racers often rode with a mechanic who performed maintenance tasks and helped repair flat tires.

1916. 8"x10" glass plate negative
Photographer: F. A. Gildersleeve
Place: Waco, Texas
Gildersleeve-Conger Collection #0430

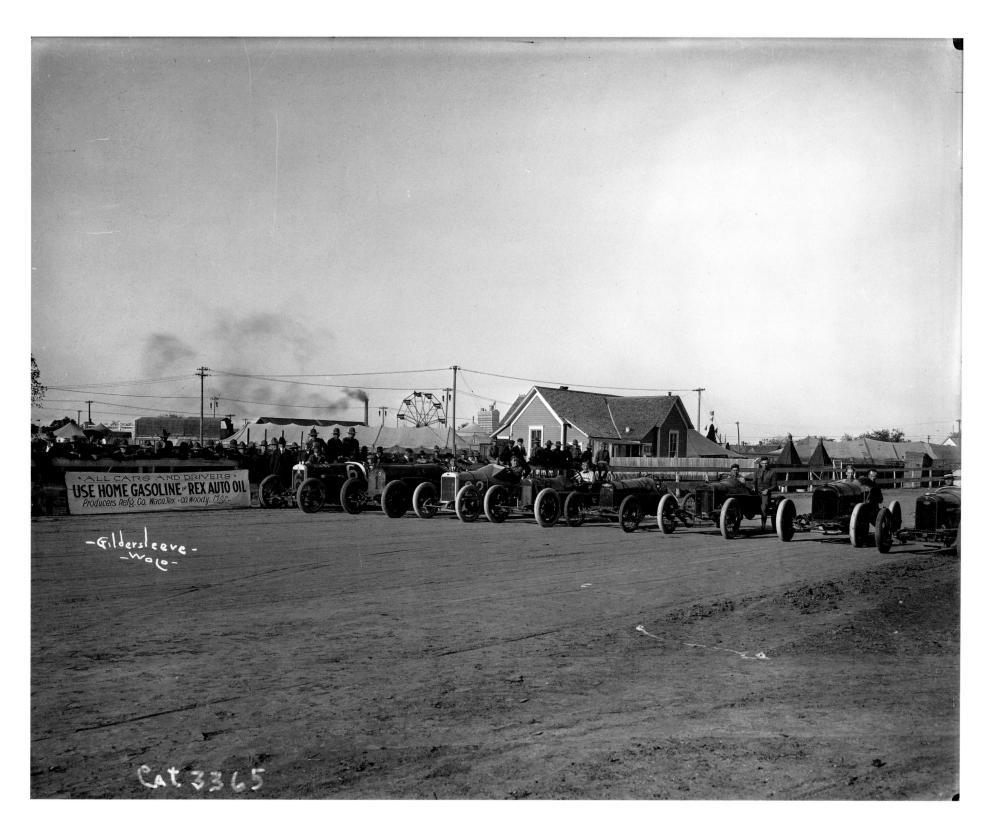

USE HOME GASOLINE and REX AUTO OIL

ALL CARS AND DRIVERS

Producers Ref. Co. Waco, Tex. - CO. Woody, Mgr.

-Gildersleeve-
-Waco-

Cat. 3365

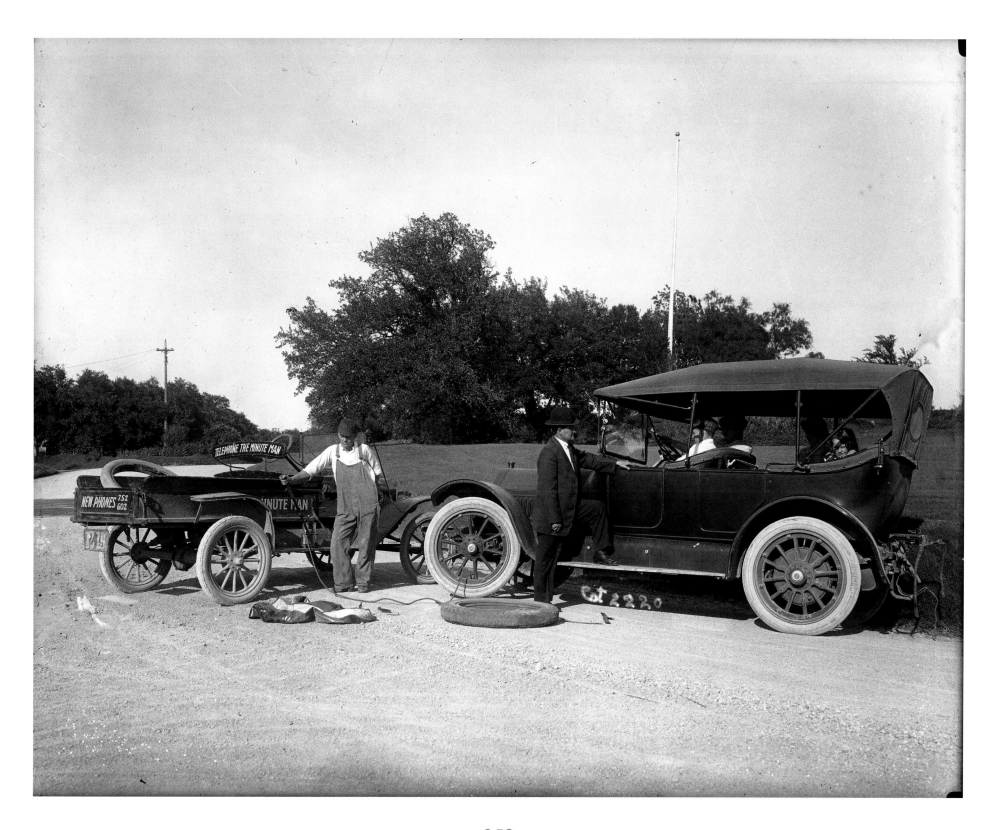

259

The Texas Cotton Palace houses a
French exhibit that displays items brought back
from the Western Front during World War I.
The remnants of a biplane and several shells
of the type used at Verdun, France, were among
items on exhibit.

1917. 8"x10" glass plate negative
Photographer: F. A. Gildersleeve
Place: Waco, Texas
Gildersleeve-Conger Collection #0430

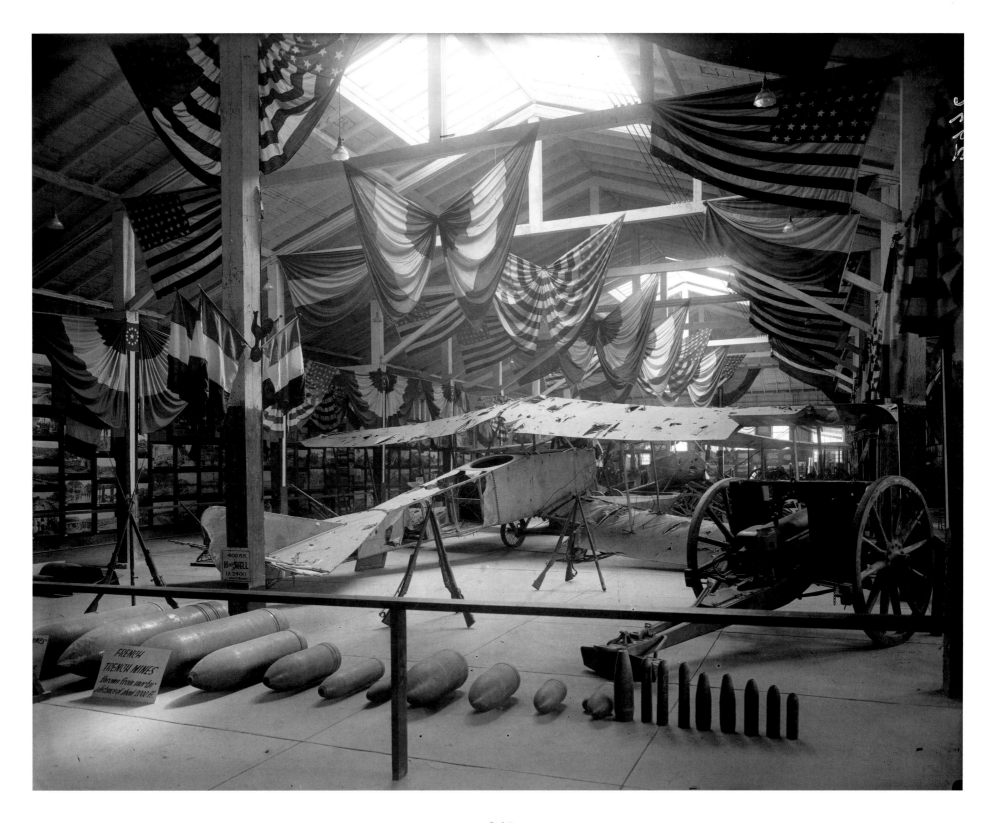

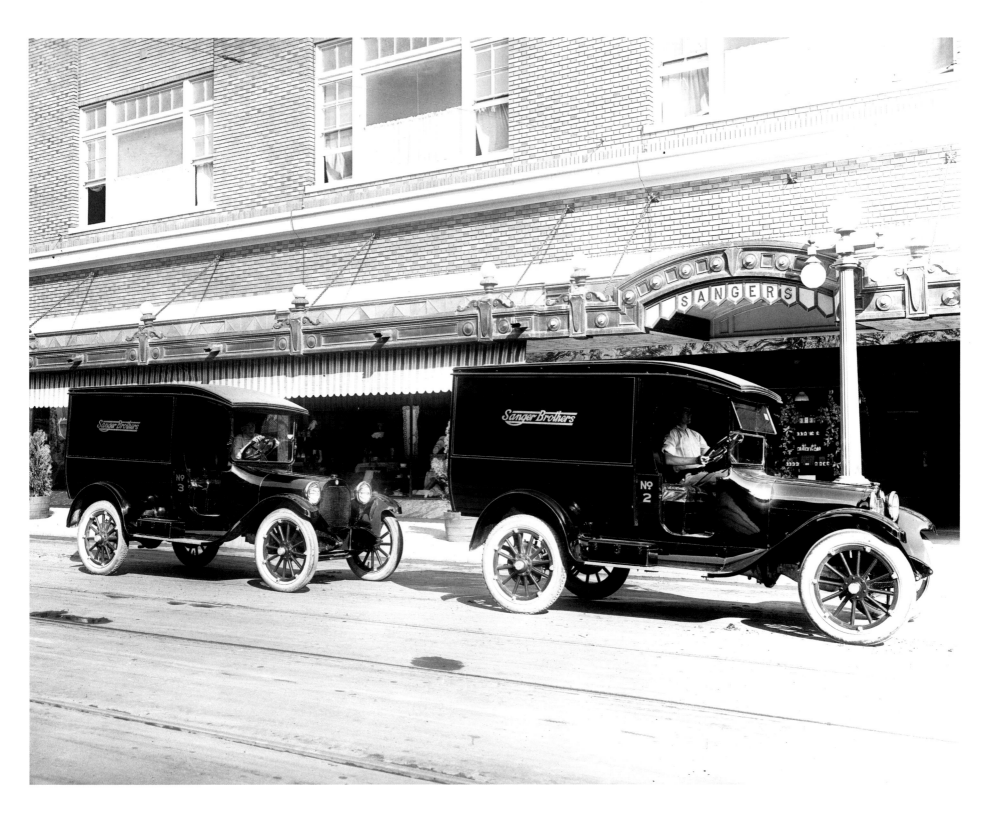

THE GILDERSLEEVES AND BIPLANE

Fred Gildersleeve with his wife, Florence, holds his
camera while the pilot, Franklin Motor Car mechanic
Marion Sterling, is in the rear. They were departing
for Mexia, Texas, to join a delegation of Waco
businessmen to the oil fields. This auto company
was known to dispatch a pilot/mechanic
to take care of customers with Franklin cars
who might need mechanical assistance.

c. 1920. 8"x10" silver gelatin print
Photographer: F. A. Gildersleeve Studio
Place: Waco, Texas
Gildersleeve-Conger Collection #0430

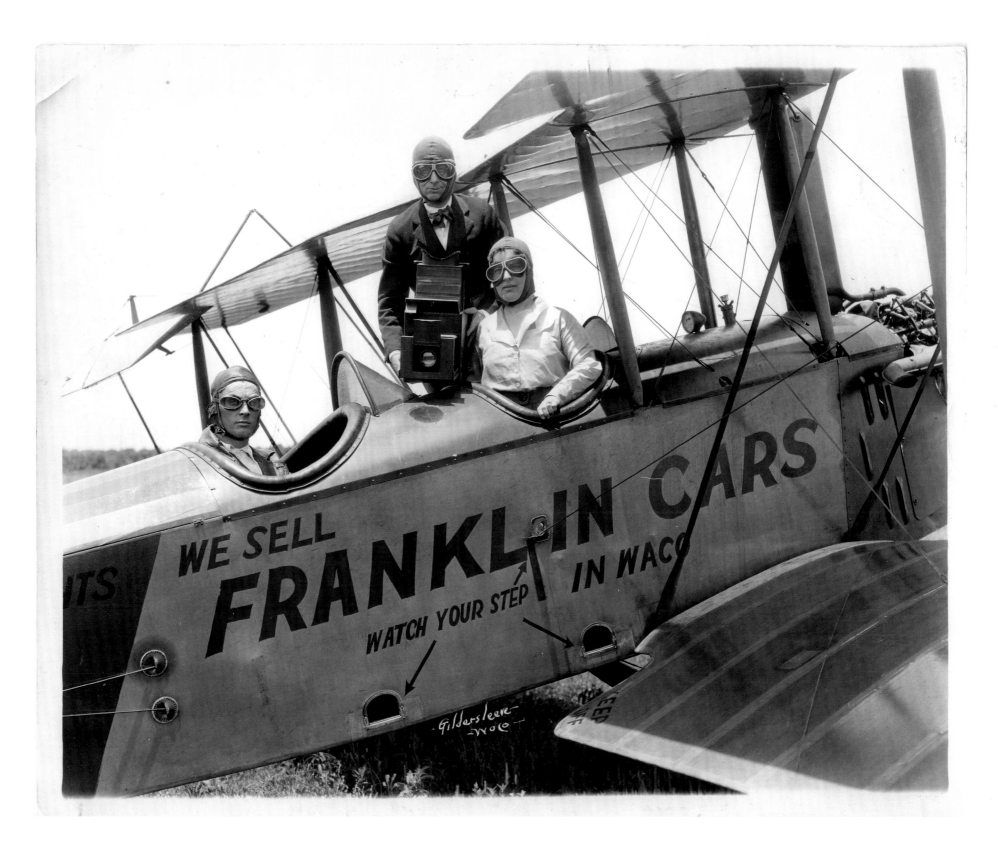

265

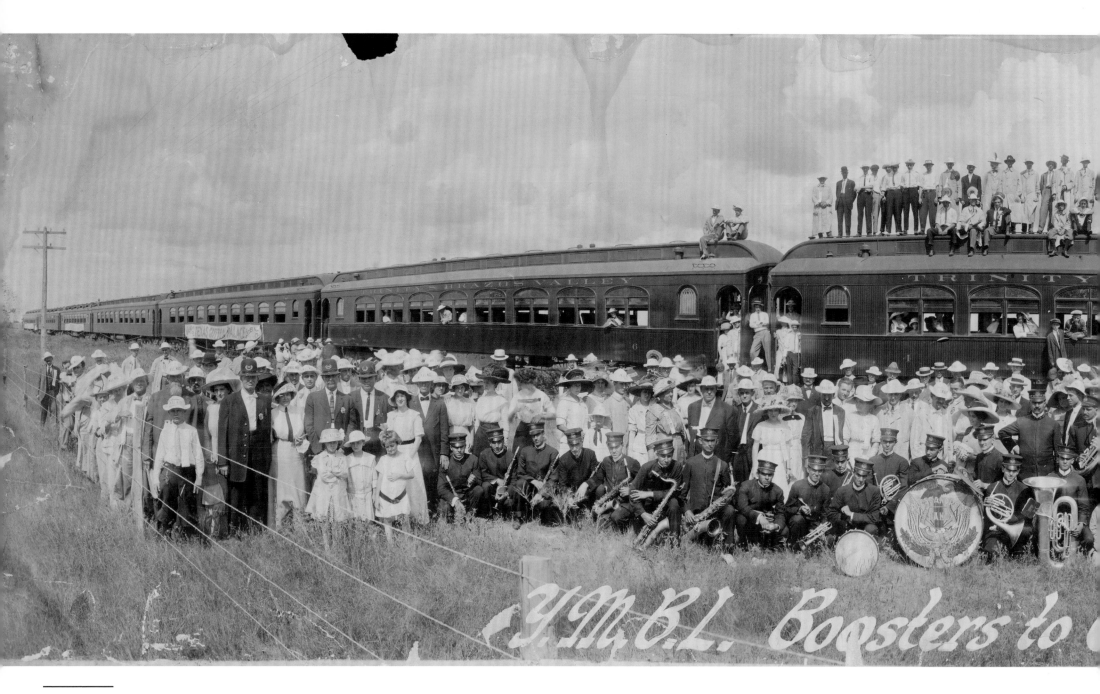

THE YOUNG MEN'S BUSINESS LEAGUE TO GALVESTON

This image shows the Y.M.B.L. along with their transportation, the Trinity and Brazos Valley Railroad, en route to Galveston, Texas.

c. 1912. 10"x33" silver gelatin print
Photographer: F. A. Gildersleeve
Place: Central Texas
The Texas Collection General Photo Files #3976

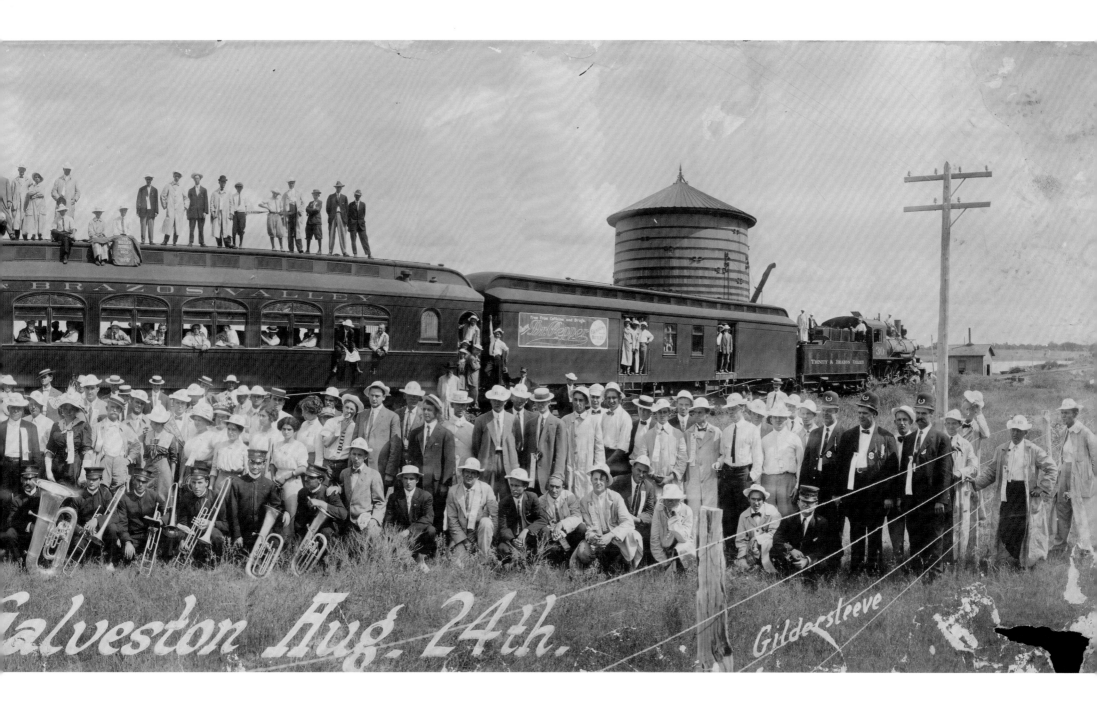

Galveston Aug. 24th.

Gildersleeve

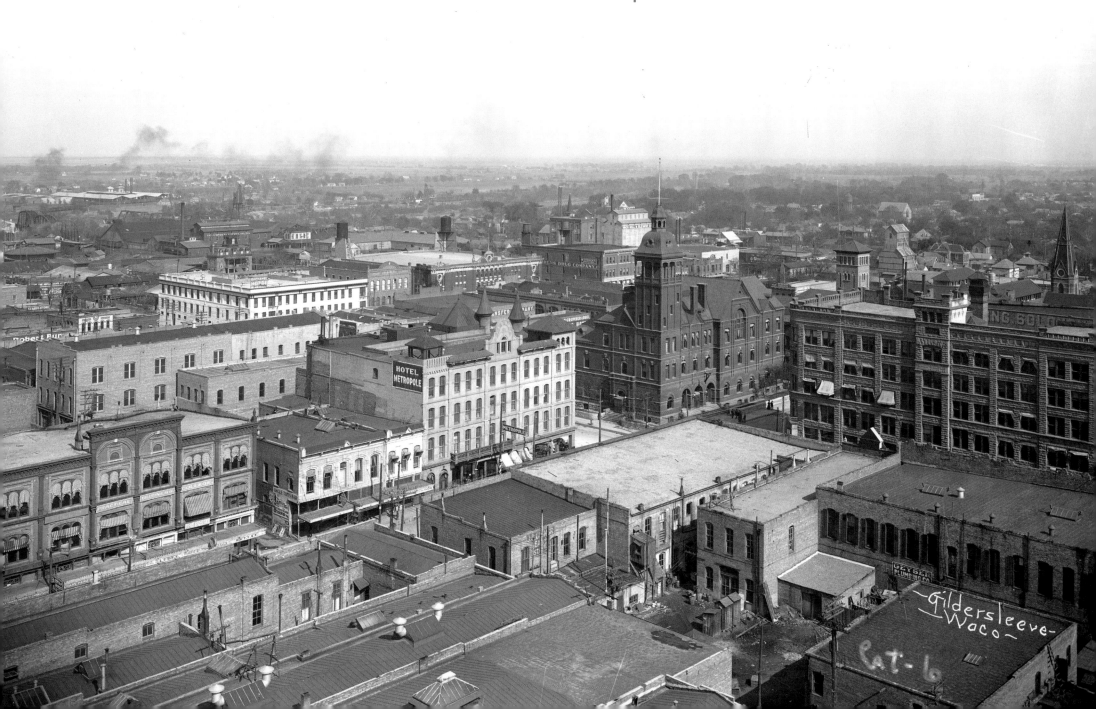

The intersection of Fourth Street and Franklin Avenue was once the location of the old U.S. Post Office (tall building with spire) and was surrounded by other grand structures such as the Hotel Metropole across the street. The Provident Building (far right) stood as one of the city's largest.

c. 1910. 8"x10" silver gelatin print
Photographer: F. A. Gildersleeve
Place: Waco, Texas
Gildersleeve-Conger Collection #0430

EARLY BRIDGE STREET

Fred Gildersleeve not only took iconic photographs of Waco, but he also photocopied much earlier pictures of the city. In doing so, he was able to preserve images such as this very early view of Bridge Street and the Waco Suspension Bridge.

c. 1880s. 8"x10" silver gelatin print
Photographer: Reproduced by F. A. Gildersleeve
Place: Waco, Texas
The Texas Collection General Photo Files #3976

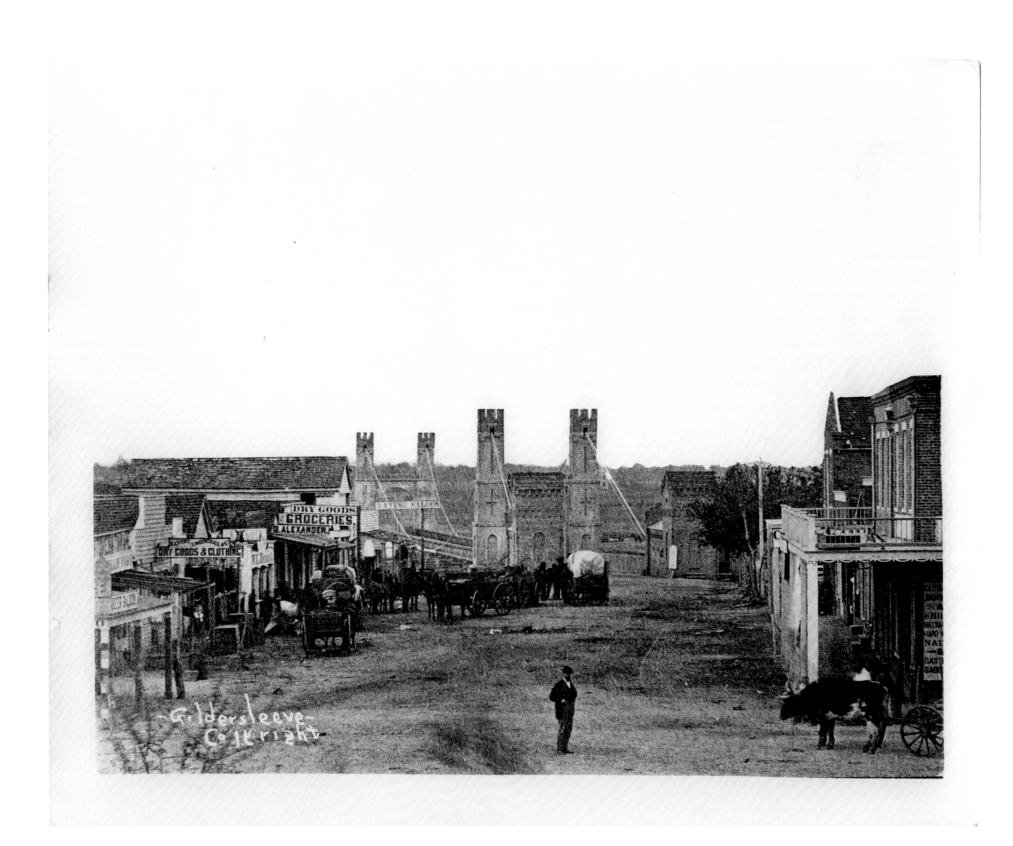

WACO SUSPENSION BRIDGE

The suspension bridge taken from the west side of
the Brazos River. Shown is how the bridge looked
before the redesign and application of stucco.

c. 1911. 8"x10" glass plate negative
Photographer: F. A. Gildersleeve
Place: Waco, Texas
Gildersleeve-Conger Collection #0430

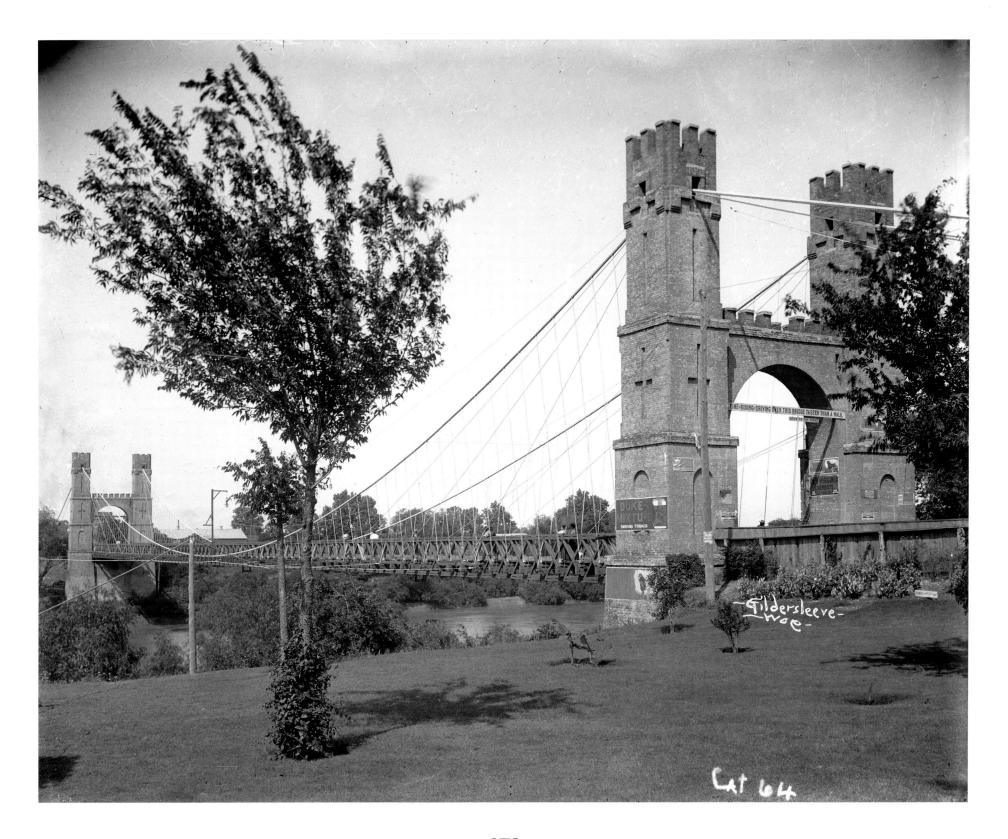

-Gildersleeve-
woe-

Cat 64

WACO SUSPENSION BRIDGE

Shown is the suspension bridge taken from the east
side of the Brozos River. The water appears to
be at flood level.

April 1916. 8"x10" glass plate negative
Photographer: F. A. Gildersleeve
Place: Waco, Texas
Gildersleeve-Conger Collection #0430

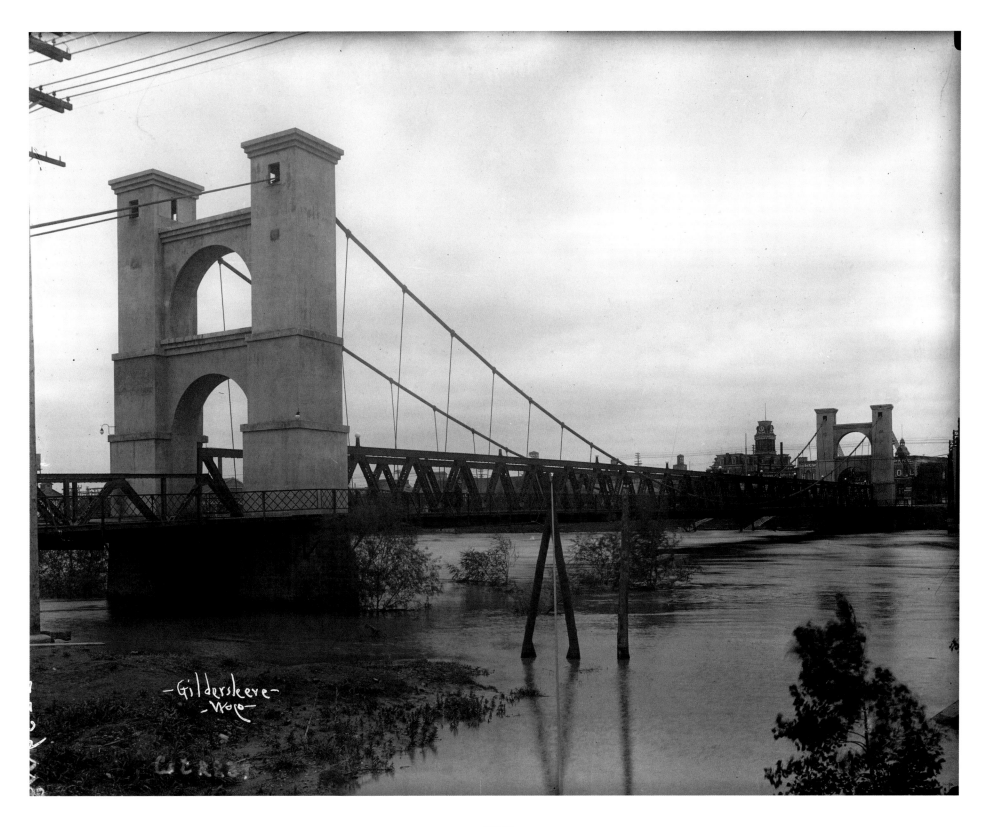

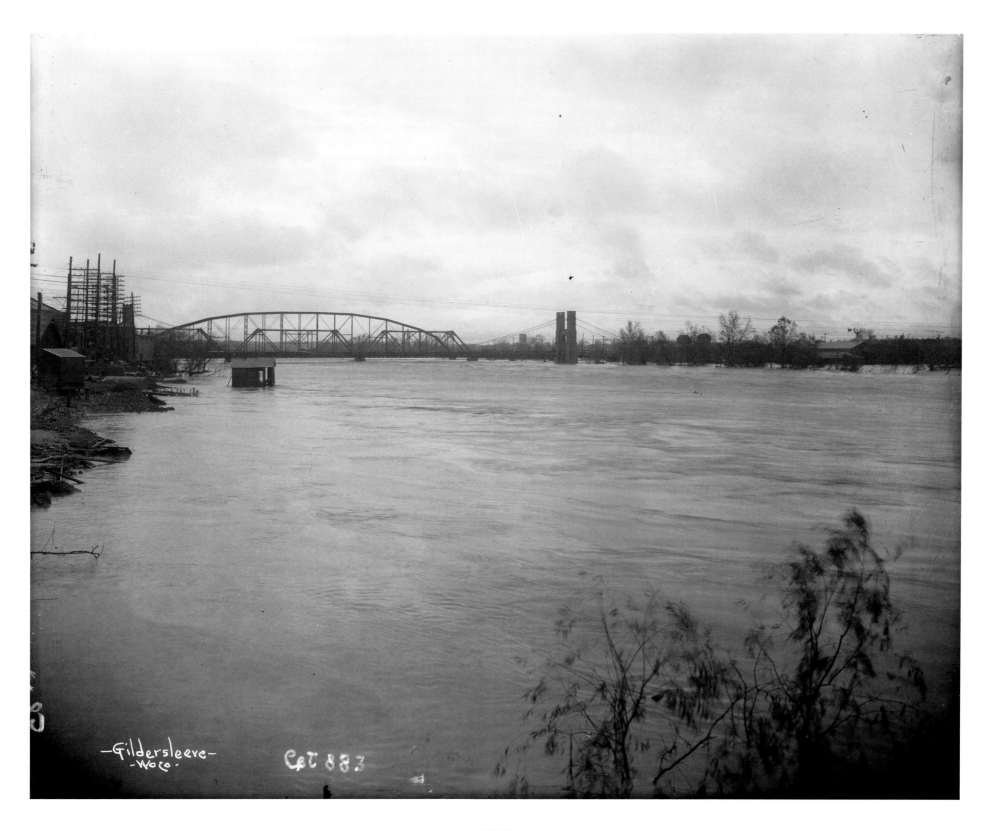

-Gildersleeve-
-Waco-

THE BRAZOS RIVER AT HIGH WATER
IN DOWNTOWN

The many buildings that once occupied Bridge Street and Washington Avenue are seen clearly from this vantage point taken from the old McLennan County Courthouse. Additionally, the Brazos River has reached a high level as can be seen in some flooding on the east side.

c. 1915. 8"x10" glass plate negative
Photographer: F. A. Gildersleeve
Place: Waco, Texas
Gildersleeve-Conger Collection #0430

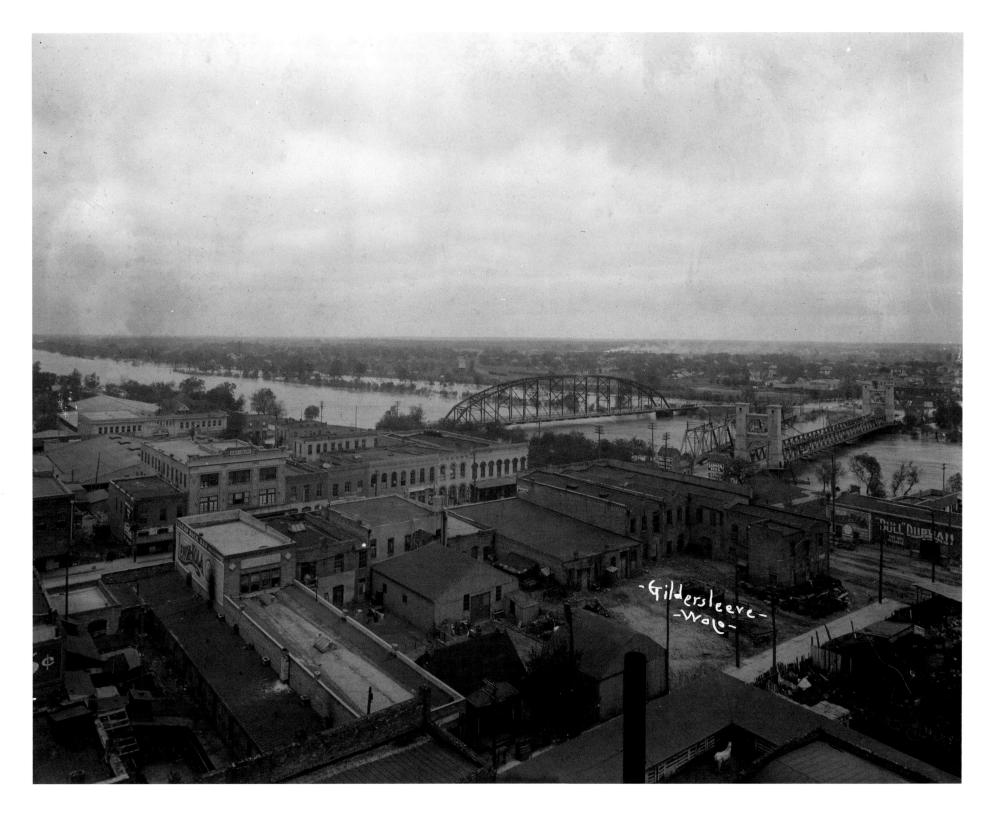

279

WACO INDUSTRY AND THE MIGHTY BRAZOS RIVER

To the left of the image stands the corner of
1st Street and Franklin Avenue, where D. June
Machinery stands. The noticeably high Brazos River
this year came very close to some of the buildings
in this once industrial part of the city.

April 1916. 8"x10" glass plate negative
Photographer: F. A. Gildersleeve
Place: Waco, Texas
Gildersleeve-Conger Collection #0430

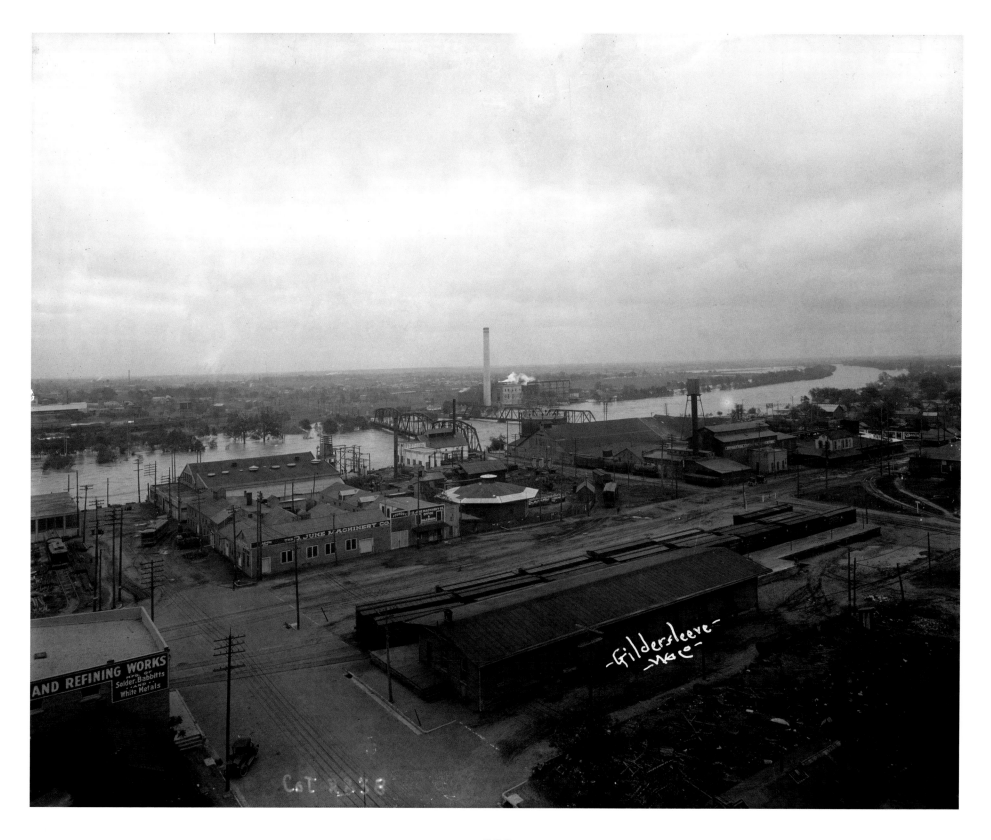

AND REFINING WORKS
Solder, Babbitts
and
White Metals

THE D. JUNE MACHINERY CO.

Gildersleeve
Waco

BIRD'S EYE VIEW OF DOWNTOWN

This view gives a good look at what was once the city square with Waco City Hall in the center and facing Austin Avenue. In the distance, the Waco Suspension Bridge and the Washington Avenue Bridge can be seen.

c. 1910. 8"x10" glass plate negative
Photographer: F. A. Gildersleeve
Place: Waco, Texas
Gildersleeve-Conger Collection #0430

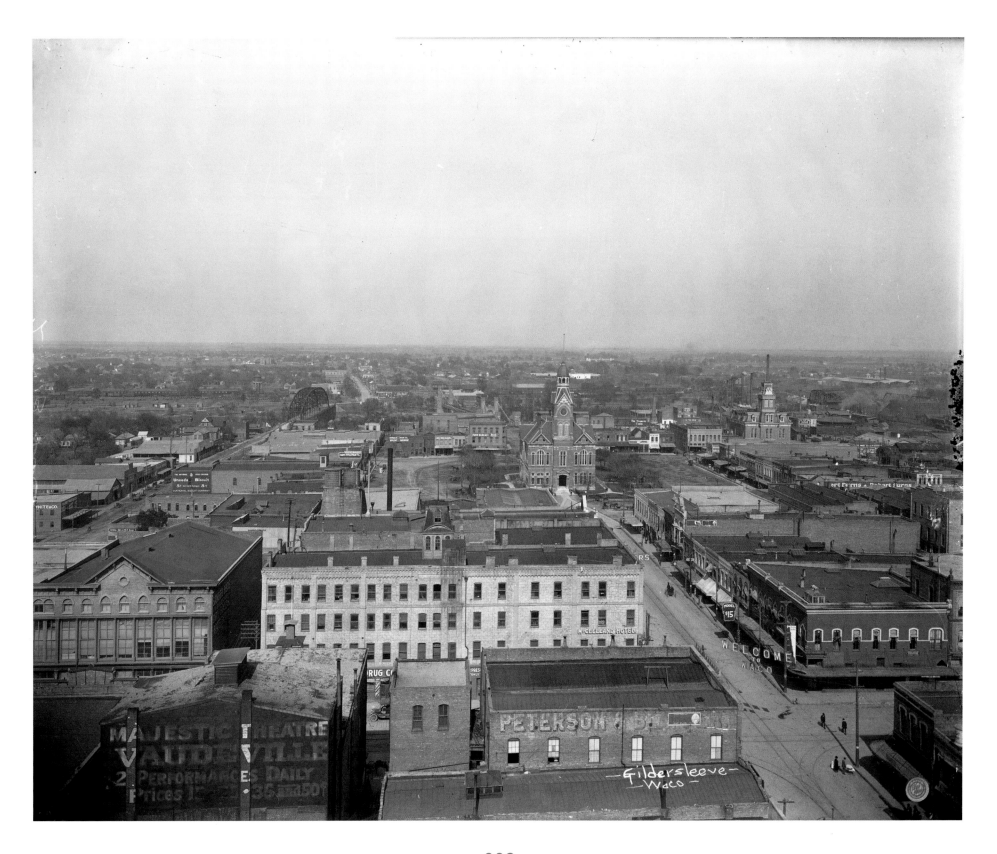

Gildersleeve
—Waco—

283

AMICABLE BUILDING CONSTRUCTION

The Amicable Life Insurance Company Building
during a very early phase of construction. In the
background, the R. T. Dennis Furniture Company
stands at the corner of 5th Street and Austin Avenue.

August 15, 1910. 8"x10" silver gelatin print
Photographer: F. A. Gildersleeve
Place: Waco, Texas
[Waco] Amicable Life Insurance Company Records #3196

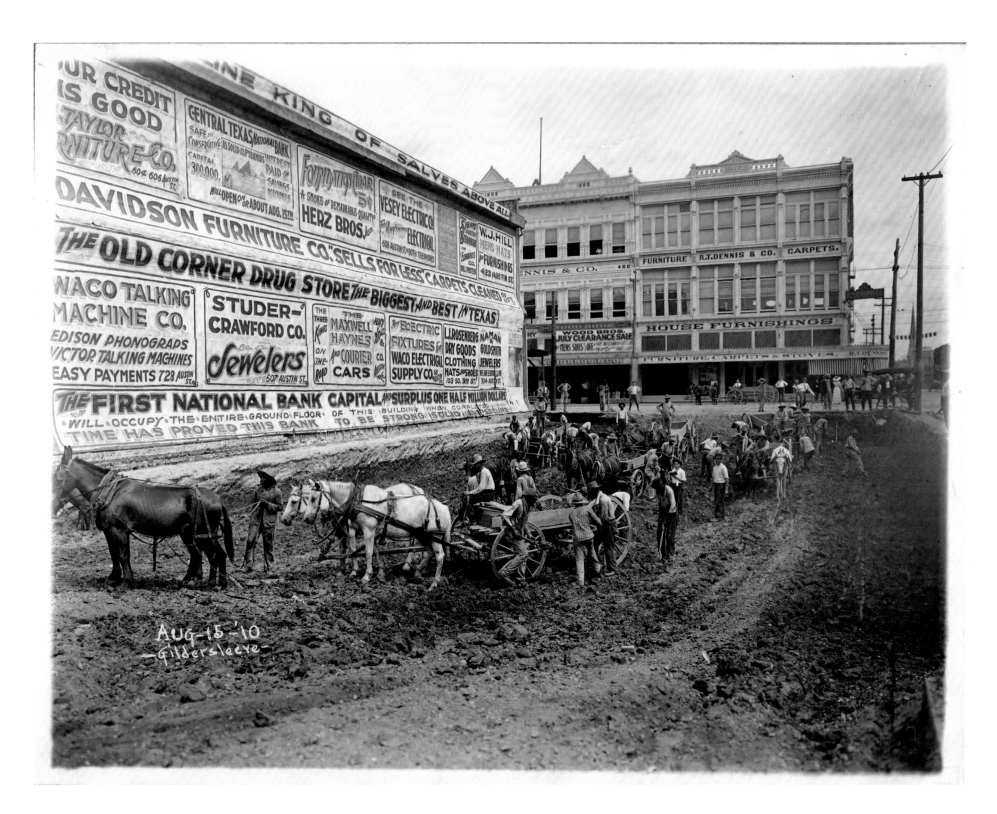

AUG-15-'10
–Gildersleeve–

AMICABLE BUILDING CONSTRUCTION

The construction of the Amicable Life Insurance Company Building drew many onlookers. This structure would soon rise above the city's skyline.

December 19, 1910. 8"x10" silver gelatin print
Photographer: F. A. Gildersleeve
Place: Waco, Texas
[Waco] Amicable Life Insurance Company Records #3196

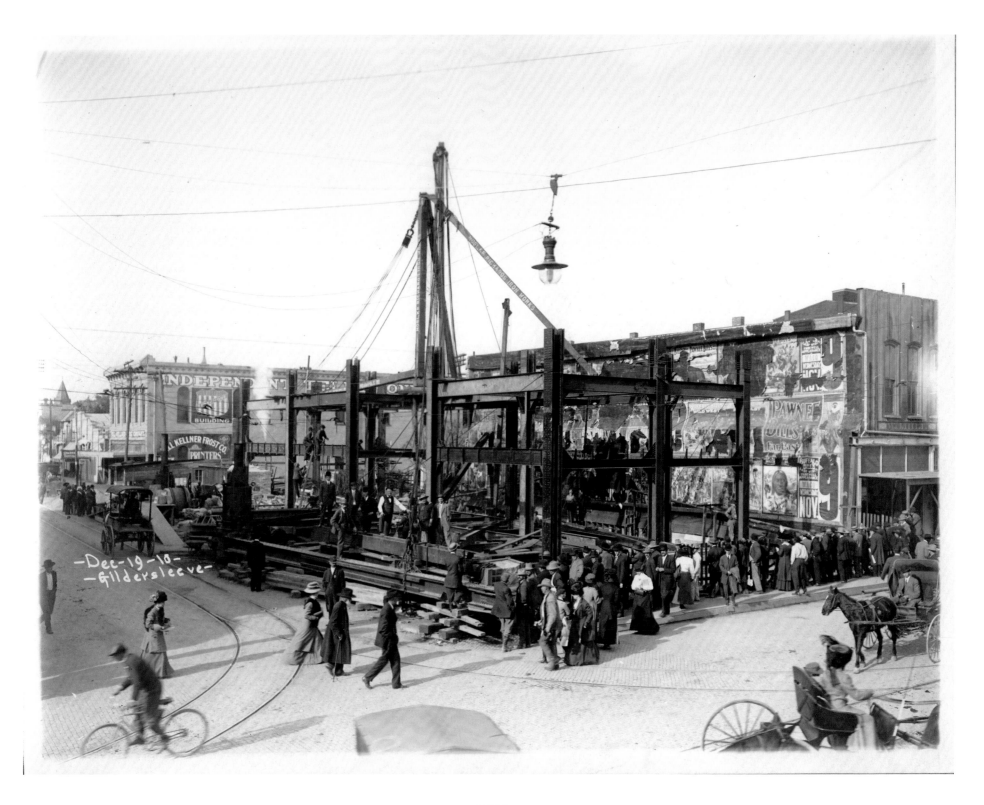

-Dec-19-10-
-Gildersleeve-

287

AMICABLE BUILDING CONSTRUCTION

The Amicable Life Insurance Company Building is starting to take shape at street level with its impressive granite columns facing Austin Avenue.

February 14, 1911. 8"x10" silver gelatin print

Photographer: F. A. Gildersleeve

Place: Waco, Texas

[Waco] Amicable Life Insurance Company Records #3196

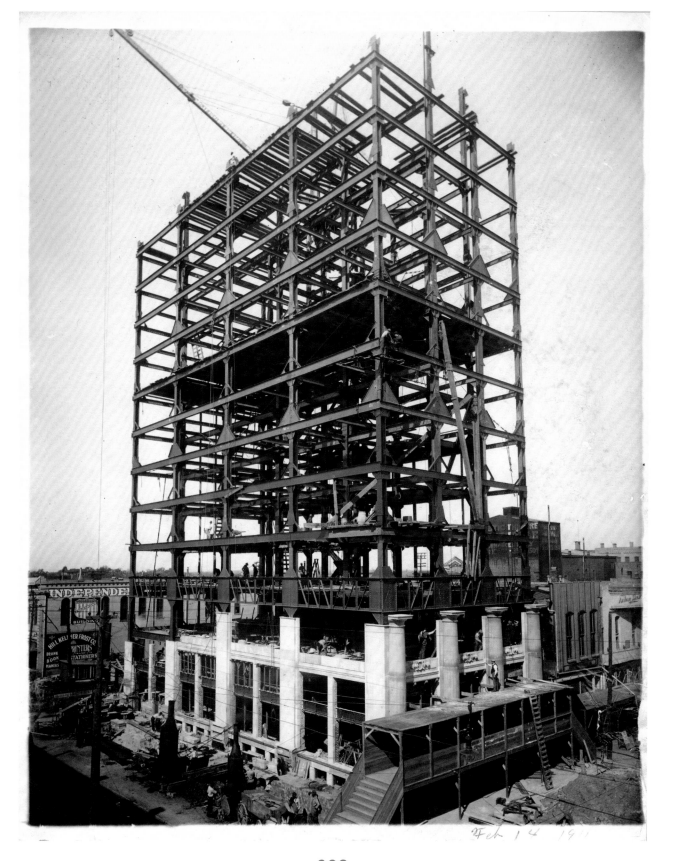

289

AMICABLE LIFE INSURANCE COMPANY BUILDING

The Amicable Life Insurance Company Building
several years after completion at 5th Street and
Austin Avenue. The structure being twenty-two
stories high once held the title as the tallest
building in the southwestern United States
in the time after its construction in 1911.

c. 1920s. 8"x13" silver gelatin print
Photographer: F. A. Gildersleeve
Place: Waco, Texas
[Waco] Amicable Life Insurance Company Records #3196

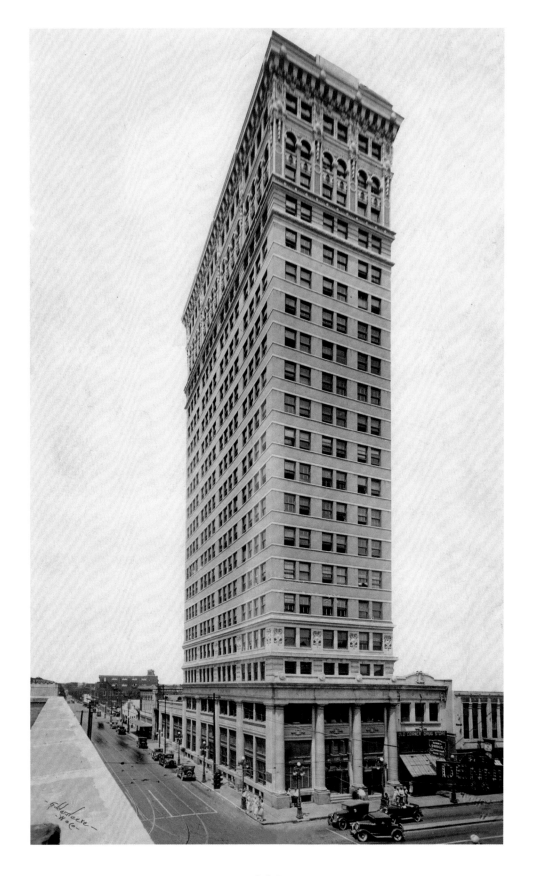

COTTON BELT RAILROAD DEPOT

**A busy Cotton Belt Depot at 4th and Mary Streets
awaits the arrival of a locomotive (far right).**

c. 1910. 8"x10" glass plate negative
Photographer: F. A. Gildersleeve
Place: Waco, Texas
Gildersleeve-Conger Collection #0430

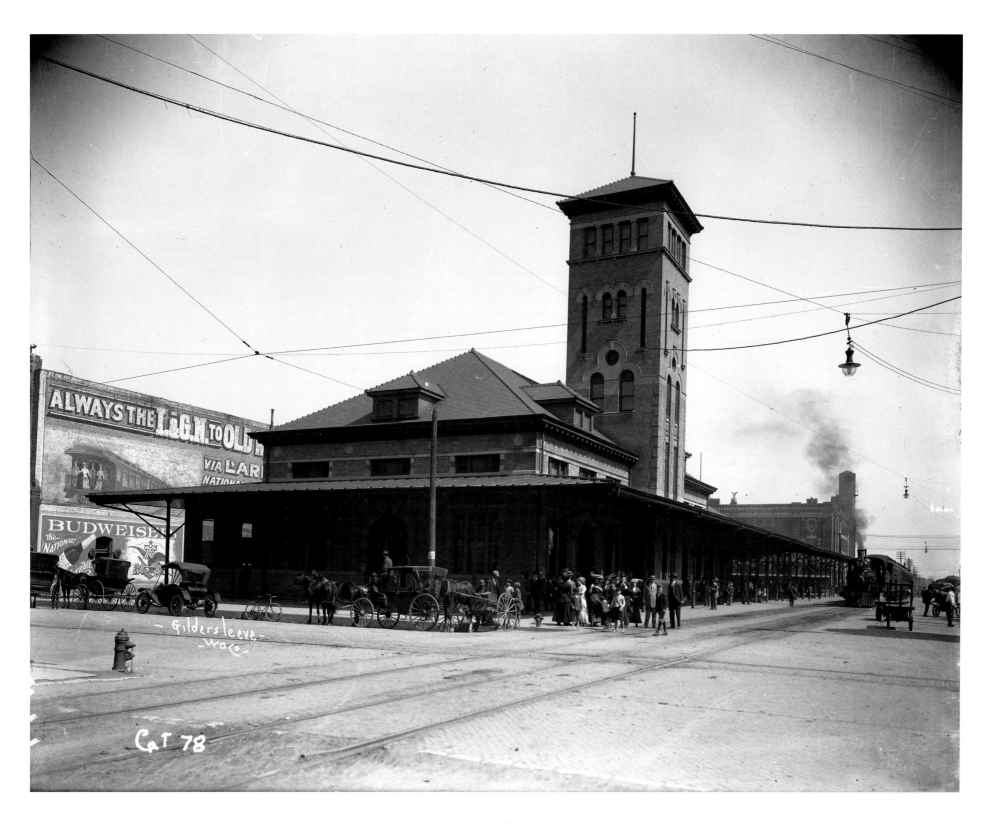

THE AUDITORIUM

The Auditorium was located at 6th Street and
Columbus Avenue. Outside, the marquee
assortment stands prominently in the photograph.

c. 1910. 8"x10" glass plate negative
Photographer: F. A. Gildersleeve
Place: Waco, Texas
Gildersleeve-Conger Collection #0430

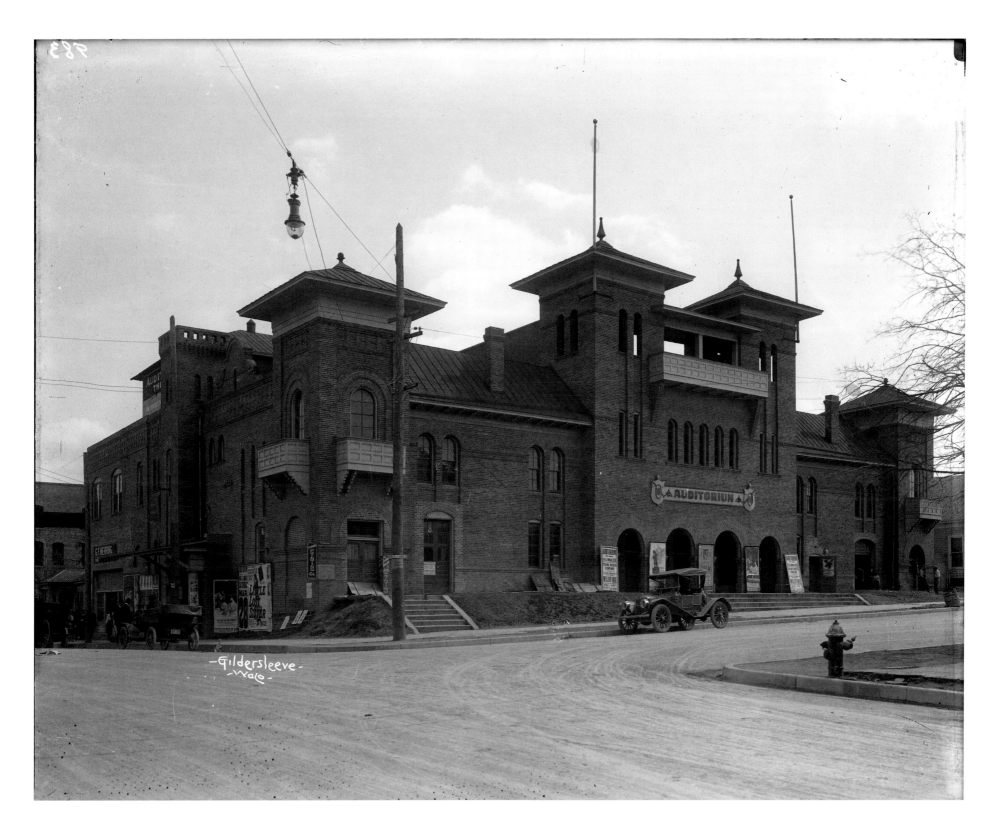

-Gildersleeve-
-Waco-

J.F. HOPKINS CARRIAGE SHOP

The J.F. Hopkins Carriage Shop specialized in blacksmithing, horseshoeing, carriage and wagon making, and services for automobiles. The business was located at 214–218 South 5th Street.

c. 1911. 8"x10" glass plate negative
Photographer: F. A. Gildersleeve
Place: Waco, Texas
Gildersleeve-Conger Collection #0430

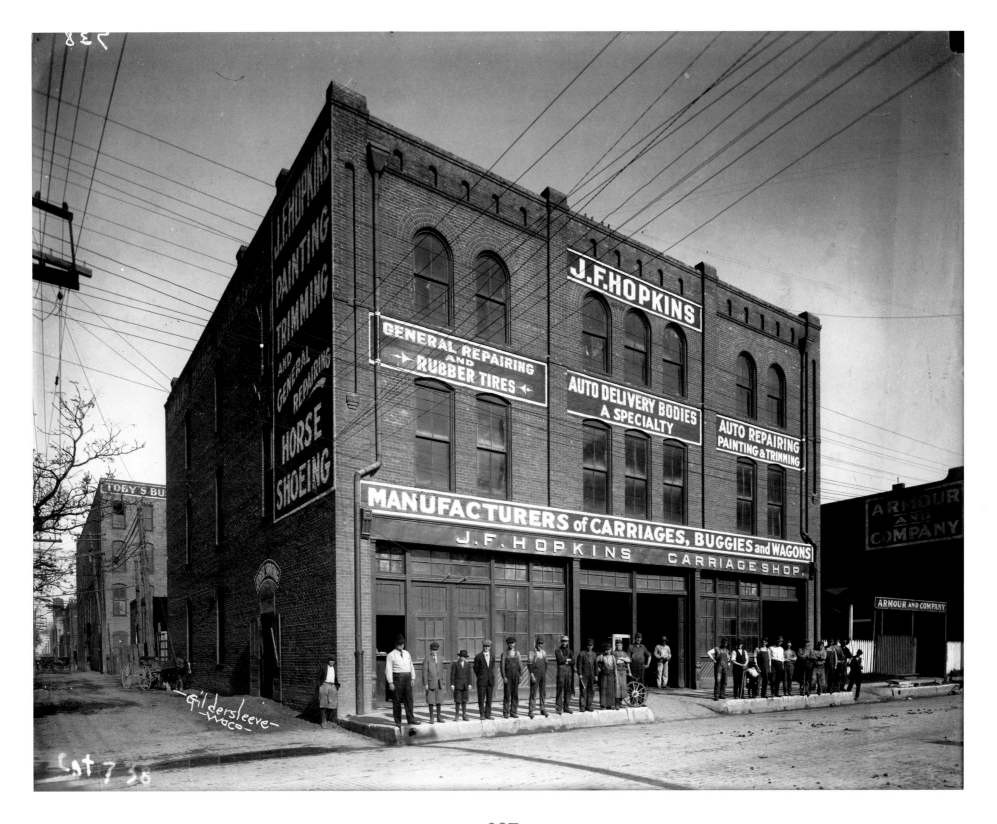

297

THE TEXAS COTTON PALACE FROM THE AIR

The Texas Cotton Palace was an enormous complex.
The original main building burned just after it was
built in 1895 and wasn't rebuilt or restarted until
1910. The event held its last exposition in 1930
and received a total of more than eight million
visitors during its two-decade existence.

c. 1919. 8"x10" silver gelatin print
Photographer: F. A. Gildersleeve
Place: Waco, Texas
George H. Williams Papers #3297

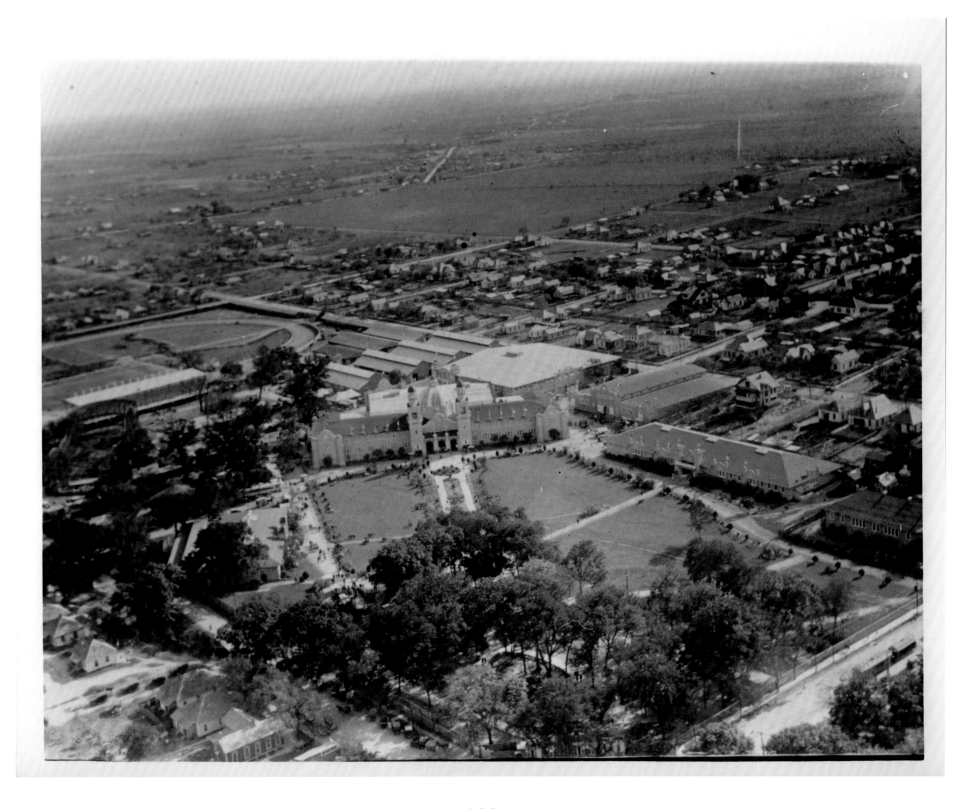

TEXAS COTTON PALACE MAIN BUILDING AT NIGHT

A view of the Texas Cotton Palace main
building lit up at night.

1912. 8"x10" glass plate negative
Photographer: F. A. Gildersleeve
Place: Waco, Texas
Gildersleeve-Conger Collection #0430

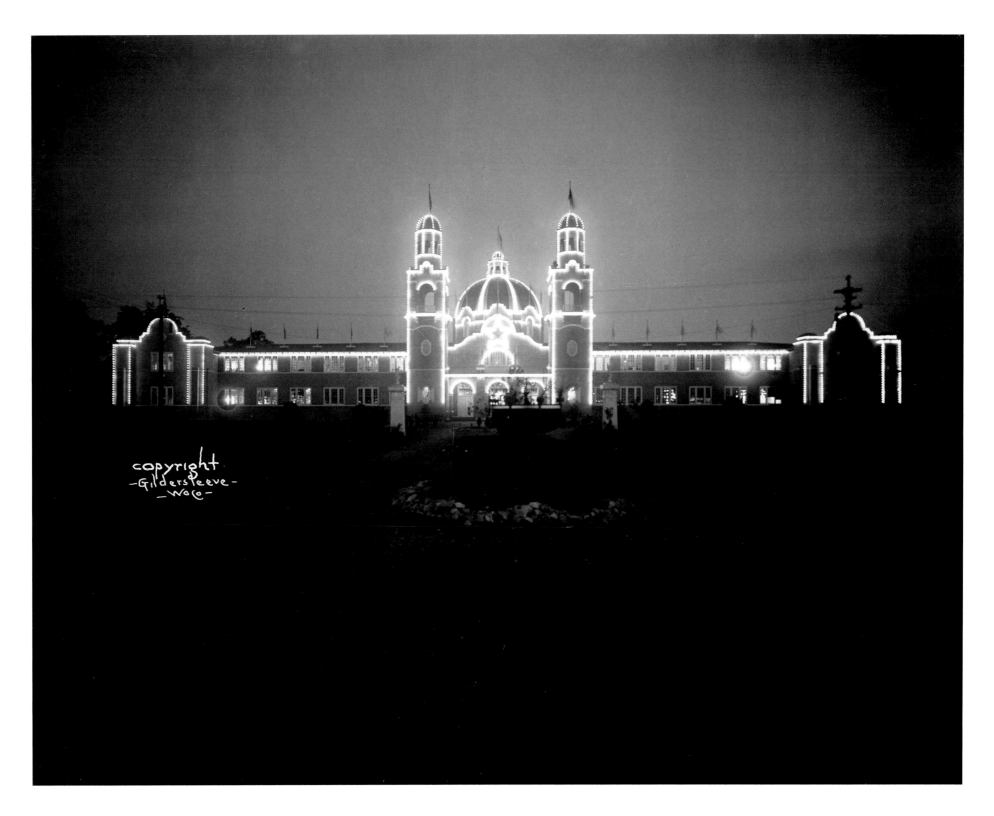

301

TEXAS COTTON PALACE MAIN BUILDING AT NIGHT

A close-up view of the Texas Cotton Palace main building lit up at night.

1912. 8"x10" glass plate negative
Photographer: F. A. Gildersleeve
Place: Waco, Texas
Gildersleeve-Conger Collection #0430

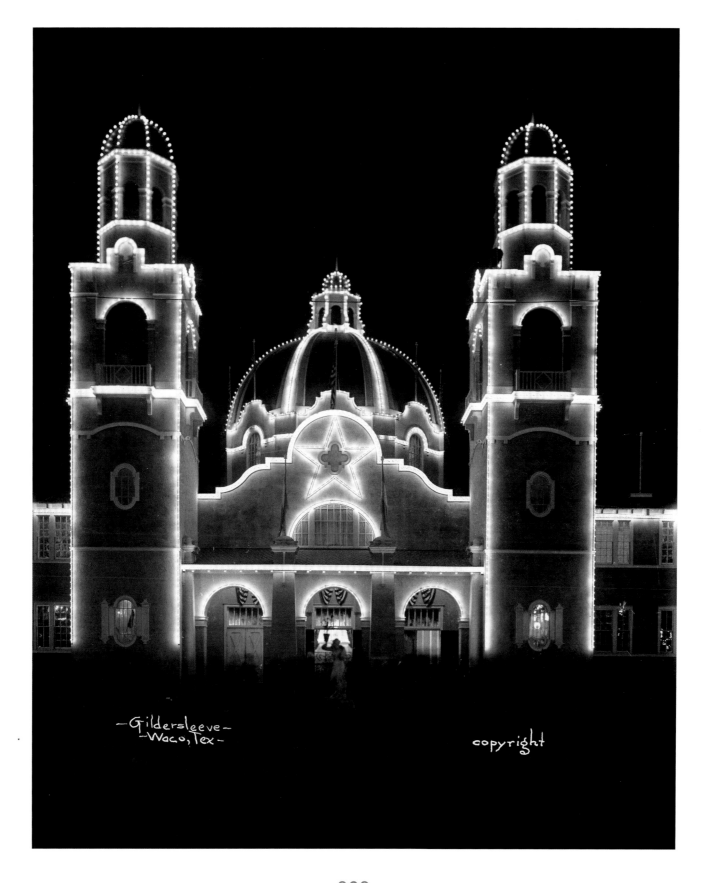

-Gildersleeve-
-Waco, Tex-

copyright

TEXAS COTTON PALACE'S BALE ARCH

The Texas Cotton Palace's bale archway
represented the event in an impressive way upon
entering. It was located at Clay Avenue
near the exposition's entranceway.

1914. 8"x10" glass plate negative
Photographer: F. A. Gildersleeve
Place: Waco, Texas
Gildersleeve-Conger Collection #0430

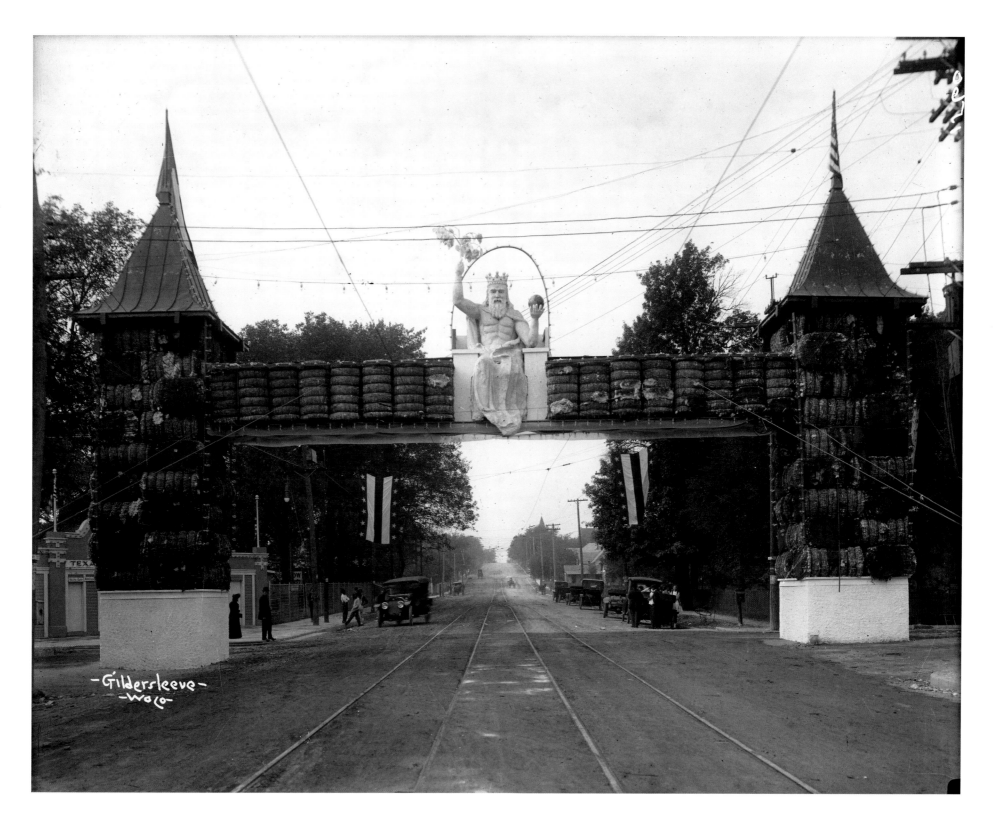

305

ST. BASIL'S COLLEGE

St. Basil's College was located near the present site of Reicher Catholic High School. Construction began in 1902, and the college was later closed by the Basilian Fathers in 1915.

c. 1912. 8"x10" silver gelatin print
Photographer: F. A. Gildersleeve
Place: Waco, Texas
The Texas Collection General Photo Files #3976

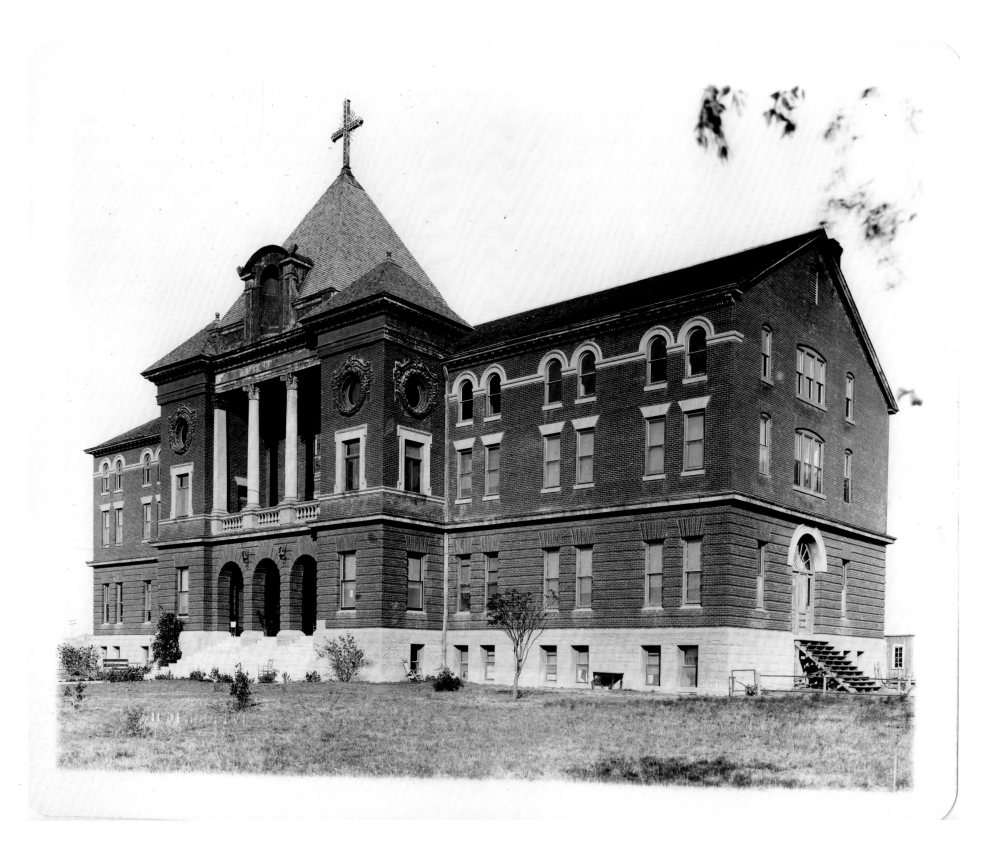

WACO CITY HALL

**Wagons full of corn and stacked with hay bales
surround the front of city hall in this market scene.**

c. 1912. 8"x10" glass plate negative
Photographer: F. A. Gildersleeve
Place: Waco, Texas
Gildersleeve-Conger Collection #0430

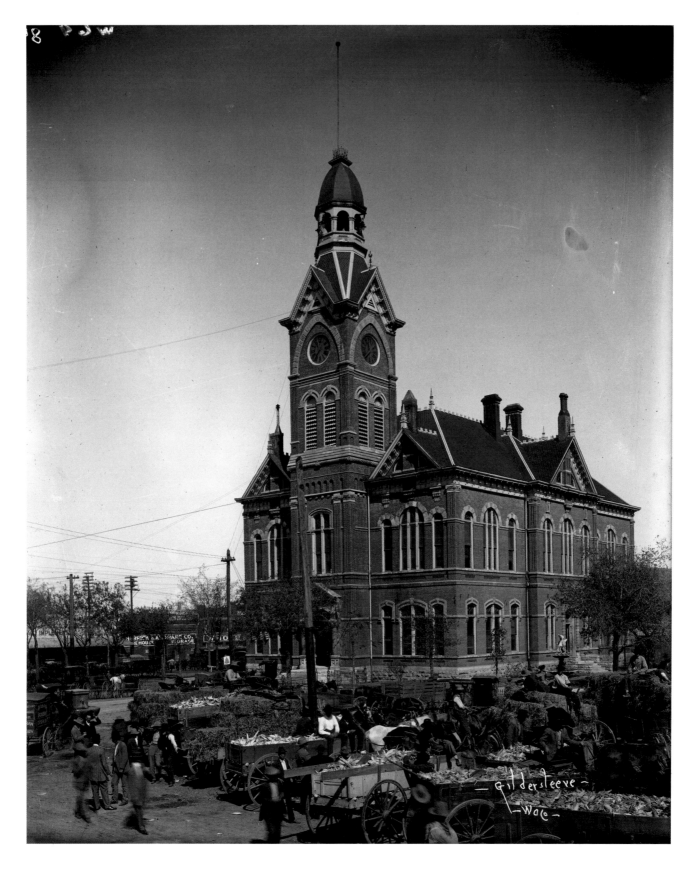

Gildersleeve
Waco

THE COTTONLAND CASTLE

Known as "The Castle," construction began in 1890
but was halted for some years and not finished
until 1913. The exterior is built of limestone and
sandstone and is located at 3300 Austin Avenue.

c. 1913. 3"x4" silver gelatin print
Photographer: F. A. Gildersleeve
Place: Waco, Texas
Roy Ellsworth Lane Collection #441

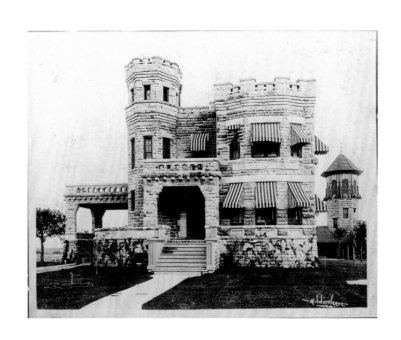

FRANKLIN AVENUE

**This view looking west up Franklin Avenue
shows an array of people, automobiles, and wagons.**

c. 1913. 8"x10" glass plate negative
Photographer: F. A. Gildersleeve
Place: Waco, Texas
Gildersleeve-Conger Collection #0430

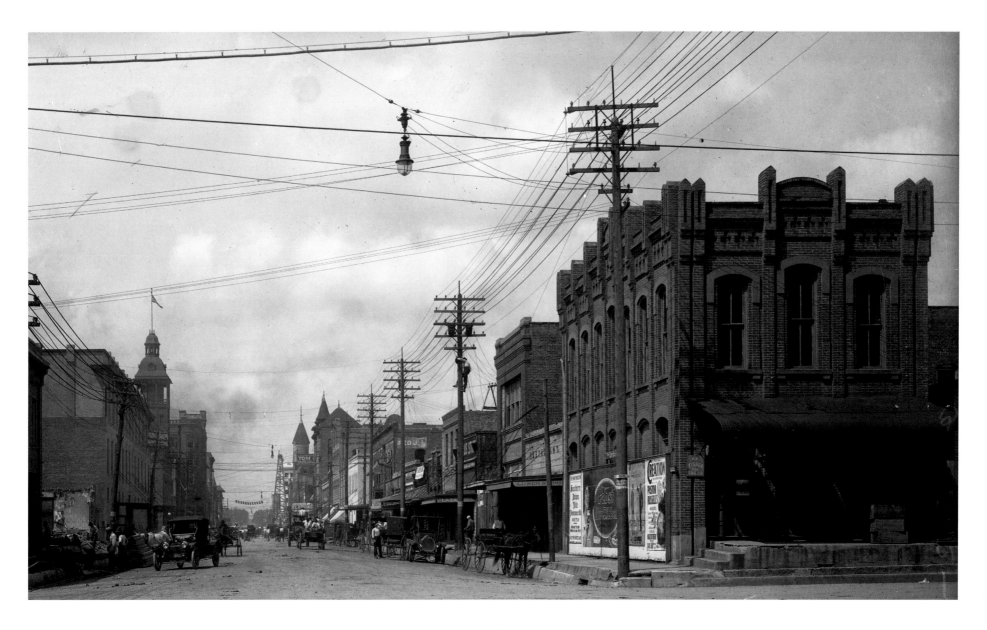

313

ELM STREET

This scene looking east from the 300 block of
Elm Street shows the complexity of the wires and
tracks of the street cars. People, horses, and carts
line the once busy but flood-prone street.

c. 1913. 8"x10" glass plate negative
Photographer: F. A. Gildersleeve
Place: Waco, Texas
Gildersleeve-Conger Collection #0430

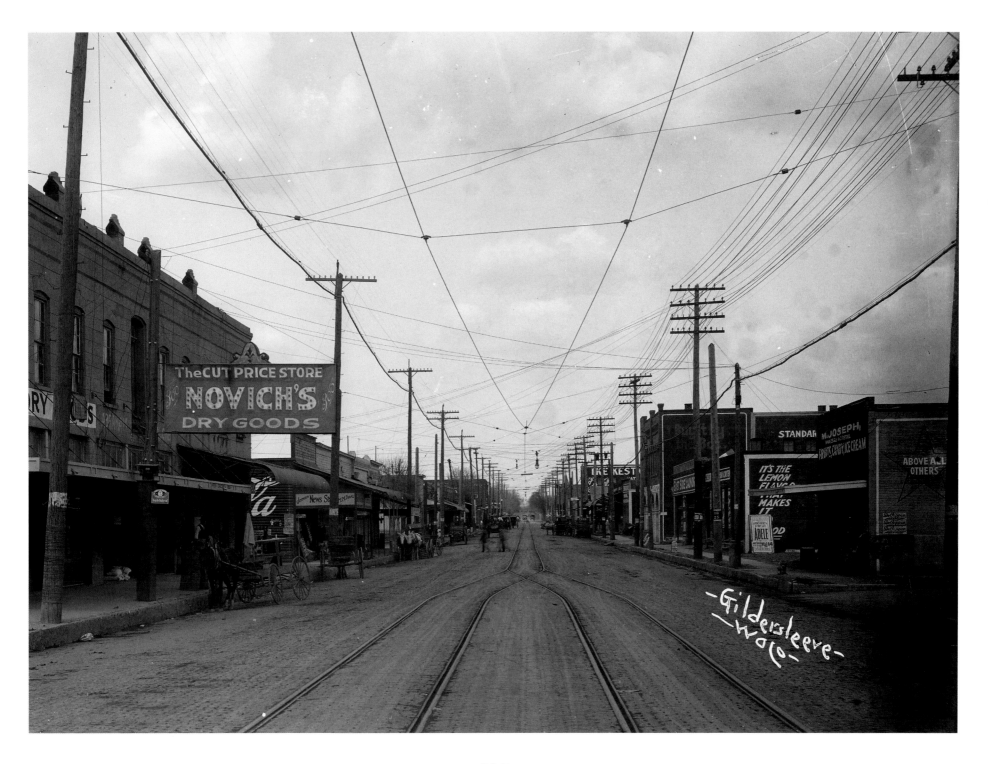

A VIEW OF WASHINGTON AVENUE

This scene shows the McLennan County Courthouse
on the left at 501 Washington Avenue and many
businesses across the street. It also depicts how
active the area was with cars, wagons, and
a streetcar in the distance.

c. 1913. 8"x10" glass plate negative
Photographer: F. A. Gildersleeve
Place: Waco, Texas
Gildersleeve-Conger Collection #0430

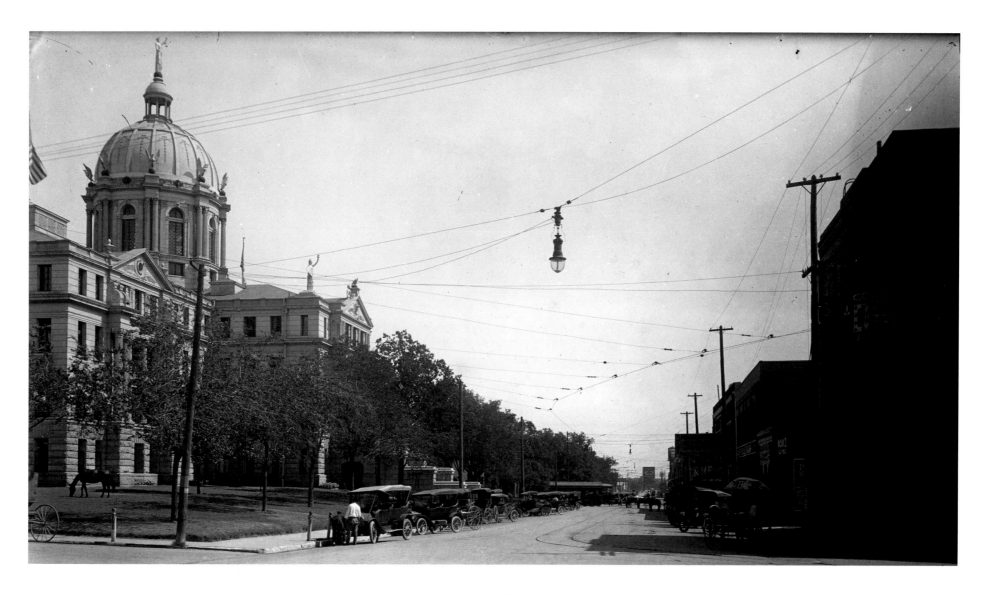

AUSTIN AVENUE

Looking toward Waco City Hall, landmarks such as
the Elite Café, Goldstein-Migel, and numerous
other long-gone establishments can be seen. Many
people line the city streets as they shop in one
of the busiest locations in the city.

1934. 8"x10" silver gelatin print
Photographer: F. A. Gildersleeve
Place: Waco, Texas
The Texas Collection General Photo Files #3976

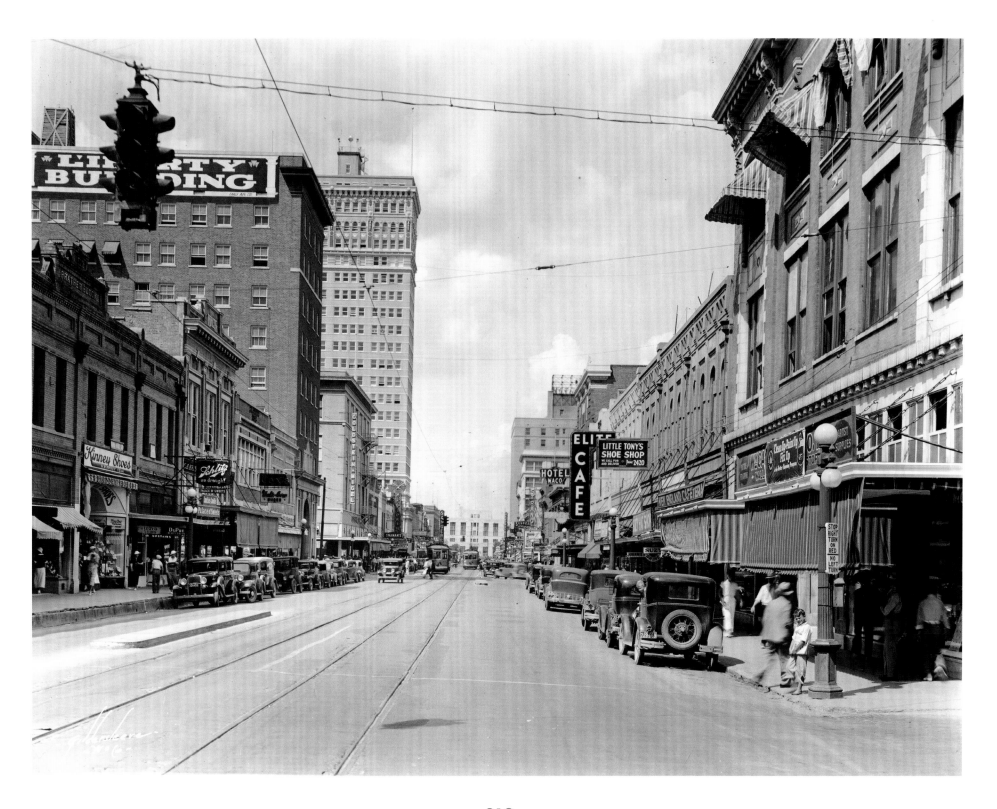

319

AUSTIN AVENUE

This image looking up Austin Avenue from Waco
City Hall shows the city's central business district.
Shops line the busy street along with shoppers,
autos, and streetcars.

1935. 8"x10" silver gelatin print
Photographer: F. A. Gildersleeve
Place: Waco, Texas
The Texas Collection General Photo Files #3976

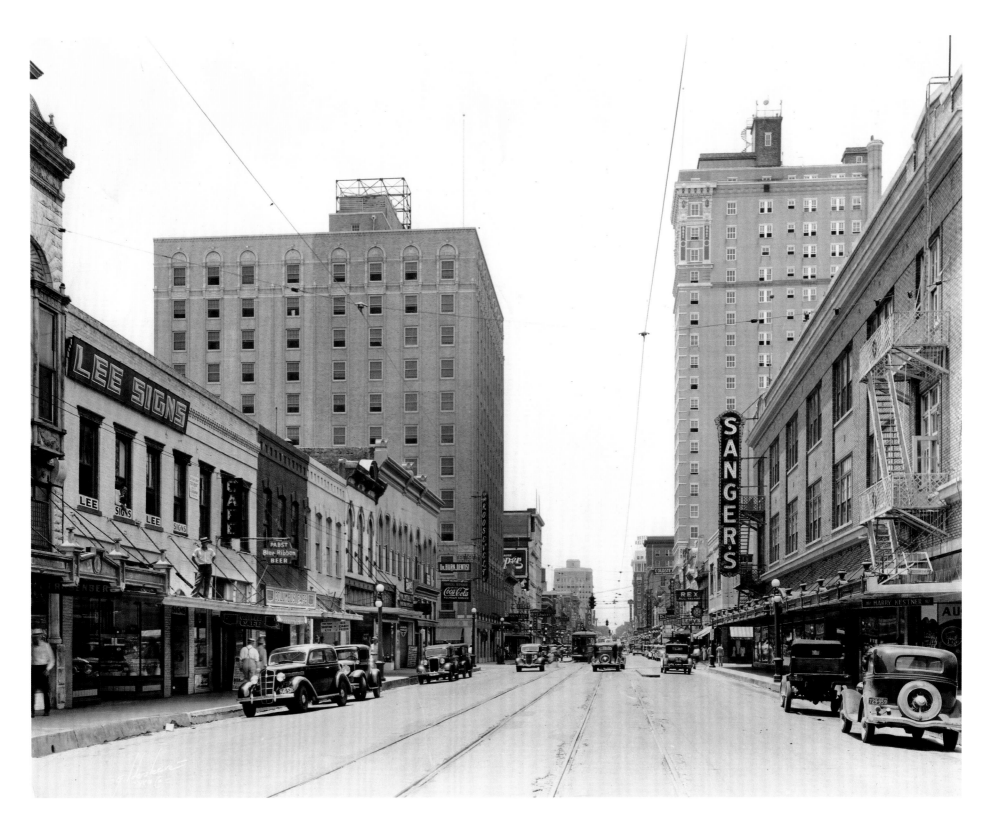

AUSTIN AVENUE AT NIGHT

An unusual early nighttime look at Austin Avenue
taken from 3rd Street looking
toward the Amicable Building.

1916. 8"x10" glass plate negative
Photographer: F. A. Gildersleeve
Place: Waco, Texas
Gildersleeve-Conger Collection #0430

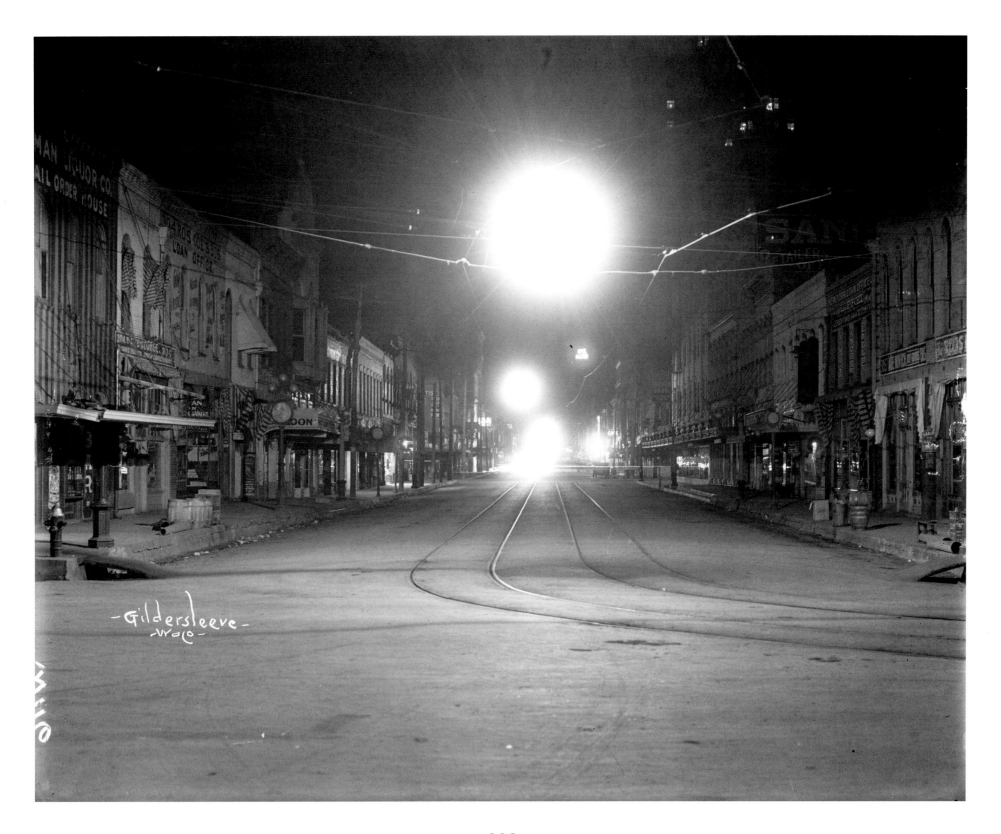

WACO MILL AND ELEVATOR COMPANY

The Waco Mill and Elevator Company was the maker of "Belle of Waco Flour." At the time, they advertised that steam driven machinery had been replaced with electric motors and that "This is the Only Flour Mill in the Entire South That Has This Modern Equipment." The facility was located at 2nd and Jackson Streets.

c. 1913. 8"x10" glass plate negative
Photographer: F. A. Gildersleeve
Place: Waco, Texas
Gildersleeve-Conger Collection #0430

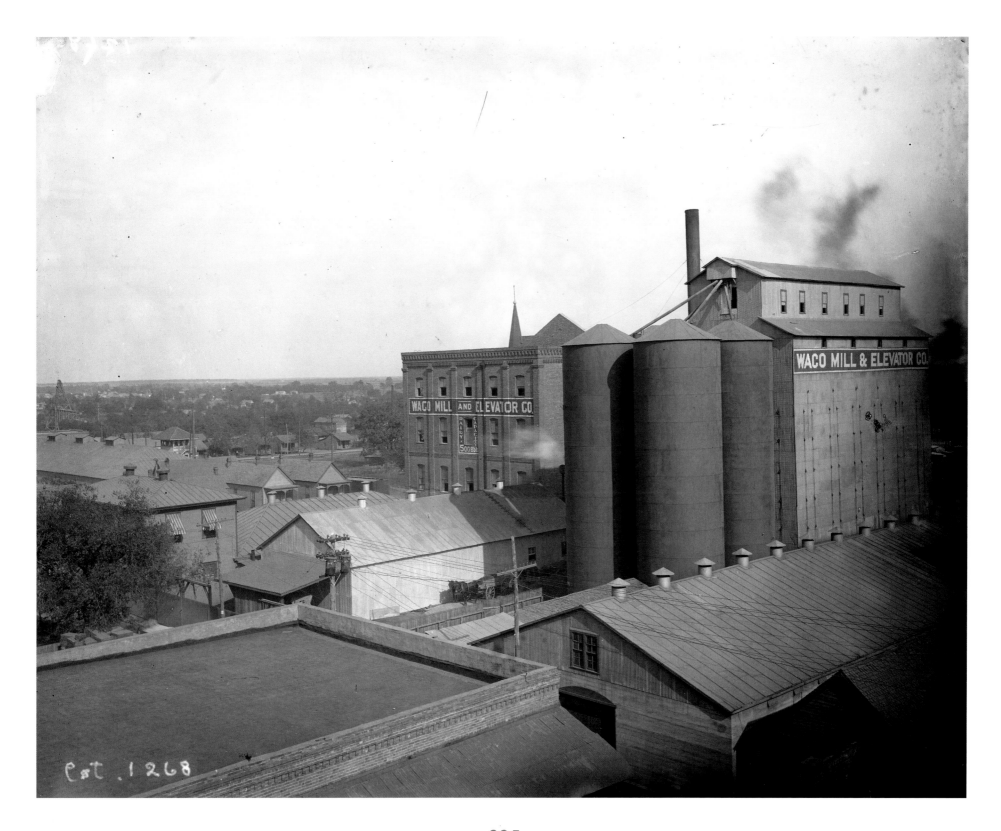

Est. 1268

HOTEL BRAZOS

A large group of people stand outside of the Hotel Brazos for this promotional picture. The business was located at 316 South 8th Street.

1913. 8"x10" glass plate negative
Photographer: F. A. Gildersleeve
Place: Waco, Texas
Gildersleeve-Conger Collection #0430

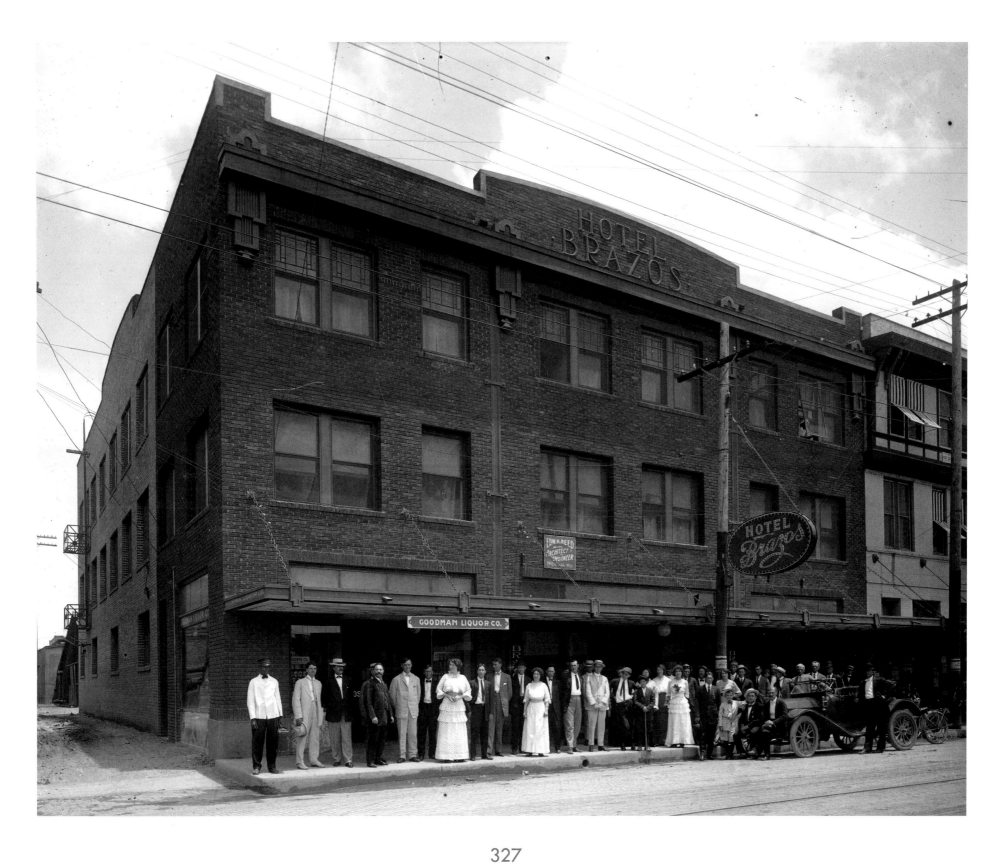

THE HOTEL METROPOLE

This hotel was once located at 4th Street and
Franklin Avenue. The establishment advertised
that it is "A good place for your mother,
wife, and sisters."

c. 1913. 8"x10" silver gelatin print
Photographer: F. A. Gildersleeve
Place: Waco, Texas
Gildersleeve-Conger Collection #0430

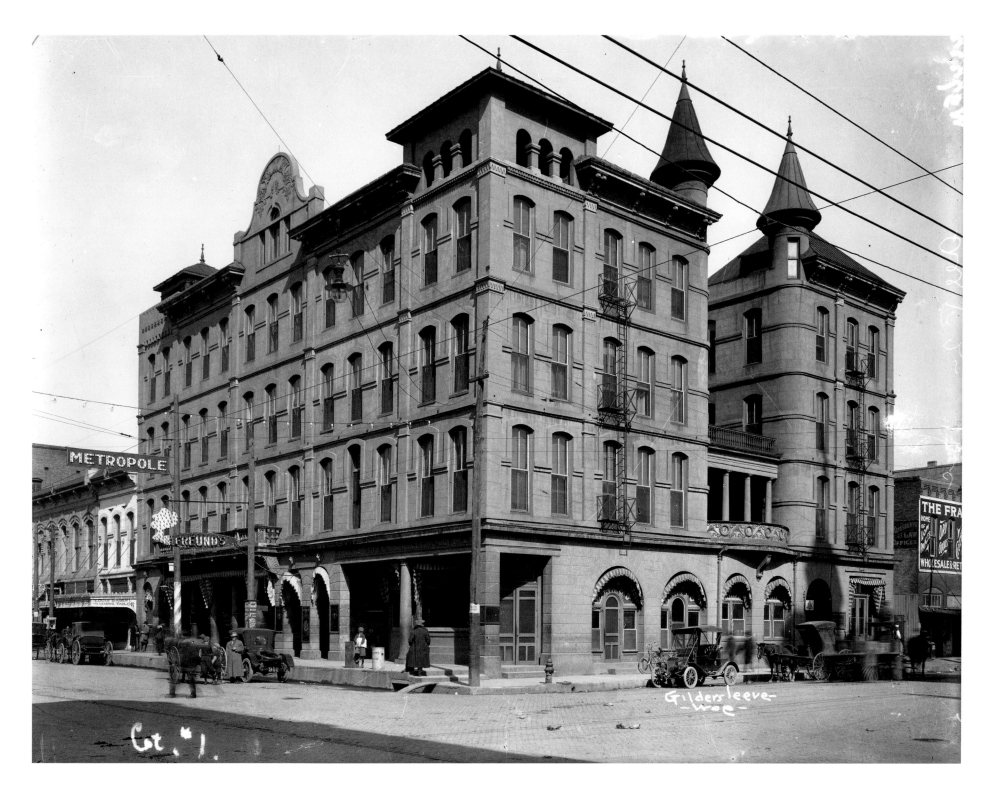

329

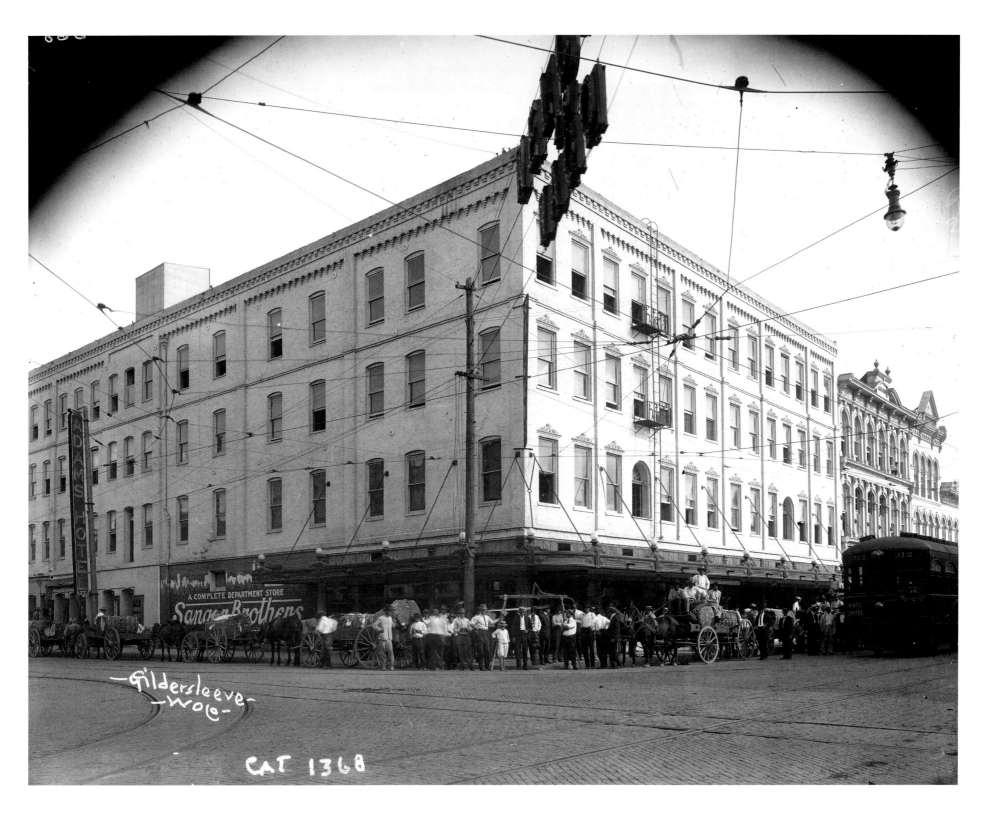

A COMPLETE DEPARTMENT STORE

Sanger Brothers

Gildersleeve
-wolc-

CAT 1368

R.T. DENNIS FURNITURE COMPANY

The R.T. Dennis Building stood at 5th Street and
Austin Avenue. In 1953, this structure and much
of the surrounding area was destroyed by
a devastating tornado. In Waco the storm
killed 114 people and 22 of these were employees
at work in this building.

c. 1915. 8"x10" glass plate negative
Photographer: F. A. Gildersleeve
Place: Waco, Texas
Gildersleeve-Conger Collection #0430

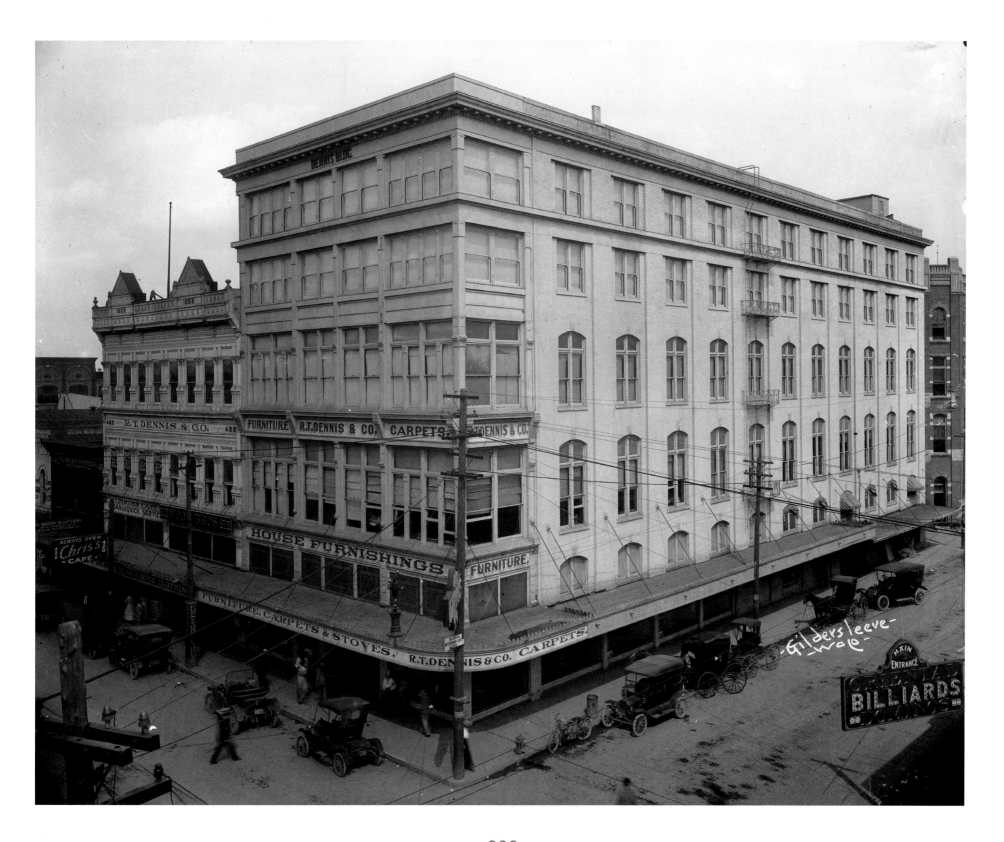

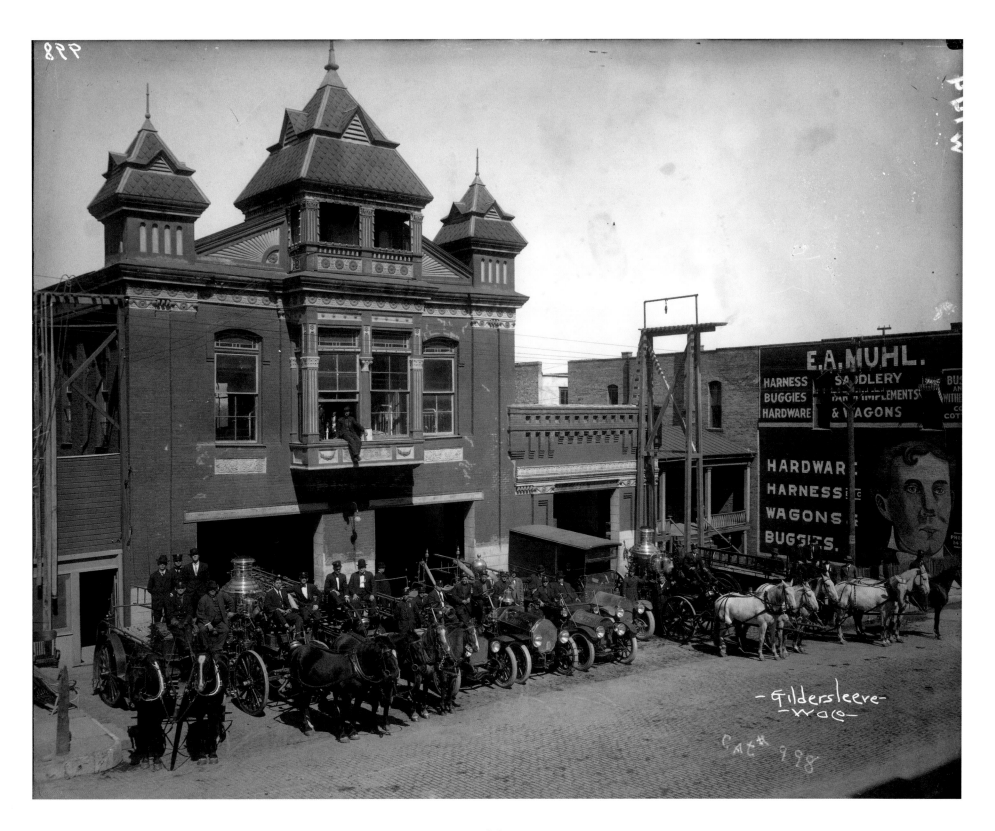

335

CENTRAL FIRE STATION

The Waco Central Fire Station displays its fine array
of fire equipment, horses, and personnel.

c. 1915. 8"x10" glass plate negative
Photographer: F. A. Gildersleeve
Place: Waco, Texas
Gildersleeve-Conger Collection #0430

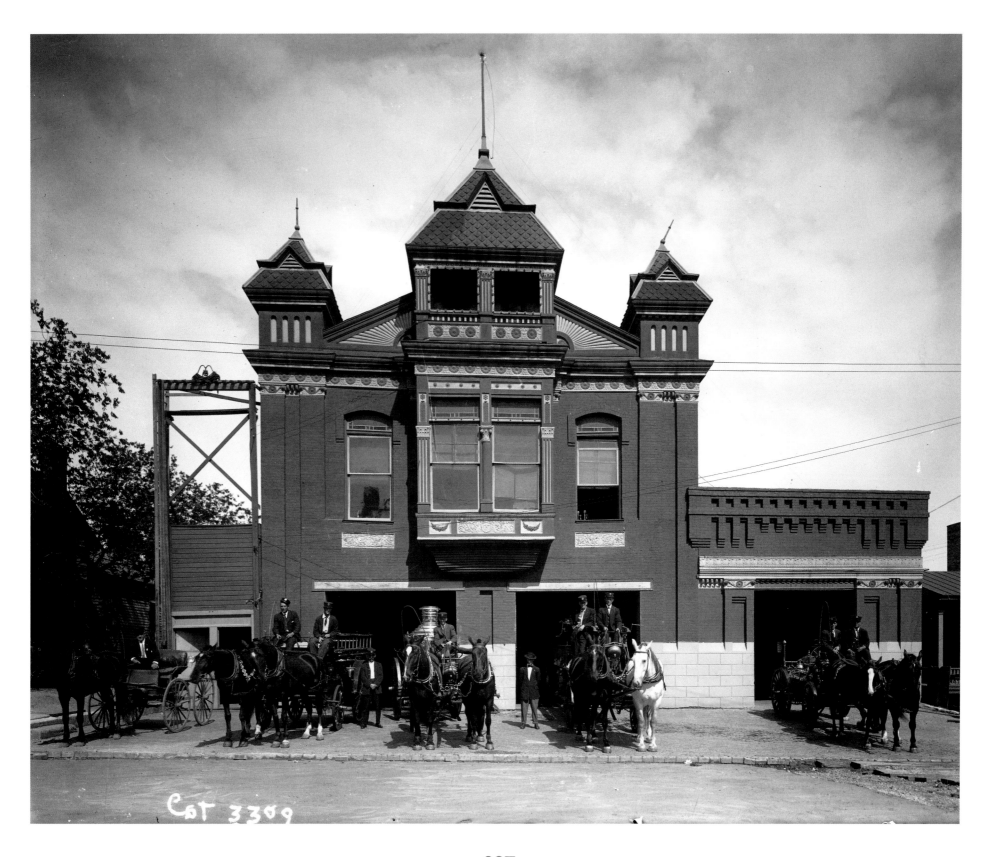

Cot 3309

PROVIDENT BUILDING

The Provident National Bank Building used to be one
of Waco's tallest structures. It was located at
4th Street and Franklin Avenue and is shown
decorated for the Fourth of July.

July 1916. 8"x10" glass plate negative
Photographer: F. A. Gildersleeve
Place: Waco, Texas
Gildersleeve-Conger Collection #0430

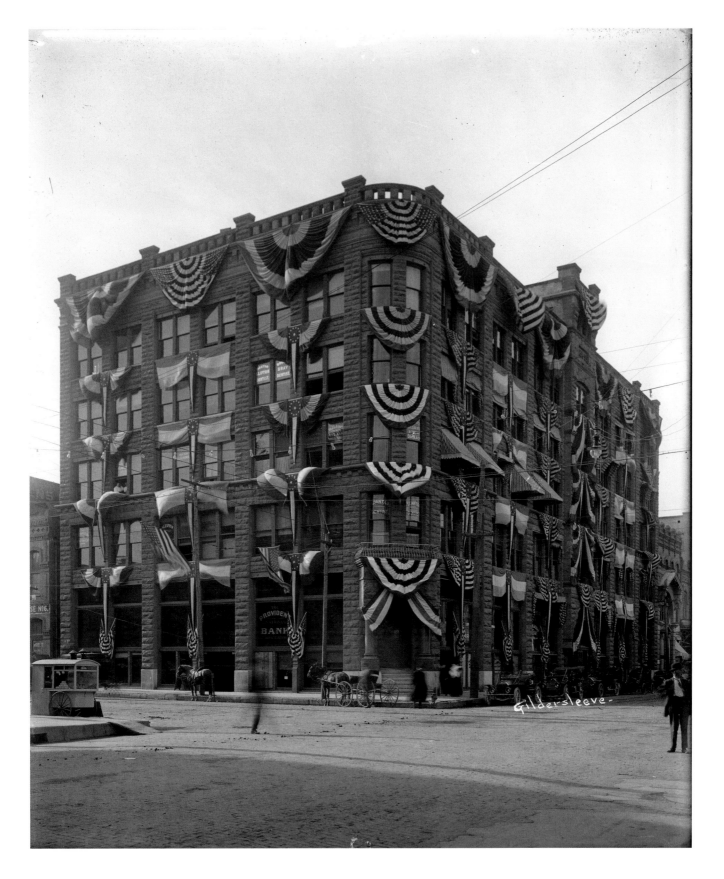

THE CRYSTAL PALACE STUDIO AND POOL

The Crystal Palace Studio and Pool was a popular
attraction located right in the city's business district.
The Padgitt Building can be seen in the background.
The palace and pool were located on 121 South
5th Street intersecting Franklin Avenue.

c. 1920. 8"x10" cellulose nitrate negative
Photographer: F. A. Gildersleeve
Place: Waco, Texas
Gildersleeve-Conger Collection #0430

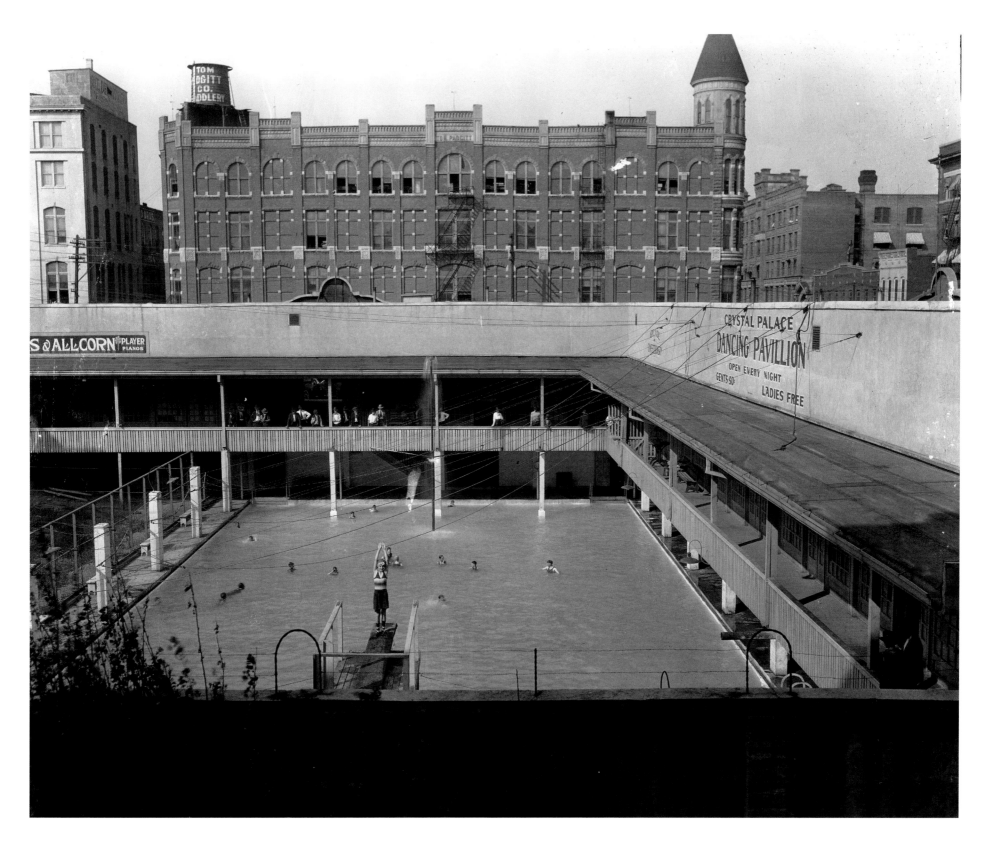

MEXIA GAS EXPLOSION

On February 16, 1916, a gas explosion brought
down or damaged a half block of buildings
including a two-story opera house and other
structures in downtown Mexia, Texas. Nine people were
killed in the incident. The image shows stunned
onlookers viewing the debris.

February 1916. 8"x10" glass plate negative
Photographer: F. A. Gildersleeve
Place: Mexia, Texas
Gildersleeve-Conger Collection #0430

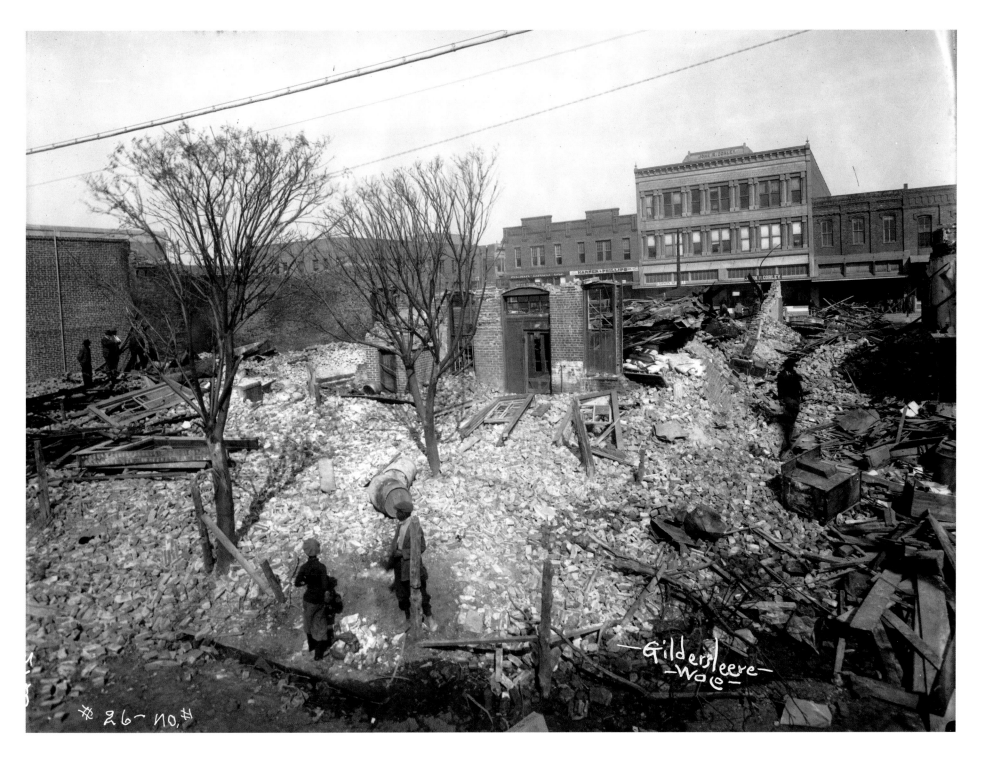

Gildersleeve
-Waco-

26-10.#

343

TEXAS STATE CAPITOL BUILDING

The Texas State Capitol building and grounds
stand prominent in this photograph. Completed in
1888, its construction took nearly seven years.

c. 1910. 8"x10" glass plate negative
Photographer: F. A. Gildersleeve
Place: Austin, Texas
Gildersleeve-Conger Collection #0430

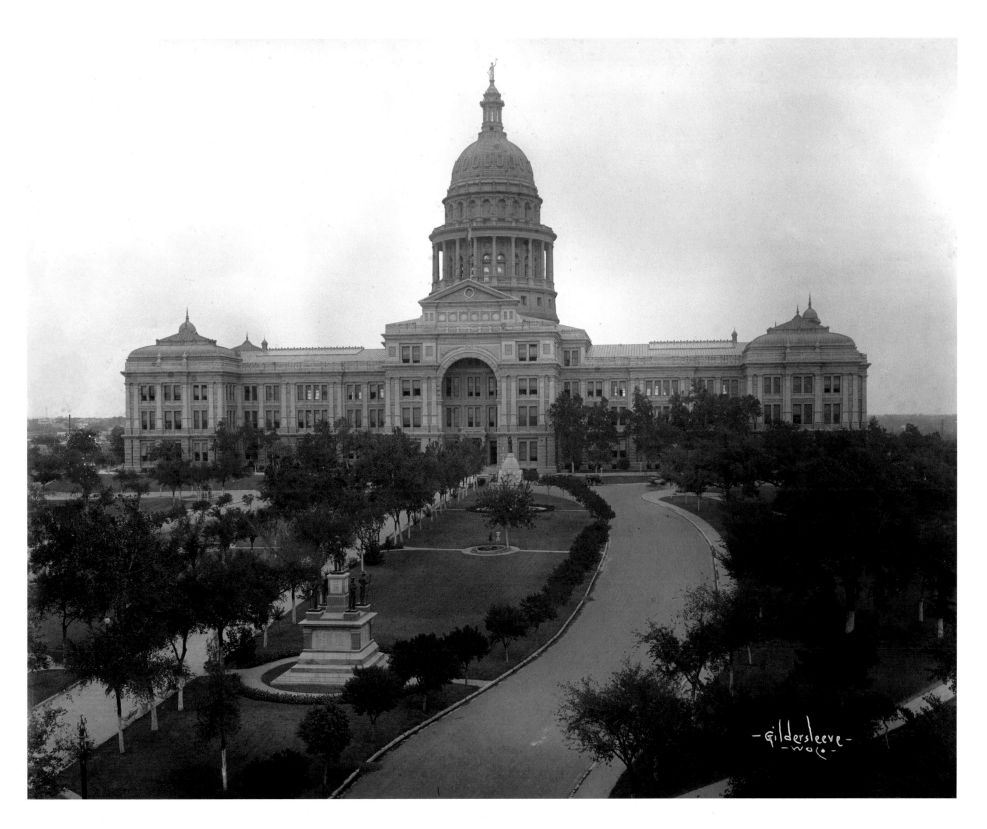

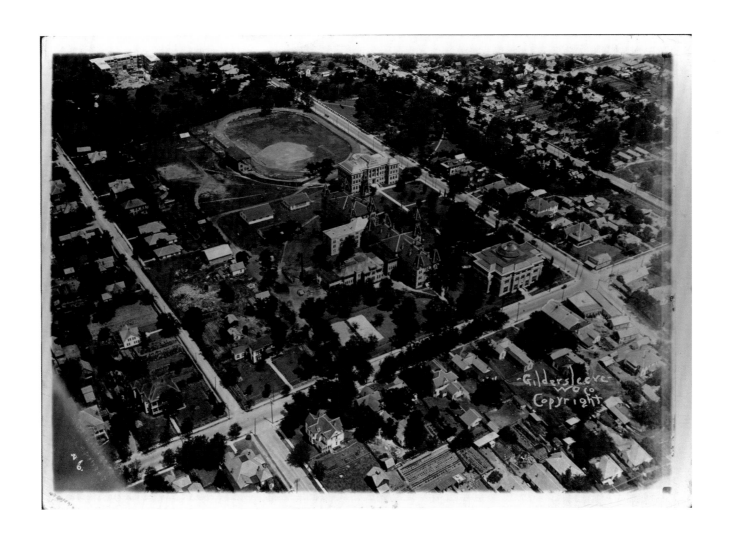

BAYLOR UNIVERSITY—OLD MAIN AND
GEORGIA BURLESON HALL

The Class of '15 prominently marks the tower
of Old Main. These two structures are
the centerpieces of the campus.

c. 1913. 8"x10" glass plate negative
Photographer: F. A. Gildersleeve
Place: Waco, Texas
Gildersleeve-Conger Collection #0430

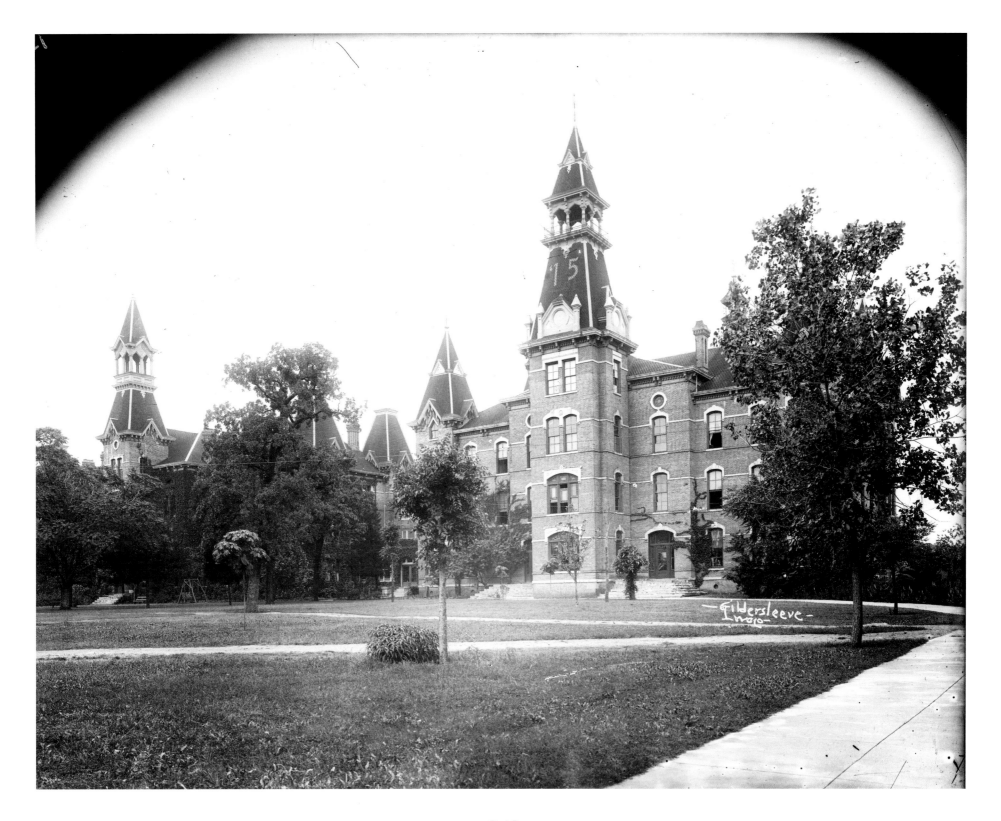

349

WACO HALL CONSTRUCTION

The exterior of Waco Hall as it nears completion.
Notice the animal-drawn transportation still in use.
The building stands at 624 Speight Avenue.

December 26, 1929. 8"x10" silver gelatin print
Photographer: F. A. Gildersleeve
Place: Waco, Texas
General Scrapbook Collection #3991

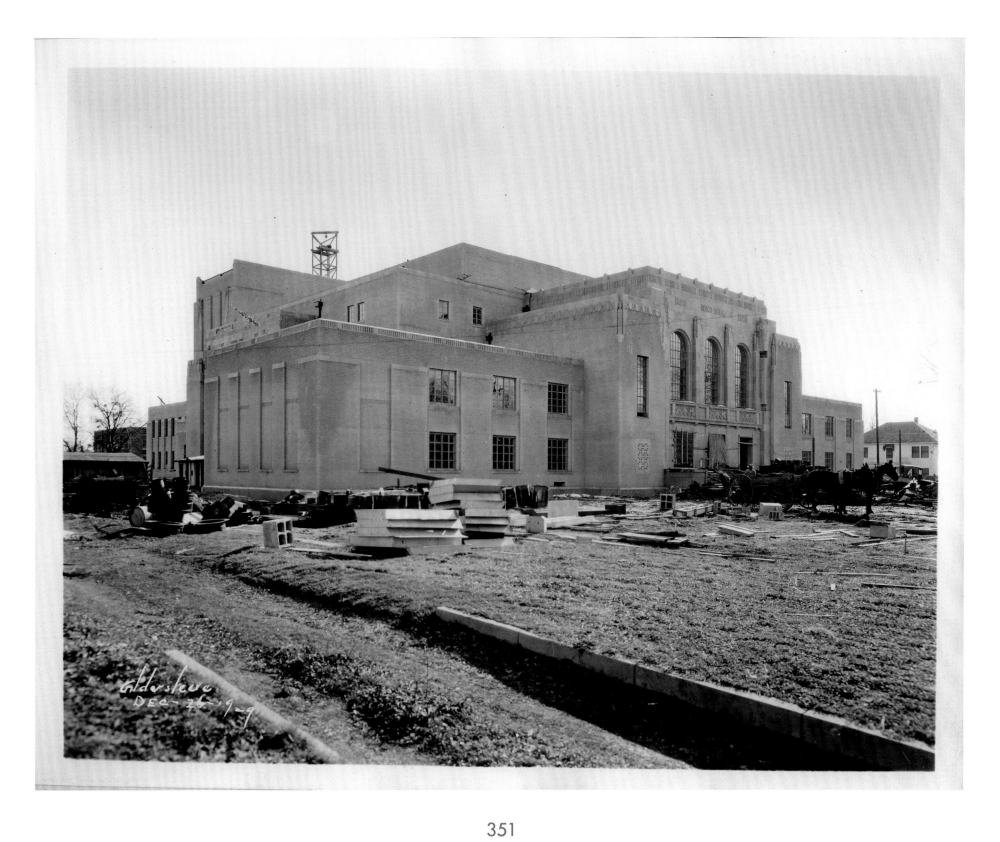

Gildersleeve
Dec 26 1929

351

CARROLL FIELD

A view of Carroll Field once located along
5th Street and behind the Carroll Science building,
from where this picture was taken.

1930. 8"x10" cellulose acetate negative
Photographer: F. A. Gildersleeve
Place: Waco, Texas
Gildersleeve-Conger Collection #0430

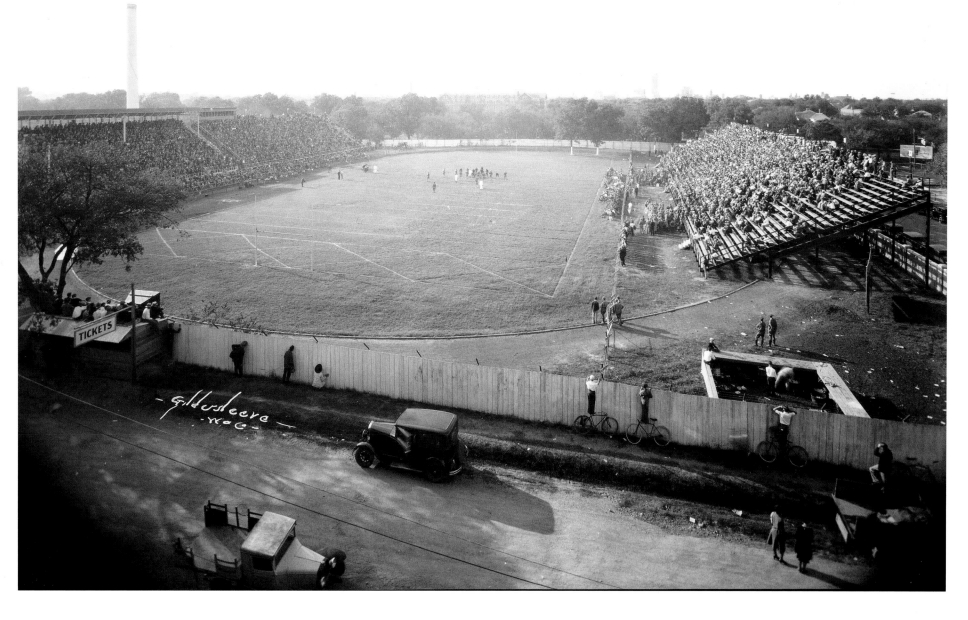

The freshman football squad of 1914 has
their team image taken on Baylor's Carroll Field.
Notice the shadow of Gildersleeve and
his large format camera.

1914. 8"x10" glass plate negative
Photographer: F. A. Gildersleeve
Place: Waco, Texas
Gildersleeve-Conger Collection #0430

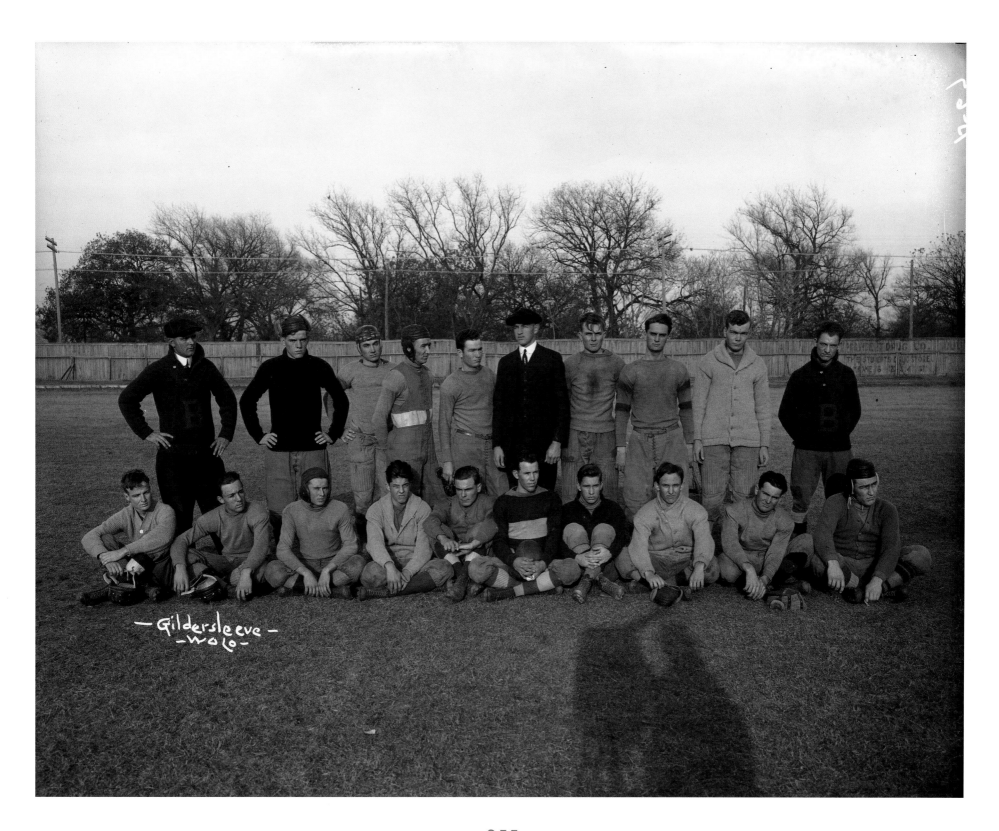

Gildersleeve
—Wolo—

**Baylor University versus Texas Christian University
at Carroll Field. The white arrow points to the ball.
Baylor won 6–3.**

November 1909. 5"x7" silver gelatin print
Photographer: F. A. Gildersleeve
Place: Waco, Texas
General Scrapbook Collection #3991

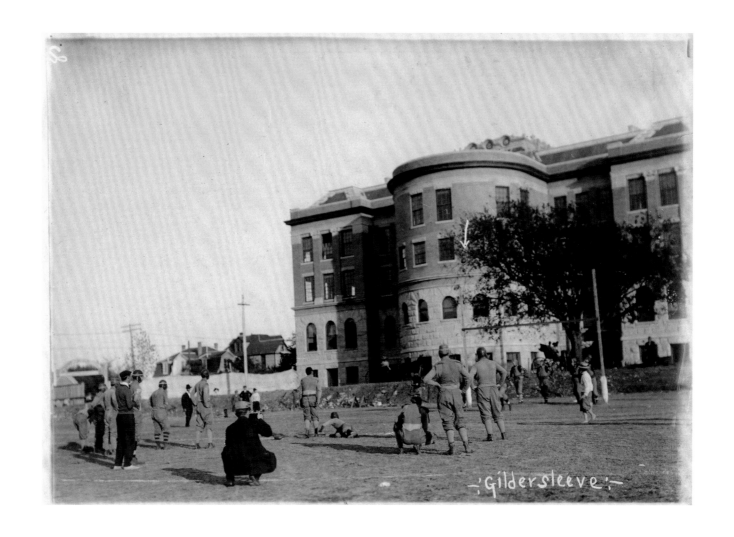

Gildersleeve

357

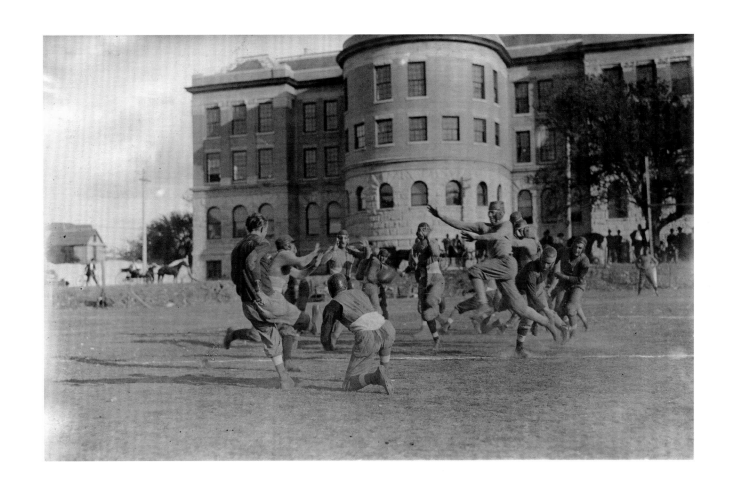

BAYLOR UNIVERSITY HOMECOMING
FOOTBALL GAME

**Baylor University versus Texas Christian University
at the homecoming game.**

November 1909. 5"x7" silver gelatin print
Photographer: F. A. Gildersleeve
Place: Waco, Texas
General Scrapbook Collection #3991

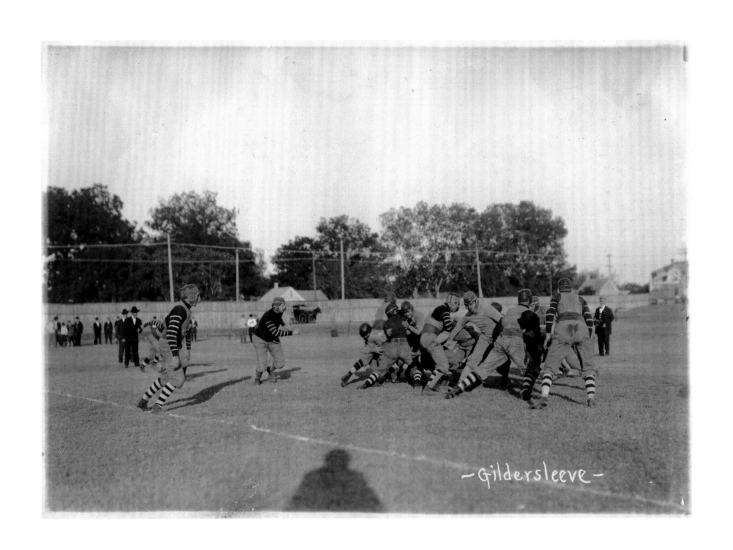

-Gildersleeve-

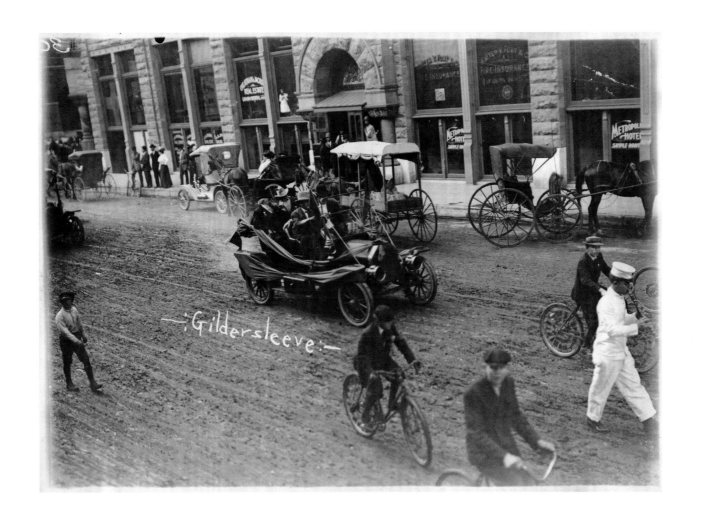

This Baylor Homecoming Parade had many
participants including members of the
Calliopean Literary Society.

November 1909. 5"x7" silver gelatin print
Photographer: F. A. Gildersleeve
Place: Waco, Texas
General Scrapbook Collection #3991

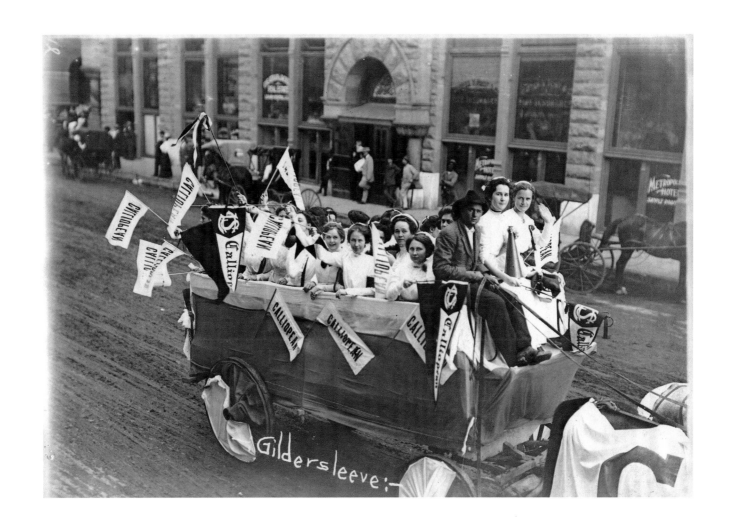

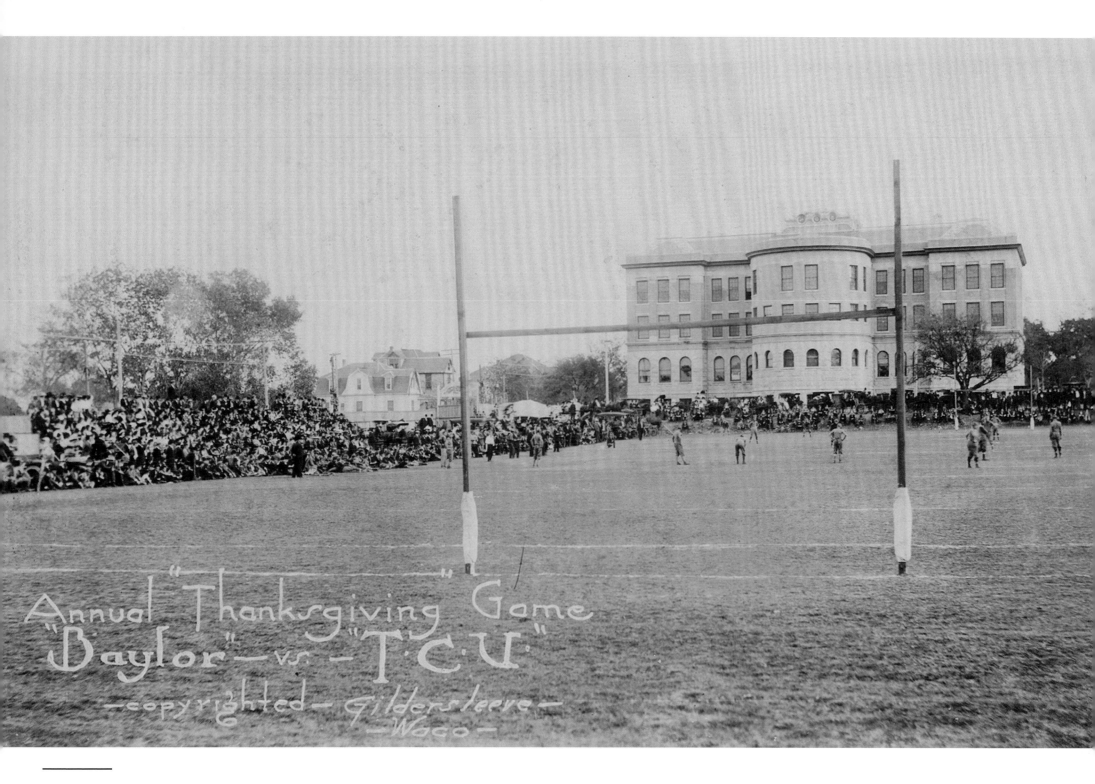

PLAYING FOOTBALL ON CARROLL FIELD

The annual Thanksgiving game against Texas Christian University at Carroll Field. The Carroll Science and Old Main buildings can be seen in the background.

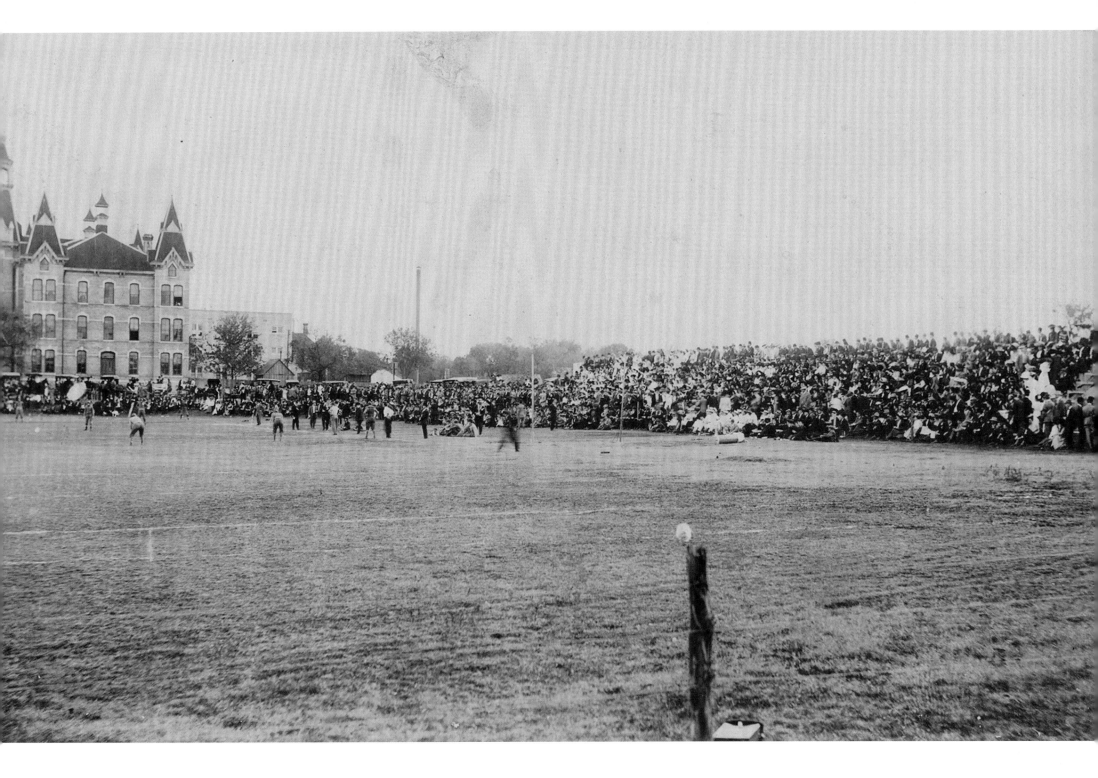

Thanksgiving 1909. 5"x17" silver gelatin print
Photographer: F. A. Gildersleeve
Place: Waco, Texas
The Texas Collection General Photo Files #3976

FRED GILDERSLEEVE AND DOG

Fred Gildersleeve and his dog, Jack, pose in the luxury of their home surrounded by wall decor and in a comfortable chair.

1944. 8"x10" silver gelatin print
Photographer: Unknown
Place: Waco, Texas
Gildersleeve-Conger Collection #0430

Jacket and Book Design by Diane Smith
Jacket Image: Detail from "A View from West of the Brazos" (panoramic on pp. 80–81)

ISBN 978-1-4813-0924-0.